Dear Kathy,

Simply put, this book would
not exist if I weren't for
your sensitive editing, your
intelligence, patience, and good
advice. What more could an
author hope for? I remain in
your debt

With warm regards,
Dolly

The Nation's First Monument and the Origins of the American Memorial Tradition

The commemorative tradition in early American art is given sustained consideration for the first time in Sally Webster's fascinating study of public monuments and the construction of an American patronymic tradition. Until now, no attempt has been made to create a coherent early history of the carved symbolic language of American liberty and independence. Establishing as the basis of her discussion the fledgling nation's first monument, Jean-Jacques Caffiéri's Monument to General Richard Montgomery (commissioned in January of 1776), Webster builds on the themes of commemoration and national patrimony, ultimately positing that like its instruments of government, America drew from the Enlightenment and its reverence for the classical past.

Webster's study is grounded in the political and social worlds of New York City, moving chronologically from the 1760s to the 1790s, with a concluding chapter considering the monument, which lies just east of Ground Zero, against the backdrop of 9/11. It is an original contribution to historical scholarship in fields ranging from early American art, sculpture, New York history, and the Revolutionary era. A chapter is devoted to the exceptional role of Benjamin Franklin in the commissioning and design of the monument. Webster's study provides a new focus on New York City as the eighteenth-century city in which the European tradition of public commemoration was reconstituted as monuments to liberty's heroes.

Sally Webster is Professor of American Art, Emerita at Lehman College and the Graduate Center, CUNY, USA.

To Nick

The Nation's First Monument and the Origins of the American Memorial Tradition

Liberty Enshrined

Sally Webster

ASHGATE

Published by
Ashgate Publishing Limited
Wey Court East
Union Road
Farnham
Surrey, GU9 7PT
England

Ashgate Publishing Company
110 Cherry Street
Suite 3-1
Burlington, VT 05401-3818
USA

www.ashgate.com

British Library Cataloguing in Publication Data
A catalogue record for this book is available from the British Library

The Library of Congress has cataloged the printed edition as follows:
Webster, Sally.
 The nation's first monument and the origins of the American memorial tradition: liberty enshrined / By Sally Webster.
 pages cm
 Includes bibliographical references and index.
 ISBN 978-1-4724-1899-9 (hardcover: alk. paper) 1. Nationalism and art—United States—History—18th century. 2. Monuments—United States—History—18th century. 3. Memorials—United States—History—18th century. 4. Montgomery Monument (New York, N.Y.) 5. Nationalism and collective memory—United States. I. Title.

N72.N38W43 2014
 725'.940973—dc23

2014038426

ISBN 9781472418999 (hbk)

 Printed in the United Kingdom by Henry Ling
Limited, at the Dorset Press, Dorchester, DT1 1HD

Contents

List of Illustrations

Introduction

I.1 St. Paul's Chapel, New York, Broadway entrance with banner "Out of the Dust," 2004. Photograph by the author

I.2 St. Paul's Chapel, New York, Broadway entrance with Jean-Jacques Caffiéri, Montgomery Monument, 1777. Photograph by Brett Beyer

I.3 Pierre-Charles L'Enfant, wooden casing with paint and plaster for General Richard Montgomery Monument, 1787. Photograph: Wurts Brothers, 1926. Box 545, File 2. Trinity Wall Street Archives

1 New York's De Lancey Family and the Origins of the American Memorial Tradition

1.1 Oliver De Lancey property, detail from Bernard Ratzer with designation of [Wolfe] monument, *Plan of the City of New York, in North America*, 41 15/16 × 35 13/16 in. (105 × 91 cm.), surveyed 1766 and 1767; published 1776. The Lionel Pincus and Princess Firyal Map Division. The New York Public Library, Astor, Lenox and Tilden Foundations

1.2 James De Lancey property, detail from Bernard Ratzer, *Plan of the City of New York, in North America*, 41 15/16 × 35 13/16 in. (105 × 91 cm.), surveyed 1766 and 1767; published 1776. The Lionel Pincus and Princess Firyal Map Division, The New York Public Library, Astor, Lenox and Tilden Foundations

1.3 John Smibert, *The Bermuda Group (Dean Berkeley and His Entourage)*, 69 1/2 × 93 in. (176.5 × 236.2 cm.), oil on canvas, begun 1728, completed 1732. Yale University Art Gallery, New Haven, gift of Isaac Lothrop

1.4 John Smibert, *Sir Peter Warren*, 92 × 58 in. (233.7 × 147.3 cm.), oil on canvas, 1746. Portsmouth Athenaeum, New Hampshire

1.5 Thomas Hudson, *Sir Peter Warren*, 53 1/2 × 52 in. (135.9 × 132.1 cm.), oil on canvas, c. 1751. National Portrait Gallery, London

1.6 Louis-François Roubiliac, *Sir Peter Warren*, marble, commissioned 1753, erected 1757. © Dean and Chapter of Westminster, London

1.7 Joseph Wilton, *Major General James Wolfe*, marble, unveiled, 1773. © Dean and Chapter of Westminster, London

4 Benjamin Franklin and the Commission of America's First Monument

4.1 Benjamin Franklin, *Hercules and the Wagoneer*, woodcut, 1747. Rare Books division, The New York Public Library, Astor, Lenox and Tilden Foundations

4.2 Benjamin Franklin, *Join, or Die*, woodcut, 1754. Library of Congress, Washington, D.C.

4.3 J.F. Moore, *Britannia, Reviver of Antique and Prompter to Modern Arts*, marble relief, 1766. Royal Society of Arts, London

4.4 Benjamin Franklin, *MAGNA Britannia; her Colonies REDUC'D*, ca. 1766. Library Company of Philadelphia

4.5 Abbé de Saint Non, after Jean-Honoré Fragonard, *Le Docteur Franklin Couronné par la Liberté*, aquatint, 1778. American Philosophical Society, Philadelphia

4.6 Jean-Honoré Fragonard, *Eripuit Coelo Fulmen Sceptrum que Tirannis au Génie de Franklin*, 19 × 14 1/2 in. (69 × 48 cm.), etching, 1778. American Philosophical Society, Philadelphia

4.7 Antoine Borel, *L'Amérique Independante Dédiee au Congres des États unis de l'Amérique*, 52 × 40 cm., engraving, 1778. American Philosophical Society, Philadelphia

4.8 Jean-Jacques Caffiéri, *Claude-Adrien Helvétius*, 82.5 × 61.2 × 39.9 cm., marble, 1772. Musée du Louvre, Paris, France, © RMN-Grand Palais/Art Resource, NY. Photograph by Thierry Le Mage

4.9 Jean-Jacques Caffiéri, *Benjamin Franklin*, bust, painted plaster, 1777. The New-York Historical Society

5 New York, Pierre-Charles L'Enfant, and a Monument for America

5.1 Jean-Jacques Caffiéri, *General Richard Montgomery Monument*, 120 × 60 in. (304.8 × 152.4 cm.), marble, 1777. St. Paul's Chapel, New York, Courtesy of Leah Reddy/Trinity Wall Street

5.2 Augustin de Saint-Aubin, *Á la gloire de Richard de Montgommery …*, 11 9/16 × 7 5/8 in. (29.4 × 19.4 cm.), engraving, 1779. I.N. Phelps Stokes Collection, Miriam and Ira D. Wallach Division of Art, Prints and Photographs, The New York Public Library, Astor, Lennox and Tilden Foundations

5.3 John Evers, after Thomas Barrow, *Ruins of Trinity Church after the memorable conflagration Sept. 21st 1776*, 10 7/16 × 12 3/16 in. (26.5 × 31 cm.), color lithograph, 1841. I.N. Phelps Stokes Collection, The Miriam and Ira D. Wallach Division of Art, Prints and Photographs, The New York Public Library, Astor, Lennox and Tilden Foundations

5.4 Thomas McBean (?), *St. Paul's Chapel*, 1764–1766; porch 1767–1768. Photograph taken before September 11, 2001. Trinity Wall Street Archives

5.5 Interior of St. Paul's Chapel with altar by Pierre-Charles L'Enfant, 1787. Photograph by Brett Beyer

5.6 Pierre-Charles L'Enfant, altar, 1787. Interior of St. Paul's Chapel. Photograph by Brett Beyer

5.7 First Die of the Great Seal of the United States, 1782, 2 1/16 in. (5.2 cm.) in diameter, brass, 1782. National Archives and Records Administration, Washington, D.C.

5.8 Society of the Cincinnati Eagle insignia owned by Lt. Col. Tench

Acknowledgments

My research on the General Richard Montgomery monument (1777), installed after the Revolution at St. Paul's Chapel in lower Manhattan, began in the archives of Trinity Church since St. Paul's is its parish church. Here I was assisted by its dedicated archivists of Trinity Church, Gwynedd Cannan, her successor, Anne Petrimoulx, and their staffs. Ms. Cannan allowed me access to the early minutes of the trustees and to the church photographic collection, where she found the picture, taken in the 1920s, of the monument's frame designed by Pierre-Charles L'Enfant. From these files I was able to piece together the monument's early years in America.

I also consulted the *Journals of the Continental Congress*, where I found confirmation that Benjamin Franklin had been assigned the task of finding a sculptor in Paris for the Montgomery Monument. From biographical sources, namely Hal T. Shelton's *General Richard Montgomery and the American Revolution: From Redcoat to Rebel* and Michael P. Gabriel's *Major General Richard Montgomery: The Making of an American Hero*, I gained knowledge of Montgomery. Also informative were George Dangerfield's authoritative biography of Montgomery's brother-in-law Chancellor Robert R. Livingston and Cynthia Kierner, *Traders and Gentlefolk: The Livingstons of New York, 1675–1790*.

This reading led me on a fascinating and multiyear study of the Livingston family and their role in both the province and the city of New York that included research in the New-York Historical Society and the New York Public Library. While working on the history of the Livingston family, I became convinced that I could establish some kind of linkage between New York's other important colonial family, their arch-rivals, the De Lanceys, which might shed light on the monument's placement in New York. While no such connection to the Montgomery Monument was established, knowledge of the

De Lancey family history led me to investigate, and subsequently, document their involvement with three earlier New York City monuments.

To better limn this early New York history I consulted Edwin G. Burrows and Mike Wallace's extraordinary narrative *Gotham: A History of New York City to 1898*, which I supplemented with Patricia U. Bonomi, *A Factious People: Politics and Society in Colonial New York*; Carl Bridenbaugh, *Cities in Revolt: Urban Life in America, 1743–1776*; Edward Countryman, *A People in Revolution: The American Revolution and Political Society in New York, 1760–1790*; and Thomas Jefferson Wertenbaker, *Father Knickerbocker Rebels: New York City during the Revolution*.

I next turned to Franklin's involvement with the monument. I had no formed opinion of Franklin, my main impression was that he was a somewhat priggish founding father who exhorted his countrymen to be early bed and early to rise. Happily my biases were challenged and overturned by H.W. Brands's *The First American: The Life and Times of Benjamin Franklin*. Brands's was a portrait very different from my ill-informed impression. Instead of a provincial bumpkin who flew kites, Brands revealed Franklin as the most cosmopolitan of Americans, comfortably at home in the international world of the eighteenth-century Enlightenment. Equally valuable was Stacy Schiff's important study of Franklin's years in Paris, *A Great Improvisation: Franklin, France, and the Birth of America*, which helped shed light on his relationship with Mme Helvétius, who was no doubt instrumental in introducing the Sage of Auteuil to the sculptor and designer of the Montgomery monument, Jean-Jacques Caffiéri.

But I needed to dig deeper in order to understand the nature of Franklin's interest in public monuments. This took me to the American Philosophical Society and the guidance of Roy Goodman, the society's gifted and generous librarian and curator of printed material, and later to the Royal Society of Arts in London where Rebecca Short was my guide

At the Royal Society of Arts I had the pleasure of meeting the Canadian art historian Joan Coutu whose *Persuasion and Propaganda: Monuments and the Eighteenth-Century British Empire* is a landmark study. The book's focus is the dissemination of the British commemorative tradition in the North America, the Caribbean, and India. In it Coutu firmly establishes her thesis through the inclusion of many monuments in varied places, each one indebted to British tradition. Her view is from a British imperial standpoint; mine is from a colonial or American viewpoint; thus our studies are complementary, each looking at similar monuments but from opposite shores. Her research was an outgrowth of her earlier study of Joseph Wilton who was the artist for two of New York's monuments. Her work has been of enormous help to me; Wilton ultimately becoming the central pivot connecting the De Lancey's, Westminster Abbey, and sculptures of General James Wolfe, William Pitt, and George III.

Soon other important aspects of my initial research needed further exploration, including the artist, Jean-Jacques Caffiéri, the sculptor of the Montgomery monument. This quest brought me inevitably to Paris and the Louvre. For initial guidance James Draper, the Kravis Curator of Eighteenth-century French Sculpture at the Metropolitan Museum of Art in New York, suggested I contact his colleague at the Louvre, Guilhelm Scherf. I remain grateful to James Draper for his support of my project and his delight in the Montgomery monument, and to Guilhelm Scherf for granting me access to the Louvre curatorial files and to my colleague and friend Louise d'Argencourt for assistance and companionship in Paris. For this trip and an earlier trip to England, I thank the Professional Staff Congress of the City University of New York for financial support.

In addition I read broadly on both the French and Indian War and the American Revolution. For the former I relied on Fred Anderson's *Crucible of War: The Seven Years' War and the Fate of Empire in British North America, 1754–1766*; for the latter, Robert Middlekauff's *The Glorious Cause: The American Revolution, 1763–1789*, and Kenneth Silverman's *A Cultural History of the American Revolution*.

The most challenging chapter to write was the first one in which I deal with the earliest forms of public commemoration in North America, including paintings by the British-born artist John Smibert and an obelisk dedicated to the memory of General James Wolfe. Over the years, a number of colleagues helped me, including fellow Americanists Richard Saunders and Ellen Miles regarding questions about John Smibert; Wendy Bellion who shared her research on New York City's liberty poles; Tom Hardiman, the librarian at the Portsmouth Athenaeum, who spoke with me about the Athenaeum's Smibert portraits; and Katie Rieder who shared information on American loyalists.

In this same chapter, I speak about the influence of the garden design and the monuments of Stowe in England, including an obelisk to Wolfe. I remain grateful to the estimable George Clarke whose work on the history of Stowe is comprehensive and invaluable, and I also extend thanks to the estate's archivist, Michael Bevington. Several historians and curators helped me to think through a description of the Wolfe obelisk—Bernard Herman (University of Delaware), Barbara Luck (Colonial Williamsburg), and Lucy Wood (Victoria and Albert Museum)—and I am grateful for their guidance and advice. Essential to my understanding of the De Lancey in-law Sir Peter Warren, I remain forever thankful for the kind generosity of the commander's estimable biographer, Julian Gwyn.

Over the years my research has been supported by colleagues who have invited me to present papers at two College Art Association panels. At the first I met the admirable Georgia Barnhill, curator of Graphic Arts emerita at the American Antiquarian Society, who introduced me to Stephen Bullock, the authority on the early history of Masonry in North America. His book

Revolutionary Brotherhood: Freemasonry and the Transformation of the American Social Order, 1730–1840 was revelatory and remains a landmark study. It was helpful to me in understanding the role of Freemasonry and its ubiquity in the early Republic. My conversations with both Georgia and Steven started me down the trail of Masonic imagery and its possible relevance to the symbols in the Montgomery Monument. Ultimately the material became overwhelming, and I leave it to others to tease out the connections.

Instead I followed the trail laid down by two authors of eighteenth-century symbolism, including two works by Lester Olson: *Emblems of American Community in the Revolutionary Era* and *Benjamin Franklin's Vision of American Community: A Study in Rhetorical Iconology*. More influential since it better dovetailed with my own focus was Benjamin Irvin's *Clothed in Robes of Sovereignty: The Continental Congress and the People Out of Doors* with its early studies of swords, medals, and monuments issued by the Continental Congress and documented in the *Journals of the Continental Congress*.

I was asked to present my research at the annual meeting of the American Society for Eighteenth Century Studies and I am indebted to Alden Gordon, Trinity College, Hartford, for the invitation. Here I presented my new findings on the L'Enfant frame, which houses the Montgomery Monument. Throughout my work on L'Enfant's career in New York, I have relied on the encouragement of Pamela Scott, the authority on Washington, D.C.'s monuments and architecture. I also extend thanks to Emily Schulz, deputy director and curator at the Society of the Cincinnati, whose medal L'Enfant designed, for her advice and help in securing images. I also thank Kim Orcutt, formerly of the New-York Historical Society, for her assistance in acquiring photographs of Joseph Wilton's *William Pitt*. As always, I remain in the debt of William Gerdts who allowed me access to his cache of material on Joseph Wilton and the sculptor's New York monuments.

It was a pleasure to also receive input from Judy Jacob, the intrepid senior conservator for the National Park Service, who invited me to view and study the trophée d'armes, a carved decoration (1796) at the top of the sally port at Fort Jay on Governor's Island in New York. We were particularly interested in its possible relationship to the iconography of the L'Enfant frame at St. Paul's. I also thank Linda Hanick and Lloyd Kaplan of Trinity Church and Glenn Boornazian of Integrated Conservation Resources for allowing me access to the monument during the course of their 2011 restoration efforts. I also appreciate the good fellowship and conversations with the hardworking photojournalist Fred Schang from CNN, who doggedly documented the monument's restoration and who later came to my rescue with still images of the conservation process and of St. Paul's interior. I am also grateful to my nephew, the photographer Brett Beyer, for coming to my aid at the last minute and supplying me with lovely images of St. Paul's interior and exterior.

Important early support of my project came from colleagues connected to the Association of Historians of Nineteenth-Century Art, who published my research titled, "Pierre L'Enfant and the Iconography of Independence," in their online journal, *Nineteenth-Century Art Worldwide*. These colleagues also invited me to submit, "Origins of the American Memorial Tradition," for publication in *Re-presentations and Re-constructions in Nineteenth-Century Art: Revisiting a Century*. I remain grateful to Gabriel Weisberg, Petra ten-Doesschute Chu, and Lorinda Dixon for their encouragement and guidance.

I gave other presentations at the New York Public Library, my home away from home since my retirement from full-time teaching, and I am indebted first to David Smith and then to Jay Barksdale for granting me access to the Wertheim Study and for their undiminished support for my Montgomery project.

It is safe to say that this manuscript in its present form would not have seen the light of day if it had not been for the enthusiasm of my colleagues both at Lehman College and the Graduate Center of the City University of New York. The former were my cheerleaders, the latter afforded me the opportunity to try out my ideas in public forums. I think back with gratitude to Claire Bishop who organized an evening's roundtable, where I shared my early efforts to connect the De Lanceys to the history of New York's colonial monuments.

I am also grateful to Kevin Murphy, the former executive officer of the doctoral program in art history, who read an early version of my project. I also came to rely on the generosity of my former students including Deborah Bershad Addao, who worked long hours as a research assistant, Karen Lemmey, and my beloved colleague Harriet F. Senie, for reading a draft of my introduction; Paul Rangovic who quickly and effortlessly turned image files into PDFs; and Lauren Ritz for her help in securing permissions and in organizing the book's images for publication. I am especially appreciative of Kathleen Luhrs's advice and fine editing of the final manuscript. Other colleagues and friends who read parts of the manuscript deserve thanks, especially Erika Doss, Kirk Savage, and Bob and Sarah LeVine. I also am forever grateful to Thayer Tolles, Stephen Edidin, Michele Bogart, Patricia Mainardi, and Peter Prescott for their friendship and support. Lastly, I want to thank Ashgate Publishing for its continued support of my manuscript and to my editor, Margaret Michniewicz, for her encouragement and oversight.

Also thanks to my family. In addition, to my husband, to whom I dedicate this book, I am grateful for the love and support of Albert and Kate, my children; Kristina Stierholz and Marsha East, their partners; Karl, Lilly, and Eric, my grandchildren; and Bob, Jack, and Jeff Beyer, my brothers, and their spouses, Karen, Kathy, and Maryam.

To one and all, my thanks and undying gratitude.

Introduction

Several years ago while planning a book on the history of American monuments, I chanced upon a timeline of American memorials published by the National Park Service. I had never heard of the first—a Revolutionary War monument, dated 1777, dedicated to the memory of General Richard Montgomery (1738–1775) and created by a French sculptor, Jean-Jacques Caffiéri (1735–1792). I was surprised to discover that it was in New York where I live. Learning that it could be found on the porch of St. Paul's chapel in lower Manhattan, I hurried downtown.

When I came out of the subway, I was brought up short. Across the street from St. Paul's graveyard was the 15-acre chasm left by the destruction of the World Trade Center. Tied to the graveyard's iron railings were mementos—flowers, notes, wreaths—tributes from thousands of visitors and further evidence of the tragedy. In a daze, I walked east along Fulton Street to the chapel's Broadway entrance in search of the monument, but it was nowhere in sight. Instead I found a wooden shed covered by an enlarged photograph of the chapel's steeple amid the smoking destruction of the World Trade Center with the words "St. Paul's Chapel, Out of the Dust" (Figure I.1), a poignant reminder of the building's almost miraculous survival. Unseen behind the shed, safely protected from falling debris, was the Montgomery Monument.

St. Paul's served for more than a year as a sanctuary for firemen and first responders and on the day I arrived the chapel was again open to the public. Filled with displays of firemen's patches, teddy bears, photographs, and plastic flowers, it had become a shrine honoring the efforts of those who aided the cleanup and a memorial for those who died. It was also the home to the country's first national monument.

When the shed came down six months later, I finally saw it, a handsome wall sculpture located near the chapel's Broadway entrance in front of a large, multipaned, Palladian window (Figure I.2). As the nation's first monument, I was surprised by how small it was and that it contained no image of the fallen hero. Instead, the carved symbolic elements on its upper portion—a discarded

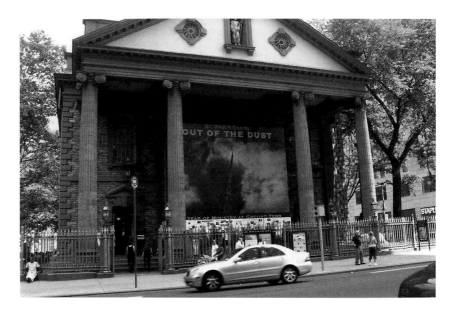

I.1 St. Paul's Chapel, New York, Broadway entrance with banner "Out of the Dust,"
2004. Photograph by the author

helmet and armor, palm fronds, and a downturned club—contained no
specific reference to either Montgomery or the Revolutionary War. Looking
more closely, however, I found two Latin words, *libertas restituta* [restore
liberty], incised on a stone ribbon encircling the club. These words, not easily
seen, are a subtle reference to the proximate cause of the colonial rebellion
and were chosen before the impact of the Declaration of Independence was
fully understood.

On the base of the monument are two inscribed plaques. The upper one
details Montgomery's life and deeds, and the lower, installed in 1818 at
the behest of his widow, Janet Livingston Montgomery, documents the
reinterment of the hero's remains at St. Paul's.

But there was more to discover. About six months into my research, the
archivist of Trinity Church (St. Paul's is its parish chapel) showed me a
photograph of a triangular-shaped box decorated with intriguing painted
symbols (Figure I.3). The photograph was taken in the 1920s at the time of
the chapel's renovation, which involved the dismantling of the Montgomery
Monument. After dislodging the memorial from its site, workmen discovered
that it had been housed in a wooden boxlike frame—the object in the
photograph. Surprisingly, according to entries in the vestry minutes, the
frame had been designed by another Frenchman, Pierre-Charles L'Enfant,
better known for his urban design plan for Washington, D.C. Following
his military service in the American Revolution and prior to his work in

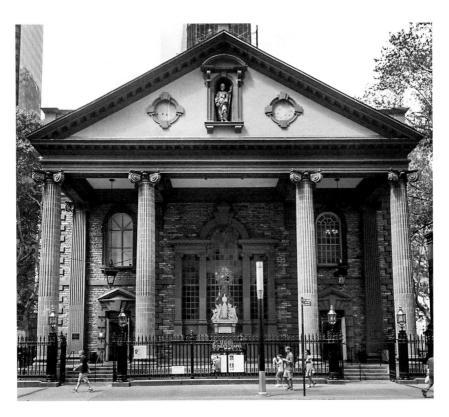

I.2 St. Paul's Chapel, New York, Broadway entrance with Jean-Jacques Caffiéri, Montgomery Monument, 1777. Photograph by Brett Beyer

Washington, L'Enfant lived for several years in New York. In 1787, shortly before the city became the nation's capital, the church wardens hired him to restore the chapel and install the monument. The wooden casing or frame was used to better secure the sculpture to the front of the windows. Before installing it, however, L'Enfant decorated it with symbols of the new nation, drawn in part from the design of the newly authorized Great Seal of the United States. L'Enfant's embellished frame, which can still be seen behind the chapel's Palladian windows, embraces the Montgomery Monument and augments its meaning. This was an important discovery, for the painted casing documented both L'Enfant's career in New York and his contribution to an emerging national iconography.

I was becoming overwhelmed with the rich history represented by this multipart installation and needed to start at the beginning. Who was Richard Montgomery and why did he warrant a monument that the National Park System deemed the nation's first? As I soon learned, Montgomery was a brigadier general in the Continental Army who in the fall of 1775, following the

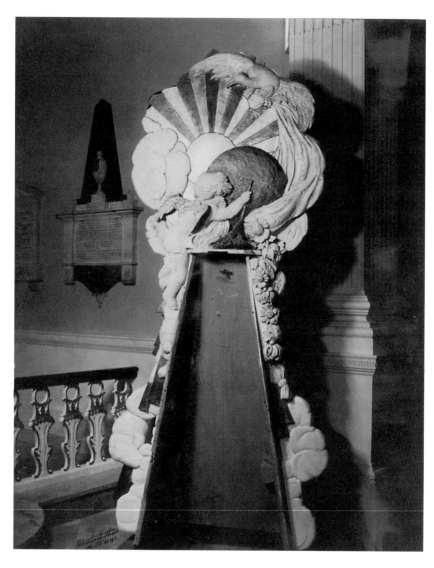

I.3 Pierre-Charles L'Enfant, wooden casing with paint and plaster for
General Richard Montgomery Monument, 1787.
Photograph: Wurts Brothers, 1926. Box 545, File 2.
Trinity Wall Street Archives

battles of Lexington and Concord and Bunker Hill, led a New York regiment on an invasion of Canada, the first American offensive of the Revolution. Tragically, Montgomery died during the siege of Quebec, the American troops were defeated, and plans to capture Canada were abandoned. Yet Congress needed a hero. Gravely saddened by the loss of a general and the whole campaign, Congress turned Montgomery's sacrifice into a national call to arms. Part of the program was a resolution authorizing a monument in his name, just weeks after his death, which included the stipulation that Benjamin Franklin commission the monument in Paris. Franklin, who would go on to serve as the nation's first ambassador to France, shortly after his arrival in Paris, hired Jean-Jacques Caffiéri, sculptor to Louis XVI. The commission was quickly completed and subsequently exhibited at the Paris Salon of 1777. These facts—its official authorization and Franklin's involvement with the commission—convinced me that this virtually unknown monument was deserving of a chapter in my prospective book on American monuments. With the discovery of the L'Enfant frame, however, I abandoned my original project and set out to write a book on the nation's first monument.

As I worked to form my thesis, I realized that I needed a context for this discovery, primarily because we know very little about the roots of our memorial tradition, which are almost exclusively European. Maybe we have not given our commemorative tradition enough thought or do not really care about it. If we did, we would have to admit that the American tradition is largely a manifestation of our strong ties to European culture. This borrowing did not stop with the American Revolution when Americans ceased being British citizens. No curtain came down between colonial tradition and post-Revolutionary practice to cause artistic forms to suddenly appear different from European and ancient models. This allegiance is found in the form and meaning of our early monuments and is seen most convincingly in the classic design of the United States Capitol. Acknowledging our reliance on European models for our art and architecture is also a way to connect the colonial past with the early visual culture of the new nation. Instead of a chasm separating two eras—colonial times and independence—a fluid interchange existed that continued to evolve until new forms emerged that became American.

At the end of the American Revolution it was impossible for the people of the new nation following the throes of war to turn on a dime and establish new symbolic and expressive forms. In fact the country's earliest emblems and monuments—the American flag, the Great Seal, the Montgomery Monument—did become transformed in their transatlantic passage. The American projects perforce are diminished in scale, refinement, and value, but not in significance.

In order to understand this indebtedness I turned to earlier commemorative representations—portraits, an obelisk, a standing statue, and an equestrian one—that are among the earliest acknowledgments of what was essentially

an Anglo-European tradition. These include portraits commissioned by Sir Peter Warren to commemorate the 1744 Siege of Louisbourg and three earlier New York monuments: an obelisk (1762) to honor General James Wolfe's heroic death on the Plains of Abraham; a full-sized standing marble statue of William Pitt (1769) on Wall Street in front of City Hall; and a gilded lead equestrian statue of George III (1769) placed in Bowling Green—the latter two both ordered from the English sculptor Joseph Wilton.

I started by assembling the lost narratives of these monuments, with a particular focus on that of Montgomery, and placed them within a historic framework. What emerged from my study was a compelling, old-fashioned concept of the hero. In the twentieth and early twenty-first centuries memorialization often honors the common soldier, the men in the trenches of World War I, the G.I. Joes of World War II, and more recently "our boys in Iraq." In contrast, 250 years ago commemoration was focused on the cult of the hero—the personality of the man who led his troops to victory. The cult of the hero, which nowadays is dismissed as focusing on the one above others, was in fact the beginning of a democratization of our understanding of who fought the wars and who helped win them. In the eighteenth century, commoners such as General James Wolfe replaced the emperor, the pope, the king, or the aristocrat as a war hero. Wolfe was none of these, but he won his right as a hero through his daring military exploits on the Plains of Abraham outside Quebec, where he died while securing victory and won Canada for England. So too did Richard Montgomery, who led his troops on an invasion of Quebec where he also lost his life, and in so doing became a hero for the newly minted patriots in the Continental Congress; one they could call their own.

My challenge then became whether I could create a narrative that would effectively link these early forms of public commemoration by placing them in an Atlantic world context. To do so, I limned the histories of these New York monuments and paid special attention to their European lineage and linked their North American sites with their European counterparts. These included Lord Cobham's English estate in Stowe with a vanished private garden in Greenwich Village; an outdoor plaza in the urban metropolis of London with a bowling green in the provincial city of New York; and Westminster Abbey with the small Anglican chapel of St. Paul's in New York.

That New York's eighteenth-century public monuments were by and large the earliest forms of public commemoration in North America may surprise the good citizens of Boston and Philadelphia. New York has never been known for its Heritage Trail or as home to Revolutionary heroes, yet it was an important military base and a lucrative trading center, factors that contributed to its unprecedented wealth and the creation of a cosmopolitan environment that expressed the cultural ambitions of its merchant class. In addition to elegant churches, shaded boulevards, and opulent estates, pre-Revolutionary New York was also graced with a private garden

punctuated by a commemorative obelisk and opened to the public, a city hall with a standing marble statue in front, and an elegant town square featuring an equestrian statue in the European manner. Although these earlier monuments were lost after the Revolution, their public ethos was supplanted by the new nation with a national monument in a church. At the same time, when compared with the architecture and monuments of the great cities of Europe, the New York examples are but shadows. On this side of the Atlantic, however, they meant something different and in some respects were antiestablishment. Even though commissioned by a variety of patrons—a private family, the General Assembly of the province of New York, and the Continental Congress—the four monuments celebrated not power and dominion but freedom and heroism. Even the equestrian statue of George III was seen by Tory merchants as a monument honoring a beneficent monarch mindful of colonial freedoms. Nor did these European/American works remain alien in form; they were widely imitated over the next two centuries—an obelisk forms the basis of the Washington Monument; a statue of a standing statesman is repeated innumerable times, including Frederick MacMonnies's *Nathan Hale* (1893) in New York's City Hall Park, Rudulph Evans's, *Thomas Jefferson* (1943–1948) at the Jefferson Memorial on the Washington Mall, and Augustus Saint-Gaudens's general-on-horseback, the *General William Tecumseh Sherman* (1903) that graces the southeast corner of New York's Central Park. Examples in imitation of Caffiéri's Montgomery Monument can be found immediately inside St. Paul's and perpetuate an earlier tradition of church wall sculptures. So familiar are these European precedents within the American commemorative landscape that their origins are seldom acknowledged, let alone explored.

This assertion calls into question the idea that there is an indigenous commemorative tradition uniquely crafted and inspired by artists working in this democratic country. More typical and truer is that an amalgamation of forms and ideas—some ancient European concepts, some Enlightenment imagery—came together in an altered political context that spells American. This hybridization is a hallmark of the Montgomery Monument's history; and, as the country's first authorized public memorial, its status invites ways to establish and rethink the American memorial tradition.

To begin my own assessment I found it essential to investigate the eighteenth-century context of the earlier New York monuments, including the Montgomery Monument. As a consequence, I spend a good deal of time discussing battles—the 1744 Siege of Louisbourg; General James Wolfe's 1759 victory at Quebec; the engagements of 1775 at Lexington and Concord, and Bunker Hill; and the invasion of Canada. This was necessary for several reasons; chiefly it is difficult to understand the commemorative impulse without knowledge of the historical circumstances that precipitated public adulation. Similarly, I spend a lot of time discussing Canada and the

geographical area of the St. Lawrence River, which throughout the eighteenth century was contested land that bordered New York—first as a French province and later as an area loyal to the British. Only with a clear understanding of the importance of this territory for European dominion, including General's James Wolfe's death on the Plains of Abraham, can we begin to appreciate the meaning of the Montgomery Monument for the American Revolution.

Another area of inquiry was the new nation's need for new symbols—flags and emblems—to signal the country's separation from Great Britain. The first was a design for a new flag (July 14, 1777), one to be flown in battle, from the high masts of ships and in front of government buildings. The second was an official seal to certify documents—treaties and the like. Others followed— medals, insignia, and monuments. All were approved by the Continental Congress and their authorization duly noted in the *Journals of the Continental Congress*. At the same time, these new American symbols, their purpose and form, were based on foreign models. For instance, the design of the American flag has been credited to several versions of the British flag, and the symbols found on the Great Seal can be traced to devices found in European emblem books. The reliance on foreign models was a necessary expediency: there was no time to seek alternatives to universal images; and there was an unstated reluctance to sever ties to the philosophic, artistic, and literary traditions of Europe. While the nation was created seemingly overnight, its symbols and instruments of government (along with much else) emerged from a respectful and learned understanding of pre-Revolutionary precedents—British and European.

A description of this tradition and its necessity for the new nation is found in comments by François-Jean, marquis de Chastellux, a major general whose French regiment helped secure victory in 1781 at Yorktown. After the war Chastellux traveled through the country, meeting Americans and assessing the social and cultural climate in the new republic. His journals, published as *Travels in North America,* are considered a precursor to Alexis de Tocqueville's *Democracy in America*. In them he describes in evocative detail the places he visited, the people he met, and the advice he gave to all who would listen, including his observations on the role of the fine arts in the United States. As Chastellux declared, "the Fine Arts are suited for America" and should be supported by "the Public, by the State, and the Government." Speaking specifically about commemorative or public art, he went on to comment:

> Call the Fine Arts to the aid of timid legislation. The latter confers neither rank nor permanent distinction; so let it be generous with statues, monuments, and medals …. Let me behold in all the great towns of America statues of Washington, with this inscription *Pater, Liberator, Defensor Patriae*; may I see, too, statues of the Hancocks and the Adamses, with only these two words, *Primi Proscripti*; and statues of Franklin, with the Latin verse inscribed in France below his portrait. What glory America would derive from these! She would

find that she has more heroes than she has marble and artists to commemorate them! And your public buildings, your *curiae*, why should they not display in sculptured relief and in painting the battles of *Bunker's Hill*, of *Saratoga*, of *Trenton*, of *Princeton*, of *Monmouth*, of *Cowpens*, of *Eutaw Springs*?[1]

Chastellux's prescription has uncanny resonance, for many of the soldiers, statesmen, and battles he mentions were eventually honored by significant monuments, and often more than one, including a series of history paintings created in the 1820s by the English-trained American painter John Trumbull for Rotunda of the United States Capitol. Furthermore, Chastellux's thoughts provide an important context for understanding the necessity the founding fathers felt to adopt a European tradition of honoring national heroes.

In some ways this is an old-fashioned project, one that relies on an older historical methodology of archival research for documentation and imagery. I also deploy an archaeological spirit—unpacking and identifying the earliest forms of public commemoration in New York City that by and large were also the earliest forms of public memorialization in North America. In so doing I have created an early map of public commemoration, one that will be useful in establishing the parameters for a larger understanding of American monuments. Later on, I include additional thoughts about its construction.

At the same time I have been influenced by a methodological construct that today's scholars refer to as the Atlantic World. A concept that Susan Manning and Francis D. Cogliano, in the introduction to their book *The Atlantic Enlightenment*, define as one concerned "with the exchanges and circulations—commercial, spiritual, intellectual and imaginative—that characterizes encounters and transformations in the eighteenth century."[2]

Primarily, though, I have written a saga that showcases the nation's first public monument. Central to my narrative are the unexpected, and certainly unanticipated, links that connect the Montgomery Monument, the Continental Congress, Benjamin Franklin, France, the Great Seal of the United States, Pierre L'Enfant, the Society of the Cincinnati, New York City, and President George Washington. All are essential components of the monument's story and suggest new ways of understanding what made monuments American.

Today St. Paul's chapel, where my journey began, is no longer shrouded in smoke and rubble but is a quiet oasis among the soaring cranes and sleek glass skyscraper of post 9/11 New York. Recently a team of conservators spruced up the building's facade, refurbished the Montgomery Monument, and cleaned the L'Enfant frame. Tourists continue to crowd in to study the 9/11 displays and to hear lunchtime concerts. For me, however, this small chapel, the Montgomery Monument, and the city itself are the inspiration for this history of eighteenth-century American commemorative sculpture and a reimagining of its origins.

Notes

1 François-Jean, Marquis de Chastellux. *Travels in North America in the Years 1780, 1781 and 1782,* revised trans. Howard C. Rice, Jr. (2 vols, Chapel Hill: University of North Carolina Press, 1963), 2: 545.

2 Susan Manning and Francis D. Cogliano, "Introduction: The Enlightenment and the Atlantic," in *The Atlantic Enlightenment* (Aldershot, UK and Burlington, VT: Ashgate Publishing, 2008), 1.

New York's De Lancey Family and the Origins of the American Memorial Tradition

The origins of the American memorial tradition date from the second quarter of the eighteenth century when the British-born painter John Smibert was commissioned to create portraits for the Boston's new marketplace, Faneuil Hall, and undertook a series of portraits of exchange ordered by the heroes of the siege of Louisbourg (1744). Generally, however, American memorialization was expressed by a lesser order of objects such as mezzotint engravings of divines, dedicatory silver, and marble plaques in churches, but before the 1760s, no public outdoor sculpture. Nor were there many civic amenities since most North American cities were still harbor towns occupied by sailors, traders, land speculators, and itinerant British administrators who served as royal governors or oversaw the interests of absentee landowners. The evolution of these communities as cities with boulevards, parks, public buildings, and outdoor sculpture only came into existence with the economic expansion of the colonies and the ascendancy of a cultured merchant class, such as New York's De Lancey family and their in-law Sir Peter Warren, a hero of the earlier King George's War (1744–1748).

Warren was a British naval officer, who while stationed in New York, married Susannah De Lancey. During the 1740s he was sent to Boston to take command of the naval forces battling the French for control of the St. Lawrence River valley. His success was such that following victory over the French during the siege of Louisbourg in Nova Scotia in 1744 he was awarded a peerage and a seat in London's Parliament. Before leaving Boston, he commissioned several commemorative portraits of exchange from the leading painter in North America, John Smibert. Later, after his death in 1751, his wife commissioned a grand marble monument commemorating his heroism that was placed in Westminster Abbey. Warren's portrait commissions and his marble monument are early manifestations of the commemorative impulse that the De Lancey family would later perpetuate in New York in the form of public monuments.

Sir Peter Warren, the Hero of Louisbourg

We are accustomed to regarding New York and other colonial American cities as autonomous within North America; yet it is more accurate to view them as extensions of the British Empire. New York, while not the largest city, Philadelphia and Boston had greater populations, was an important trading center and strategic naval base from which frigates and men-of-war patrolled the Atlantic protecting British trade in the Caribbean from privateers, and jockeying with France for control of northern fisheries and the St. Lawrence River.

The competition, particularly between France and England, for control of the North Atlantic at mid-century was exacerbated by the wars fought on the European continent to preserve dynastic rule. The middle two of these colonial contests—the War of the Austrian Succession (1744–1748), known as King George's War in North America, and the Seven Year's War (1756–1763), or the French and Indian War—were fought in North America primarily along the St. Lawrence River in southern Canada.[1] The French and Indian War continues to be regarded as an important prelude to the American Revolution, but the earlier King George's War was also significant, for it signaled the moment when America ceased to be a series of forts and outposts and became a loose confederation of burgeoning provinces full of merchants and landowners in bustling cities—Portsmouth, New Hampshire; Kittery, Maine; Boston; New York; Newport, Rhode Island; Philadelphia; Williamsburg; and Charleston—who believed they could succeed on their own, but at the same time were dedicated to the furtherance of British domination in the Atlantic world.

Not much attention has been paid to the presence and impact of the British military and naval forces in American cities. New York in particular was home away from home for sailors and soldiers—their captains, commanders, admirals, and generals were not outsiders but respected and venerated citizens of the city. These included Captain Peter Warren who settled in New York in the 1720s and was later stationed in Boston during King George's War. Warren was an ambitious Irishman who became a seaman at an early age. In the eighteenth century a career in the navy afforded advancement and riches for men who were not sons of wealthy landowners or of the aristocracy. Warren's success was such that over the years through prize money and property investments in North America, he became one the wealthiest admirals in the navy.[2]

During the 1730s Warren sailed to ports in the western Atlantic and the Caribbean protecting British imperial interests and those of its merchants. While on a mission to Veracruz, Mexico, Warren received his appointment as captain of the HMS *Solebay*, a 20-gun frigate that served as the station ship for the province of New York. He was only 27, but his prestige was such that upon his arrival in New York he was awarded the freedom of the city,

which meant that he could own property and conduct business, rights that were immediately furthered by the enactment of the Montgomerie Charter in 1732.[3] The rights established by the charter were extended to "freemen" such as Warren and also to a broad spectrum of the population, making New York one of the most open communities in the colonies. In addition to an elite class of merchants and landowners, as well as naval personnel, there were freemen who were shipbuilders and rope makers, men who could run sugar refineries, rum distilleries, and operate shops and taverns that catered to seamen and residents alike. During the time Warren lived in New York, the Second Lutheran Church was completed, as was a new edifice for Trinity Church, a stone building with a 58-foot spire, and the first Jewish synagogue was consecrated. A library was established and new wharves and slips were created on the island's west side, opening up the Hudson or North River to sea traffic and commercial development. The development of its civic amenities was a reflection of the city's growing prosperity and cultural ambitions.

Like his in-laws, Warren began to acquire property, building a house for his wife on Broadway, and further uptown he purchased 300 acres in what is today's Greenwich Village, where one of his brothers-in-law Oliver De Lancey later lived (Figure 1.1).[4]

Another brother-in-law, James De Lancey, the province's chief justice and sometimes acting governor, bought a similar parcel on the opposite side of the island in the area now known as the Lower East Side (Figure 1.2). Their properties were among a number of large country estates built in the northern parts of the city that were part sustainable farmland and part suburban park with formal gardens and statuary modeled after the estates of the landed gentry in England. As one historian has written: "Out in the nearby countryside ... it was customary for the successful merchant or government official or land speculator to purchase a farm on lower Manhattan, erect a mansion, lay out an elaborate garden, and cultivate fields. The Bowery Lane and the Greenwich Road, the two chief highways leading out of the city, were lined with handsome estates."[5] This twentieth-century assessment is confirmed by reference to a pre-Revolutionary map based on a survey done in the early 1760s that shows the large estates of the De Lancey and Warren families with carefully tended gardens laid out in a formal European manner.

Another source of income for Warren was prize money from the capture of booty from enemy vessels, a form of privateering sanctioned by the crown. He invested his money well, and over the next 15 years bought 1,000 acres in South Carolina and additional properties in Massachusetts and New York, including 13,000 acres on the south side of the Mohawk River, an aqueous highway that linked the region of Lakes Erie and Ontario to Albany, the Hudson River, and New York City.[6] He was also a moneylender, and, through loans to prominent New Englanders and his land investments, he made many colonial contacts and acquired considerable knowledge of North American

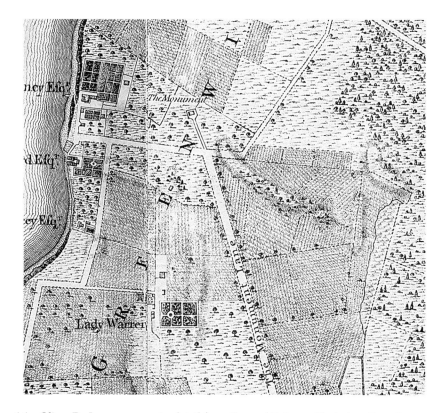

1.1 Oliver De Lancey property, detail from Bernard Ratzer with designation of [Wolfe] monument, *Plan of the City of New York, in North America*, 41 15/16 × 35 13/16 in. (105 × 91 cm.), surveyed 1766 and 1767; published 1776. The Lionel Pincus and Princess Firyal Map Division. The New York Public Library, Astor, Lenox and Tilden Foundations

prospects and their value to the advancement of British interests. In the 1740s he shared his thoughts with the British Admiralty, penning an assessment regarding colonial trade and imperial expectations. He began his appraisal, which anticipated William Pitt's opinion a decade later, by stating that the Atlantic seaboard was more than a collection of scattered settlements but had become an entity unto itself and that its northern boundary, the St. Lawrence River, was a corridor that needed to be vigilantly guarded, since the French controlled the forts along its length and around its broad harbor. Its defense, Warren believed, was critical for New York and the prosperity of the empire: "nothing cou'd be a great[er] acquisition to Great Britain, and its dominions, than the dispossessing of the French of Cape Bretton and Quebeck, by which the whole fur, and fish trade, wou'd be in our hands, a source of immense treasure."[7] A prescient view that Warren shortly would be called upon to, literally, defend.

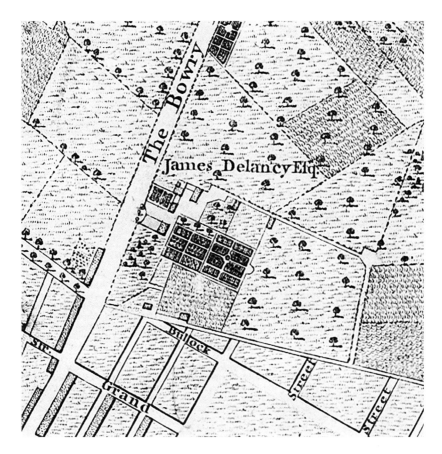

1.2 James De Lancey property, detail from Bernard Ratzer, *Plan of the City of New York, in North America*, 41 15/16 × 35 13/16 in. (105 × 91 cm.), surveyed 1766 and 1767; published 1776. The Lionel Pincus and Princess Firyal Map Division, The New York Public Library, Astor, Lenox and Tilden Foundations

Even though his family's official residence was New York, Warren remained on active service, commanding first the HMS *Squirrel* (1735–1742), a 20-gun frigate that he captained to patrol the southern Atlantic coast; then the even larger 40-gun *Launceston* (1742–1744), and the 60-gun *Superbe*. It is this latter ship that he sailed to Cape Breton Island in Nova Scotia and made a successful bombardment against the French-held fortress at Louisbourg.

The Louisbourg expedition was mounted because the French stationed in the borderlands of the British colonies were becoming increasing hostile after the outbreak of war in Europe in 1744. The threat was the most serious in the Bay of St. Lawrence, where the French occupied Cape Breton Island and its strategic fort at Louisbourg. The causal event was the French assault on the British fort at Annapolis Royal, then the capital of Nova Scotia. Coming to

the aid of the British garrison were reinforcements from Massachusetts sent by its provincial governor William Shirley also head of the militia. He justified the commonwealth's involvement by claiming that it was in colonial interests to protect British trade and, more importantly, to keep the rich fishing waters of the North Atlantic free from French competition. Over the years Shirley had pleaded with London to oust France from eastern Canada altogether and with the go-ahead from London, he joined forces with Warren, who hurried from his station in the Caribbean to Boston, to aid in the attack. After some daring military and naval maneuvers the French surrendered.[8]

Boston celebrated by creating Louisburg Square in Beacon Hill in honor of the victory and proclaimed a number of seamen and members of the Massachusetts militia—Shirley, William Pepperell, Richard Spry, Edward Tyng, Samuel Waldo, and Warren—the Louisbourg heroes. To further honor the occasion a number of dedicatory portraits were commissioned by Warren and others from the Scottish-born and Boston-based artist John Smibert, which collectively have come to be called the Louisbourg series.

John Smibert's Studio

Unlike other colonial portraitists, Smibert was no journeyman painter, having studied painting in London before traveling to Italy to study and paint. To his studio in Boston he brought the tools of his trade—pigments, canvases, and brushes—as well as reproductive engravings and copies of old master paintings. During the first half of the eighteenth century, no other artist in North America was as experienced or as cosmopolitan.

It was in Italy where he first met the philosopher and theologian Dean George Berkeley who in the mid-1720s invited the painter to join him as a member of the faculty of a college he was planning to establish in the New World. Berkeley's ambition was to provide religious and academic instruction, including the arts, to colonial and Native American children, a venture that was officially sanctioned by a royal charter. When he arrived in Rhode Island in the 1729, he was the highest ranking Anglican official in New England and an international celebrity, known for his philosophical writings on materialism and treatises on the corrupt state of the British nation, concerns that were expressed in his 1720 *Essay Towards Preventing the Ruin of Great Britain*, which contained the provocative phrase "other nations have been wicked but we are the first to be wicked on principle." By the time he was 40 he had secured a deanship in Ireland at Derry and could look forward to "an orderly, rational, cultivated, calm life sure to win universal approval and acclaim."[9] Yet, as reflected in his writings, he held the idea of a different life for himself, one that involved leaving Great Britain and immigrating to Bermuda, where he hoped to establish a school that "would preserve and

propagate the liberal arts, elevate morals, rescue religion, and cultivate good taste."[10] Its purpose was to train ministers for work in the New World, and he anticipated that his students would include "the English youth on our plantations" and "a number of young American savages." He believed that the latter would "become the fittest missionaries for spreading religion, morality and civil life among their countrymen" and would be better believed and trusted than white Englishmen.[11] It was Berkeley's dream "to create a New World community, to rescue historic Christianity, to purify and preserve Western civilization."[12] He fixed on Bermuda because of its location midway between the West Indies and the American continent. It had a good climate, which he believed was conducive to study, and, with its rock-bound coast and safe harbor was relatively secure from invasion. Other churchmen who had had experience in America applauded his vision but privately opined that Bermuda was the "unfittest place in America" for such an undertaking.[13] Over the next few years, Berkeley became more familiar with the reality of his undertaking and before leaving England decided to begin his school in Rhode Island, which, unlike Massachusetts and Connecticut, had no college and was not dominated by Puritans or Congregationalists.

Before leaving England one of Berkeley's admirers, John Wainwright, commissioned Smibert to create a painted document of the undertaking, which became known as *The Bermuda Group* (Figure 1.3). In this painting, the first large-scale group portrait created in New England, Smibert renders Berkeley; his wife, Anne, and their infant son; her companion, Miss Handcock; and Berkeley's followers in an elegant interior, seemingly in conversation around a table covered with a luxurious Turkey carpet.[14]

Berkeley, in a black robe and white clerical collar, stands at the right looking heavenward with his right hand supporting an upended book. Across the table is the young man John Wainwright who commissioned the painting. He is dressed in a dark red velvet suit and a voluminous crimson satin robe and serves, for the purposes of the portrait, as Berkeley's amanuensis. Between them are four figures—Miss Handcock, Anne Berkeley holding baby Henry, and a Berkeley associate. The women are attired in open-neck satin day dresses with lace at their bodices. Behind them leaning on Miss Handcock's chair is either John James or Richard Dalton, who observes the words being written by the elegantly attired seated scribe. Neither James nor Dalton, who were committed to supporting Berkeley's scheme, were members of Berkeley's faculty but genteel men of fortune.[15]

At the far left of the portrait, the painter Smibert stands attentively and looks out at the viewer so as to fully identify himself with the historic undertaking— Berkeley's dream. *The Bermuda Group* then is testimony to this divine's refined vision for British America and is a key to understanding the cultural ambitions of families such as the Warrens and the De Lanceys, ambitions that they did not gain through direct contact with Berkeley, who only stayed in

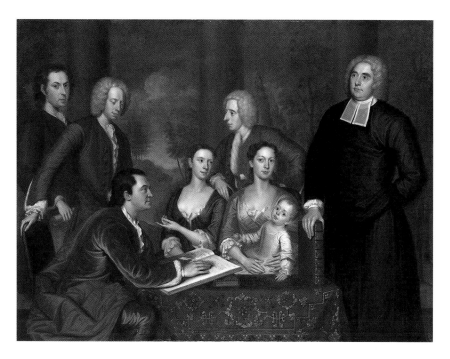

1.3 John Smibert, *The Bermuda Group (Dean Berkeley and His Entourage)*, 69 1/2 × 93 in. (176.5 × 236.2 cm.), oil on canvas, begun 1728, completed 1732. Yale University Art Gallery, New Haven, gift of Isaac Lothrop

Newport for three years, but through the example established by Smibert in Boston. While Berkeley's experiment had only limited success, what has yet to be acknowledged is how much of his dream Smibert transmitted to his Boston patrons and fellow artists. As Margaret Lovell has noted, "Smibert's studio was key to the development of painters and painting and the *idea* of art in New England," and I would add for citizens of Boston and the patrons of the arts as well.[16]

In the first half of the eighteenth century, portrait painters in the Atlantic colonies relied on a formula learned either firsthand in London or from imported engravings based mainly on the precepts established by Sir Godfrey Kneller, in which portraiture is treated more as craft than art. An exception was Smibert, whose training, experience, and familiarity with masterpieces of Europe set him apart from his contemporaries in North America. There is also the certainty that Smibert, infused with the idealism he shared with Berkeley of bringing civilization to the New World, established an artistic community in Boston that included aspiring artists and patrons.[17] Evidence of his intent is the description left by the Scottish physician Alexander Hamilton, who in his 1744 *Itinerarium* described a visit he paid to Smibert's studio where he saw

"a collection of good busts and statues, most of them antiques, done in clay and paste, among the rest Homer's head and a model of the Venus of Medicis."[18] Nowhere else in the colonies was there so much abundant evidence of European culture, and over the course of the century his studio remained a mecca for succeeding generations of artists, including his son Nathaniel, Robert Feke, John Singleton Copley, Charles Willson Peale, John Trumbull, and Washington Allston. Nor did he limit himself to painting but promoted the art of architecture as well, an enthusiasm he shared with Berkeley. In the 1740s he designed Boston's landmark Faneuil Hall (1740–1742), a meeting and market hall near the waterfront, and there is evidence that he planned Holden Chapel for Harvard College.[19] It is also in Boston at this time that the first commemorative sculptures appear, not as outdoor monuments but as private tributes in churches. It was sometime after 1746 that Governor Shirley commissioned an elaborate memorial plaque from Smibert's London friend the sculptor Peter Scheemakers, which was installed in Boston's King's Chapel as a tribute to his wife Frances. The two artists had been neighbors on London's St. Margaret Lane, and Smibert, in his Boston studio, had a reduced replica of Scheemakers's *Shakespeare,* the original having been placed in Westminster Abbey in 1740. Such was the esteem or perhaps knowledge of the sculptor's work in Boston that later in 1762, Scheemakers was hired by the province of Massachusetts to undertake a monument to one of the heroes of the French and Indian War, George Augustus, third Viscount Howe, which was placed in Westminster Abbey. The artistic milieu that Smibert's studio represented also supplied the Warren and De Lancey families with an introduction to the fine arts of portraiture and the power of public commemoration.

The Louisbourg Series

It was Ellen Miles who in an article, "Portraits of the Heroes of Louisbourg," first proposed that the Smibert portraits commissioned by Warren and others formed a commemorative group that she called the Louisbourg series.[20] At the same time, she acknowledges that the series was ill-formed, meaning that it was not initiated by a single individual nor for a specific locale such as a city hall, nor was it undertaken by one artist but by three, two in Boston and one in England. Nor were the portraits to be hung together in the manner say of Charles Willson Peale's assemblage of bust portraits of American worthies in his Philadelphia museum. If any one person was responsible for this far-ranging enterprise, it was Warren, who lived off and on in Boston with his wife and daughters, two of whom were born there, Elizabeth in 1737 and Ann in 1738. Oliver De Lancey, Susannah's brother also had his portrait done by Smibert, which is now lost.[21]

The Louisbourg series, as detailed by Miles, began with a desire by a group of Bostonians to honor their governor William Shirley for his courage and leadership during the war, and they ordered a portrait of him from Smibert in 1746 that "hung in Faneuil Hall at least until 1775."[22] Shortly after Shirley's portrait was completed, Warren ordered three portraits from Smibert that he intended as tokens of exchange with the others who ensured victory at Louisbourg: one was of Warren himself (Figure 1.4), another of William Pepperell, and a third of Richard Spry. Two of them—the Warren and the Pepperell—were gifts to Pepperell and hung in his Kittery mansion until his heirs gave the Warren to the Portsmouth Athenaeum and the Pepperell to the Peabody Essex Museum in Salem.[23] The Spry, for reasons unknown, Warren never received; but it was also given to the Portsmouth Athenaeum early in the nineteenth century.[24]

Following a tried and true format for eighteenth-century British and colonial portraits, Smibert represents Warren full length, standing at an open window elegantly dressed in a red waistcoat and the blue satin coat of a British naval captain. He holds a telescope in his right hand and with his left gestures out the window toward three ships moored in a harbor, symbolically representing his capture of the French frigate *Vigilante*.[25] This ambitious full-length painting, done late in Smibert's career, is not among his most successful—the figure is too summarily rendered and is not happily integrated within the balconied interior. A similar awkwardness is found in the other paintings for this series in which Smibert repeated the format of the standing seaman gesturing out the window to the victorious scene beyond. Even so the Warren and Spry portraits are large and impressive. Attired in their official uniforms, the subjects exude confidence and worldliness and represent the further flowering of the cultural ambitions encoded in *The Bermuda Group*.

In honor of his naval success at Louisbourg, Warren was knighted and awarded a seat in Parliament. He promptly moved his family to England, where they continued to assume the trappings of refinement. He bought an elegant estate, Westbury Manor, in the Hampshire district and maintained a London house on fashionable Grosvenor Square. There he, his wife, and daughters, and no doubt attendant De Lancey relatives, entertained and hobnobbed with the British bon ton.[26] He also engaged one of the city's leading portraitists, Thomas Hudson, to paint his portrait and that of his wife, Susannah, both of which he planned to send to Pepperell as a further token of their friendship.[27] Hudson's portrait of Warren (Figure 1.5) is strikingly similar in pose and organization to Smibert's. This is not to suggest copying on Hudson's part but rather to underscore Smibert's familiarity with the contemporary tropes of British portraiture. At the same time the Hudson portrait is more refined—Warren's figure is more securely placed within the two-dimensional pictorial space, and the details of clothing and accessories

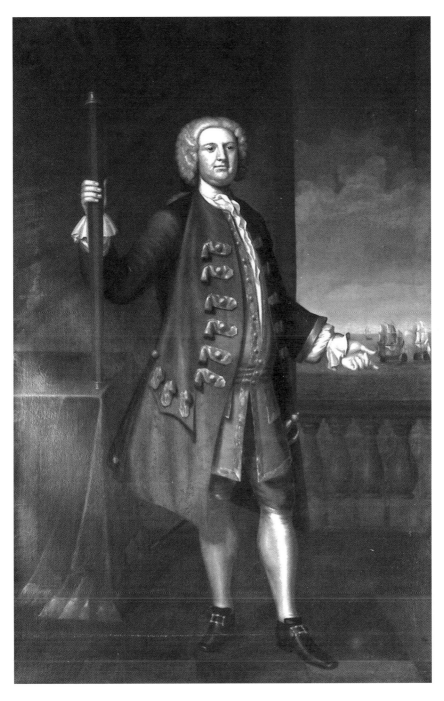

1.4 John Smibert, *Sir Peter Warren*, 92 × 58 in. (233.7 × 147.3 cm.), oil on canvas, 1746.
Portsmouth Athenaeum, New Hampshire

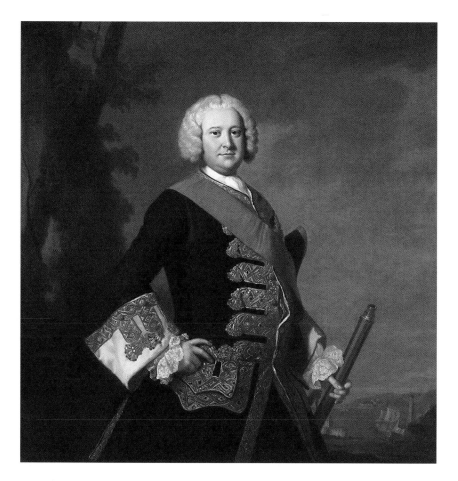

1.5 Thomas Hudson, *Sir Peter Warren*, 53 1/2 × 52 in. (135.9 × 132.1 cm.), oil on canvas, c. 1751. National Portrait Gallery, London

are rendered with glorious precision. As in the Smibert, Warren holds a telescope, and while he is pictured out-of-doors, the harbor scene at the right is close to what is found in Smibert's painting. Similar to the fate of some of the Smibert paintings, the Hudson-Warren portrait did not reach its intended owner, William Pepperell, and remained in private hands until it was given to London's National Portrait Gallery.

The Louisbourg series is important because it is among the first to be conceived of as a group of portraits "painted for exchange or for public display."[28] As such these tokens of military tribute serve as a starting point by which to trace the evolution of the commemorative tradition inaugurated by the De Lancey family, which was advanced not with an American manifestation but by a monument to Warren's memory installed in Westminster Abbey.

Its commission was overseen by members of the De Lancey family and by New York's colonial agent Robert Charles.

A Self-made Hero

With Warren's death five years after his return to Great Britain, unexpectedly at age 48, his memorialization came into full flower with the commission by his wife, Susannah, of a monument for Westminster Abbey. Their great wealth enabled her to purchase space in the abbey and to hire the celebrated French-born sculptor Louis-François Roubiliac for the commission. When completed, it became the visible manifestation of the Warrens' desire for status and acceptance within aristocratic London circles. Additionally, the artistic milieu attached to Westminster Abbey commissions offered Susannah Warren and the De Lancey family a glimpse of the complex world of British commemoration, just as Smibert's studio, on a less grand scale, had been an academy of culture in Boston a decade earlier.

Aiding and advising the family was the British-born Robert Charles, who had earlier served as Warren's personal secretary, and was later appointed the colonial agent for New York. It was Charles who helped secure the space for the monument in Westminster Abbey.[29] Susannah was also assisted by Warren's two other legatees: her brother James (whose role would be assumed by Oliver after James's death in 1760) and Rear Admiral Richard Tyrell, Warren's nephew.[30] However, it may have been Susannah herself who hired Roubiliac since he was a close friend of Hudson, with whom he had traveled on the Continent several years earlier.

Installed in 1757, the Warren monument was one of an early series of military monuments undertaken in the 1750s for Westminster Abbey, many of which were created by Roubiliac.[31] A broad-based multifigure homage to the admiral's success as a naval hero (Figure 1.6), its wide podium contains a lengthy inscription and supports a smaller incised base upon which a bust of Warren is being placed by a bearded, heavily muscled figure of Hercules, the ancient symbol of the hero. On the right is a beautifully draped, seated, female figure who leans on the plinth that supports Warren's bust. As the personification of Navigation, she looks on admiringly, while behind her, slightly concealed by her voluminous skirt, is an overflowing cornucopia of fruits, grains, sheepskins, and coins alluding to Warren's own wealth and his contribution to Britain's economic success. Through the addition of this abundance, the figure of the woman becomes a multifaceted blending of Navigation and Commerce.

Roubiliac was a French-born artist whose early background is sketchy. He began training in his native Lyon and spent time studying and working in Paris and Dresden before immigrating to England in 1730. His contact with

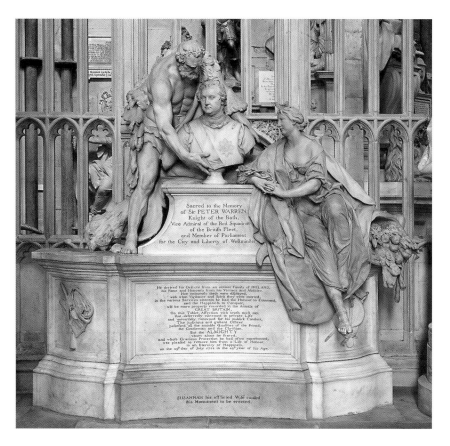

1.6 Louis-François Roubiliac, *Sir Peter Warren*, marble, commissioned 1753, erected 1757. © Dean and Chapter of Westminster, London

late Baroque works, such as those undertaken for the pavilions of Dresden's Zwinger, is evidenced in his Westminster commissions in which animated figures are assembled asymmetrically in dramatic emotive poses. The introduction of this new continental style led to Roubiliac's early success, and by the middle of the next decade he had established himself in the artists' quarters in St. Martin's Lane, where he counted among his friends the painter William Hogarth, whose bust portrait he did around 1740. This was the same period in which the artist began to receive commissions for tomb sculptures; the most important of which were placed in Westminster Abbey.

The abbey, formally known as the Collegiate Church of St. Peter, Westminster, dates from the early seventh century and over the millennia became the site of a great number of monumental sculptures. Nearly every sculptor of note is represented there, making the abbey an important site for the survey of early British sculpture. The subjects who are honored represent

nearly all of England's great monarchs, churchmen, government leaders, military heroes, poets, and artists—a virtual national pantheon. According to Matthew Craske, "throughout the eighteenth century, the abbey was acknowledged as *the* public space in which the notion of the exemplary national citizen was articulated through the erection of monuments."[32]

Most of Roubiliac's abbey commissions were for monuments to war heroes, and with the tomb he designed for John Campbell, second Duke of Argyll, a field marshal during the War of the Austrian Succession, Roubiliac inaugurated a new tradition in England.[33] Installed at the time of the Warrens' arrival in England, the Argyll tomb is a multitiered, multifigured monument with an elevated sarcophagus backed by an obelisk. The first tier is of polished green marble and flanking it on the right is the attentive figure of Valor, and on the left a highly animated, demonstrative image of Eloquence. Above them the contemplative hero sits atop his casket supported and promoted by a female personification of History, who inscribes Argyll's heroic deeds on the obelisk behind them. In the center of the monument there is a bas-relief plaque that contains a new conception of Britannia holding a liberty pole and resting her foot on a cornucopia that Roubiliac later repeated on the Warren monument.

Another one in this series of military monuments is a smaller memorial that was ordered by the province of Massachusetts to honor the memory of Viscount Howe by Scheenmakers and is another piece of evidence of British colonial contribution to a trans-Atlantic trade in commemorative monuments. The Howe monument with its single figure on a high base is not nearly as grand as those by Roubiliac. Situated in the abbey's nave, the monument consists of a large inscribed base detailing Howe's deeds and death. Above the inscription, which forms the bulk of the monument, is a female personification of the province who rests against a shield inscribed "Massachusetts Bay New England."

The culmination of these heroic monuments in Westminster—space would be found for the heroes of the Napoleonic Wars in St. Paul's—is Joseph Wilton's General James Wolfe monument. Coincidentally, Wilton is the same artist who was later invited by New York's General Assembly to create two monuments for lower Manhattan. And it is around the figure of Wolfe that the patriotism of the De Lancey family, the leadership of William Pitt, and the artistry of Joseph Wilton began to coalesce.

General James Wolfe, the French and Indian War, and the Fate of British America

The first outdoor monument in British North America was an obelisk in New York City dedicated to the memory of General James Wolfe. It served both as a tribute to his heroism during the French and Indian War and as a symbol

of colonial gratitude for the ousting of the French from the North Atlantic seaboard. This victory protected British colonial trading interests and, it was believed, secured English liberties.

The Wolfe obelisk, however, was not ordered by the royal governor, the city's Common Council, or the province's General Assembly, rather it was commissioned by a private citizen, Oliver De Lancey, for his estate in Greenwich Village. He placed it there in the early 1760s and petitioned the city for a new public road called Monument Lane, the terminus of which was the Wolfe obelisk. Such a public gesture, to allow access to one's private property for the display of a public monument, followed the precedent of British estates which were filled with sculpture, most notably Stowe in Buckinghamshire, where its owners over a series of decades created an Elysian Fields with temples to ancient and modern worthies including an obelisk to Wolfe's memory.

Wolfe became an international hero with his death on the Plains of Abraham outside Quebec on September 14, 1759. His daring strategy to lead his men up the sheer walls on the city's outskirts led to a victorious outcome for the English but not before Wolfe died of wounds inflicted in battle. The eighteenth-century apotheosis of Wolfe was echoed a decade later in the death of another fallen hero of Quebec, General Richard Montgomery, who would come to be called the American Wolfe.[34] Neither Wolfe nor Montgomery were aristocrats, kings, or religious leaders but were representative of a new ideal of personal sacrifice, a new type of hero. The death of both men engendered American monuments and paintings (in Wolfe's case by the American-born Benjamin West, and in Montgomery's by the American-born, English-trained John Trumbull), in addition to poems, plays, and eulogies. Unlike Montgomery, Wolfe continues to engage the historical imagination in the United States from Francis Parkman to Simon Schama. Parkman's stirring and romantic nineteenth-century account of Wolfe the person and his military prowess is included in the sixth volume, titled *Montcalm and Wolfe*, of his history *France and England in North America*. It is also the jumping-off point for Schama's book *Dead Certainties,* a psychological mediation on Wolfe, Francis Parkman, and Parkman's uncle George Parkman, who was murdered in 1849. In it Schama suggests that Wolfe served as Francis Parkman's doppelgänger. Both Parkman and Wolfe were frail but undertook superhuman endeavors—Wolfe in war; Parkman in his literary adventures—both succeeding under tremendous odds.[35] For Schama their personal narratives serve as sources for a provocative inquiry into the nature of historical practice.

For two centuries Spain and France controlled most of North America with the English holdings confined to the North Atlantic seaboard. William Pitt, the elder who came to power as secretary of state in 1757, was so committed to securing North America for Great Britain that he persuaded George II and Parliament to finance and support full-scale warfare against the French forts in the Ohio Territory, Pennsylvania, and northern New York along the

St. Lawrence River. Pitt was determined to not just defeat the French but, in Parkman's words "annihilate [the power of France]; crush her navy, cripple her foreign trade, ruin her in India, in Africa and … gain for England the mastery of the seas, open to her the great highways of the globe, make her supreme in commerce and colonization; … [and] give to her [England] the whole world for a sphere."[36] Such imperial ambitions validated Wolfe's heroic sacrifice.

In Europe, England was engaged militarily in the Seven Year's War, of which the French and Indian War was a phase. It was on the Continent that Wolfe first saw action, coming to Pitt's attention in 1757 through his daring and aggressive maneuvers during the siege of Rochefort off of the Atlantic coast of France. Subsequently, Pitt appointed Wolfe second in command to Jeffery Amherst, commander in chief of forces in North America. Their first victory was the expulsion of the French from the Cape Breton citadel of Fort Louisbourg, the initial step in Pitt's plan to take control of the St. Lawrence. It was too late in the year to continue moving west, so Amherst went south to New York for the winter, and Wolfe returned to London to receive further directives from Pitt, who ordered him to return to the St. Lawrence and capture Quebec. It was Pitt's plan to create a pincher action with Amherst's troops moving north through New York, capturing the French-held forts along Lake Ontario, Lake George, and Lake Champlain—his intent being the capture of Montreal. Amherst would then join forces with Wolfe, and together they would defeat the French and secure Canada for the British.

Wolfe's point of embarkation was Louisbourg. In late spring 1759, he and his troops ventured along the St. Lawrence laying siege to Quebec for three months. In a last, desperate attempt to oust the French, Wolfe organized a brazen and risky assault up the sheer cliffs west of the city proper, the summit of which opened onto the Plains of Abraham. At dawn, September 13, his troops with two small cannon scaled the rock faces, surprising the French and their leader General Louis-Joseph de Montcalm. The British made short work of the French, defeating them in 15 minutes, but in that short space of time, Wolfe was shot and his opponent, Montcalm, also mortally wounded.

When news reached England that Wolfe had been killed, Horace Walpole confided in his notebooks that "they [the British] despaired, they triumphed, and they wept; for Wolfe had fallen in the hour of victory. Joy, curiosity, astonishment was painted on every countenance. The more they inquired, the more their admiration rose."[37] By 1763 with the signing of the Treaty of Paris, the whole of Canada was ceded to Great Britain. Commemoration of this victory was often conflated with the memorialization of Wolfe.

The call in London for a Wolfe monument came, not unexpectedly from Pitt, who on November 21, 1759, two months after Wolfe's death, appealed for a memorial to be set in Westminster as a monument to the fallen hero that would also serve to commemorate the British victory over the French and the

nation's new domination of the Atlantic world. Less than a year later, Joseph Wilton was awarded the commission.[38]

Wilton, who trained in the studio of his father, a successful decorative artist, had larger ambitions and was drawn to the fine arts, particularly the art of sculpture. He traveled to Paris for training and spent three years studying there with one of the leading sculptors of the day, Jean-Baptiste Pigalle. It was in Pigalle's studio, according to an early history of British sculpture, that Wilton "acquired the power of cutting marble, an art hitherto unknown to the sculptors of this country."[39] Following his training in Paris he spent several years in Rome and Florence before returning home in 1754. At the time, this was unique training for a British sculptor, and he returned to England where he was employed mainly in making copies of antiquities, for which there was an insatiable market during the period of the Enlightenment. His greatest patron was Charles Lennox, third Duke of Richmond, who in the 1750s outfitted a gallery for art students in Whitehall where they could study copies of antique sculpture, including statues, busts, and models, which Wilton helped assemble. This gesture on the part of Richmond was short-lived but paralleled the newly formed Society of Arts' desire to improve conditions for artists and art students.

The following decade saw Wilton's greatest achievements. He was appointed sculptor to George III and completed the Monument to General Wolfe (Figure 1.7) in 1772. It was only the second tomb sculpture commissioned from a British-born sculptor in Westminster Abbey. Wilton's elaborate monument to Wolfe is in a crowded area adjacent to the north transept and near the Warren monument, which it dwarfs. Not surprisingly, its complex narrative focuses on several aspects of Wolfe's heroic death at Quebec. The lowest register is a podium to which is affixed a low bronze relief designed by one of Wilton's assistants. It is a bird's-eye view of the battle, showing soldiers disembarking at the bottom of the cliff and troops in combat on the Plains of Abraham at the top of the ramparts. Above the podium rests an elegant sarcophagus with two large lions at its feet, above which is the monument's capstone, a mythical tableau of Wolfe's death scene set inside his tent. On the right the expiring hero, shown in profile, is seated on a low, classically styled bed. No longer in uniform, he is seminude, in the manner of an ancient hero, supported from behind by an unidentified aide. The aide gestures with his right hand, directing Wolfe's gaze to an angel who descends from the left holding a wreath of laurel in one hand and a palm branch in the other, both symbols of victory and immortality. Behind, in low relief, is a second attendant shown against the interior folds of the tent. In this work are combined the historical moment and the supernatural, a representation of the classic ideal of the fallen warrior with images of his enduring fame.

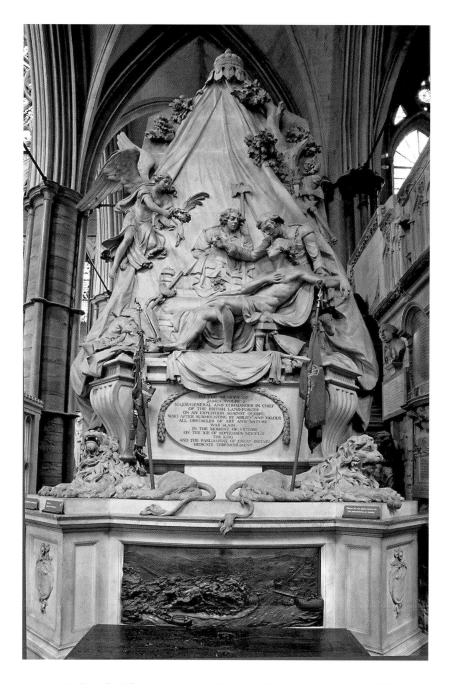

1.7 Joseph Wilton, *Major General James Wolfe*, marble, unveiled, 1773.
© Dean and Chapter of Westminster, London

Discussions of the eighteenth-century Enlightenment often center on the philosophical debates among an international array of thinkers who, according to Alan Bullock, "were ready to unite in support of what they had in common, a program of humanity, secularism, cosmopolitanism, and freedom, the right to question and criticize, free from the threat of arbitrary interference by either the church or state."[40] Although these intellectuals argued abstractions, many were empiricists and pragmatists and some, namely Franklin and Jefferson, were also politicians, men who put words into action.

Coincident with the philosophic and political inquires of the Enlightenment was a renewed interest in antique sculpture and the substitution of the secular hero for the image of the saint and monarch. Prime examples of these impulses could be found, in addition to Westminster Abbey, on private British estates where elaborate landscape designs often included sculptural programs based on classical models. Among the earliest and most notable of these was the estate of Richard Temple, Lord Cobham, at Stowe in Buckinghamshire, guidebooks of which were published as early as 1744. In eighteenth-century colonial America, Stowe and other British estates were emulated although never on the same scale or with the same cultural ambitions. It also may be that Stowe, in particular, fired the ambition of Oliver De Lancey in his placement of a monument to Wolfe on his property in Greenwich Village.

The Monument in the Garden

Located 50 miles northwest of London, Stowe comprises about 400 acres and is, according to British architectural historian John Robinson, "the largest, grandest and most important landscape garden in England." Robinson also describes its political importance: "Stowe was one of the half dozen principal seats of the Whig aristocracy, and its owners, the Temple-Grenvilles, were a dominant force in the political life of the country. Here policy was framed … liberty defended and the expansion of the British Empire planned."[41] An importance seconded by Philip Ayres: "The whole point of the gardens and temples at Stowe was that one should entertain one's political friends in them, for their chief value lay in the political and classical associations they evoked."[42] Among Cobham's political protégés was William Pitt who married Hester, one of the Grenville sisters and Cobham's niece.

Lord Cobham, before being elevated in 1718, was known as Richard Temple, fourth Baronet. In 1733, he retreated to Stowe, in a show of dissension from Prime Minister Robert Walpole. Here he devoted his energies, working with the leading architects, gardeners, and sculptors of the age, including James Gibbs and Capability Brown, to create a new natural or picturesque form of landscape design. Over the course of the eighteenth century, both Cobham and his nephew, Richard Grenville-Temple, first Earl Temple, who continued

his uncle's endeavors, created landscape effects that included classically inspired buildings meant to exemplify the Enlightenment concepts of heroism and civic virtue. For instance in the 1730s, under the supervision of Cobham, the architect William Kent created Elysian Fields to the southeast of the house that included a Temple of Virtue (Figure 1.8), and a Temple of British Worthies (Figure 1.9). The round Temple of Virtue, modeled on the Temple of Sibyl at Tivoli, contains four full-standing sculptures carved by Scheemakers of ancient worthies—Homer, Socrates, Epaminondas, and Lycurgus—placed in niches around the rotunda wall (Figure 1.10). Above each are carved plaques with Latin inscriptions describing the worthy's virtue. All of them were regarded as defenders of liberty in the eighteenth century and appropriate precursors for the occupants of a second temple for an ever expanding number of British worthies. This other temple is not really a temple but a curved wall with a shallow rank of steps that together form an exedra. The wall is divided in half; each half is segmented by slim engaged columns that separate eight carved niches. These niches hold sculpted busts of modern heroes, and above each are Latin inscriptions extolling the person's character. On the left are men of thought and letters: William Shakespeare, John Milton, John Locke, Isaac

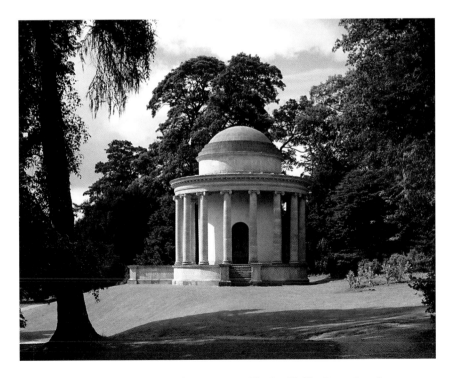

1.8 William Kent, The Temple of Virtue, 1737. Elysian Fields, Stowe Landscape Gardens, Buckinghamshire, England. National Trust Images

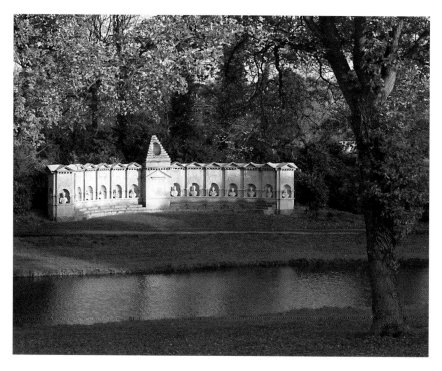

1.9 William Kent, The Temple of British Worthies, c. 1735. Elysian Fields, Stowe
 Landscape Gardens, Buckinghamshire, England. National Trust Images

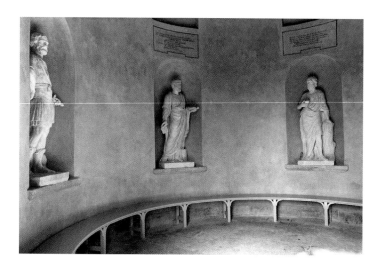

1.10 Peter Scheemakers, interior of the Temple of Virtue with sculptures of Homer,
 Socrates and Epaminondas, c. 1737. Stowe Landscape Gardens,
 Buckinghamshire, England. National Trust Images

Newton, and Francis Bacon among them. To the right are distinguished rulers and statesmen, including Elizabeth I, William III, Sir Walter Raleigh, and Sir Francis Drake. These two tributes—one to ancient exemplars and the other to English laudables—were augmented by Earl Temple, who four decades later added a section called the Park on the north side of the estate where he placed an obelisk (Figure 1.11) dedicated to the memory of Major General James Wolfe (1759).

These garden monuments and designs found at Stowe are contemporaneous to the discoveries of Herculaneum (1738), Pompeii (1748), and the establishment of the Society of the Dilettanti (1734) and anticipate the birth of neoclassicism. Both Thomas Jefferson and John Adams toured Stowe in 1786. Its classical allusions and picturesque design would later influence Jefferson's vision, if not his plans, for Monticello.[43]

Elysian Fields for America

At Stowe the area called the Elysian Fields speaks conceptually to a restoration of the classical ideal of an Elysium, which Hesiod in his *Works and Days* described as the place where the "godly race of men-heroes" are sent by Zeus to "the limits of the earth; and these dwell with a spirit free of care on the Islands of the Blessed beside deep-eddying Ocean—happy heroes, for whom the grain-giving field bears honey-sweet fruit."[44] While Pindar in his *Olympian Odes* similarly included reference to those who have kept "their souls free from all unjust deeds" and who reside "where ocean breezes flow round the Isle of the Blessed, and flowers of gold are ablaze, some from radiant tees on land, while the water nurtures others."[45] By the beginning of the eighteenth century, two types of Elysian Fields emerged in English literature. One is a pastoral concept, an exaltation of nature, closer to an Edenic vision, as in first lines of Pope's poem "Summer": "See what Delights in Sylvan scenes appear! / Descending Gods have found Elysium here." The other emerges more directly from classical mythology. As described by the eighteenth-century essayist and playwright Joseph Addison, the Elysian Fields were the final resting place of the souls of the heroic and virtuous, where "glades populated by temples, ruins, marble trophies, carved pillars, and statues of lawgivers, heroes, statesmen, philosophers and poets."[46] Addison was not unknown to Americans of the Revolutionary generation since his influential play *Cato* (1712) was performed for George Washington and his troops at Valley Forge. In his play Addison re-creates the last days of Cato the Younger, whose principled opposition to the tyrannical rule of Julius Caesar led him to martyrdom. As a moral defender of the Roman Republic, Cato was a fitting symbol for the patriots' and the Continental Army's defiance of British authority.

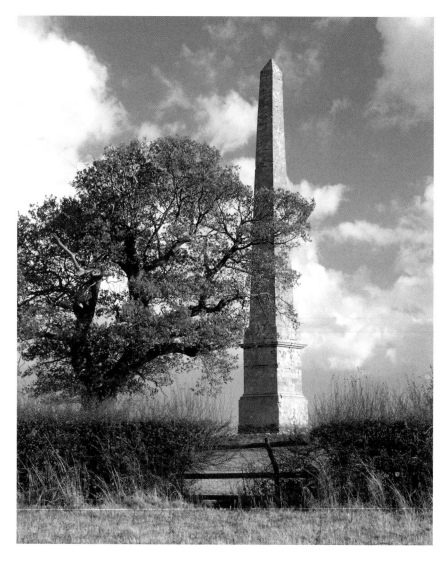

1.11 General Wolfe's Obelisk, built 1759. Stowe Landscape Gardens, Buckinghamshire, England. National Trust Images

There was also an American allusion to the Elysian Fields during the Revolution in an essay published in February 1776, following Montgomery's heroic death. Historically attributed to Thomas Paine, the essay is titled *A Dialogue between the Ghost of General Montgomery Just Arrived from the Elysian Fields and an American Delegate in a Wood Near Philadelphia.* It is written as a short playlet in which Montgomery's "shade" warns an unnamed member of the Continental Congress to accept no accommodation with the British.[47]

It can also be claimed that Oliver De Lancey, even earlier, may have wanted to create an American Elysian Fields by his placement of a Wolfe obelisk in his formal garden. Evidence of such a plan is found in two contemporary maps that include a new road, known "The Road to the Obelisk" or "Monument Lane," which ran from Broadway to the De Lancey property. The earliest of these maps, *Plan of the City of New York and its Environs to Greenwich, on the North or Hudsons River* (Figure 1.12), was designed by Captain John Montresor and published in 1767. The other was drawn by Bernard Ratzer, *Plan of the City of New York, in North America*, and surveyed just a few months later (Figure 1.13).[48]

The cartographer of the earlier of the two maps was Montresor who came from a family of military engineers and remained loyal to Great Britain. As an engineer he was often called upon to create maps, and this map, dated December 1766, was ordered by General Thomas Gage, later the military governor of Massachusetts, who was stationed in New York as commander in chief of military forces in North America from 1763 to 1774.

The second map was ordered by the new provincial governor, Sir Henry Moore, in 1767. Ratzer, an experienced surveyor, draftsman, and lieutenant in the 60th or Royal American Regiment of Foot, retraced Montresor's steps, extending and improving the earlier map.[49] W.P. Cumming writing about both maps ranked them "among the most accurately and beautifully executed and detailed plans of any American colonial city."[50] The maps also signaled New York's coming of age and its military and financial importance to Great Britain.[51]

It is Ratzer's map, in particular, with its careful delineation of an allée shown between rows of trees in a manner that most strongly suggests the arbored paths found in the great estates of England and also, interestingly enough, the plantations of the American South. There were several such estates, particularly along the James River in the tidewater area of Virginia that had formal gardens that included bordered walks, herb knots, mazes, urns, and obelisks. Chief among them was Colonel William Byrd's Westover estate, begun in 1726, which had a brick-walled garden framed with dwarf boxwood and flowering trees.

Inside Westover's walled garden were carefully organized plots with fruit trees, a vegetable garden, and grape arbors. Internal paths formed an equilateral cross at the center of which was a "monument" that is still there today and probably dates from the late 1740s following Colonel Byrd's death in 1744.[52] The garden historian Peter Martin has noted that the landscape design by the elder Byrd "represented one of the important early links in eighteenth-century Virginia between English, Williamsburg, and Virginia plantation gardening," and that "Byrd … understood the political underpinnings of much of the new gardening going on in England."[53] In political terms then, if there is an American equivalent of Stowe, it is Westover, which sat on the crossroads of the southern battles during the French and Indian War.

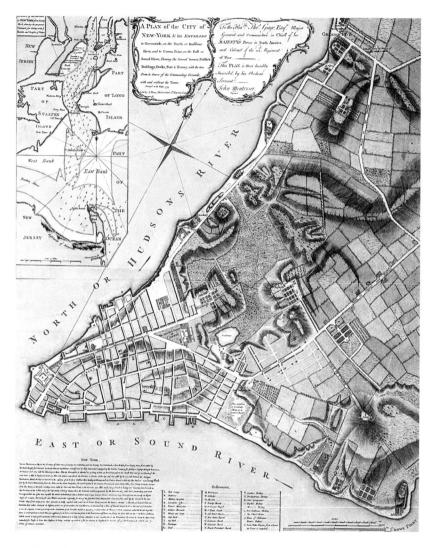

1.12 John Montresor, *A Plan of the City of New York and its Environs to Greenwich on the North or Hudsons River*, 24 13/16 × 20 1/2 in. (63 × 52 cm.), hand-colored map, depicted 1766; published 1767. The Lionel Pincus and Princess Firyal Map Division, The New York Public Library, Astor, Lenox and Tilden Foundations

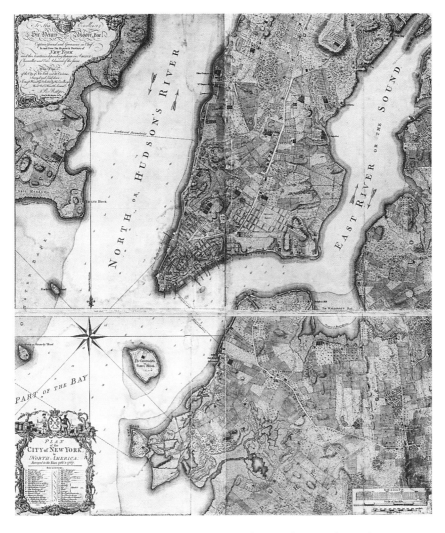

1.13 Bernard Ratzer, *Plan of the City of New York, in North America,*
41 15/16 × 35 13/16 in. (105 × 91 cm.), surveyed 1766 and 1767; published, 1776.
The Lionel Pincus and Princess Firyal Map Division, The New York Public Library,
Astor, Lenox and Tilden Foundations

Later, and after the Revolution, it was visited by American, British, and French officers, including Washington, Benedict Arnold, Lord Cornwallis, and the Marquis de Chastellux who claimed that Westover was the "most renowned house in the region."[54]

In contrast to the attention paid the gardens of the South and to Philadelphia, the great seat of botanical inquiry, British colonial gardens in New York have received scant notice. This is due in large part to the disappearance of all of the estates in lower Manhattan, and little is known of the garden designs of the ones that remain further north, most notably the Morris-Jumel Mansion near Audubon Terrace and the Van Cortlandt Mansion in the Bronx. Yet through the evidence of maps and a description of eighteenth-century Manhattan written by William Smith, the most noted contemporary historian of the province, a picture of the city emerges as an eighteenth-century Eden: "No part of America is supplied with markets abounding with greater plenty and variety. We have beef, pork, mutton, poultry, butter, wild fowl, venison, fish, roots, and herbs, of all kinds, in their seasons This city is the metropolis and grand mart of the province."[55] New York was a bountiful paradise with oysters from the Hudson, wheat, and fruit— "apples and pears of wonderful size ... and still more wonderful peaches so plentiful that were fed to the pigs."[56] At mid-century the Swedish botanist, Peter Kalm also noted the city's "fine buildings [and] opulence."[57] He found walking in the city, with its elegant trees and songbirds, a pleasure and further noted that the citizens liked to sit outside in the evening and enjoy the view.

The prosperity of the 1760s resulted in a number of the province's wealthiest families building new and lavish houses for themselves in the city and its environs. Most of these houses were not for city living but were built as rural retreats surrounded by farmland and gardens, some of which were formal in the manner of contemporary British gardens. While they had trimmed hedges, complex planting patterns, fountains, and sculpture, the purpose of these gardens more often than not was utility—to supply the manor house with vegetables, herbs, and flowers. Chief among them were the properties of the Warren and De Lancey families. And it was on Warren's property, then occupied by Oliver De Lancey, that an obelisk to the memory of General Wolfe was placed. Given Oliver's years in England aiding his sister Susannah and helping to oversee the commission of the Warren monument, there is every likelihood that De Lancey visited Stowe, and that he was inspired to create an American equivalent, although on a much smaller scale, that was open to the public and contained his tribute to Wolfe.

A Wolfe Monument for New York

Most of the documentation of New York's Wolfe monument was assembled in the early twentieth century by I.N. Phelps Stokes and published in his *Iconography of Manhattan Island*. In addition to including unsurpassed visual documents such as the Montresor and Ratzer maps and numerous contemporary prints, Stokes also constructed an important chronological history based on original sources including contemporary newspapers, John Montresor's *Journals*, William Smith's *History of New York*, and nineteenth-century narratives, much of which were also assembled from original documents by historians such as George Bancroft and Francis Parkman. Within his chronology, Stokes also included a commentary on the French and Indian War and its impact on the city.

As noted by Stokes, when news of the British victory at Quebec reached New York, the city rejoiced—cannons were fired, military colors displayed, and at night "the city [was] extraordinarily illuminated by two large Bonfires erected on the Commons."[58] Celebrations continued into November with Governor James De Lancey declaring a "Day of Publick Thanksgiving, on the Success of His Majesty's Arms," which included a "Grand Dinner" and "was concluded with Illuminations and Fire Works."[59] At the same time the city was saddened by the news of Wolfe's death, and Governor De Lancey subsequently gave an address to the General Assembly that summarized the great successes of the British army and included this encomium to Wolfe: "the glorious Victory gained by General Wolfe, over the Enemy, on the Plains of Abraham, near Quebec, with the Surrender of that City, the Metropolis of Canada; are Events which add fresh luster to the Reign of the Best of Kings ... and open to these Colonies a favorable Prospect of future Security."[60] The General Assembly responded, in turn, with an even longer encomium of Wolfe, calling his a "memorable conquest over the enemy," and that the general "with almost unparalleled Disinterestedness ... sacrificed his Life to the public Weal; and whose Bravery and Conduct ... has added luster to his Majesty's Arms; reflected peculiar honor on the Nation; and rendered his own Memory precious to every lover of his Country."[61] But there was no comparable call in New York for a monument similar to the one ordered by Pitt to be placed in Westminster Abbey. There was, however, a private commission by the governor's brother Oliver. Stokes believed he was influenced by James's address, by the words spoken in the General Assembly, and by the public's enthusiasm.[62]

No evidence documenting this commission exists, and the only evidence of the Wolfe monument remains notations on the Montresor and Ratzer maps (Figures 1.14 and 1.1). Working from them Stokes concluded that the Wolfe monument "was a stone obelisk [placed] near the north-west corner of Eighth Ave. and 14th St.," which was at the time the property of the Warrens

where Oliver had been living since the early 1760s prior to the installation of the Wolfe monument.[63] The monument disappeared, according to Stokes, sometime in the late eighteenth century. He based his conclusion on the fact that the Wolfe monument did not appear on Bancker's 1773 *Survey of Lands belonging to the Estate of the late Sir Peter Warren,* where "The Road to the Obelisk" was now called "Old Greenwich Lane." This renaming, according to Stokes, "controverts the theory of several writers that De Lancey demolished it after his Estate was confiscated" due to his being a Loyalist.[64] Stokes also relied upon two modern articles, both of which he cited. The first, simply titled, "Monument to General James Wolfe," was written by Dr. Edward Hagaman Hall and Jennie F. Macarthy, and appeared in the *Annual Report of the American Scenic and Historic Preservation Society.* The second was written anonymously and published in *The New-York Historical Society Quarterly Bulletin.*

Hall and Macarthy's article was the earlier of two, and they began with a summary of what was known about the Wolfe monument, which they claimed was the "first public monument erected in New York City" and was in its day a famous landmark. Like Stokes they based their findings on the inclusion of the Wolfe monument on the Montresor and Ratzer maps, mentioning that on the former (Figure 1.14), "the monument is represented by a microscopical picture, showing a pedestal with cubical die surmounted by an obelisk." They then went on to speculate that the monument was erected sometime between 1760 and 1767 and conceded that "there is much mystery" surrounding its commission and disappearance. They, like Stokes, concluded that it was probably Oliver De Lancey who put it up. "The fact that it was erected on De Lancey's property suggests that he must have been the moving spirit in the undertaking, and that probably he himself put it up. He was a man of wealth and easily able to bear the expense. His family was accounted by some as the most influential, politically and socially, in New York."[65]

The next writer to weigh in on the history of the Wolfe obelisk was the unnamed author of "The Elusive Monument Erected to General James Wolfe," written in 1920. The writer begins by acknowledging Hall's article and the research of Jennie F. Macarthy of the New York Title Guarantee and Trust Company.[66] "They both agree ... that in the absence of any public appropriation for the enterprise, it is reasonable to assume that General Oliver De Lancey paid for it, especially as it was erected on his Estate and that he also removed it."[67] Working from that assumption, the writer made note of an intriguing description of a "Monument in Memory of General Wolfe," published in the *New York Mercury* of July 12, 1762. This description is worth quoting in full since it raises the possibility that the Wolfe obelisk in New York was a more complex monument than just a plain-sided obelisk.[68] The elements included in the description also suggest that it may have been based on an early design by John Michael Rysbrack a Flemish-English sculptor who had submitted early designs for the Westminster Abbey Wolfe competition:

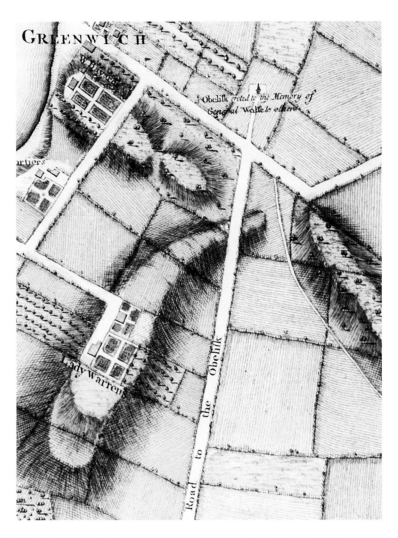

1.14 Detail of Oliver De Lancey property with indication of General Wolfe monument.
John Montresor, *A Plan of the City of New York and its Environs to Greenwich on the North
or Hudsons River*, 24 13/16 × 20 1/2 in. (63 × 52 cm.), hand-colored map, depicted 1766;
published 1767. The Lionel Pincus and Princess Firyal Map Division, The New York
Public Library, Astor, Lenox and Tilden Foundations

This to inform the Gentleman and Ladies of this City, That there is just brought
to Town, and to be disposed of by Way of drawing of Tickets, at the House
of Widow Alstine, next Door to Mr. Rutherford's, near the Bowling Green,
a most curious Piece of Work representing a County Seat, with the Chapel,
Summer House, Flower Gardens and Grottos belonging to it; also a Monument
in Memory of General Wolfe, on the Top of which is the Image of Fame, below
which are the Ensigns bearing the English Standards; in the Body of the Piece is

the Corps on a Couch, at the foot of which is Minerva weeping, at the Head is Mars, pointing to General Amherst, who stands at a small Distance, as meaning *Behold a living Hero*, with other pieces too tedious to mention. Any Gentleman or Ladies inclining to adventure, may see it at any Time of Day, and know the Terms of disposal, which will be on Thursday next, in the Afternoon, at 5 o'clock, without fail. The Whole is enclosed in a Glass Case.[69]

The author of the article concluded that this was "an interesting description of what seems to be a model of the Wolfe monument and the De Lancey Estate."[70] So what is this "most curious Piece of Work?" It appears to be an architectural model of some sort that included elements of an elaborate garden along with a "Monument in Memory of General Wolfe," all of which were "enclosed in a Glass Case." The later assertion that it seemed "to be a model of the Wolfe monument and the De Lancey Estate" was one made by commentators in the early twentieth century. Whether or not this latter claim is true, we are still left with the dilemma of the description of a Wolfe monument that almost exactly fits one of several designs created by Rysbrack in response to a call for submissions to the Wolfe competition of 1760 in London.[71]

Rysbrack immigrated from Antwerp to England in 1720 and over the next 40 years established himself as one of the foremost sculptors in England. He worked closely with the architect James Gibbs on the design of several important monuments for Westminster Abbey, including the *Monument to Matthew Prior* (1721) that "brought both immediate and enormous success."[72] Rysbrack also "supplied a set of historical portrait busts … for Gibbs' buildings in the celebrated landscape gardens at Stowe."[73] He further established his reputation with a monument to Sir Isaac Newton (1731) for the abbey, and even though close to retirement, Rysbrack responded to the call for designs for the Wolfe memorial (Figure 1.15). In this drawing a flat pyramidal-shaped obelisk is set on a high Neoclassical podium, which includes a bas-relief of Wolfe, flanked by descriptions, being carried by his soldiers. Backing onto the obelisk are flags and standards in front of which a group of figures mourn the death of Wolfe. His body is supported by a helmeted figure who reads as Minerva and behind the body is a soldier who perhaps represents General Amherst. To the far left is a draped figure of Britannia holding a shield with the British coat of arms. Above the scene flies a winged image of fame blowing a trumpet. All of this seems to conform loosely to the 1762 description of the Wolfe model: "on the Top of which is the Image of Fame, below which are the Ensigns [there appears to be only one 'ensign'] bearing the English Standards; in the Body of the Piece is the Corps on a Couch, at the foot of which is Minerva weeping [in the drawing this figure is Britannia], at the Head is Mars [now Minerva], pointing to General Amherst, who stands at a small Distance."[74]

And here the trail ends. The historical evidence implies a monument in New York of some distinction, enough so that a road was named for it and

1.15 John Michael Rysbrack, *Design for a monument to General James Wolfe*,
13 1/8 × 9 9/16 in. (33.5 × 24.3 cm.), ink, watercolor and ink wash on paper,
c. 1760. Victoria and Albert Museum, London

it appeared on two maps of the period. It is also agreed that the monument was on property owned by Susannah De Lancey Warren, who either deeded it to her brother or allowed him to live there, and that Oliver was the person who commissioned the monument. Regardless of what little is known about the New York Wolfe monument, there is enough data to substantiate the De Lancey's involvement with its commission. The placement of this heroic monument by De Lancey can also be seen as the culmination of early ambitions among the Warrens and De Lanceys to establish the seeds of public commemoration.

Such commemoration in eighteenth-century America is a reflection of English tradition, adopted from a distance—perhaps not by direct example but through verbal reminiscence, prints, and travel. Commemorative portraits and monuments were also the visual manifestations of the same idealism inherent in creating the trappings of community—churches, schools, colleges, hospitals, newspapers, fire companies, town halls, and marketplaces—a community ethos articulated in British America almost simultaneously by Benjamin Franklin in Philadelphia and Bishop Berkeley in Newport, Rhode Island. This ethos was articulated by Franklin in his 1743 treatise, "A Proposal for Promoting Useful Knowledge among the British Plantations in America," the practical implementation of which became the American Philosophical Society, established in 1768. Franklin's communitarian efforts are relatively well known, certainly in comparison to Berkeley's similar contribution to colonial life in Newport.[75] Here in the 1720s Berkeley introduced, through his preaching and writing, the codes of European civilization that one assumes he shared with Smibert and which the artist later instilled in the elite citizenry of Boston.

An offshoot of these seeds sown in Newport and Boston is the Wolfe monument erected by Oliver De Lancey in Greenwich Village. De Lancey and the Warrens were patrons of Smibert, and when Peter Warren died Oliver participated in the commissioning of a large figurative tomb for Westminster Abbey. New York's Wolfe monument also extends the Enlightenment's interest in classical forms and the honoring of the secular hero. This enactment of these early civilizing gestures was furthered in the next generation by Oliver's nephew, Captain James De Lancey, who supported and helped commission two impressive public sculptures for New York: a standing monument of William Pitt and an equestrian statue of George III—both designed by the author of the Wolfe memorial in Westminster Abbey, Joseph Wilton. Both of these were commissioned by New York's General Assembly as impressive gestures of thanks for Pitt's support of, and the king's acquiescence to, the repeal of the Stamp Act. Both statues embodied the fealty of colonial citizens and in New York would compete with Wolfe as liberty's heroes.

Notes

1 In my discussion of the French and Indian War, I have relied upon Fred Anderson, *Crucible of War: The Seven Years' War and the Fate of Empire in British North America, 1754–1766* (New York: Alfred Knopf, 2000). According to Anderson, "the Seven Years' War was far more significant than the War of the American Revolution," xviii.

2 According to Warren's primary biographer, Julian Gwyn, at the time of his death in 1752 Warren "possessed assets of £155,000 making him one of the rich men of the kingdom." "Money Lending in New England: The Case of Admiral Sir Peter Warren and His Heirs, 1739–1805," *New England Quarterly* 44 (March 1971): 121. I remain grateful to Dr. Gwyn for his responsiveness to my inquiries about Sir Peter Warren, his wife Susannah, and her brother Oliver De Lancey.

3 *Minutes of the Common Council Corporation of the City of New York, 1675–1776* (8 vols, New York: 1905), 4: 44, February 11, 1730.

4 Julian Gwyn, *An Admiral for America: Sir Peter Warren, Vice Admiral of the Red, 1703–1752* (Gainesville: University Press of Florida, 2004), 162. Warren's property was located along the Hudson River between today's Christopher and West 21st Streets. I.N. Phelps Stokes, *The Iconography of Manhattan Island, 1498–1909*, (6 vols, New York: R.H. Dodd, 1915–28), 1: 866.

5 Thomas Jefferson Wertenbaker, *Father Knickerbocker Rebels: New York City during the Revolution* (New York: Charles Scribner's Sons, 1948), 15.

6 Gwyn, *Admiral for America*, 23. Warren invited members of his family from Ireland, including his cousin William Johnson, to help settle his property along the Mohawk River. Johnson, called the "white savage," was superintendent of Indian affairs for the colony of New York from 1756 to 1774. See Fintan O'Toole, *White Savage: William Johnson and the Invention of America* (New York: Farrar, Straus and Giroux, 2005).

7 Quoted in Gwyn, *Admiral for America*, 54.

8 Ironically, as part of the Treaty of Aix-la-Chapelle (1748), which formally terminated the War of the Austrian Succession, Louisbourg came under French control again in exchange for the return of Madras in India to British rule. Two decades later, the British, at the end of the French and Indian War, ousted the French permanently from this Northeastern fortress.

9 Edwin S. Gaustad, *George Berkeley in America* (New Haven: Yale University Press, 1979), 24.

10 Ibid., 66.

11 Quoted ibid., 25.

12 Ibid., 50.

13 Ibid., 42.

14 The original *Bermuda Group* was begun in July 1728 and completed over the next three years. It remained in Smibert's studio for many years; it was sold in 1808 and then given to Yale College. There is a study for the final version, 24 × 27 1/2 inches, at the National Gallery of Ireland and a modern copy of the study

done by Donald E. Forrer for Berkeley College, Yale University. There are also three copies of the original, one by Matthew Pratt, now at Brown University, Providence, a second at the Redwood Library, Newport, Rhode Island, and a third at the University of California, Berkeley. See Saunders, *John Smibert, Colonial America's First Portrait Painter* (New Haven: Yale University Press, 1995), 170–73.

15 According to Berkeley's editor and biographer, A.A. Luce, "James and Dalton were monied men traveling for pleasure; they left the ship at Virginia [Berkeley and his followers had been driven off course and stopped first at Virginia before proceeding to Newport], and traveled northwards independently, foregathered at Newport, and settled for some years in Boston." George Berkeley, The *Works of George Berkeley, Bishop of Cloyne*, ed. A.A. Luce and T.E. Jessop (9 vols, London and New York: Thomas Nelson, 1948–1957), 9: 75.

16 Margaretta M. Lovell, *Art in a Season of Revolution: Painters, Artisans, and Patrons in Early America* (Philadelphia: University of Pennsylvania Press, 2005), 142.

17 Fiske Kimball, "The Beginnings of Sculpture in Colonial America," *Art and Archaeology* 8, no. 3 (May–June 1919): 184–9.

18 Ibid, 185.

19 Saunders, on the basis of stylistic sophistication and its similarity to Faneuil Hall, proposed that Smibert designed Holden Chapel, Harvard University, in 1744. The original Harvard building still exists, while the present Faneuil Hall is a Thomas Bulfinch rendition of Smibert's original. Smibert's portrait of the donor Peter Faneuil (1743) disappeared in the eighteenth century. An 1807 copy by Henry Sargent hangs in the hall's auditorium.

20 See Ellen Miles, "Portraits of the Heroes of Louisbourg, 1745–1751," *American Art Journal* 15 (Winter 1983): 48–66. I am grateful for the lengthy telephone conversations I had with Dr. Miles and Dr. Saunders on Smibert and the Warren and De Lancey families.

21 Oliver De Lancey sat for Smibert in December 1742. It is assumed the portrait was painted in Boston at the time his relatives were living there. See Saunders, *John Smibert*, 223.

22 The Shirley portrait is known only through a mezzotint copy by Peter Pelham, published in 1747. See ibid., 236.

23 There are two articles written about Pepperell's extravagant lifestyle in Kittery. According to Burton F. Trafton, Jr. in "Louisbourg and the Pepperell Silver," *Antiques* 89 (March 1966): 366: William Pepperell (1696–1759) "maintained a deer park, kept a retinue of servants, and as the great public feature of his baronial way of life, owned a luxurious barge, manned by a colored liveried crew …. When he visited England in 1749 he was received with great ceremony and given an extravagantly ornamented silver cup and cover by the lord mayor of London on behalf of a grateful city." Joseph William P. Pepperell Frost also wrote on Pepperell in "Living with Antiques: Pepperell Mansion, Kittery Point, Maine," ibid., 89 (March 1966): 373: Pepperell was the owner of "one of the largest colonial merchant houses, with shipping routes to the Caribbean, to Europe, and to the Maritime Provinces."

24 Another portrait, *Brigadier General Samuel Waldo* painted by Robert Feke, c. 1748 (Bowdoin College Museum of Art, Maine) has been identified as being a part of this series. See Miles, "Portraits of Heroes," 64.

25 Saunders, *John Smibert*, 206.

26 Julian Gwyn, *The Enterprising Admiral: The Personal Fortune of Admiral Sir Peter Warren* (Montreal: McGill-Queen's University Press, 1974), 158.

27 Warren wrote Pepperell: "Our Pictures [by Hudson] should have been with you ere now could we get the Painter to finish them." Quoted in Miles, "Portraits of Heroes," 61.

28 Ibid., 50.

29 The commission of the Sir Peter Warren monument (commissioned 1753; erected 1757) is detailed in David Bindman and Malcolm Baker, *Roubiliac and the Eighteenth-Century Monument: Sculpture as Theatre* (New Haven: Yale University Press, 1995), 318–23.

30 After his death, Tyrell too would be honored by a Westminster monument unveiled in 1770 and designed by Roubiliac's assistant Nicolas Read.

31 Bindman and Baker, *Roubiliac,* 5.

32 Matthew Craske, "Westminster Abbey 1720–70: A public pantheon built upon private interest," in Richard Wrigley and Matthew Craske, eds., *Pantheons: Transformations of a Monumental Idea* (Aldershot, UK, and Burlington, VT: Ashgate, 2004), 57.

33 Bindman and Baker, *Roubiliac*, 147.

34 For my understanding of Wolfe's mythical status in the eighteenth century, I have relied upon Alan McNairn. *Behold the Hero: General Wolfe and the Arts in the Eighteenth Century* (Liverpool: Liverpool University Press, 1997).

35 Simon Schama, *Dead Certainties: Unwarranted Speculations* (New York: Alfred Knopf, 1991). Imaging Francis Parkman at the moment he is writing about Wolfe at Quebec, Schama describes the historian's identification with Wolfe thusly: "Past and present dissolved at this moment. He became Wolfe and Wolfe lived again through him; the man's perseverance and fortitude; the punishments of the body; the irritability of his mind; the crazy agitated propulsion of his energies all flowed between subject and historian," 64–5.

36 Francis Parkman, *Montcalm and Wolfe: The French and Indian War* (1884; reprint, New York: De Capo Press, 2001), 329.

37 Quoted in ibid., 495.

38 Joan Coutu, "Eighteenth-Century British Monuments and the Politics of Empire," PhD. diss., University College, London, 1993, 26 n 5. Dr. Coutu remains the authority on Wilton, and I am grateful for the time and advice she gave me when we were both in London working in the archives of the Society of the Arts.

39 E. Beresford Chancellor, *The Lives of British Sculptors and Those Who Have Worked in England…* (London: Chapman and Hall, 1911), 131.

40 Alan Bullock, *The Humanist Tradition in the West* (New York: W.W. Norton, 1985), 49.

41 John Martin Robinson, *Temples of Delight: Stowe Landscape Gardens* (London: George Philip in association with the National Trust, 1990).

42 Philip Ayres, *Classical Culture and the Idea of Rome in Eighteenth-Century England* (Cambridge and New York: Cambridge University Press, 1997), 80.

43 William L Beiswanger, "Thomas Jefferson's Vision of the Monticello Landscape," in *British and American Gardens in the Eighteenth Century* (Williamsburg, VA: Colonial Williamsburg Foundation, 1984), 170–88.

44 Hesiod, *Works and Days,* trans. Glenn W. Most (Cambridge, Mass.: Harvard University Press, 2006), lines 156–73.

45 Pindar, *Olympian* (Cambridge, Mass.: Harvard University Press, 1997), 2: 56–83.

46 Quoted in Peter Willis, *Charles Bridgeman and the English Landscape Garden* (Newcastle Upon Tyne: Elysium Press, 2002), 5.

47 The classical allusion contained in this essay is also evidence of Americans broad familiarity with Greek and Roman writers that many modern scholars believe provided a critical underpinning to the drive for independence and the design of the Constitution. These new discussions of the importance of classical learning on the formation of the Republic and the education of the Founding Fathers include: David J. Bederman, *The Classical Foundations of the American Constitution: Prevailing Wisdom* (Cambridge and New York: Cambridge University Press, 2008); Richard M. Gummere, *The American Colonial Mind and the Classical Tradition: Essays in Comparative Culture* (Cambridge, Mass.: Harvard University Press, 1963); and Meyer Reinhold, *Classical Americana: The Greek and Roman Heritage in the United States* (Detroit: Wayne State University Press, 1984). The latter contains an excellent historiographical essay.

48 Montresor's plan was the first map to designate the area as Greenwich Village. There are two different maps by Ratzer both drawn between 1766 and 1767. The Ratzer Plan was published in 1769; the second, known as the Ratzen Plan (the misspelling was a printer's error) was published in 1770.

49 Ratzer's map "was advertised for sale" in August 1769. W.P. Cumming, "The Montresor-Ratzer-Sauthier Sequence of Maps of New York City, 1766–76," *Imago Mundo* 31 (1979): 57.

50 Ibid., 55.

51 According to Edward Countryman, *A People in Revolution: The American Revolution and Political Society in New York, 1760–1790* (Baltimore: Johns Hopkins Press, 1981; New York: W.W. Norton, 1989), 8: "In 1720 New York had legally imported British goods worth £37, 397, but in 1764 it brought in British goods worth £515, 416. That was higher than the value of the imports of Pennsylvania, Virginia, or all the New England provinces together."

52 Edith Tunis Sale, ed. *Historic Gardens of Virginia*, (Richmond, VA: William Byrd Press, 1930), f. 24.

53 Peter Martin, "'Long and Assiduous Endeavours:' Gardening in Early Eighteenth-Century Virginia," in *British and American Gardens*, 112.

54 Marquis de Chastellux, *Travels in North America in the Years 1780, 1781 and 1782*, trans. Howard C. Rice, Jr., rev. ed. (2 vols. Chapel Hill: University of North Carolina Press, 1963), 2: 430.

55 William Smith, *The History of the Late Province of New York from Its Discovery to the Appointment of Governor Colden in 1762* (2 vols, New York: New-York Historical Society, 1829–30), 1: 300.

56 Quoted in Alice B. Lockwood, ed. *Gardens of Colony and State* … (2 vols, New York: Charles Scribner's Sons, 1931–1934), 1: 259.

57 Quoted ibid.

58 Stokes, *The Iconography of Manhattan Island, 1498–1909 …*, 4:709.

59 Ibid.

60 James De Lancey, "Address to the Council and General Assembly," December 6, 1759, *Journal of the Votes and Proceedings of the General Assembly of the Colony of New York …, 1665–1765* (2 vols, New York: Hugh Gaine, 1766), 2: 44.

61 W. Nicoll, "The Humble Address of the General Assembly of the Said Colony," December 11, 1759, ibid., 52.

62 Later on in volume six, Stokes contradicted himself, or at least raised the possibility that it was General Robert Monckton, Wolfe's second in command, who erected the obelisk. Monckton, pictured to the left of the prostrate Wolfe in Benjamin West's history painting *The Death of Wolfe,* was wounded and sent to New York City to recuperate. He took up residence in the Warren house, and Stokes raises the possibility that Oliver De Lancey "could not have felt the same loyalty and devotion to Wolfe that Monckton was known to have entertained." The Warren house that Monckton lived in was on property further downtown than that occupied by Oliver De Lancey.

63 Stokes, *Iconography*, 4: 1761. According to Gwyn, *Enterprising Admiral*, 33, "during his years as his sister Susannah's agent, Oliver De Lancey charged her no commission. In return, between 1761 and 1775 he lived rent-free in one of the Warren houses in Greenwich Village."

64 Stokes, *Iconography*, 3: 866.

65 [Edward Hagaman Hall and Jennie F. Macarthy,] "Monument to General James Wolfe," *Annual Report of the American Scenic and Historic Preservation Society*" (1914), 121 and 122. In a note on page 126, Hall acknowledges that "the same investigation was being pursued independently by Miss Jennie F. Macarthy, the historical expert of the New York Title Guarantee and Trust Company."

66 "The Elusive Monument Erected to General James Wolfe," *New-York Historical Society Quarterly Bulletin* 4, no. 3 (October 1920): 74.

67 Ibid., 74.

68 I want to thank Dr. Bernard Herman of the University of Delaware and Lucy Wood, senior curator of the Victoria and Albert Museum for their advice concerning the 1762 description of the Wolfe monument.

69 Ibid., 74–5.

70 Ibid., 75.

71 Joan Coutu in *Persuasion and Propaganda: Monuments and the Eighteenth-Century British Empire* (Montreal: McGill-Queen's University Press, 2006), 211, makes a similar point that this description "sounds remarkably similar to some of the competition entries for the monument to Wolfe in Westminster Abbey."

72 Katharine Eustace, *Michael Rysbrack, Sculptor, 1694–1770* (Bristol: City of Bristol Museum and Art Gallery, 1982), 16.

73 Ibid., 17.

74 "The Elusive Monument," 75.

75 Today in studies of American art history, George Berkeley is best remembered for his poem "On the Prospect of Planting Arts and Learning in America." This poem, which contains the famous phrase "Westward the course of empire takes its way," retained extraordinary resonance through the nineteenth century. After the Revolution, it was the New York writer Gulian Verplanck who wrote an appraisal of Berkeley that was quoted at length, along with a reprinting of the poem, in William Dunlap's first volume of *History of the Rise and Progress of the Arts of Design in the United States* (2 vols, New York: 1834). This publication was almost simultaneous with Thomas Cole's five-part series *The Course of Empire,* commissioned by Luman Reed, a mutual friend of Cole, Dunlap, and Verplanck. In it Cole traces the evolution of a civilization from its natural state to its maturity and destruction, thus replacing Berkeley's utopian vision with a pessimistic one. Twenty-five years later, Emanuel Leutze, of *Washington Crossing the Delaware* fame, revisited Berkeley's poem and adopted it as a subject for a mural commissioned for the United States Capitol. Titled *Westward the Course of Empire Takes Its Way: or, Westward Ho!* Leutze's mural embodies a mid-century embrace of America's Manifest Destiny, an interpretation that puts a new spin on Berkeley's optimism as justification for the nation's expansionist policies. An enduring tribute to the dean is the Berkeley campus of the University of California, which was named after the divine in 1866.

Celebrating the Repeal of the Stamp Act:
New York Tributes to William Pitt and George III

It is a curious idea that the annulling of a legislative act would lead to the commission of two monuments. But this is, in fact, what New York's General Assembly did ordering from England a standing marble William Pitt and a gilded lead equestrian statue of the later reviled George III. Both were credited by the colonists with the repeal of the 1765 Stamp Act and were subsequently declared defenders of liberty. Even an early tribute, a liberty pole put up by the Sons of Liberty in New York, was erected to honor "his Majesty, Mr. Pitt, and Liberty."[1] The colonists were grateful for Pitt's impassioned support of colonial rights during the Stamp Act crisis. Virtually every major city in North America legislated for some type of public accolade to him, which often included a nod to George III. These commemorative gestures took diverse forms, including rings and medals that were made in England and sent as presents to influential colonial merchants. There was also an early pre-Stamp Act print by the Boston silversmith and engraver Nathanial Hurd (Figure 2.1), which contained three medallion portraits of George III at the top, Pitt to the left, and a third icon of liberty, General James Wolfe, below.[2] The Hurd engraving, known by its inscription, "behold the best of kings," was published in 1762 and advertised in the *Boston Evening Post* as a print "fit for a picture, or for Gentlemen and Ladies to put in their watches."[3]

In Boston, on its commons, Pitt and George III, as well as some colonial heroes, were honored by an obelisk known today through an engraving by Paul Revere (Figure 2.2). At the time, the obelisk was described in the *Massachusetts Gazette* as "a magnificent Pyramid, illuminated with 280 Lamps; the four upper Stories of which were ornamented with the Figures of their Majesties, and fourteen of the worthy Patriots who have distinguished themselves by their Love of Liberty."[4] This illumination, drawn on transparent vellum, was never intended to be permanent. Fortunately, there is a print of it by Revere that gives us some sense of its appearance and lines of text aid in

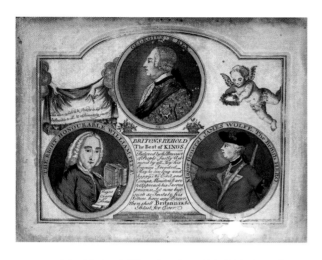

2.1 Nathanial Hurd, *Britons, behold the best of kings*, 3 15/16 × 5 1/8 in. (10 × 13 cm.), engraving for watch papers, hand colored, 1762. American Antiquarian Association, Worcester, MA

the identification of the bust portraits. Another gesture of respect, a *Pillar of Liberty*, was commissioned by the Sons of Liberty in nearby Dedham in honor of Pitt "who saved / America from impending Slavery," and included a declaration of "our most loyal / Affection to KG George III."[5] The most complex of these American accolades to Pitt was a life-size allegorical portrait by Charles Willson Peale for the province of Maryland. In it the young Peale, who at the time was

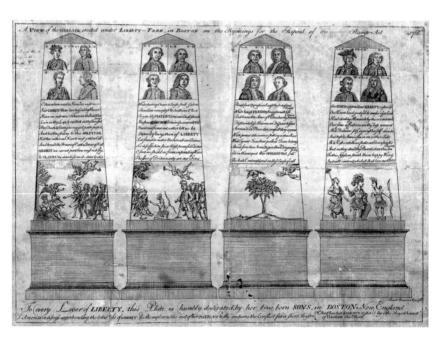

2.2 Paul Revere, *A View of the Obelisk erected under Liberty-Tree in Boston*, 9 3/8 × 13 1/4 in. (26 × 40.5 cm.), line engraving, 1766. American Antiquarian Association, Worcester, MA

studying with Benjamin West in London, created a learned pictorial treatise that linked Pitt to the liberties won during the Glorious Revolution of the late seventeenth century to contemporary colonial bids for freedom. There were also single tributes to George III that most often took the form of official portraits for city halls. However, the most important colonial tributes were those paid for by the General Assembly of New York: a full-length marble statue of Pitt and a life-size equestrian statue in gilded lead of George III ordered from Joseph Wilton, the English sculptor of the Wolfe memorial for Westminster Abbey.

Peacetime New York, 1763–1775

About the same time that the General Wolfe monument was installed in Greenwich Village, the city welcomed a new provincial governor, Robert Monckton, who had been at Wolfe's side when he was killed at Quebec.[6] The appointment of a military governor underscores the fact that the French and Indian War was not over, and New York, still an important naval station, was filled with soldiers and sailors. Even after the Treaty of Paris was signed in 1763, the city remained the principal military base for North America. It was there that General Thomas Gage, replaced Amherst as commander in chief of his majesty's forces in North America.[7]

Over the course of three decades, from 1760 to 1790, New York evolved from being a strategically vital harbor town, to becoming a commercial city, to serving as the headquarters of the British military, to finally, and surprisingly, becoming the first capital of the United States. Propelling this evolution was a strong and ambitious merchant class who, wishing to establish the trappings of the well to do, hired newly arrived European artists and craftsmen eager to create images of the city and its inhabitants.[8] For instance the German immigrant Michael de Bruhls offered a series of engravings that were advertised to be "an exact Account of the wholsom Climate, pleasant Situation, Products, etc. of this Province."[9] New York merchants also wanted to have their portraits painted, and the American-born Abraham Delanoy, newly arrived from Benjamin West's studio in London, "settled at Mr. Turner's in New Dutch-Church-street, near Colonel Robinson's where he intends to carry on Portrait Painting."[10]

The city's merchants also supported civic improvements, such as the upgrading of roads, ferry slips, wharves, and warehouses, all of which created an infrastructure that supported mercantile interests. This expansion called for updated land surveys and maps, which were supplied by John Montresor, Gerard Bancker and Bernard Ratzer. Prosperity was also evident in the large number of new homes built for merchants, such as James Beekman's

summer house Mount Pleasant built far from lower Manhattan near what is Fifty-first Street today. Their manor houses needed furniture, and John Brimner, one of the many cabinetmakers from England, could supply "every article in the cabinet, chair-making, carving and gilding business."[11] An increased population also led to the expansion of churches, and Trinity, as the leading Anglican church in America, built a new parish chapel, St. Paul's, on Broadway opposite the Fields or Commons (the present-day City Hall Park). Mercantile ties with Canada, now a British dominion, were also established, and communication between the two colonies prompted Benjamin Franklin, postmaster general for British America, to establish "monthly postal service between Canada and New York."[12]

This period of expansion of the city's welfare and mercantile interests was upended with the enactment of several tariffs by the British parliament. New York's businessmen, like their counterparts in Boston and Philadelphia, were restive and chaffed at British restrictions on trade, including a tariff on sugar. Heretofore, such taxes had been largely ignored but they were now being enforced, and New York's General Assembly, in protest of the Sugar Act (1764), petitioned the House of Commons to remove the impositions of levies "upon the Subjects *here*, by Laws to be passed *there*," words that would become rallying cries during the ensuing Stamp Act crisis. Members of the Assembly went further, invoking the province's contribution and sacrifices during the French and Indian War, and forwarded a plea to London from the city's merchants to end this burden on the sugar trade.

New York merchants also sought ways to undercut dependence on British manufacturers by supporting local producers who could fabricate wool and process foods, including flour and sugar, in competition with England. To encourage such initiatives, a group of civic-minded citizens, most of them businessmen, formed in 1764 the Society for the Promotion of Arts, Agriculture and Economy modeled on London's Society of Arts, established 10 years earlier.[13] The first announcement of the creation of the society read: "The public is informed that, on account of the present deplorable State of our Trade, a 'Society for the Promotion of Arts, Agriculture and Economy in the Province of New York' has been formed to promote the true Interest of this Colony, both public and private." This invitation, issued by the society's treasurer John Van der Spiegel and its secretary Benjamin Kissam, was for a meeting to take place at the house of Samuel Francis.[14] Like their London counterparts, the New Yorkers offered premiums for "industrious Persons in the Linen Branch" and decreed that "an honorary Gold Medal be given for each of the three first Flax-Mills that should be erected in this Province," and in the spring members established a "flaxspinning school."[15] Their awards were announced regularly in the newspapers, and such was the interest in their mercantile initiatives that two years later, after the repeal of the Stamp Act, a group of merchants formed the New York Chamber of Commerce in

1768 (the first in North America) to further protect and promote New York's commercial interests. The merchants of New York were not idealists who thought of community in utopian terms; rather they were practical men who yoked their desire for profit to the welfare of the city. These men and others who shared their Tory interests were among those who petitioned for statues of Pitt and George III.

For I.N. Phelps Stokes, the great chronicler of Manhattan's history, 1763 and the termination of the French and Indian War also marked the end of what he terms the English period (1664–1763), from the end of Dutch rule to the Treaty of Paris. The next era is what he calls the Revolutionary period (1763–1783).[16] These are useful demarcations; yet they reflect, as do almost all studies of pre-Revolutionary America, an inescapable desire to read the years following the French and Indian War as a run-up to independence, focusing on the unrest and quarreling with the London Board of Trade and Parliament and the patriots' resistance and protests. At the same time Stokes's account is valuable, more so than most, because he evenhandedly describes the comings and goings of the city's merchants and tradesmen, including those who would later be termed Tories or loyalists. Yet even Stokes does not adequately explain the commissioning and sudden appearance of two major sculptures for lower Manhattan. To better understand the commissioning of these monuments, it is necessary to view the period through a wider lens, one that acknowledges the elite rule of the city and the influence of the families, among them the De Lanceys, most of whom would remain loyal to the crown. This is a serious challenge since there is a dearth of information on Tory families before the Revolution. Part of the problem is that their papers, such as may exist, are in distant archives in places such as Nova Scotia and Newfoundland, where many loyalists emigrated, as well as in Great Britain. There is, however, increased interest in loyalist history and a spate of recent books that focus in particular on New York, which after the defeat of Washington's troops in 1776 was the most important loyalist stronghold in the colonies and home to British troops.[17] Yet few of these books take as their focus civic life in the city before the war—how did prosperous merchants live, what were their cultural ambitions for themselves and for the city? This lacuna relative to Tory history is painfully apparent when undertaking a study of pre-Revolutionary New York since it was largely run by a wealthy, educated, and cultured population, some of whom, in efforts to preserve their property and status, remained loyal to the king and Parliament.[18]

There is, however, one good contemporary source written by the loyalist Thomas Jones, whose *History of New York during the Revolutionary War and of the Leading Events in the Other Colonies of that Period* was later edited and published by his descendant, Edward De Lancey in 1869. Jones, who had married Lieutenant Governor James De Lancey's sister Anne, stayed in New York until 1779 when his estate was confiscated by the newly incorporated

State of New York. That December he and his wife sailed for England where he continued to write his history. Full of gossip and complaints, Jones's history has the benefit of communicating the tensions and disappointments felt by members of New York's ruling class during the revolutionary decades of the eighteenth century.

Given this lack of knowledge at what might be termed the other side of the story, it is hard to even characterize the decade. Some commentators see it as a period of decline, others as an era of prosperity, conflicting analyses that often reflect the predisposition of the writer. These same biases hold true in discussion of the rebellious New York Sons of Liberty—they have been regarded equally as working-class heroes who challenged the authority of the royal governor, as marauding thugs who destroyed private property, or as hapless dupes manipulated by the elite—Tory and Whig alike—for their own ends. The unrest created by the Sons of Liberty was real. British soldiers, who earlier were regarded as the city's protectors, came to be reviled and insulted. Even the admired commander of the French and Indian war Jeffrey Amherst was burned in effigy, and Governor Cadwallader Colden's carriage was attacked and set aflame in Bowling Green. Yet none of these well-documented agitations account for the unexpected appearance of two major works of public sculpture in lower Manhattan. None of these interpretations help us understand why a group of freemen, some members of the Sons of Liberty, convened at a coffeehouse in June 1766 and wrote a petition to the General Assembly for a statue to William Pitt, a commission that was expanded by the Assembly to include an equestrian statue of George III. With the memorialization of the hero, whether it be the self-promotion of Warren or the semipublic effort of Oliver De Lancey to honor Wolfe, New York City had caught the fever of commemoration, and by the end of the 1760s two statues would be placed in lower Manhattan to celebrate the repeal of the Stamp Act.

New York and the Stamp Act Crisis

The Stamp Act, ratified March 22, 1765, required that certain documents— land grants, attorney licenses, playing cards, dice, newspapers, and pamphlets—be affixed with a stamp of appropriate value purchased from an official distributor. The revenues from said act were to help offset the cost of the French and Indian War and the garrisoning of British troops in the colonies. The defeat of the French was of great benefit to the British citizenry of North America, and a standing army protected them from Indian allies of the French, so Parliament felt justified in imposing such a tax. The earlier Sugar Act had called for a three pence per gallon levy on molasses; but the Stamp Act was more comprehensive, and constitutional issues were raised

immediately. If the colonials were British citizens then they could not be taxed without their consent. However, they had no representation in Parliament. Thus a crisis was precipitated, and the colonists became painfully aware of their lesser status as citizens of the realm. During the six-month period from enactment to when it was to take effect on November 1, there were uprisings throughout the colonies. Citizens protested, sometimes violently, and the men who led these intercolonial protests were dubbed the Sons of Liberty.[19] The announcement of their first meeting in New York City, held October 1765, included this strident cry: it "is earnestly desired by a great number of the inhabitants, in order to form an association of all who are not already slaves, in opposition to all attempts to make them so."[20]

The opposition to the Stamp Act in New York has a complex history. It included enmity between the anti-British sentiments of New York's General Assembly and the Liberty Boys (as the Sons of Liberty were often called) and the pro-British factions surrounding the acting governor, Cadwallader Colden.[21] Colden was a Scots polymath—physician, naturalist, surveyor, historian of the New York Indian tribes the Five Nations, and a politician. After completing medical training in Edinburgh, he came to North America early in the eighteenth century and continued to study medicine in Philadelphia. In 1718 he was invited by New York governor Robert Hunter, himself a natural philosopher, to join his administration as surveyor general. Colden continued in that position under the administration of Hunter's successor, William Burnet, who appointed Colden as one of 12 members of the governor's council. But with a growing family and a disdain for the contentiousness of New York politics, Colden moved his family up the Hudson near Newburgh in the late 1720s. There he became a pioneer in public health and one of the leading botanists in North America. With the death in 1760 of the lieutenant governor, James De Lancey, Colden, at age 73, was called back into public service as De Lancey's replacement. Today he is best remembered as the controversial lieutenant governor of New York during the Stamp Act crisis. Yet his papers remain important documents on the history of colonial New York from an official Tory perspective.[22]

Opposing Colden were the Sons of Liberty, an inchoate group of men— lawyers, merchants, mechanics, and workmen—who were disparagingly described by Colden to London's Board of Trade:

> Proprietors of the Large Tracts of Land..Gentlemen of the Law …. Merchants … many of them have suddenly rose from the lowest Rank of the People to considerable fortunes and chiefly in the last war, by illicit Trade. In the last Rank may be placed the Farmers & Mechanics. This last Rank comprehends the bulk of the People and in them consist the strength of the Province. They are the most useful and the most moral, but all ways the Dupes of the former, and often are ignorantly made their Tools for the worst purposes.[23]

As a historian of the Stamp Act crisis in New York has said: the Liberty Boys "were unorganized and without clear-cut objectives—that is, other than resisting Prime Minister George Grenville's tax and [Governor] Colden's enforcement of it."[24]

New York was not alone in opposing the Stamp Act. Throughout 1765 colonial assemblies met to decide how the crisis should be met and, through committees of correspondence, decided that there was strength in numbers and convened a Stamp Act Congress, which met in New York City in 1765.[25] The representatives from New York were Robert R. Livingston, John Cruger, Philip Livingston, William Bayard, and Leonard Lispenard.[26]

The congress's grievances were summarized in four separate documents; one was addressed to colonial and British readers, the second a petition to the king, and the two others were memorials, one each for the House of Lords and the House of Commons. All four documents made the same basic point: colonial Americans were British citizens. By living in North America, they had not abandoned any of their traditional rights and liberties, taxation through representatives being one such right. Ultimately, they declared that the Stamp Act would wreck the provincial economy, hamper trade, harm British finances, and ultimately damage relations between the colonies and Great Britain. To back up their demands, members of the Stamp Act Congress, many of whom were leading colonial merchants, called for the boycott of English imports or nonimportation agreements if their grievances were not met. Their united front was effective; before any true rebellion broke out, King George revoked the act.

The king's announcement of the repeal was published in the March 18, 1766, edition of the *London Gazette*, a copy of which was first sent to Boston and then to New York. When the news reached New York on May 20, celebrations went on for days:

> On the glorious Occasion, of a total Repeal of the Stamp-Act, there will be a general Meeting, and Rejoicing at the House of Mr. R. Howard. The Lovers of their Country, loyal Subjects to his Majesty George the Third King of Great-Britain, and real Sons of Liberty, of all Denominations, are hereby cordially invited to partake of the essential & long look'd for Celebration. The City will be illuminated, and every decent pleasure will be observed, in demonstrating a sensible acknowledgement of Gratitude to our illustrious Sovereign, and never lo be forgotten Friends at Home and Abroad, particularly the Guardian of America—*Pitt*.[27]

A few weeks later in June, celebrations of the king's birthday were joined with "Rejoicings for the Authenticated arrival of the Repeal of the Stamp Act Two oxen are roasted whole Beer and Grog for the Populace, and an Entertainment or Dinner provided at the City Arms for the General, Governor, officers military, naval and civil, at the Expence of the Inhabitants and cannon fired at each Toast, accompanied with Huzzas. The Town entirely is illuminated."[28]

New York's Liberty Poles

Even before the official portraits and statues of Pitt and the king were ordered, the Sons of Liberty erected a liberty pole in response to the repeal of the Stamp Act. The liberty pole, usually a wooden pole topped with a Phrygian cap, has an ancient lineage that goes as far back as ancient Rome when it was created as a symbol of freedom.[29] Its modern manifestation occurred at the time of the Stamp Act crisis in North America when it appeared first as a liberty tree and in New York as a pole that, at first, was either a flagstaff or a mast.[30] Although its first appearance, as a symbol of repeal, was benign, over the next few years it became a symbol of colonial frustration and rebellion. During the run-up to the American Revolution, New York's liberty poles would repeatedly be taken down and put back until British troops ousted the patriots and the Continental Army from Manhattan. As such it was an early gesture of commemoration but also of protest.

Its first incarnation was on June 4, 1766 (the king's birthday), on the Fields somewhere between Broadway and Park Row. Although intended as a gesture of gratitude, British soldiers stationed in the city saw it as a sign of protest and cut it down three months later. The overt cause of the soldiers' actions was rooted in New Yorkers resistance to the recently passed Quartering Act (1765) that formalized an ongoing obligation for the province to house and provision what was essentially a standing army.[31] Unlike the Stamp Act, which did not affect the soldiers personally, this noncompliance threatened their livelihoods, and more to the point, without local support, there was the potential that they would be stranded and without pay. The construction of the second liberty pole, then, had less to do with the Stamp Act and more to do with the Sons of Liberty's protest of the soldiers' presence. Raised on August 12 on the same site near the army's barracks, it, in turn, was cut down about three weeks later but was quickly replaced on September 24. The replacement remained there until the following March when soldiers, on the first anniversary of the repeal of the Stamp Act, destroyed it with gunpowder.[32] A fourth liberty pole was "immediately erected in its Stead" on March 19, 1767, and this time was reinforced with "Iron to prevent such another Action." It withstood repeated attempts at destruction for nearly three years. By early 1770 hostilities had reached fever pitch, and when British soldiers finally managed to destroy the fourth liberty pole, violent clashes occurred culminating in the Battle of Golden Hill on January 19. When news of the battle reached Boston, it is said to have precipitated the better known Boston Massacre (famously commemorated by Paul Revere) six weeks later.[33] New York regrettably had no Revere to visually memorialize its rebellious actions.

Undaunted, members of the Sons of Liberty—Peter Van Zandt, Isaac Sears, Joseph Bull, Jasper Drake, and Alexander McDougall—tried a different tack and sought legislative approval to put up a fifth liberty pole. They added

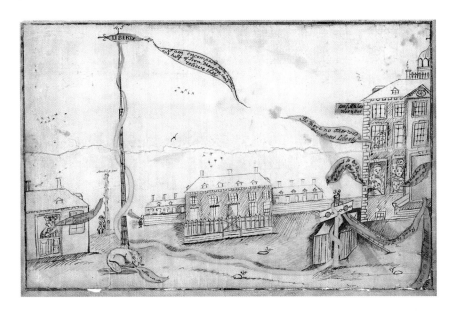

2.3 Pierre Eugène du Simitière [*Raising of the Liberty Pole in New York City*], drawing, ca. 1770. Library Company of Philadelphia

that, in the event of the board's opposing both of these locations, they would erect the pole "in the Fields on private grounds."[34] One of the few, if only, contemporary illustration of any of New York's liberty poles (Figure 2.3) was drawn by the Swiss-born artist Pierre Eugène Du Simitière. Stokes in his *Iconography* describes the print as an image of "City Hall with the adjoining old jail, liberty pole, the stocks, etc. at the time of the beefsteak dinner to Alexander McDougall ... [provided] by the group of 'forty-five.'"[35]

To mark the occasion the day it was installed, the pole was "drawn through the streets from the ship yards by 6 horses, decorated with Ribbands, 3 flags flying, with the Words Liberty and Property It was raised without any Accident while the French horns played God Save the King."[36] Additionally, the Sons of Liberty published a broadside dated February 3, 1770, which invited fellow members (and presumably all interested citizens) to celebrate the installation of the newest and latest liberty pole.[37] This fifth and last pole remained in place until Governor William Tryon ordered it removed in October 1776 after the arrival of General William Howe's troops and the British occupation of Manhattan.

While the Sons of Liberty tangled with British soldiers to secure the placement of the liberty pole, other citizens, some of whom also belonged to the Sons of Liberty, worked to commission and install more permanent and less provocative monuments to the repeal that were more avowedly pro-British.

William Pitt and George III, American Heroes

King George's ascension as a colonial hero rests on a paradox that had substantial force later, when at the time of Independence, colonists called Loyal Whigs made a distinction between the crown and Parliament. In their minds, the king was somehow immune from the consequences of legislation enacted by Parliament in the form, for instance, of the Stamp Act. As stated by Edward De Lancey in his preface to Thomas Jones's loyalist history of New York: "Their enemy was the ministry of Lord North, not the King of England to whom they owed, and had sworn allegiance."[38] Colonial fealty, along with economic self-interest, played a large role in the colonial debates between loyalists and patriots at the time of independence, and from the loyalists' point of view the American Revolution was a civil war.

There is another factor; the king's disdain of the colonists was not well known. The reporting of English news was seldom independent or intended to promote colonial interests. Most colonists were unquestionably loyal, and in the late 1760s, following the repeal of the Stamp Act, they credited George III, who officially overturned the act, as being responsible, along with Pitt, for its repeal. Condemnation of the king largely stems from the list of denunciations penned by Thomas Jefferson for the Declaration of Independence, which finds the king much more the villain than Parliament and more directly responsible for the American rebellion. Jefferson's attacks start at the end in the second paragraph of the Declaration of Independence: "The history of the present King of Great Britain is a history of repeated injuries and usurpations, all having in direct object the establishment of an absolute Tyranny over these States." Jefferson then goes on to enumerate the king's offensives, which number at least 40, including the charge that he "plundered our seas, ravaged our Coasts, burnt our towns, and destroyed the lives of our people."

There is, however, another side to George III that is less familiar, which is his erudition as one of the best-educated British monarchs. He was instrumental in the support of the Royal Academy, and his collection of books and incunabula contained within a glass-walled repository physically form the core of the British Library. He also gave half of his personal income to charity; was passionately interested in agriculture, science, and industry; and formed a large collection of scientific instruments. His utilitarian interests were reflected in programs sponsored by the Society of Arts, later the Royal Society of Arts. It was this more humanitarian aspect of the king's personality that was known to British citizens; how well known it was to colonists is hard to judge. The king and Pitt were often associated because at the time George III ascended the throne the French and Indian War was going poorly, and it was he who engaged Pitt to oversee its administration. Pitt's promotion of Amherst and Wolfe, his visionary plans for British America, and the final success of the war, which resulted in the ouster of France from the Atlantic coast, won

the new prime minister the admiration of all British subjects, including the citizens of British America.[39]

Pitt's support for the American cause and the repeal of the Stamp Act is contained in a fervent speech he made, January 14, 1766, in the House of Lords when he was no longer prime minister. According to Pitt's biographer, this speech, made when he was 60 years old and suffering from gout, was "his life's noblest and hardest task … in the battle for liberty he spent his strength as freely as in conquering an empire."[40] The following excerpts convey his vehemence that Parliament acted illegally, since to his mind the colonists were English citizens and as such were entitled "to all the natural rights of mankind and peculiar privileges of Englishmen." His speech also illuminated the conflicting allegiances that the colonists needed to maintain: loyalty to the king versus their right to participate in their own governance.

> It is my opinion that this kingdom has no right to lay a tax upon the colonies. At the same time, I assert the authority of this kingdom over the colonies, to be sovereign and supreme, in every circumstance of government and legislation whatsoever. They are the subjects of this kingdom, equally entitled with yourselves to all the natural rights of mankind and peculiar privileges of Englishmen. Equally bound by its laws, and equally participating of the constitution of a free country. The Americans are the sons, not the bastards, of England. Taxation is no part of the governing legislative power.

This double loyalty, as history would confirm, became impossible for many colonists to preserve. Pitt then went on to detail the evolution of the right of the crown and Parliament to impose taxes and continued with a discussion of colonial representation in Parliament:

> There is an idea in some, that the colonies are virtually represented in this House. I would fain know by whom an American is represented here? Is he represented by any knight of the shire, in any county in this kingdom? Would to God that respectable representation was augmented in a greater number! Or will you tell him that he is represented of a borough–a borough which perhaps, its own representative never saw. This is what is called "the rotten part of the constitution." It cannot continue the century; if it does not drop, it must be amputated. The idea of a virtual representation of America in this house, is the most contemptible idea that ever entered into the head of a man.

After a bit of back and forth with his fellow members, he concluded with this ringing call for repeal:

> Upon the whole, I will be leave to tell the House what is really my opinion. It is, that the Stamp Act be repealed absolutely, totally and immediately. That the reason for the repeal be assigned, because it was founded on an erroneous principle. At the same time, let the sovereign authority of this country over the colonies, be asserted in as strong terms as can be devised, and be made to

extend to every point of legislation whatsoever. That we may bind their trade, confine their manufactures, and exercise every power whatsoever, except that of taking their money out of their pockets without their consent.[41]

When news of the repeal reached New York in May, John Montresor noted in his journal that the Sons of Liberty were going to propose to erect "a statue of Mr. Pitt (as a friend) in the Bowling Green, on the identical spot where the Lieut. Governor's [Cadwallader Colden] chariot was burned and to name that Green, 'Liberty Green' forever."[42] At their first meeting the committee, made up of "freemen and freeholders," was held June 23, 1766, at the Merchants' Coffee-House, where they drew up a formal petition that read: "impressed with the deepest Sense of Gratitude to all the Friends of Liberty and America who exerted themselves in promoting the Repeal of the Stamp Act, think it our indispensable Duty to endeavor, by erecting a proper Monument, to perpetuate the Memory of so glorious an Event, to the latest posterity." And they concluded their notice with the idea that this was the "second Time [that Pitt had] been the preserver of his Country," the first time being his leadership during the French and Indian War.[43] The New Yorkers who drafted this petition regarded themselves as British citizens and most of them who drew up the petition remained loyal to the crown during the Revolution: Captain James De Lancey, Isaac Low, William Walton, John Thurman, Henry White, and John Cruger (nephew of Mayor John Cruger).[44]

They sought to secure funding for this monument from the General Assembly and forwarded their petition through the good offices of Mayor John Cruger, Leonard Lispenard, and William Bayard—who were Assembly members. These three were among the leading citizens of the city. Cruger had been a longtime mayor of New York, was later speaker of the Assembly, and also served as the first president of the Chamber of Commerce.[45] Lispenard, was on the board of King's College and became what one might call a loyal Tory—he supported the patriot cause in the beginning but later, like Low, had second thoughts. Thomas Jones in his *History* considered Lispenard two-faced: "no sooner was it known in New York that the provisional articles of peace were signed, than he threw off the mask, [and] declared himself publicly a friend of Independence."[46] Little is known of Bayard other than his participation in the General Assembly and that he was among the many loyalists who in October 1779 were included in the New York Act of Attainder, which stipulated that they were charged as "enemies of the State."[47] Collectively these men—the members of the committee and their supporters in the General Assembly—were conservative, if not reactionary, businessmen whose economic interests were furthered by the maintenance of the status quo, and many were members of an important nongovernmental organization, the Chamber of Commerce of New York. When it was established in April of 1768, it was the first such mercantile organization in the English-speaking world.[48]

This informal board of trade formalized the interlocking relationships—both business and familial—among New York's business class. In a broadside announcing the formation of the chamber they referred to themselves as a mercantile society that had "been found useful in Trading Cities, for promoting and encouraging commerce, supporting Industry, adjusting Disputes, relative to Trade and Navigation; endeavoring to procure such Laws (establishing such Regulations) as many be found necessary of the Benefit of Trade in General)."[49]

It can also be surmised that the contemporaneous interest in forming the Chamber of Commerce and the commissioning of statues of Pitt and the king, were two sides of the same coin. The establishment of the Chamber of Commerce asserted New York's mercantile competitiveness with their counterparts in England, while the statues were dramatic and expensive signs of fealty. At the same time the opposition of the New York Tories to the stamp tax is evidence that they were not blindly beholden to London. Ideally, they wished to be regarded as citizens of the realm and businessmen who could operate competitively on an equal footing with their peers in England.[50]

From its early beginnings the Chamber of Commerce was also involved in the commission of commemorative portraits, a tradition that echoed the initiatives taken by citizens of Boston for the ornamentation of their marketplace, Faneuil Hall, and the tradition of the acquiring of royal portraits for colonial city halls. Similarly in New York, the same year that the General Assembly commissioned the Wilton sculptures, the city's Common Council bought portraits of Pitt by an unknown artist and of George III by the American-born painter John Mare.[51] Six years later the Chamber of Commerce commissioned its first portrait of the on-again, off-again provincial governor Cadwallader Colden (New York State Museum, 1772), who had helped the organization obtain its royal charter. It was painted by Matthew Pratt, one of the students of Benjamin West.

The most important commissions, by far, were those for a standing Pitt and an equestrian George III, the latter seemingly an after thought.[52] The reasons for this late-day request were summarized by William Smith, who noted in his *Historical Memoirs* on July 10, 1766, how complex the issue of including a statue of the king had become. "The Vote for a Statue to Mr. Pitt was next & carried on the motion of Cruger the Mayor, who was afraid of his Constituents [members of the Freeman's Committees], and [was] urged by Instructions from them." Smith then noted that the other members of the Assembly "were agt It but durst not speak for Fear of the People [and here he probably is referring to the Sons of Liberty]." Smith, however, had received a letter from the Londoner John Sargeant. In his letter to Smith, Sargeant dissuaded him "from that Measure lest it should treat Pitt, as if he went pari passu with the King, & as if he acted for us only to gain popular Confidence." Smith could not

attend the final meeting but passed along the information to other members who "after the Vote … were chagrined that they were forced into it …. This is certain, that if they had not voted for a Statue for Pitt, the King would have had none, for in Truth they were disposed to give none, & deliberated much on taking back the Vote for Pitt after several of them saw Sargeant's Letter to me & yet thus they have gone directly counter to his advice."[53]

In any case and for reasons that are not clear, a year and half would go by before any action was taken. Finally, in early 1768 the Assembly agreed to the petition and authorized their colonial agent Robert Charles in consultation with Sir William Baker Knight of London, to spend "out of the monies now in their hands belonging to this Colony … for the Equestrian Statue of His most Sacred Majesty the sum of One thousand pounds. For the Statue of the Right Honorable William Pitt, Esquire now Lord Chatham Five Hundred pounds."[54]

Monuments for New York

It is intriguing, given Benjamin Franklin's later involvement with the Montgomery commission, that the Wilton monuments were commissioned while he served as Pennsylvania's colonial agent in London. There is a likelihood that Franklin was aware of the order since he was good friends with Robert Charles and had served as co-agent of Pennsylvania with him from 1756 to 1761. Charles had even "arranged for Franklin's living quarters at Craven Street."[55] Colonial agents played an important, if little noted, role in the relationship between the colonies and Great Britain.[56] They acted like today's lobbyists, pleading the causes and desires of their colonial assemblies to the crown, Parliament, and other governmental bodies. They were either from North America, like Franklin, or from England, like Charles, who had earlier lived in Philadelphia before acting as personal secretary to Sir Peter Warren. The tasks they were assigned varied from delivering a petition on behalf of the citizens of Pennsylvania to Parliament (Franklin), to setting boundaries between New York and Massachusetts (Charles). With regard to the securing of commemorative monuments, Charles had a long history that began with the procurement in the 1750s of the Liberty Bell for Philadelphia and included the commission in the 1750s of the Roubiliac memorial for Sir Peter Warren in Westminster Abbey

The little we know of Charles comes primarily from the letters unearthed in the late 1950s by the historian Nicholas Varga who came across, as he put it, "a rich cache of Charles correspondence among the Papers of William Smith, Jr." This corpus consists of copies of 99 letters made by Smith's clerks for his colonial history of New York [*Historical Memoirs of the Province of New York*] and remains the most important archival source for information on Charles,

and it provided the substance for Varga's biographical sketch.[57] Charles traveled to Philadelphia early in the century and in 1726 served as private secretary to the colony's new governor, Patrick Gordon. Charles remained in Philadelphia for 10 years. It was during this time that he made Franklin's acquaintance (Varga describes him as Charles's "long-time friend").[58] After Charles returned to London, he became in 1743 Admiral Warren's private secretary, a position he held for seven years until the latter's death in 1751. In 1754 Charles was appointed agent for Pennsylvania, a post he would share with Franklin. Simultaneously, as was often true for colonial agents, and even before Warren's death, Charles was appointed colonial agent for New York, an office he held from 1748 to 1770, an assignment no doubt due to the good offices of Warren and the De Lancey family.[59]

It was in this capacity that 10 years after Charles had served as the De Lanceys' representative in negotiations with Westminster and the sculptor Roubiliac, he was called upon again to order monuments, this time from Roubiliac's successor, Joseph Wilton. And once again the De Lancey family is involved. Susannah's brother James died in 1760, and his role in New York politics was carried on by his eldest son, also named James but known as Jamie or Captain James. He had received the rank of captain for his services in the British army during the French and Indian War when he fought in the Lake George campaign of 1758, and saw service again during the capture of Fort Niagara in 1759.[60] Captain De Lancey was also the most prominent member of the body of freeholders who petitioned for the sculptures, and by leading the call for tributes to Pitt and George III he continued the family tradition of commissioning commemorative art. There is scant documentation to confirm the younger James De Lancey's direct involvement with the commissions, but it is known that he was in London between 1767 and 1768 when Wilton was working on the sculptures.[61] Furthermore, there is a note in *The Colonial Laws of New* York that states that the treasurer of the colony was ordered to pay £808 6s.7d. to James De Lancey and Jacob Walton "for monies advanced by them for the freight of the Statues of his Majesty and Lord Chatham, and for erecting the same in this City."[62] Given that few of the members of the General Assembly would have knowledge of who to hire for these important commissions, it is not surprising that the Assembly would turn to their colonial agent Charles for advice, and given his close ties with the De Lancey family, he may have welcomed Jamie's involvement.

It took some time for the statues to be cast. Their arrival was further delayed because the General Assembly did not appropriate funds until January 27, 1770, an act that may have been prompted by the establishment of the fifth liberty pole a week earlier, payment being a sign of their loyalty to king and Parliament. In the same piece of legislation that contained the authorization to send money for the sculptures to England, the General Assembly also appropriated 200 pounds "for defraying the expenses of erecting the statue of

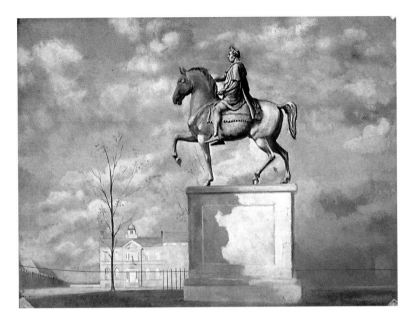

2.4 Charles MacKubin Lefferts, *Equestrian Statue of King George III, Bowling Green,*
15 × 20 in. (38.1 × 50.8 cm.), gouache, watercolor, and graphite on heavy paper board,
ca. 1912. New-York Historical Society

his majesty, and railing the same in."[63] The sculptures finally arrived in early
June. The one of George III, the first to be installed, was placed on Bowling
Green in August (Figure 2.4): "The Britannia has brought over the Statues of
his Majesty and Mr. Pitt …. We hear his Majesty's statue is to be placed in
the Bowling Green, facing the Fort Gate, where Preparations are accordingly
making for that Purpose."[64] Although the Sons of Liberty had hoped that
the Pitt statue would be placed there, the king's greater and more enduring
eminence, the larger size of the sculpture, and the nature of an equestrian
statue versus the less grandiose standing sculpture mandated the more
conspicuous and complementary location in Bowling Green.

Bowling Green, a small public park still located at the foot of lower
Broadway, dates back to the Dutch occupation of Manhattan and was
originally "a hill outside the fort." Under Dutch rule, Bowling Green served as
a market place, a parade ground, and "a common out-door meeting-place of
the inhabitants and for bonfires, Maypole dances, and similar celebrations."[65]
Later on in the seventeenth century, after the British had gained control of
the province in 1664, the city council had it refurbished as a public space.
With lovely walks and elegant plantings, it was designed intentionally as a
separate space away from the jostling hubbub of city life.[66] Bowling Green,
not unlike the enclaves in London's squares, was the first and oldest park in

the city. Up until the early nineteenth century, it would be part of the city's most fashionable neighborhood. As such it was an appropriate space for a new statue, not for the statue of Pitt but for an equestrian George III.[67]

Given that the monument to George III was the first equestrian statue in North America, its installation was no doubt fascinating to the public, yet unfortunately no description or notice of such enthusiasms has been uncovered. In any case, after all the delays, it took only three months to unpack, assemble it (one wonders, too, if Wilton sent over assistants to do the work), and place it on its pedestal. While no notice was made of its installation, its unveiling was reported on Monday, August 20, 1770, in the *New-York Gazette, or, The Weekly Post-Boy*:

> Thursday last the Statue of his Majesty King George the Third, was fixed on the Pedestal erected for it in the Bowling Green: His Honour the Lieut. Governor [Colden] having invited most of the principal Gentlemen in the City, both Civil and Military; about 12 o'clock they attended his Honour in Fort George, where his Majesty's Health, &c. was drank, under the discharge of 31 Cannon from the Battery. *The following Inscription is on the Pedestal of his Majesty's Statue.* EQUESTRIAN STATUE OF GEORGE III. KING OF GREAT BRITAIN, &c. ERECTED M, DCC, LXX.

The notice also included the note that the "sculptor is said to have 'used as his model the equestrian Statue of Marcus Aurelius in Rome." A few days later the *New-York Gazette: and the Weekly Mercury* reported that the "beautiful Statue is made of Metal, richly gilt, being the first Equestrian one of his present Majesty, and is the workmanship of that celebrated Statuary, Mr. Wilton, of London." Acting Governor Colden further confirmed its placement in a letter to Lord Hillsborough, secretary of state for the colonies, that the occasion of the unveiling of the George III was testimony to "our loyalty & firm attachment and affection to his Majesty's person."[68]

Three years later, in 1773, John Adams spent a week in New York en route to Philadelphia and described Bowling Green and the statue in his diary. He took lodgings near City Hall and after dinner walked to the southern tip of Manhattan: "Between the fort and the city is a beautiful ellipsis of land, railed in with solid iron, in the centre of which is a statue of his majesty on horseback, very large, of solid lead gilded with gold, standing on a pedestal of marble very high."[69] There is an additional contemporary description, one written by a member of Washington's troops, Lieutenant Isaac Bangs, before the statue was torn down in July 1776 after Washington's reading of the Declaration of Independence. Washington and his troops had traveled from Massachusetts to New York with the hope of defending it against British invasion. While on duty Bangs kept a journal of his impressions of the city, which he "found vastly surpassing my Expectations."[70] He walked along the Battery, observing its construction, and up Broadway to Bowling Green where he saw the statue

of George III, which he believed "was in imitation of one of the Roman Emperors on Horseback." He noted its size, estimating that the figure of the king was about a third again as large as a "Natural Man," or larger than life, and that the horse was similarly proportioned and the pedestal was "about 15 Feet high."[71]

Wilton's New York George III is a copy of one commissioned in 1766 by the king's aunt, the Princess Amelia, for Berkeley Square in London where it was installed in 1772.[72] The English version was removed in the early nineteenth century, but a line engraving published the following year in London's *Town and Country Magazine* gives some sense of the original appearance of the New York version. And in many aspects the statue does bear a striking resemblance to the *Marcus Aurelius*, which Wilton would have seen when studying in Rome. Like the Aurelius, the George III is on a high base and arrayed in a toga in imitation of a Roman emperor. His right hand is raised, not in a gesture of benediction, as with Aurelius, but with a truncheon signaling his high office. The two horses are also remarkably similar, each with its legs positioned in an identical manner.

A month after the George III was placed in Bowling Green, the Pitt statue was installed on Wall Street, at the top of Williams Street opposite City Hall (the present location of Federal Hall). On Monday, September 19, 1770, the following notice appeared in the *New-York Gazette, or, Weekly Post-Boy:*[73]

> Last Friday, the STATUE of the Right Hon. William Pitt, Esq; Earl of Chatham, was fixed on a Pedestal erected for it on Wall Street, admist the Acclamations of a great Number of the Inhabitants. The statue is of fine, white Marble, the Habit Roman, the right Hand holds a Scroll partly open, whereon we read, ARTICULI MAGNA CARTA. LIBERTATUM; the left Hand is extended, the Figure being in the Attitude of one delivering an Oration. On the South Side of the Pedestal, the following Inscription is cut on a Table of white Marble. THIS STATUE OF THE RIGHT HONORABLE WILLIAM PITT, EARL OF CHATHAM, WAS ERECTED AS A PUBLIC TESTIMONY OF THE GRATEFUL SENSE THE COLONY OF NEW-YORK RETAINS OF THE MANY EMINENT SERVICES HE RENDERED AMERICA PARTICULARLY IN PROMOTING THE REPEAL OF THE STAMP ACT. ANNO. DOM. M, DCC, LXX.

The New York Pitt was one of three versions done by Wilton, the first and original was commissioned by the citizens of Cork, Ireland (Figure 2.5). It is also the version which is in the best condition, but curiously, Wilton changed Pitt's robes for his New York and Charleston versions.[74] The replica procured by Charleston (Figure 2.6), which was spared the exigencies of war, is in better shape than the New York version, the remnants of which are at the New-York Historical Society (Figure 2.7).

In the Cork version, Pitt is in the contemporary dress of a statesman, swathed in the swirling robe worn by members of the House of Lords; the baroque exuberance of the robe is heightened by an active contraposto pose.

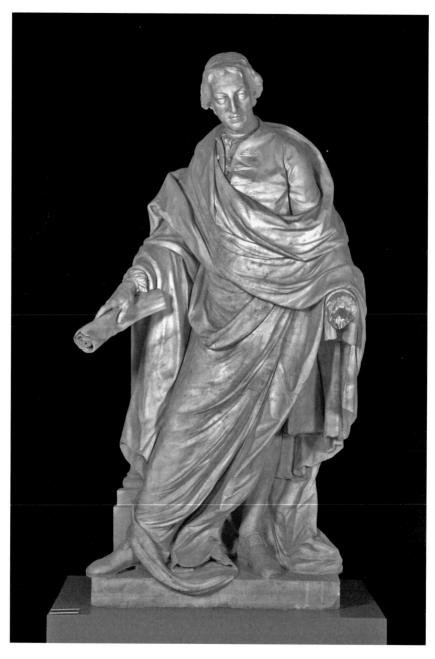

2.5 Joseph Wilton, *William Pitt, the Elder*, 1764–1766.
Crawford Art Gallery, Cork, Ireland

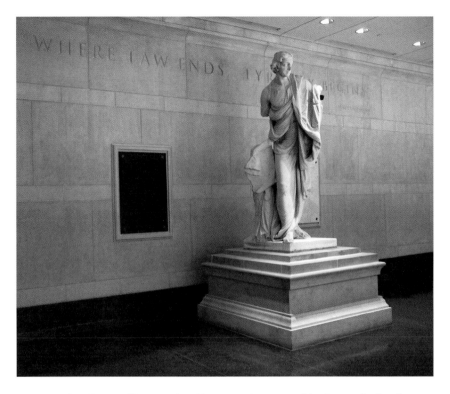

2.6 Joseph Wilton, *William Pitt the Elder*, erected 1770, marble. Originally South
Carolina State House, Charleston, South Carolina. Now located in the Charleston
Judicial Center. Charleston Museum

His head is tilted slightly to the right accenting the extension of the right
leg. In his right hand he holds a copy of the Magna Carta. In contrast, in the
American versions he is clothed in a toga, his right shoulder is exposed and his
left arm extended. The lower part of the left arm is missing in both American
versions but presumably they too held the Magna Carta.

The survival of the New York version, even in its in mutilated condition, is
due largely to chance. During the Revolution the Pitt did not suffer the same
iconoclastic fate as George III; instead it was subject to wartime abuse and
neglect. After the end of hostilities, the Common Council in 1788 ordered it
removed. It was then thrown into a trash heap in what is now City Hall Park.
Twenty years later it was recognized by someone, perhaps John Trumbull,
who thought it worthy of preservation. Trumbull, who was then president
of the nearby American Academy of the Fine Arts, assumed guardianship
of the statue and invited the visiting British sculptor Robert Ball Hughes
to restore it, but Hughes left town before finishing the work. Later in the
nineteenth century the statue was consigned to the Harlem Railroad Depot

2.7 Joseph Wilton, *William Pitt*, erected 1770, marble. Installed on Wall Street, August
1770; removed in late eighteenth century. New-York Historical Society

and eventually carted back downtown and placed, like a cigar store Indian, in front of the Museum Hotel in the First Ward.[75] Eventually it was rescued again and given to the New-York Historical Society.

Hughes did, however, discover some part of the inscription on the sculpture's base: "Articuli Magnae Chartae Libertatum" [loosely translated Articles of the great Charter of our Liberties].[76] As it turns out this brief inscription can be connected to a curious eighteenth-century broadside titled *The Speech of the Statue of the Right Hon, William Pitt, To the Virtuous and Patriotic Citizens of New-York*, which was published anonymously shortly after the statues arrived but before the Pitt was installed. The subject's speech begins by acknowledging his "mettle companion" [the gilded lead George III], whose presence he assumes "will insure me a welcome reception amongst you." His words are intended, however, for a specific audience, "Sons of Liberty, foes to Tyranny, [and] glorious Non-Importers." For the writer the statue is no longer a simple heroic tribute but embodies the ongoing fight for liberty. The text continues, "listen attentively, to the words that shall proceed from my marble mouth …. I have bellowed for you both in the lower and upper houses of the British Senate until my guts are wore to fiddle strings, and the extremities of my body, thro' the excruciating pain of the gout, are petrified to stone." He was motivated because "your views and mine have been always similar." Now, however, the supporters of liberty should "be advised by me to take care of your own interests, and be convinced from my experience, that the most successful fishing is carried on in troubled waters—Let the mechanics cry punic faith, take no notice of them.—Let the Plebeians murmur, and if the French and Indians are now too pacific to take off their scalps, you can starve them, which will answer the same end.—Be courageous my friends. Does not hemp grow in your country [the implication being that there is rope available for nooses]?" The speech closes enigmatically with the promise that the subject will have more to say "when properly fixed upon my pedestal."[77] As far as is known, no such subsequent "speech" appeared, nor is it known who published it. Yet the substance of the "speech" imbues the sculpture with political meaning not found on the Wolfe obelisk or the equestrian George III. Instead it echoes a contemporaneous portrait of Pitt, which now graces the Maryland statehouse.

Charles Willson Peale's Portrait of William Pitt, Defender of American Liberties

An important connection exists between Charles Willson Peale's 1767 allegorical portrait of William Pitt (Figure 2.8) and the Wilton statues for Cork (1764–1766), Charleston (1770), and New York (1770): each held a copy of the Magna Carta, a sign of the liberties to which British Americans felt entitled.

2.8 Charles Willson Peale, *William Pitt*, 94 × 57 in. (238.8 × 144.8 cm.),
oil on canvas, 1768. Maryland State Archives

Peale based his rendition on Wilton's statue and referred specifically to a bust of his head which, at the time, was owned by Franklin (Figure 2.9). This painting, which launches Peale's commitment to commemorative portraiture, is visual testimony to the remarkable role Pitt played in the colonial imagination; a symbolic status detailed in a text, written by Peale that accompanied a reproduction of the painting. Additionally, Peale furthered the commemorative portrait tradition inaugurated by John Smibert by adopting a European tradition of emblematic portraiture and deploying the tropes of sculpture. There is no other painting or political print by an American artist of this period that comes near the passion and complexity of Peale's emblematical portrait.

Peale, who is most often associated with Philadelphia, was born in Maryland where his politics of rebellion were

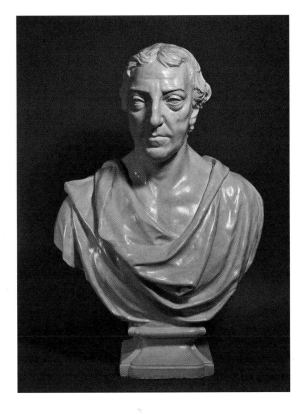

2.9 Joseph Wilton, *William Pitt, Earl of Chatham*, 27 × 20 × 9 in. (68.6 × 50.8 × 22.9 cm.), plaster, ca. 1768. Harvard University Art Museums/Fogg Museum, Harvard University Portrait Collection, Gift of Dr. Benjamin Franklin, 1769, P17

formed and where he became an ardent and active member in the antiproprietary Sons of Freedom. While still a member of this seditious group, he began taking art instruction from John Hesselius, the American-born son of the better-known Swiss émigré artists Gustavus Hesselius. Realizing that he needed greater exposure to the craft of painting, Peale took himself to Boston to meet John Singleton Copley and to visit Smibert's studio, then maintained by his wife and artist-son, and where his *Bermuda Group* still hung. So inspired was he by his Boston trip that shortly after his return he persuaded friends to sponsor his study in London with Benjamin West. With a letter of introduction from William Allen of Philadelphia, Peale presented himself to West as a pupil and became one of his first students, who would later include John Trumbull, Washington Allston, and Samuel F.B. Morse.[78]

Peale arrived in London in February 1767 and spent two years studying with West. He completed an original and one copy of his Pitt portrait in 1768, the commission of which is complicated. Virginian Richard Henry Lee originally had wanted a portrait of Charles Pratt, first Lord Camden, who also supported colonial opposition to the Stamp Act, for placement in the new Westmoreland County Court House. He turned to his Maryland friend Edmund Jenings, a Virginia-born lawyer who lived in London, for help. Lee had hoped that Sir Joshua Reynolds or Benjamin West would be willing to undertake the commission.[79] But Jenings had no luck in tracking down Lord Camden, who was too busy to sit for his portrait, and Jenings suggested instead a portrait of Pitt recently completed by West's pupil Peale.[80] The Westmoreland version, however, is not the original but a slightly smaller replica. Peale brought the original back to Annapolis in 1769, and it was subsequently purchased by the Maryland Assembly in April 1774 for £100.[81] This version (Figure 2.8) still resides in the Annapolis State House.[82] In addition, Peale printed a mezzotint after the painting and published a learned explanation of it as an advertising broadside (Figure 2.10).[83]

In the print, as in the painting, Pitt stands on an open balcony in front of a view of the Banqueting Hall at Whitehall. In his left hand he holds a copy of the Magna Carta, and with his right hand he points to the sculpted image of "British Liberty," depicted as holding a staff topped by a liberty cap. Beneath this image is a carved figure of an American Indian with a dog. In front of Pitt and to his right is an altar with a sacred flame ornamented with bust portraits of two martyrs of the 1689 Glorious Revolution—Algernon Sydney and John Hampden. On top of the altar are a laurel wreath and a perpetual flame. To ensure that these symbolic elements would be understood by more than just his radical friends, Peale published a passionate and erudite description which he hoped would promote his print and advance his strong political views.

He began his text by explaining that Pitt is shown making a speech "in defense of the Claims of the American Colonies." To Peale's mind these were legitimate claims since the colonial authors of the Stamp Act petition based their appeal "on the Principles of the British Constitution [1689]." By ignoring these claims, British liberties were compromised, an idea that Peale communicates through the image of British Liberty trampling "under Foot the Petition of the [Stamp Act] Congress of New York." Even though Pitt points to liberty, as Peale explains, the gesture was "justly sarcastic on the present faint Genius of BRITISH Liberty," and he pictorially amplifies the image of British Liberty as compromised by including two images carved on its base, which Peale descried as "An INDIAN … in an *erect* Posture, with an attentive Countenance, watching, as AMERICA has done for Five Years past [the precise date of Peale's painting is unknown so it's not clear whether he is referring to the Treaty of Paris, signed in 1763 or the Sugar Act of 1764], the extraordinary Motions of the BRITISH Senate—He listens to the Orator, and

2.10 Charles Willson Peale, *William Pitt*, 22 9/16 × 15 1/4 in. (57.3 × 38.7 cm.),
mezzotint and burin, 1768. Davis Museum at Wellesley College,
Wellesley, MA. Dorothy Braude Edinburg (Class of 1942) Collection

has Bow in his Hand, and Dog by his Side, to shew the natural *Faithfulness and Firmness of* AMERICA."

To further buttress the legitimacy of colonial claims to liberty, Peale in his text includes two quotes in French from Montesquieu's *De l'Espirit des Lois* [The Spirit of the Laws] (1748), one of the most frequently referenced Enlightenment authors in British America during the 1760s.[84] In that context the Magna Carta held by Pitt in his left hand is the key to Peale's entire allegory. Although a document written in the twelfth century, its stipulation of the separation of the crown and Parliament formed the basis of the charter revisions of 1689, a point made by the inclusion of carved bust portraits of Sydney and Hampden, both heroes of the Glorious Revolution of 1688.[85] Between these portraits is what the artist terms a "banner" with the Latin words SANCTUS AMOR PATRIAE DAT ANIMUM [may the sacred love of the nation animate the soul]. These references to the Glorious Revolution, which established Parliamentary power, are amplified by the representation of the Banqueting House at Whitehall, which was the site of Charles I's execution in 1649. As Peale explained, he included the building "not merely as an elegant Piece of Architecture, but as it was the Place where [Charles] suffered, for attempting to invade the Rights of the BRITISH KINGDOMS." Furthermore, he placed the statue of British Liberty and the altar near the "Spot where the great *Sacrifice* [meaning Charles I's beheading] was made, through sad Necessity to the Honour, Happiness, Virtue, and in one Word, to the Liberty of the BRITISH People." He then goes on to further conjoin Pitt's defense of colonial liberties with the death of Charles I by drawing together the "Petition of the [Stamp Act] Congress at NEW-YORK" with Whitehall as symbolizing the time, 1768, and "almost the Place, where the Speech [that is Pitt's speech] was delivered." Peale concludes by acknowledging that his chief purpose was to express America's gratitude to Pitt for support of its citizens' liberties that were founded on historical precedent—the Magna Carta, the overthrow of Charles I, and the restoration of liberties by Hampden and Sydney.

Peale's allegorical portrait of Pitt has been underestimated by art historians. Even his dedicated biographer Charles Sellers deemed the painting, "not good portraiture, not even fine art. It is an inflated political cartoon."[86] Seen out of context, the figure of Pitt in his rhetorical stance appears awkward, a stiltedness not ameliorated by the ludicrousness of his Roman costume. The composition appears too jammed, and its symbolic references, some of which are only dimly seen in the background, are unfamiliar to a modern audience. Bolstered by Peale's written description it remains, however, an illuminating document of that fraught period between the Stamp Act crisis and independence when British Americans had not yet become disillusioned with the king and laid their grievances on Parliament's doorstep.

Liberty Defended

With the departure of France from the Atlantic seaboard after the French and Indian War, cities like New York flourished, and British Americans began to have a larger sense of themselves as citizens of the realm. They celebrated General James Wolfe as one of their own and credited him with helping to secure British liberties and his death on the Plains of Abraham was honored with an outdoor monument in Greenwich Village. They were disillusioned a few years later when the politics surrounding the Stamp Act made it clear that in London's eyes they were vassals, not British citizens. So it was with great joy that they greeted the repeal of the Stamp Act, which, for some, signaled a happy return to business as usual, while for others it reinforced the belief that British colonials were entitled to protection under the British Constitution. Both the economic and political consequences of the repeal prompted the calls for statues to William Pitt and George III.

Given the unstable tenor of the era, it is not surprising that neither statue rested happily. From the time of their placements in 1770, even before the Revolution, they suffered indignities; serving as magnets for community frustration and unrest.[87] The greatest indignity, however, was suffered by the statue of George III. The destruction of the monument occurred the evening of July 9, 1776, following the reading of the newly arrived broadside from Congress, the Declaration of Independence. Washington addressed his troops that afternoon by reading the Declaration, and his soldiers responded joyously and there was a great deal of carousing and drinking—enthusiasms that culminated in the bringing down of George III. Bangs in his journal offered an everyman's view of that evening's events

> Last night the Statue on the Bowling Green representing George Ghwelph alias George Rex … was pulled down by the Populace …. The Lead, we hear, is to be run up into Musquet Balls for the use of the Yankies, when it is hoped that the Emanations of the Leaden George will make as deep impressions on the Bodies of some of his red Coated & Torie Subjects & that they will do the same execution in poisoning and destroying them, as the superabundant Emanations of the Folly & pretended Goodness of the real George have made upon their Minds, which have effectually poisoned & destroyed their Souls, that they are not worthy to be ranked with any Beings who have any Pretensions to the Principles of Virtue & Justice.[88]

Bangs was right in his assumption that the lead from the statue would be turned into musketballs, which it was by the ladies of Litchfield, Connecticut. But not all the material from the sculpture was used—some fragments were discarded and found later in the late nineteenth century buried on a farm in nearby Wilton. They included parts of the horse's tail and flank, which much later were bought by the New-York Historical Society.[89] Much has been made of the destruction of this monument, many historians seeing it as a

2.11 Franz Xavier Habermann, *Destruction de la Statue royale a Nouvelle Yorck*, 11 × 15 3/4 in. (28 × 40 cm.), hand-colored engraving, 1776. The Miriam and Ira D. Wallach Division of Art, Prints and Photographs, The New York Public Library, Astor, Lenox and Tilden Foundations

symbol of the patriotic response to Congress's Declaration of Independence. Yet another view point is expressed in a set of luridly colored engravings (Figure 2.11) published in Germany by Franz Xavier Habermann who was unaware that the statue of George III was an equestrian not a standing stature. According to Arthur Marx these prints "were probably conceived in support of the English Certainly, none of the prints celebrated any American achievements."[90] Unlike later nineteenth-century representations, Habermann's prints warned viewers that savage violence ensues when the established order is threatened.

The pedestal of George III also assumed an interesting afterlife. Following the Revolution when the Americans recaptured New York and the cult of Washington was in full swing, the empty pedestal in Bowling Green was used by two artists to signal Washington as the new leader of America. The earliest of the two was by John Trumbull, who following his study with West in England, returned with a determination to create a pantheon of Revolutionary heroes and history paintings of the American Revolution that would rival works by his Anglo-American colleagues—West and John Singleton Copley.[91] Trumbull's portrait of Washington was one of the earliest portraits commissioned by the City of New York for placement in its new City Hall, continuing the tradition of commemorative civic portraiture begun in Boston. It is also contemporaneous with its sculpted counterpart, Houdon's

standing Washington for the statehouse in Richmond, Virginia.[92] Trumbull rendered Washington as he might have appeared standing alongside his horse in front of Bowling Green with its empty pedestal on his arrival back to the city, November 25, 1783, the day that the British left Manhattan, a date celebrated for many years in New York as Evacuation Day. Trumbull's comments on the portrait's background confirm this connection, which contains "a view of Broadway in ruins, the old fort at the termination. British ships and boats leaving the shore with the last of the officers and troops of the evacuating army."[93]

A second image, also showing Washington at the time of the British evacuation, conflates Washington and the empty pedestal in a richly emblematic engraving by the amateur artist Charles Buxton printed in 1798 (Figure 2.12). In it Buxton has depicted a statue of the living Washington, placing him on a pedestal in front of Bowling Green with the small empty pedestal of the George III seen off to his right. Here Washington has not only replaced George III in practice, he has replaced him as a monument in New York. Additionally, the varied symbols surrounding Washington, and constituting an elaborate frame, can be fairly compared to similar ones found in two paintings inside St. Paul's Chapel—one of the state seal of New York, the other the Great Seal of the United States—and on the painted frame constructed for the Montgomery Monument. Some of these symbols also appear in a contemporaneous carved sandstone trophée des armes on top of the sally port at Fort Jay on Governor's Island. Collectively these emblems, among them a globe, obelisk, cannon, and battle flags, constitute the nation's earliest iconography.

Three commemorative monuments—the two Wilton sculptures and the Wolfe Monument on Oliver De Lancey's property—graced New York during the 1760s. All three were signs of colonial approbation, of gratitude: first to Wolfe for his military leadership and heroic sacrifice and then to Pitt and George III, for their support of colonial liberties with the repeal of the Stamp Act. To further understand the American homages to Pitt and George III it is important to see the revolt against the Stamp Act not exclusively as a prelude to the Revolution, but as a brief moment in time when American Tories and Whigs came together with fervent hopes that they had been heard by the king and his ministers and had secured colonial autonomy. But Pitt's promise to America was soon overwhelmed by Britain's need for money and the king's desire to impose his will. Revolutionary events also overtook Peale's mezzotint of Pitt, which found few buyers, since American heroes replaced British ones. Similarly, both of the statues installed in 1770 soon became victims to the ravages of war. The first to go was the George III, famously

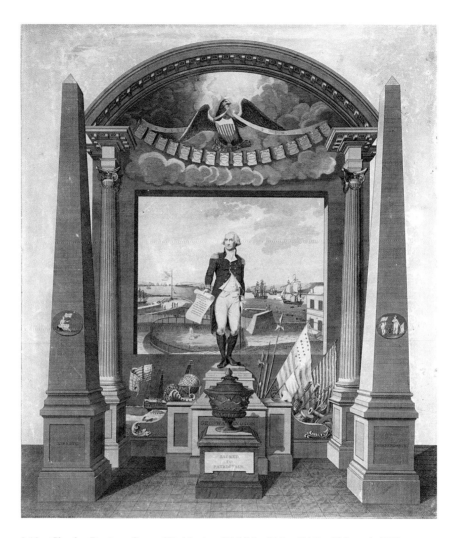

2.12 Charles Buxton, *George Washington*, 25 5/16 × 21 in. (64.3 × 55.3 cm.), 1783.
Engraved by Cornelius Tiebout and issued 1798. I.N. The Phelps Stokes Collection of
American Historical Prints, The New York Public Library, Astor, Lenox and Tilden
Foundations

unseated and decapitated. That of Pitt, in a less conspicuous location and not
quite the center of the patriot's discontent if not rage, was severely damaged
and finally removed at the time the Montgomery Monument was installed.
The by-product of this evolution was the installation of a new monument, one
that, like the tribute to General Wolfe, would commemorate the death of a war
hero and, like the Pitt and the George III monuments, signal a call for liberty.

Notes

1 I.N. Phelps Stokes, *The Iconography of Manhattan Island* (6 vols, New York: R.H. Dodd, 1915–28), 4: 806.

2 Nathaniel Hurd (1730–1778) was the son of the silversmith Jacob Hurd and the subject of a portrait by John Singleton Copley. See: Hollis French, *Jacob Hurd and His Sons Nathaniel and Benjamin* (Cambridge, MA: Riverside Press, 1939).

3 Quoted in *Art in New England: Early New England Printmakers* (Worcester, MA: Worcester Art Museum, 1939), 24.

4 *Massachusetts Gazette. And Boston Newsletter,* May 22, 1766, quoted in Clarence S. Brigham, *Paul Revere's Engravings* (Worcester, Mass.: American Antiquarian Society, 1954; rev. edn, New York: Athenaeum, 1969), 21. The 15 "worthy patriots" were: Ernest Augustus, Duke of York; Charles Watson-Wentworth, second Marquis of Rockingham; Queen Charlotte; George III; General Henry Seymour Conway; Colonel Isaac Barré; William Pitt the Elder; William Legge, second Earl of Dartmouth; William Beckford; Charles Townshend; Lord George Sackville; Dennis De Berdt; John Wilkes; Charles Pratt, Lord Camden; and one unidentified British aristocrat.

5 The original Dedham pillar was placed on a four-foot high granite base, which supported an eight-foot tall wooden column that bore a bust of Pitt. The column and bust of Pitt were destroyed in 1769 following the imposition of the tea tax. In the early nineteenth century, a group of citizens placed a bronze plaque detailing the pillar's history on the granite base. In 1886 it was moved across the street to its present site at the corner of Court and High Streets in Dedham.

6 Monckton had served earlier as provincial governor from May 4 to November 18, 1761, when he left to take command of the British invasion of French-held Martinique. His second governorship lasted a little over a year from June 14, 1762 to June 23, 1763. Frustrated by the pettiness of New York politics, he left for England, and Cadwallader Colden served as acting governor until the arrival of Henry Moore in 1765.

7 Thomas Gage is best known as the beleaguered British general who ordered soldiers to capture Boston dissidents in April 1775, thus precipitating the battles of Lexington and Concord and the American Revolution. It is less well known that he was stationed in New York for 10 years from 1763 to 1773.

8 For a detailed discussion of elite colonial prosperity in New York in the eighteenth century, see Cynthia A. Kierner, *Traders and Gentlefolk: The Livingstons of New York, 1675–1790* (Ithaca, NY: Cornell University Press, 1992). The important economic role played by colonial merchants is ably summarized in Marc Egnal and Joseph A. Ernst, "An Economic Interpretation of the American Revolution," *William and Mary Quarterly* 29, no. 1 (January 1972): 3–32.

9 Pierre Eugene Du Simitière, the Swiss portraitist, naturalist, and collector, who is most often associated with Philadelphia, lived in New York off and on in the late 1760s. He claimed that Michael de Bruhls's prints were never published, that De Bruhls kept the money from the subscription and "never finished the work." Stokes, *Iconography* 4: 727.

10 Ibid., 735. According to Helen Burr Smith in "John Mare (1739–ca. 1795), New York Portrait Painter," *New-York Historical Society Quarterly* 35, no. 4 (October 1951): 370, Mare had a near monopoly on portraiture in the city until the arrival of John Durand (1767), Cosmo Alexander (1768), Pierre Eugene Du Simitière (1769), William Williams (1769), John Singleton Copley (1771), and Matthew Pratt (1772).

11 Stokes, *Iconography* 4: 728.

12 Ibid., 729.

13 Egnal and Ernst, "Economic Interpretation," 19–20.

14 *New-York Gazette,* December 3, 1764, quoted in Stokes *Iconography* 4: 805. Samuel Francis, the proprietor of Queen's Head or Queen Charlotte's Tavern (later Fraunces Tavern) had purchased the building from the De Lancey family in 1763. His tavern would also serve as the second headquarters of the Chamber of Commerce and was most famously the site of Washington's 1783 Farewell Address to his troops.

15 Stokes, *Iconography* 4: 746.

16 Ibid. 1: xxxvii.

17 These include Judith Van Buskirk, *Patriots and Loyalists in Revolutionary New York* (Philadelphia: University of Pennsylvania Press, 2002); Richard M. Ketchum, *Divided Loyalties: How the American Revolution Came to New York* (New York: Henry Holt, 2002); and Ruma Chopra, *Unnatural Rebellion: Loyalists in New York City during the Revolution* (Charlottesville: University of Virginia, 2011). There are, in addition, two other recent books on the larger arena of American Tories and loyalists: Maya Jasanoff, *Liberty's Exiles: America's Loyalists in the Revolutionary World* (New York: Alfred Knopf, 2011) and Thomas B. Allen, *Tories Fighting for the King in America's First Civil War* (New York: Harper Collins, 2010).

18 Gordon S. Wood's preface to a new edition of his influential *The Creation of the American Republic, 1776–1787* (1969; repr. Chapel Hill: University of North Carolina Press, 1998), vii–viii, notes: "Monarchial and republican values … existed side by side in the culture, and many loyal monarchists adopted what were in substance if not in name classical republican principles without realizing the long-term implications of their actions."

19 The name Sons of Liberty was given rebelling colonists by Isaac Barré. Son of a French Huguenot living in Ireland, he became a member of the House of Commons after serving in the British army. He was an ardent supporter of the American cause and included references to the protestors in a speech in Parliament on February 6, 1765.

20 Quoted in Carl Becker, "Growth of Revolutionary Parties and Methods in New York Province 1765–1774," *American Historical Review* 7 (October 1901): 62.

21 Gary Nash, *The Unknown American Revolution: The Unruly Birth of Democracy and the Struggle to Create America* (New York: Viking Press, 2005), 54–5.

22 A good overview of Colden's life and importance in the pre-Revolutionary period is: Alfred R. Hoermann, *Cadwallader Colden: A Figure of the American Enlightenment* (Westport, CT: Greenwood Press, 2002).

23 Quoted in Stokes, *Iconography* 4: 907.

24 Roger J. Champagne, "Liberty Boys and Mechanics of New York City, 1764–1774," *Labor History* 8, no. 2 (1967): 118.

25 Historically the Stamp Act Congress is regarded as a precedent for the First Continental Congress, which met nine years later in support of Massachusetts and its protest against the Boston Port Act.

26 The literature on New York's Sons of Liberty and New York during the Stamp Act crisis includes in addition to those cited above: Milton Klein, "Democracy and Politics in Colonial New York," *New York History* 40 (July 1959): 221–46; Roger J. Champagne, "Family Politics versus Constitutional Principles: The New York Assembly Elections of 1768 and 1769," *William and Mary Quarterly*, 20, no. 1 (January 1963): 57–79; and "New York's Radicals and the Coming of Independence," *Journal of American History* 51, no. 1 (June 1964): 21–40.

27 Stokes, *Iconography* 4: 765.

28 Ibid., 915.

29 As far as is known, none of New York's liberty poles had a cap attached. Interestingly a carved, truncated pole with such a cap was included on the Montgomery Monument in 1777.

30 See, Arthur M. Schlesinger, "Liberty Tree: A Genealogy," *New England Quarterly*, 25, no. 4 (December 1952): 435–58. I want to thank Professor Wendy Bellion for generously sharing with me her unpublished paper, "The Space of Iconoclasm: New York, 1776," which included a detailed discussion of New York's liberty poles which she gave at the College Art Association annual conference, Chicago, February 13, 2009.

31 There were two Quartering Acts: the first was given royal assent March 24, 1765; the second, and better known one, was enacted on June 2, 1774, and is historically listed as one of the Intolerable Acts. Both acts obligated the provincial governments to pay the costs of housing and provisioning troops.

32 "The Liberty Pole on the Commons," *New-York Historical Society Quarterly Bulletin* 3, no. 4 (January 1920): 112.

33 The full title of Paul Revere's engraving is *The Bloody Massacre in King Street, Boston on March 5th, 1770 by a party of the 29th Regt.*

34 A detailed history of the Fields can be found in Henry B. Dawson, *The Park and Its Vicinity, in the City of New York* (Morrisania, NY, 1867).

35 Stokes, *Iconography* 3: 234. Du Simitière was probably representing a banquet held on February 14, 1770 when McDougall was still in jail. The number 45 referred to by Stokes and seen on top of the liberty pole refers to issue No. 45 of the weekly newspaper the *North Briton*, in which the Englishman John Wilkes had published his denunciation of the king and Parliament on April 23, 1763. Wilkes was later arrested and imprisoned for libel. Similarly McDougall published a broadside *To the Betrayed Inhabitants of the City and Colony of New York*, December 16, 1769, for which he was arrested and after which McDougall's martyrdom was compared to Wilkes's and he was dubbed the American Wilkes.

36 "The Liberty Pole on the Commons," 125.

37 Ibid.

38 Thomas Jones, *History of New York during the Revolutionary War and of the Leading Events in the other Colonies at that Period,* Edward Floyd De Lancey, ed. (New York: New-York Historical Society, 1879), x. Jones, a justice of the New York province's supreme court, had married Anne De Lancey, one of Oliver's sisters. During the British occupation, "Judge Jones [d. 1792], whose health had become impaired, sailed from New York with his wife, his niece Miss Elizabeth Floyd, and two servants … for a visit to Europe, his especial object being to try the efficacy of the famous warm spring in the city of Bath …. The negotiation of the peace in 1782, which took effect the succeeding year, prevented his return, as he was one of the fifty-six gentlemen, and three ladies included by name in the New York Act of Attainder," ix. Jones wrote his highly personalized history between 1783 and 1788. The editor, Edward De Lancey, states in the preface that it is "a Loyalist history" and provides a provocative justification for its publication in the late nineteenth century explaining that the term loyalty gained new meaning following the Civil War: "Americans then learned by experience for the first time, and in a way never to be forgotten, that 'loyalty' was a virtue, that the supporters of 'the powers that be' were worthy of honor, and that 'rebels' and 'rebellion' were to be put down at any cost by a strong hand," ix.

39 Presciently, a statue of Pitt that was intended for the colonies was included in the background of the political cartoon "The Repeal," even before the colonial assemblies voted to commission one. Published "three days after Parliament repealed the Stamp Act … [it] was probably the most popular satirical print issued. Its reception was immediate and extraordinary." The print's full title is "The Repeal. Or the Funeral Procession of Miss Americ-Stamp" (London: Benjamin Wilson, 1766). R.T. Haines Halsey, "'Impolitical Prints': The American Revolution as Pictured by Contemporary English Caricaturists; an Exhibition," *Bulletin of the New York Public Library* 43, no. 11 (November 1939): 801.

40 J.C. Long, *Mr. Pitt and America's Birthright: A Biography of William Pitt, the Earl of Chatham 1708–1778* (New York: Frederick A. Stokes Company, 1940), 179.

41 Pitt's repeal speech, January 16, 1766, reprinted in *Prologue to Revolution: Sources and Documents on the Stamp Act Crisis, 1764–1766,* ed. Edmund S. Morgan (Chapel Hill: published for the Institute of Early American History and Culture, Williamsburg, VA, by the University of North Carolina Press, 1959), 13–141.

42 John Montresor, March 18, 1766, in *The Montresor Journals,* ed. G.D. Scull (Collections of the New-York Historical Society, New York, 1882) 14, 351.

43 *New York Gazette, or, The Weekly Post-Boy,* June 26, 1766, 2.

44 Initially Isaac Low worked actively with the rebels to protest the imposition of unfair taxes but in 1776 was unable to accept Congress's Declaration of Independence from Great Britain.

45 Jones, 2: 57, n 1.

46 Ibid., 1: 40.

47 Ibid., 2: 269, includes a list of the New Yorkers who were attained.

48 The first chambers of commerce were founded in the late sixteenth century in Marseilles, France, and Bruges, Belgium.

49 Reprinted in Peter P. Grey, *The First Two Centuries: An Informal History of the New York Chamber of Commerce* (New York: New York Chamber of Commerce, 1968).

50 Ibid., 4–6: "Matters of conflict with Great Britain appear nowhere in the Minutes of meetings during those years." Chamber membership was split between loyalists and patriots. During the Revolution members of the Chamber, "acted in many respects as a de facto government … passing necessary regulations concerning commerce, issuing various types of licenses, setting standards for flour and fresh produce and developing rule for the sale of staples." After the Revolution the Chamber was quickly reconstituted through an application to the New York State Legislature which passed an act April 13, 1784, "to Remove Doubts Concerning the Chamber of Commerce to Confirm the Rights and Privileges Thereof." Members changed its name from the New York Chamber of Commerce to the Chamber of Commerce of New York State. "All the prerogatives of the Royal Charter were ratified and the new organization held it first meeting on April 20, 1784."

51 The Common Council purchased the Pitt portrait from William Davis Jr., a seaman who had brought a portrait of Pitt from England by an unknown artist. Stokes, *Iconography* 4: 766. Neither portrait appears to have survived. For further information on Mare, see Helen Burr Smith and Elizabeth V. Moore, "John Mare: A Composite Portrait," *North Carolina Historical Review* 44 (1967): 18–52; and Helen Burr Smith, "John Mare, New York Portrait Painter." According to Smith in "John Mare" (1951), 363, while no "trace of Mare's portrait of *George III* can now be found, … it was undoubtedly based upon one of the numerous engravings with which the shops of New York were then well stocked." Also see *Minutes of the Common Council of the City of New York 1675–1776* (8 vols, New York: Dodd Mead, 1905), 7: 20.

52 *New York Mercury,* June 30, 1766, 2. Also see *Proceedings of the General Assembly of the Colony of New-York,* entry for June 23, 1766 (New York, 1766).

53 William Smith, *Historical Memoirs from 16 March 1763 to 25 July 1778 of William Smith,* ed. William H.W. Sabine (New York: New York Times and Arno Press, 1969), 32–3.

54 *The Colonial Laws of New York from the Year 1664 to the Revolution…* (5 vols, Albany, NY, 1894) 4: 1002–3. February 6, 1768.

55 Nicholas Varga, "Robert Charles: New York Agent, 1748–1770," *William and Mary Quarterly* 18 (April 1961): 214.

56 The basic study on colonial agents remains Michael G. Kammen. *A Rope of Sand: The Colonial Agents, British Politics and the American Revolution* (Ithaca, NY: Cornell University Press, 1968).

57 Varga, "Robert Charles: New York Agent," 211. These papers are among the William Smith, Jr. Papers, Manuscript Division, New York Public Library.

58 Ibid., 214.

59 Ibid., 213.

60 One of the few modern sources on James DeLancey, Jr. is "Richard B. Morris's James DeLancey: Portrait in Loyalism," ed. by Philip Rantlet, *New York History* 80 (April 1999), 185–210. I am grateful to Kathleen Luhrs for bringing this article to my attention.

61 According to Patricia U. Bonomi, *A Factious People: Politics and Society in Colonial New York* (New York: Columbia University Press, 1971), 242 n 21, "James De Lancey was on a visit to England when the Assembly was dissolved for the new election, and had not yet returned home when the election took place in March 1768."

62 Charles Z. Lincoln, ed., *The Colonial Laws of New York from the Year 1664 to the Revolution* (5 vols, Albany, NY, 1894) 5: 183, February 16, 1771.

63 *Journal of the Votes and Proceedings of the General Assembly of the Colony of New York*, (January 27, 1770), 103–4.

64 *New-York Post Boy*, June 4, 1770.

65 Stephen Jenkins, *The Greatest Street in the World: The Story of Broadway, Old and New, from the Bowling Green to Albany* (New York: G.P. Putnam, 1911), 14.

66 Ibid., 19.

67 One of the few contemporary documents that records the placement of the George III statue is a pen and ink and watercolor drawing by the mapmaker Claude Joseph Sauthier titled *A plan of Fort George at the city of New-York*, 1773, in the Library of Congress Geography and Map Division, Washington, D.C.

68 Stokes, *Iconography*, 4: 813.

69 Quoted ibid., 4: 864.

70 Isaac Bangs, *Journal of Lieutenant Isaac Bangs, April 1 to July 29, 1776*, ed. Edward Bangs (Cambridge: John Wilson and Son, 1890), 24.

71 Ibid., 25.

72 *Annual Register or a View of the History Politicks, and Literature …* 9 (December 1766): 106, and 15 (December 1772): 132.

73 *New-York Gazette, or, Weekly Post-Boy*, September 10, 1770, 3.

74 For information on the Charleston commission of Wilton's statue of *Pitt*, see Joan Coutu, *Persuasion and Propaganda: Monuments and the Eighteenth-Century British Empire* (Montreal: McGill-Queen's University Press, 2006).

75 Philipp Fehl, "John Trumbull and Robert Ball Hughes's Restoration of the Statue of Pitt the Elder," *New-York Historical Society Quarterly* 56 (January 1972): 15.

76 Ibid., 11–12, n. 13. Below the inscription on the Pitt statue was a medallion with the image of "Justice in a sitting position with her sword and truncheon."

77 Stokes, *Iconography*, 4: 810–11.

78 Dorinda Evans, *Benjamin West and his American Students*. Washington, D.C.: National Portrait Gallery, 1980.

79 Charles Coleman Sellers, "Virginia's Great Allegory of William Pitt," *William and Mary Quarterly* 9 (January 1952): 59.

80 Charles Henry Hart, "Charles Willson Peale's Allegory of William Pitt, Earl of Chatham" in *Proceedings of the Massachusetts Historical Society* 48 (Boston: 1915): 298.

81 The Westmoreland courthouse was not built at the time and the painting stayed with the Lee family until 1848, when it was moved to the state capitol in Richmond. It remained there for 50 years before it was returned to Westmoreland County and hung in a new courthouse until the 1940s. At that point it was moved next door to the Westmoreland County Museum.

82 According to Sellers, "Virginia's Great Allegory," 65, Peale's painting was in lieu of a marble statue that the Maryland Assembly, like New York and Charleston, had ordered in November 1766.

83 Peale's broadside advertisement is reproduced in Hart, "Charles Willson Peale's Allegory," n.p, before page 65.

84 See: Donald S. Lutz, "The Relative Influence of European Writers on Late-Eighteenth-Century American Political Thought," *American Political Science Review* 78, no. 1 (March 1984): 189–97.

85 John Adams included a quotation attributed to Algernon Sydney in his successful defense of Captain Thomas Preston, who was charged with inciting the Boston massacre: "Manus haec, inimica tyrannis, ense petit placidiam sub libertate quietem," which loosely translates: this hand, hostile to tyrants, seeks with the sword a quiet peace under liberty. The last part of this phrase was later adopted for the Commonwealth of Massachusetts seal in 1775. W.H. Bond, *Thomas Hollis of Lincoln's Inn: A Whig and His Books* (New York: Cambridge University Press, 1990), 120–22.

86 Sellers, "Virginia's Great Allegory," 66.

87 On February 7 and again on March 23, 1774, payments were made to workmen to repair the Pitt statue. See *Minutes of the Common Council* 8:5, 16.

88 Bangs, *Journal of Lieutenant Bangs*, 57.

89 Alexander J. Wall, "The Equestrian Statue of George III and the Pedestrian Statue of William Pitt," *New-York Historical Society Quarterly Bulletin* 4 (July 1920): 50, 54.

90 Arthur Marks, "The Statue of King George in New York and the Iconology of Regicide," *American Art Journal* 13, no. 3 (Summer 1981): 74.

91 When Trumbull received this Washington commission he was in the midst of creating a series of history paintings based on events of the American Revolution. The second one of these was the *Death of General Richard Montgomery*. Two of this series, along with *Signing of the Declaration of Independence* and *Washington Resigning his Commission*, were later commissioned by the United States Congress for the walls of the Capitol Rotunda.

92 Evidently it was Trumbull himself who advised Houdon that the general should be represented in modern dress, a recommendation that stemmed from his teacher West, who rendered the earlier hero, James Wolfe, in his contemporary British uniform.

93 John Trumbull, *Autobiography, Reminiscences, and Letters* (New York, 1841), 141.

A Memorial to General Richard Montgomery: Commemorating the Death of an American Hero

America's earliest public monuments were the obelisk dedicated to the memory of General James Wolfe, who died heroically during Britain's fight against the French in Quebec, and the two monuments by the British sculptor Joseph Wilton that honored William Pitt and King George III for their leadership in the repeal of the Stamp Act. In the 1770s a fourth was commissioned by the Continental Congress after the start of the American Revolution; a wall monument by the French sculptor Jean-Jacques Caffiéri in memory of the Irish-born General Richard Montgomery, who, like Wolfe, died a hero's death in Quebec. Compared to these earlier men, Montgomery, a former soldier in the British army, was a relatively obscure figure and neither by temperament nor conviction destined for fame. Opportunity for such honor came in tragic form when, with his death during the siege of Quebec on New Year's Eve 1775, he was anointed the first hero of the American Revolution. Such was the significance of his sacrifice that the Continental Congress three weeks later authorized the commission of the monument that is today installed on the porch of St. Paul's Chapel in lower Manhattan. A simple marble wall monument, it contains symbols for the death of a hero and the cause of liberty: a cinerary urn, discarded armor, a Phrygian cap, and carved branches of palm and cypress.

As it turns out Montgomery's apotheosis had political implications, coming as it did when members of Congress were, with some reluctance, turning from their desire for the restoration of liberties by the British Parliament to a declaration of independence from the crown. The colonial militias' early victories in Massachusetts and northern New York, and Montgomery's victories in Canada had led colonists to expect that the war would be brief. With Montgomery's death, however, many realized that a long and intractable, and maybe unwinnable, war lay ahead. Was it worthwhile to continue? Congress needed a hero for the patriot cause, and soon Montgomery's name and memory were invoked in the fight for independence.

Few are aware that in 1775 the Continental Army invaded Canada: New York regiments led by Montgomery marched from the west and south, while from the east through what later became Maine, troops commanded by Colonel Benedict Arnold made their perilous way to Quebec. Of the two forays Arnold's is the better known, since journals of his expedition kept by members of his men survive and early in the twentieth century Kenneth Roberts published his popular *Arundel*, a fictionalized account of the brutal trek made by Arnold and his soldiers through the unmapped territory of northern New England. In contrast there is little documentary evidence (or fictionalized accounts) of Montgomery's campaign, and today he is regarded as a minor figure in the broad panorama of the American Revolution. As the historian Thomas Robinson noted: "It is somewhat ironical that this heroic general, who ranked so high in the opinion of his contemporaries, should now occupy such an obscure place in the history of this conflict."[1] Yet upon his death at Quebec, New Year's Eve 1775, Montgomery became an early hero of the American cause and the subject of the nation's first monument.

The center of conflict was the relatively small area of Quebec Province that bordered the St. Lawrence River from Newfoundland to Montreal and Lake Ontario (Figure 3.1). Throughout the eighteenth century the province and the river were important strategically because the St. Lawrence and its tributary, the Richelieu River (also known as the Sorel or the Chambly), provided access to New York's interior via Lake Champlain and Lake George. Overland portage connected these waterways to the Hudson River and Albany's profitable trading posts, from which furs, lumber, and agricultural products were transported to New York City's deep water port and the global markets beyond. The strategic importance of this corridor was critical during the French and Indian War and continued to be so during the American Revolution.

Montgomery in North America: The French and Indian War

Richard Montgomery began his career as an ensign in the British army in the Seventeenth Infantry Regiment or Regiment of Foot and was part of the contingent involved in the 1758 siege of Louisbourg (which to the consternation of many in England had been returned to France following the termination of King George's War under the Treaty of Aix-la-Chappelle), a fort strategically located on the eastern shore of Nova Scotia, which controlled access to the St. Lawrence.[2] Under the command of Colonel John Forbes, his unit proceeded from Ireland to the city of Halifax Nova Scotia, which served as a launching site for the campaign. Plans to take the fort, however, were aborted and the regiment instead spent the winter in northern New York at Fort George.

3.1 Detail of Louis Brion de la Tour, *Carte du théâtre de la guerre entre les Anglais et les Américains*, 30 × 20 1/16 in. (76 × 51 cm.), 1777. Norman B. Leventhal Map Center at the Boston Public Library

That spring Montgomery's regiment, now led by General Jeffrey Amherst, returned to Nova Scotia where they fought in the Battle of Louisbourg, which fell to British forces on July 26, 1758. This was also an important year for Montgomery (Figure 3.2)—he saw his first battle, received his first promotion, and most importantly he gained geographical and strategic knowledge that would later, during the American Revolution, prove to be invaluable.

The following year, 1759, Prime Minister William Pitt, in an effort to end the war, called for a coordinated attack on the French in Quebec and Montreal. Wolfe was assigned to take Quebec; Amherst and his troops, Montreal. Montgomery's regiment traveled with Amherst to Albany to begin their advance, first to Fort Carillon (later renamed Fort Ticonderoga) on the outlet that connects Lake George and Lake Champlain. They then traveled to Crown Point at the north end on Lake Champlain. After extended battle in southern Canada along the Richelieu River, the British took Montreal in September 1760, and by the end of the year all of Canada was in British hands. Following this victory, Montgomery and his regiment were assigned to duty in the Mohawk Valley north and west of Albany, a dismal assignment that was soon annulled when orders were received for them to proceed to New York City in preparation for service in the West Indies. There hostilities between the French and the English continued to be played out on the islands of Martinique and Cuba. Havana eventually fell to the British, but the army suffered heavy losses primarily because of disease, probably malaria, which Montgomery caught. He was sent back to New York to recover. After the war ended the following year, British troops were still needed to suppress Indian uprisings on the western frontier, and once again Montgomery was deployed to the Mohawk Valley. En route north, traveling up the Hudson River, the ship went aground opposite Clermont, the estate of Judge Robert Livingston. The officers were invited to come ashore and were entertained by the family. It was here that Montgomery met his future wife, the judge's daughter Janet.[3] After their ship was unmoored, Montgomery and his regiment continued on to Fort Stanwix. Montgomery, however, did not stay long in the province's wilder reaches; he faced recurring health problems and was sent home to Ireland in the fall of 1764.

Once home and given his extensive military experience, Montgomery had expectations of advancement. Yet these were unsettled times in England and antiwar sentiment ran strong, leaving Montgomery and other disgruntled British officers little choice but to sell their commissions and find opportunity elsewhere. A number of them, including Montgomery, returned to North America to seek fame and fortune since the colonies offered economic opportunities that valued enterprise and hard work over hereditary connections. At 30 years of age, and after 12 years of service, Montgomery resigned from the army and left Great Britain with the intention of living the life of a gentleman farmer. As he wrote to his cousin, John Montgomery:

3.2 *General Richard Montgomery*, steel engraving. Emmet Collection, Miriam and Ira D. Wallach Division of Art, Prints and Photographs, The New York Public Library, Astor, Lennox and Tilden Foundations

You no doubt will be surprised when I tell you I have taken the resolution of quitting the service and dedicating the rest of my life to husbandry, for which I have of late conceived a violent passion. A passion I am determined to indulge in, quitting the career of glory for the substantial comforts of independence. My frequent disappointments with respect to preferment, the little prospect of future advancement to a man who has no friends able or willing to serve him, the mortification of seeing those of more interest getting before one, the little chance of having anything to do in the way of my profession, and that time of life approaching when rambling has no longer its charms, have confirmed me in a the indulgence of my inclination. And as a man with little money cuts a bad figure in this country among Peers, Nabobs, &c., &c., I have cast my eyes on America, where my pride and poverty will be much more at their ease. This is an outline of my future plans.[4]

Before sailing he bought books on husbandry, farming, natural philosophy, anatomy, and science, including Benjamin Franklin's *Experiments and Observations on Electricity*. He also purchased a microscope, a barometer, a hydrometer, a thermometer, an air pump, and a globe, and set sail for America in the fall of 1772.[5] Like his future brother-in-law Robert R. Livingston (later the chancellor of New York and so-called to distinguish him from others of the same name), Montgomery wanted nothing more than to settle down, pursue scientific farming, and enjoy the good life.

Prelude to Revolution

No estimate has been made of the number of British soldiers and officers, tempered by battle in North America during the French and Indian War, who either stayed or returned to the continent after the war's end. I imagine the number was considerable. Three officers of that earlier battle went on to distinguish themselves as American officers during the Revolutionary War: Montgomery, Charles Lee, and Horatio Gates. As history would soon prove, these men could not avoid the colonial ferment they encountered, beginning with the furor around the implementation of the Stamp Act in 1766. Committees of Correspondence were established in several cities, most notably Boston and New York, where the Sons of Liberty took the lead in mounting protests. William Pitt the elder, who had masterminded Britain's defeat of France, came to the defense of the colonies and was effective in convincing Parliament and the king to repeal the hated act. But Pitt did not remain in power; he was later succeeded as prime minister by George Grenville who imposed the first of the Townsend Acts (1767–1770) and later the tea tax, which precipitated the Boston Tea Party of December 1773. Intercolonial support of Boston's protests led to the meeting in Philadelphia of the First Continental Congress in the fall of the following year. But Parliament turned a deaf ear and with the consent of the king retaliated with passage of the Intolerable or Coercive Acts in 1774.

Flotillas of British warships congregated at the ports of Boston and New York, and in mid-April 1775, troops landed near Boston and were met with armed resistance at Lexington and Concord. The other colonies quickly responded, and in two short months the Second Continental Congress had met, appointed Washington a general, and called for the formation of the Continental Army. With these formative events transpiring in their adopted country, former British officers such as Montgomery, Lee, and Gates responded as newly minted patriots.[6]

None of these issues were on Montgomery's mind when he arrived in New York City in early November 1772. The city was prospering and was newly graced by Joseph Wilton's equestrian monument to George III on Bowling Green and his standing William Pitt in front of City Hall on Wall Street. Montgomery, however, had no intention of living in the city, and a few months after his arrival he purchased a farmhouse, a barn, orchard, and 70 acres of good grazing fields in King's Bridge (now Kingsbridge, the Bronx). A year later and in the prime of his life—"tall and slender, well limbed, genteel, easy, graceful, [and of] manly address"—he married one of Chancellor Robert R. Livingston's sisters, Janet (1743–1828), at Clermont.[7] He then sold his Kingsbridge property and consolidated his landholdings near the Livingston family at Rhinebeck in Dutchess County, New York. From all accounts he was an industrious and innovative farmer and worked in emulation of his in-laws, drawing close, in particular, to Janet's brother Chancellor Livingston. In 1774 he and Janet began to build their own farm called Grasmere.[8] These were years that Montgomery prospered socially and economically.

This idyll, however, was about to be interrupted. Citizens of Massachusetts, including Samuel Adams and the Sons of Liberty, were agitating against parliamentary injustices, not the least of which was the Tea Act that allowed the East India Company to export tea to the colonies tax free and thus establish a monopoly. Colonial merchants were outraged at this favoritism and urged a boycott of tea, which culminated in the Boston Tea Party. In this protest the Massachusetts Sons of Liberty on December 16, 1773 tossed 45 tons of tea into Boston Harbor. The New York Sons of Liberty had responded earlier, and while their "tea party" was called off, there was clear support for these colonial protests in New York.

In response, the king and Parliament, furious with the destruction of private property, enacted a series of punitive measures that came to be known as the Intolerable or Coercive Acts. These were five acts passed over the spring and summer of 1774, most of which were directed toward punishing the colony of Massachusetts. In response, the citizens of Massachusetts increased their agitation and strengthened their interprovincial Committees of Correspondence. Led by Samuel Adams, they asked other provinces to join them in closing their ports and suspending trade with Great Britain. For the remainder of the year, colonials—conservative and radical alike—continued

to deny Parliament's authority, for, according to Robert Middlekauff, "the Intolerable Acts left no doubt that the British government had set out to destroy American liberties."[9] One of these pieces of legislation that would have fateful consequences for Montgomery was the Quebec Act, an overt ploy by Parliament to ensure the loyalty of the French Canadians, who dominated the city and the province. Samuel Adams, at a meeting at Faneuil Hall in February 1775, spelled out the peril for the colonies and in particular New York: "The plan of the British Court, as I have been well informed this winter, is to take possession of New York, make themselves masters of Hudson's River and the Lakes [Lake George and Lake Champlain], cut off all communication between the Northern and Southern Colonies, and employ the Canadians, upon whom they greatly rely, in distressing the frontiers of New England."[10] Part of the colonists' response was the convening of the First Continental Congress, an unprecedented coming together of representatives from 12 colonies that met from September 5 to October 26, 1774. As a test of colonial cohesiveness the convention was a success, but its proceedings had little impact on ameliorating the unrest that continued to fester among much of the population, particularly those in port cities that were the most affected by British tax policies.

These events barely touched Dutchess County, which was home to many who remained loyal to England. The Livingstons themselves were moderates, and as Montgomery wrote to the New York bookseller and newspaper publisher James Rivington in the fall of 1774, "I live in a district totally undisturbed by political commotion. We have so little sensibility, as not yet to have felt for our *unhappy* country."[11] But like Cincinnatus, the Roman soldier/farmer to whom Washington also would be compared, Montgomery would soon be called to leave his farm and take up arms against the British.

Cincinnatus

Montgomery spent New Year's Eve of 1774 at Clermont, the Livingston family's estate on 13,000 acres in what is now Columbia County.[12] Montgomery, surrounded by his wife and her family, to whom he had become much attached, was a happy man. A year later to the day, Montgomery would lie dead in Quebec. Over those intervening 12 months, colonial militia precipitated the American Revolution. The Second Continental Congress convened, created an army, appointed Montgomery a brigadier general, and ordered the invasion of Canada.

Events began early in 1775 in Massachusetts, where opposition to the Intolerable Acts, which closed Boston's port and required that troops be quartered at colonial expense, had its strongest voice. Armed resistance to the enforcement of these acts was talked about openly. Ever since the Boston

Tea Party, in anticipation of military reprisals, citizens throughout the colony had formed Committees of Correspondence and Committees of Safety, arming themselves and forming private militias. Some, known as Minute Men, including Paul Revere, were to be ready for battle at a minute's notice. London was aware of the ferment, and British secretary of state William Legge, second Earl of Dartmouth, ordered Thomas Gage, the military governor of Massachusetts and the commander-in-chief of British troops in North America, to confiscate the munitions of the rebels and arrest their leaders, principally Samuel Adams and John Hancock. The protestors, however, had learned from friends in London of Dartmouth's instructions and left Boston along with their munitions. These included Adams and Hancock who hid out in Lexington. Two other patriots, Joseph Warren and Revere, stayed behind to keep track of the army's preparations in Boston. In mid-April British soldiers began to muster, and small detachments were sent inland to harass travelers suspected of aiding the rebellion and to search homes for munitions. On the evening of April 18 the insurgent leaders learned that an armed contingent had been ordered westward to Lexington to more purposefully shut down the stockpiling of armaments and to arrest the rebels' principal organizers. With little thought to the larger implications of taking on the British army, the colonials were determined to oppose Parliament's rule, even at the end of a gun. Warren and Revere, through their network of informants, learned of the army's plans. Revere and friends established a signal with lanterns to be hung in the Old North Church to alert their comrades in Cambridge if British troops were arriving by land or by sea. One lantern would signal that troops were moving inland over Boston Neck (which connected Boston to the mainland to the south), and two lanterns if they were coming by water over Back Bay to Charlestown to the northwest. Revere then left Boston, taking his now legendary midnight ride through the countryside to Lexington and warning citizens along the way that British troops were on the march. Men from all walks of life took their muskets off the walls and joined with fellow townsmen to defend themselves, their families, their livelihood, and for some, their country.

The encounters between the British regulars and the colonial militias that transpired over the next two days are known as the Battles of Lexington and Concord and have become the stuff of legend. After two days of fighting there was no real victor, but the colonials' success in repulsing the British and harassing them back to Boston and their ships were the opening salvos in the American Revolution. News of the repelling of the British by the Massachusetts militia spread quickly. In response, the Second Continental Congress hastily came together on May 10 in Philadelphia and began debating the larger implications of war with Great Britain.

Another group responded as well; prominent landowners in western Massachusetts and the Connecticut River valley feared that in the wake of the

Boston uprising British troops would be sent to the St. Lawrence and invade the lower colonies from the north. Memories of the French and Indian War and the struggle to control access to the St. Lawrence, Lake Champlain, and Lake George were ever present. These landowners approached Ethan Allen, the leader of the Green Mountain Boys, a colonial militia formed in western New Hampshire in what is present-day Vermont, to reconnoiter at the forts on Lake George. Simultaneously, Benedict Arnold, who had organized a regiment from his native Connecticut and was casting about in Cambridge, was approached by the eastern-dominated Massachusetts Committee of Safety to undertake a mission to explore and secure the northern forts of Ticonderoga and Crown Point. "Arnold's avowed aim in proposing his expedition was merely to get cannon," according to Justin Smith, an early historian of the Canadian campaign, while the Green Mountain men's intention seems to have been "capturing the forts … as a measure of self-defence against the British."[13] When Allen with his 200 soldiers and Arnold, solo, met at Hand's Cove across from Fort Ticonderoga in early May, a dispute, not surprisingly given the temperaments of these two men, arose as to who would lead the assault. Even so, this extra-legal force easily overwhelmed the small British garrison at Fort Ticonderoga. With even fewer guards, Crown Point was similarly captured a few days later. These colonial forays changed the nature of the American engagement with British forces "from limited self-defense in Massachusetts to offensive war …. They had also brought the Revolution to New York, changed the balance of power on the northern frontiers, and opened the door for an invasion of Canada."[14]

Meanwhile in Philadelphia, the Continental Congress, which had become the de facto intercolonial government, began to debate British aggression, to weigh reconciliation or independence, and to plan for war. Congress's first reaction to the rebels' capture of Ticonderoga was mixed, and they played a waiting game. On the one hand they believed that there was "indubitable evidence" that the British ministry was making plans to invade the colonies from the north. At the same time, they were worried that the maneuvers of the New Englanders jeopardized accommodation with Great Britain, the thought being that Parliament would rescind the Intolerable Acts just as it had earlier overturned the Stamp and Townsend Acts. So they ordered that the forts be abandoned and that committees of the cities and counties of New York and Albany remove the cannon and stores "from Ticonderoga to the south end of Lake George." As Smith concludes: "Congress would safeguard the interests of both people and Crown but do nothing that could even look aggressive; New York would act as a property-clerk."[15] In a matter of weeks, however, Congress began to change its mind. Not only did it have second thoughts about an incursion into Canada, but since the end of May the 64 gun British man-of-war, the HMS *Asia*, had been anchored in New York's East River. Many in the city were alarmed by its presence, so Congress in

response ordered construction of fortifications along the Hudson and the arming of its citizens.

It is difficult to generalize about New York's reaction to the uprising in Boston. New York, then and now, was ruled by different factions who were not divided simply by upstate rural interests and downstate merchant concerns. There were also manorial disputes with tenants, mechanics in the city who felt disenfranchised, border contests with the Green Mountain Boys for the territory in the northeast that would soon become Vermont, and there were the ever-present issues with the Native Americans. According to the historian Edward Countryman, "New Yorkers entered the revolutionary crisis from many different directions, and they brought with them many different, often conflicting goals. People who stayed with the Revolution as it gathered force were in an overall majority, but the balance between them and royalists varied widely."[16]

Given the heterogeneity of its population and their competing interests, New York did not have the same coordinated province-wide commitment as Massachusetts to opposing the Tea Act and the ensuing Intolerable Acts. Instead, New Yorkers formed in May 1774 a Committee of Fifty in New York City, which was later increased to fifty-one, and by the end of the year had assumed administrative control of the city but not of the province. The committee also sent delegates to the First Continental Congress, which, when it met in Philadelphia in September, voted to boycott British imports. Upon their return, delegates urged the Committee of Fifty-one to enforce the Congress's ordinance, an initiative that met with varying degrees of success. Over the next six months, dissension not surprisingly arose between conservative patriots and radical hotheads, and a new election was called in March 1775, when the committee expanded to 60.

Membership on the committee still had not stabilized, and when news of the Battles of Lexington and Concord reached New York, the committee was increased to 100. They also expanded their extra-legal authority by assuming the role of the province's General Assembly. New York, however, unlike Massachusetts, was not yet in open rebellion. During the hectic days of May, the committee sent assurances to Acting Governor Cadwallader Colden that, while they were opposed to the laws of Parliament, they remained loyal to the king. The contingent of rebels, however, had the upper hand and encouraged committee members and others to continue to enforce the boycott of British goods. They also turned a blind eye to the harassment of loyalists—those who sought accommodation with England.

The Committee of One Hundred, however, was too large and unwieldy and could not maintain control of political and military situations that were in a constant state of flux, and bowed to a need to establish a smaller organization to assume its duties. Called the Provincial Congress, it was convened in late May 1775 with Richard Montgomery as a representative

from Dutchess County. The New York congress' first order of business was to declare allegiance to the edicts of the Second Continental Congress, which had begun to meet in Philadelphia on May 10. This included orders for the removal of munitions and cannon from Ticonderoga and Crown Point and the fortification of New York City. The Provincial Congress also ordered the disarmament of all loyalists and the formation of militia regiments; at the same time they fervently hoped that accommodation could be made with the British government.

After an early meeting in Albany, Montgomery wrote his brother-in-law, then one of New York's representatives at the Philadelphia meetings of the Continental Congress, to keep him informed both of the province's plans and his own thoughts. As a former military man, he studied news of the fighting in Boston and forays by the Green Mountain Boys and Arnold in northern New York, commenting, often at length, on the tactics of both. He wrote in early June that he was still "sanguine" about the future, believing the patriots' cause was just, and that "the minister [in England] has fallen a victim to the just resentment of an injured people."[17] His letters are a continuous mixture of military appraisal and personal convictions: "I would most willingly decline any military command from a consciousness of want of talents—nevertheless I shall sacrifice my own inclinations to the service of the public, if our Congress should be of opinion they cannot find a more capable servant." He then went on to describe the arrival of "800 weight of powder Ammunition is an essential point—tho' for my own part, should I have any command, I would use it with more scarcity than has been usual of later years in military operations."[18] At the same time he supported Livingston's efforts in the Continental Congress to seek common ground with London. Neither Montgomery, nor Livingston and those meeting in Philadelphia imagined that the battle would become a contest for independence. The more immediate concerns of Montgomery and Livingston were the preservation of their liberties and their way of life. As Livingston's biographer described him, the Chancellor was "a man looking in two directions—forward as a scientific farmer, backward as a landlord, forward as a republican, backward as an aristocrat" and with a "private aversion to popular politics."[19] Yet his grandfather (Robert of Clermont) and his father (the judge), both of whom died in late 1775, supported the patriot cause and joined their voices to those of other colonists—mechanics and elite alike—who demanded liberty from the king and Parliament. The Chancellor's grandfather, according to his biographer, was filled "with rapture" over the news from Lexington and Concord.[20] Evidence of his father's support of the patriot cause was included in a letter he wrote to his son in Philadelphia in the spring of 1775. The Chancellor was very close to his father, and his biographer stated that "for lack of any evidence to the contrary, [this letter] could be taken to represent their joint thinking at this critical moment." The letter read in part, "every good man wishes that America may remain free; in this I join

heartily; at the same time I do not desire, she should be wholly independent of the mother country."[21] These sentiments, voiced in early May 1775, were ones that virtually all elite citizens shared—they passionately wished to preserve their freedoms, but at this point in time, independence was not desired. Given that Montgomery died before independence was declared, it is impossible to know his beliefs. What is known is that he had little interest in politics, but when called upon as a member of New York's Provincial Congress he worked actively to prepare the province for war.[22]

These were fateful times, and on June 14 the Continental Congress voted to create an army made up of soldiers from all the colonies that would come to the aid of the beleaguered citizens of Boston. Massachusetts needed help, and it was now clear that given the congressional decision to form an army, warfare would soon spread to the other colonies. Not long afterward Montgomery was inducted as a brigadier general and placed as second in command to Philip Schuyler, the head of one of Albany's most powerful and influential old Dutch families, who had, like Montgomery, served in the French and Indian War.

"O Canada"

During the summer of 1775, the focus of the patriots' armed rebellion was in and around Boston. One hero, Joseph Warren, posthumously appointed an officer in the Continental Army, had already died at Bunker Hill, and help was needed from the other colonies to check British aggression. Regiments from all over New England began to muster and join the Continental Army under the command of novice general George Washington, who had seen military service as a major in the Virginia militia during the French and Indian War.

Over the next six months there were continued skirmishes, and much to everyone's surprise, patriots and British alike, militiamen and the Continental Army created a stalemate. Finally, threatened by cannon secured by Colonel Henry Knox from Ticonderoga and mounted on Dorchester Heights, the commander of the British army, Sir William Howe, who had recently succeeded Gage, finally ordered his troops to leave Boston, and on March 17, 1776, they sailed for New York. The patriots promoted the British army's evacuation from Boston as a victory, but the reality, and one acknowledged by Washington, was that the British had departed only to regroup in New York, a city more hospitable to the crown and the military. With its large harbor and landing sites on Long Island, the east and west sides of Manhattan, Brooklyn, Staten Island, and New Jersey, and direct access via the Hudson River to the upper reaches of New York, western New England, and Canada, it was the best locale from which to mount full-scale warfare against the rebels.

However, even before the British army left Massachusetts, Congress made a preemptory decision to invade Canada. As important historically as they were, the Battles of Lexington and Concord, as well as Bunker Hill, were defensive, not offensive, battles, unlike the invasion of Canada. The reasons for the incursion were two-fold. It was feared that British troops would move south from Montreal and Quebec and invade the lower provinces. Congress also believed that French Canadians were similarly frustrated with British rule, and that they would ally with the Americans as a fourteenth colony, the Continental Army serving as an army of liberation. The reality was that there was little commonality between Canada's French-Catholic citizens and the lower provinces, where anti-Catholic feeling was high and well-known. Since passage of the Quebec Act, the French Canadians had little incentive to overthrow British rule. Congress was stymied, a status that John Adams summarized in a letter to his friend James Warren in early June: "Whether we should march in to Canada with an army sufficient to break the power of Governor Carleton, to overawe the Indians, and to protect the French has been a great question. It seems to be the general conclusion that it is best to go, if we can be assured that the Canadians will be pleased with it and join."[23] Another viewpoint was expressed by representative George Read: "Defense was constitutional; aggressiveness would be revolt. The Canadians had not sent delegates to Congress and did not stand as one of the United Colonies. Crossing their boundaries, the colonials would change from oppressed to oppressors; and to invade with armed force a peaceful royal province and then drive it into rebellion would be treason of a double dye."[24]

After a bit more dithering in mid-June the Continental Congress ordered Major General Philip Schuyler, commander of the Northern Department and Montgomery's superior, to assume command at Ticonderoga, where he was to prepare troops to take custody of the forts along Lake Champlain and the St. Lawrence, including Montreal and Quebec—in other words to invade Canada. Meanwhile Arnold, who after seizing the forts at Ticonderoga and Crown Point, had hoped he would be appointed to lead the invasion. Disappointed, he returned to Massachusetts where he met with Washington, who was still encamped in Cambridge, and the two men discussed the wisdom of mounting a parallel campaign to that of New York. As Arnold explained to the commander-in-chief, it was not enough that Ticonderoga and Crown Point were won; the larger challenge of securing the St. Lawrence River was, he declared, a necessity. Later on, Arnold, who was considered by many to be one of the best generals and most daring soldiers in the Continental Army, was passed over for promotion; several years later he switched sides, and his name then becoming synonymous with treason.

In the early months of the Canadian campaign, if one could call it that, it was not always clear who was in command—Congress or Washington. Both were convinced of the rightness of a Canadian foray but they approached

the issue from different vantage points. Congress believed it necessary to secure the forts connecting the St. Lawrence to the Hudson and gave the responsibility to the New York province; Washington, from his outlook in Massachusetts, recommended Arnold. Actually, it was not so much that Washington recommended him as that he liked his plan—one that involved traveling by sea from Massachusetts to southern Maine. The compromise was that there would be a two-pronged attack on Quebec—one from New York and the west down the St. Lawrence, the other from the south and east through Maine up the Kennebec and overland to Point Levis on the eastern shore of the St. Lawrence opposite Quebec.[25]

In contrast to Arnold's enthusiasm, Schuyler and Montgomery faced the prospect of invading Canada with great uncertainty. The avowed purpose was to win over the Canadians and secure the St. Lawrence against British incursions. For this plan to succeed, however, the Canadians had to be convinced that they shared common political ground with the rebels and had to be willing to fight the British. The reality was that there was no resistance to British rule in Canada as there was in New England, and there was even less incentive to oust the military and barricade the St. Lawrence against the British navy. Nonetheless, the New York regiment prepared for the incursion, and with the promise of reinforcements from Arnold's expedition, made plans to take the northern forts at Montreal and Quebec.

Montgomery detailed his response to his deployment in a series of letters to his brother-in-law that illuminate his personality and the particular qualities of character that were often referred to in subsequent tributes. They also testify to the high regard in which each man was held by the other.

An early communication from Montgomery to Livingston is dated July 1, while he was still in New York, and Livingston, as a member of the Continental Congress, was in Philadelphia. After commiserating with Livingston on the death of his father, Judge Livingston, as well as his maternal grandfather, Henry Beekman, he praised the efforts of "New Englanders," and acknowledged their bravery at Bunker Hill, closing with this statement: "It is possible I shan't remain much longer in this town—you know why—Schuyler talks of setting out on Monday. Farewell."[26] The next day Montgomery met with Schuyler, General David Wooster of Connecticut, and General Horatio Gates who was en route to Boston to discuss a northern strategy with Washington. Schuyler then left for Lake Champlain to assume command and oversee the training of raw recruits, secure provisions, and order the construction of boats and barges for the campaign through the northern lakes. Montgomery, who remained in Albany, wrote to Livingston of Schuyler's plans, "You have no doubt seen all of Schuyler's letters to the Congress—it will be therefore unnecessary to descant on his situation with respect to the expediency of the measures on foot, I am not possessed of the necessary information to form any judgments of it." He then went on to state his own estimate of the planned invasion and

its possible consequences: "Should the Canadians relish the intended visit, it will effectually secure us from Indian hostilities. Should we have success it will show our strength to the world—but it will much enlarge the sphere of our operations, and next year we shall require a great force to maintain our footing should this unhappy controversy continue at such a distance and in a country where assistance we can't rely on."[27] He then went on to comment on the "inconvenience of failure," as he described it, believing nonetheless that the Americans would be successful.

After much recruiting, provisioning, and overseeing of the fortifications of the Hudson, such as they were, Montgomery set out with his troops to join Schuyler at Ticonderoga. His wife, Janet, had accompanied him as far north as Saratoga just south of Fort Edward on the Hudson River. From there Montgomery and his troops traveled overland to Fort George, arriving at Ticonderoga on August 17, the same day that Schuyler returned to Albany for meetings with the Provincial Congress and the Iroquois, leaving Montgomery in command. Now closer to the action, Montgomery began to assess the conflicting reports on the situation in Canada. Were the Canadians willing to join the patriots? Was there a buildup of British troops at St. Johns? Were they building boats for naval defense? These were serious questions, and Montgomery decided that he needed to find out the answers himself and notified Schuyler of his decision to move down the lake toward the Richelieu River. According to Justin Smith: "Scarcely did Montgomery find himself in command at the lake, before he declared that, in view of the British preparations, the Americans must hasten to 'crush their naval armament' before it could 'get abroad'; and, without instructions to do so he gave orders, under the pressure of necessity, to sail for St. Johns on the second of September."[28]

St. Johns was a fort strategically located on the southern bank of the St. Lawrence at the mouth of the Richelieu, and capturing it would put the New Yorkers within striking distance of Montreal. At the same time Schuyler, who joined the expedition briefly in early September, sent the Canadians a pronouncement written in French to explain Congress' appeal to them to seek common cause with the Americans:

> The decision of the Grand Congress to send an army into Canada in order to drive away, if possible, the troops of Great Britain, who—acting to-day at the instigation and under the orders of a despotic ministry:—aim to subject their fellow-citizens and brethren to the yoke of a hard slavery. Yet however, necessary such a step, be assured, gentlemen, that the Congress would never have resolved upon it, had there been reason to suppose that it would not be agreeable to you; but, judging your feelings by their own, they have believed that only pressing necessity could bring you to put up with daily insults and outrages inflicted upon you, and see with a quiet eye the chains made ready which are to find you and your remotest posterity in a common bondage.[29]

Schuyler's words were also a justification for the invasion.

On their initial forays against the fortifications of St. Johns, Montgomery's troops did not cover themselves in glory. If truth be told, most of them cut and ran. After the debacle on the shores of the Richelieu and the retreat back to the Isle aux Noix, Montgomery began the systematic training, cajoling, and discipline that eventually made a rag-tag band of farmers and mechanics into a fighting regiment. While encamped near St. Johns, Montgomery finally had a chance to bring his brother-in-law up-to-date on their progress in a long letter in which he vented his frustration with his troops and outlined how he would justify the capture and military takeover of Montreal: "I will give a sketch of my politicks. I state myself commanding for the time being the auxiliary army in Canada. I have requested that they will as soon as possible choose faithful representatives to take their seats in the Continental Congress and make a part of that union now so formidable to tyrants." He then explained that he planned to show them how the destinies of the Canadians and the rebel patriots were linked by stating "that our liberties are so intimately connected with freedom in Canada that we can never have them on a secure foundation, so long as arbitrary government is established here. That no reconciliation can take place 'till their liberties are secured on the same basis with our own." He closed by candidly admitting that "being not a great politician my plan perhaps may not be approved of," but he hoped that his leadership of the invasion had "the merit of being liberal, and coming from an honest heart void of any ambition but that of serving the public."[30]

After this sincere expression of his intentions, Montgomery vented his frustration with his troops and his desire to be back on his farm:

> The first reg't of Yorkers is the sweepings of the York streets—and they have not more spirit than the New Englanders—their morals are infamous, and several of them have deserted …. The subalterns are wretches in general, 'tis no uncommon thing to be an officer beastly drunk even on duty—our military code will never do. I have at this instant a deserter in irons and dare not try him lest the trifling punishment allotted to his crime should rather encourage than prevent repetition …. The master of Hindustan could not recompense me for this summer's work and nothing shall ever tempt me again to hazard my reputation at the head of such ragamuffins. Honor the very soul of the soldier has no existence among us. I do assure you, I have envied every wounded man who has had so good an apology for retiring from a scene where no credit can be obtained. O fortunati agricolai! Would I were at my plough again![31]

At the time of Livingston's reply, help of another kind had already arrived, and Montgomery's forces were soon joined by regiments from Connecticut and New Hampshire, including some of Allen's Green Mountain Boys, now under the command of David Wooster. The combined forces lay siege to the defenders of Fort St. Johns, cutting off supplies and communication between the fort and Montreal. The fort finally surrendered to the Americans in early November. Montgomery and his men then marched overland to the

St. Lawrence, where they encamped on St. Paul's Island before crossing to Point St. Charles, capturing Montreal a week later (November 13). Representatives of the "citizens and inhabitants" of Montreal sent "Articles of Capitulation" to Montgomery, which he refused on the grounds that they could "claim no title to a capitulation" and more to the point it was not in his power to grant such requests as the guarantee of free trade and issuance of passports. He did, however, subscribe to the spirit of their requests and ensured that there would be a minimum of violence and that "the inhabitants, whether English, French, or others shall be maintained in the free exercise of their religion." Furthermore, he told the citizens that "speedy measures will be taken for the establishing courts of justice, upon the most liberal plan, conformable to the British constitution."[32] Essentially Montgomery wanted to reassure Canadians that he and his troops came in peace and that he was acting on orders from his superiors in Philadelphia.

Montgomery successes in capturing the lake forts and Montreal were duly reported to the Congress in Philadelphia and written up in newspapers and broadsides. Some of the reports contained Montgomery's own words extracted from a letter he wrote to Schuyler that was forwarded to the Congress in Philadelphia which, over a two-week period, appeared in the *New-York Gazette* (November 22); *New-York Journal* (November 23); New Haven *Connecticut Journal* (November 29); and Williamsburg *Virginia Gazette* (December 1). Other colonial newspapers published Montgomery's response to the Montrealers' "Articles of Capitulation," including the Philadelphia *Pennsylvania Evening Post* (November 30); Philadelphia *Pennsylvania Mercury* (December 1); *Dunlap's Maryland Gazette*; or *The Baltimore Advertiser* (December 5); the Philadelphia *Pennsylvania Gazette* (December 6); New London *Connecticut Gazette, and the Universal Intelligencer* (December 8); and other newspapers in Rhode Island, Connecticut, Massachusetts, Virginia, and New Hampshire. Americans could also follow the course of battle through a series of letters published in December "by order of the Hon. Continental Congress." These included dispatches from Montgomery, Schuyler, and Arnold. This colonial-wide interest, and one assumes support, of the Canadian invasion led the Continental Congress to promote Montgomery to Major General on December 6. Tragically Montgomery died before receiving the news.

Following victory in Montreal, Montgomery wrote to Livingston saying that he had "courted fortune and found her kind."[33] He did not, however, rest on his laurels but looked ahead to victory at Quebec and outlined his strategy, which he essentially followed:

> It will be absolutely necessary to throw a considerable body of troops into this Province as soon as the ice will bear. General [Charles] Lee should have this important command. Quebec if it doesn't fall before winter it must be attacked early in the spring … however if the season remains favorable and the troops will follow me, I shall lend a hand to Arnold—should Quebec fall into

our hands, some post below the town will be necessary to occupy where the channel is narrow and dangerous—there the troops strongly posted a boom over the channel and floating batteries with a clever fellow to command may I think baffle all Ministerial attempts in this Province.[34]

In mid-November Montgomery received a letter from his father-in-law, the judge, who congratulated him on his victory at St. John's and the public approbation he had received: "Surely Providence favors the American cause," and continued by describing the enthusiasm that Montgomery's victories have engendered: "Your reputation before the surrender of St. John's was very high, how you contrived it, I know not but not a sick soldier, officer or deserter that passed through the country these several months, but has agreed to praise you wherever they stopped."[35]

It took a while for this letter to reach Montgomery. When he finally had a chance to respond, it was mid-December, and he and his troops were encamped outside Quebec, after establishing a provisional government in Montreal, which he left in charge of General David Wooster. In his letter, Montgomery described the morale of his troops, his own feelings about remaining in the army, his reasons for continuing on to Quebec, and the importance of this venture for the future of the American colonies. He began by relating the challenge of managing troops who wanted to go home: "The unhappy profession of going home which prevails among the troops has left me almost too weak to undertake the business I am about—I have little more than 800 men fit for duty beside some Canadians, who will not be of much service in any serious affair." But he was insistent that an assault on Quebec was doable. Although the city's fortifications "are very extensive" he believed they could be taken by "a sudden attack." He had also learned that "the [Quebec] Garrison is little to be depended upon there being not above sixty regular troops—the rest are ragamuffins, sailors and towns people to the amount of near 1200." In his own defense, he related that he had duly communicated his plans to the residents of Quebec but to no avail. Nor was he able to reach an accommodation with Guy Carleton, Canada's provincial and military governor, whom Montgomery believed condoned unsoldierly behavior: "I have taken much pains to undeceive the inhabitants of the town, with respect to the villainous falsehoods which have been propagated against us and have endeavored to prevail on Mr. Carleton to give me admission peaceably, by offering him a safe conduct to embark for England but he will not admit a flag of truce. In short I believe he is desperate and perhaps wishes to be covered by death from the disgrace and shame which must attend his wretched politicks and still more despicable military conduct." He also said that he had lost his taste for military life but at the same he was committed to conquering Quebec, since, as he wrote: "It is of great consequence to be masters of Quebec 'till then I think we can't expect the Canadians to enter heartily into a union by sending deputies to Congress [since] they will be afraid of falling next Spring into the power of the [British] ministry." However he was optimistic that "affairs at

present [are] in prosperous a situation" so much so that he daydreamed about being back on his farm in Rhinebeck but stated and underscored to emphasize that: "*Should the scene change, I shall always be ready to contribute my mite to the public safety.*"[36]

The next day he wrote in a similar vein to his brother-in-law, who was in Ticonderoga as part of a congressional delegation sent north to evaluate the situation in Canada. Montgomery, in what would be his last letter, recounted some of the information he had written the day before to Livingston's father but added more detail regarding his military strategy. He began by saying that he was overjoyed that Livingston was appointed to the committee but was "no less mortified to find the committee thought it unnecessary to proceed" further north than Ticonderoga, since he thought it was important that these Congressional representatives meet with the Canadians directly: that the issues debated in Philadelphia were "too far distant to impress one here." Furthermore, Montgomery believed that the presence of Livingston's delegation would help "curb licentious troops" and would be proof to the Canadians of the Americans peaceful intent, that the American delegation "might have had the happiest effects in influencing the people to a choice of representatives." What was left unsaid was how essential it was for American civilians to persuade the Canadians of the necessity of joining them in the rebellion. Pleas from the military alone sent the wrong message. Montgomery further complained that he had been left too long to his own devices: "I should not then have been under the disagreeable necessity of acting out of my own head and running the hazard of mistaking the intentions of Congress," a direct reference to his response to the Canadians' "Articles of Capitulation." He also wanted his brother-in-law, both as a relative and as a member of Congress, to know what he was up against: many of his troops had deserted and only 800 remained to "go with me to Mr. Arnold's assistance" in the capture of Quebec, which he considered an important "prize."[37]

Montgomery and his troops had rendezvoused earlier with Arnold on December 1 at Pointe-aux-Trembles on the northern banks of the St. Lawrence, 20 miles southwest of the city. The meeting was propitious—Montgomery, as he had told Livingston, was impressed with Arnold and with his troops, who had marched for six weeks through horrific weather and the uncharted wilderness of northern Maine. He wrote his estimation of Arnold, who he believed "will make an excellent assistant. He is very active, intelligent and enterprising. I think he should have rank given him."[38]

Montgomery's plan of attack, which he devised with Arnold, was different from the one he had described the month before, and was more of a siege strategy than an assault. They eliminated Wolfe's earlier tactic, to meet the enemy on the Plains of Abraham outside the city walls, and instead opted to attack the lower town on the easterly side of the city below the palisades and devised a pincer offensive—Arnold and his troops would approach from

the north and west following a path that paralleled the St. Charles River; while Montgomery and his men would travel a southern route bordering the St. Lawrence. Their plan was to capture the much smaller lower town and mount the palisades with ladders and storm the citadel itself, which involved an "escalade [the use of ladders to mount a fortification], the only mode of attack which can succeed this season and considering our want of Artillery." Montgomery thought such a plan would work and fatefully concluded that "at any rate 'tis worth the experiment—*Asidce Fortuna jouvat* [Fortune favors the bold] is almost an axiom and should we fail I don't see any fatal consequences which are like to attend it."[39]

Governor Carleton was in Montreal when the Americans joined forces outside Quebec. Having learned of their plans he hurried back to the city where he oversaw the assembling of troops, munitions, and provisions for what he imagined could be a long siege. Meanwhile Montgomery and his troops proceeded eastward and bivouacked near St. John's gate, a northwesterly entrance to the city. While encamped, Montgomery sent a public letter to the Quebecois in which he detailed the "confusion, carnage and plunder" that would result if they did not surrender. Such warnings were ignored, and Montgomery got ready for the attack that he and Arnold believed was best carried out under the cover of darkness and preferably during a snowstorm that would further conceal their movements. On New Year's Eve 1775, conditions were perfect, and around 3 a.m. both forces were on the move. The Canadians, however, had put up barricades and wooden pickets, making passage along a narrow and icy defile extremely difficult. The Americans also encountered a blockhouse that they thought deserted but was stationed with British troops who opened fire. In the melee, which was later pictured by an unknown artist (Figure 3.3), the fatally wounded general fell in to a wild embrace of tumbling men and collapsing ladders. Arnold was also gravely injured, and he and his troops were no more successful. Six months later the battle to win Canada to the patriot cause was abandoned.[40] Although the Quebec campaign was a failure, Montgomery in his death became an international hero for the patriot cause. As Justin Smith would report 130 years later, "Not only were encomiums of Burke, Fox, and Barré in the House of Commons anticipated, but it could already be seen that his [Montgomery's] glorious death was to broadcast seeds of heroism, the noble harvest of his blood."[41]

Richard Montgomery: A Necessary Hero

During the fall of 1775, when accounts of Montgomery's success in capturing St. John's and masterminding the capitulation of Montreal were published, Congress and the public had come to expect victory in Canada. The thought

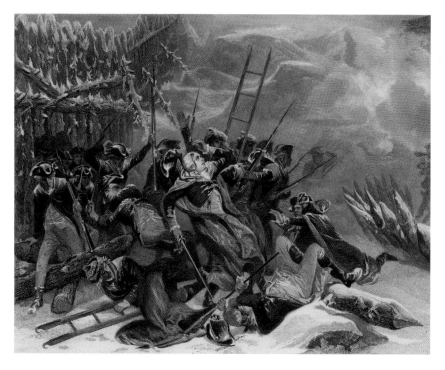

3.3 *The Death of General Montgomery*, steel engraving. Emmet Collection, Miriam and Ira D. Wallach Division of Art, Prints and Photographs, The New York Public Library, Astor, Lennox and Tilden Foundations

being that his victories would provide the patriots needed allies in their petitions to Parliament and inhibit access to the southern colonies by British troops. The unanticipated news of Montgomery's death and the loss of Quebec were met with disbelief and dread, for not only had the patriots lost a hero but fears of invasion from the St. Lawrence were reignited. At the same time, Montgomery was not blamed for the defeat—on the contrary, in his death Montgomery became a potent symbol of the patriots' cause and virtually overnight songs, poems, plays, speeches, and essays eulogized what was deemed his heroic sacrifice.[42]

Representative of the feelings Montgomery's death engendered are the sentiments of his deputy quartermaster, Colonel Donald Campbell, who wrote to the general's brother-in-law, Robert R. Livingston, describing Montgomery's heroism and expressed condolences and the sad necessity he felt in "informing you of the death of my valuable friend and your dear relation, the brave gallant and amiable General Richard Montgomery." He then described Montgomery's efforts and the esteem in which he was held by his troops: "General Richard Montgomery whose excellent talents were such

for the laborious and arduous task of command and conciliating the affections of officers, soldiers and inhabitants of every degree, that few who love the character of the gentleman and soldier would wish to die greater than he fell! In the cause of his country!!" He continued by reassuring Livingston that Montgomery's body had been recovered and treated with respect by Carleton and his men "who have given his corpse a genteel and splendid burial … with the honors of war and the same to the corpse of that lovely youth, his adored aide-de-camp, Capt John Macpherson, who fell by his side in the front rank, whose great abilities is seldom equaled by those of his years!"[43]

Montgomery's chief engineer, Edward Antill, delivered the dispatch written by Lieutenant Colonel Rudolphus Ritzema, one of the leaders of the New York First Regiment to Schuyler in Albany. This letter was reprinted in the *Journal of the Provincial Congress*. In it Ritzema described in detail the combat on December 31 and Montgomery's death, declaiming, "*Weep America* for thou hast lost one of thy most virtuous and bravest sons," a prelude to the tributes to follow.[44] From Albany, Antill continued his journey, arriving in Philadelphia on January 17, where he delivered a full report to Congress of Montgomery's death and the attack that preceded it.

Reactions to Montgomery's death were wide ranging. Besides public eulogies, many prominent Americans penned their regrets: Washington wrote that "America has sustained a heavy loss," while General Nathanael Greene informed General Charles Lee that "We are all in Mourning for the loss of the Brave General Montgomery." Fellow New Yorker, future mayor of the city, and friend of the Livingstons, James Duane, reported, "Every Tongue is loud in celebrating his [Montgomery's] praises, and lamenting his Fate."[45] And Thomas Lynch, a representative from North Carolina, wrote to General Schuyler, Montgomery's commanding officer, a few days later describing the impact his death had on Philadelphians: "Never was any City so universally Struck with grief, as this was on hearing of the Loss of Montgomery. Every lady's Eye was filled with Tears. I happened to have Company at Dinner but none had Inclination for any other Food than sorrow or Resentment."[46] It was Lynch who called for a monument to honor Montgomery.

Congress acted swiftly and voted on January 22 to appoint a committee "to consider of a proper method of paying a just tribute of gratitude to the memory of General Montgomery." They named three members: Benjamin Franklin, William Livingston of New Jersey (Robert's cousin), and William Hopper of North Carolina. The committee did not delay and soon delivered a report that included a flowery description of what was deemed Montgomery's heroic sacrifice. This was the first such call for an intercolonial monument, and in anticipation of the need for others, the committee prescribed that those fallen heroes who later "distinguished themselves in the glorious cause of liberty" should be remembered by the creation of "the most durable monuments [to be] erected to their honor." The first matter of business, though, was paying

tribute to Montgomery, and in response to the committee's recommendations Congress passed the following resolution

> That, to express the veneration of the United Colonies for their late general, Richard Montgomery, and the deep sense they entertain of the many signal and important services of that gallant Officer, who, after a series of successes, amidst the most discouraging difficulties, fell at length in a gallant attack upon Quebec the capital of Canada; and for transmitting to future ages, as examples truly worthy of imitation, his patriotism, conduct, boldness of enterprise, insuperable perseverance, and contempt of danger and death; a monument be procured from Paris, or any other part of France, with an inscription, sacred to his memory, and expressive of his amiable character and heroic achievements: And that the continental treasurers be directed to advance a sum to not exceed £300 sterling, to Dr. Benjamin Franklin (who is desired to see this resolution properly executed) for defraying the expence thereof.[47]

Purely a tribute to Montgomery's heroism, nothing in the congressional order hints at the colonials' fight for liberty or even the conflict with Great Britain, let alone independence. Why then was a monument commissioned so early in the conflict? What did Montgomery's death symbolize? What did Congress deem to be at stake here?

The colonial militias' early victories in Massachusetts and northern New York, and Montgomery's victories in Canada had led colonists to expect that the war would be brief. With Montgomery's death, however, many realized that a long and intractable, and maybe unwinnable, war lay ahead. Was it worthwhile to continue? As it turns out, Montgomery's apotheosis had political implications, coming as it did when members of Congress were, with some reluctance, turning from their desire for the restoration of liberties by the British Parliament to a declaration of independence from the crown. Congress needed a hero for the patriot cause, and soon Montgomery's name and memory would be invoked in the fight for independence.

Rendering a Hero

Testimony to the importance of Montgomery's heroism for the American cause was duly recorded in the nation's first history books. Mercy Otis Warren, one of the earliest of these historians, described the events leading up to his death, details that may have been supplied by Montgomery's widow and gleaned from eyewitness accounts:

> The enemy had gained intelligence of his movements, the alarm had been given, and a signal made for a general engagement in the lower town, some time before Montgomery had reached it. He, however, pushed on through a narrow passage, with a hanging rock on the one side, and a dangerous precipice of the banks of the river on the other, and with a resolution becoming his character, he

gained the first barrier …. But to the regret of the army, the grief of his country, and the inexpressible sorrow of his numerous friends, the valiant Montgomery, with the laurels fresh blooming on his brow, fell at the gates by a random shot from the frozen walls of Quebec.[48]

Likenesses of Montgomery also appeared in the early years of the Republic in the form of engravings that were printed in illustrated books of the nation's revolutionary heroes.[49] For the most part these engravings were based on a portrait done by Charles Willson Peale about 1790 (Figure 3.4).[50] Family legend has it that Peale's miniature was a copy of an original that was sent to Janet Montgomery from Montgomery's relatives in Ireland and later owned by John Ross Delafield of Montgomery Place. Said to predate his entry into the Continental Army, there is an insignia of the United States depicted on Montgomery's sleeve. This makes it suspect. There was no independent United States at the time of Montgomery's death. Instead the reverse may be true—the Delafield portrait may be based on Peale's imagined portrait of Montgomery. In any case, Peale included his portrait of Montgomery as part of his Gallery of Distinguished Persons, which he installed in a purpose-built 60-foot gallery added to his house.[51] His desire to create a pantheon of American heroes was an extension and elaboration of his earlier emblematic portrait of William Pitt and the European tradition of honoring great men.

A second American painter, John Trumbull, also wanted to document the American Revolution and began a series of paintings based on European-style history painting that included *The Death of General Montgomery in the Attack on Quebec, December 31, 1775* (Figure 3.5), a direct tribute to Benjamin West's *The Death of General Wolfe* (Figure 3.6), which furthered the association between the two soldier/heroes.

West's painting had created a sensation when it was exhibited at the Royal Academy in London. The response of the public, fellow artists, and the king himself was due in no small part to the veneration in which Wolfe's memory was held 11 years later.[52] Historically, the painting is credited with charting a new direction in history painting. In the eighteenth century the image of the hero was traditionally represented in classical garb, and hence deemed timeless. In contrast West clothed his hero in contemporary dress and made history painting modern. In *The Death of Generral Wolfe*, the British hero is placed in the center foreground collapsing into the arms of his comrades. It is a solemn moment, a break in the war's action, represented by the respectful and mournful poses of the other officers, soldiers, and a lone Native American. Behind them are the walls of Quebec, its ramparts silhouetted against a storm-cloud sky that is being pushed eastward by lightning symbolic of success in battle, which was confirmed by the arrival of a scout who informs the hero that the French are defeated: Wolfe's last words were said to be, "God be praised. I can die in peace."[53]

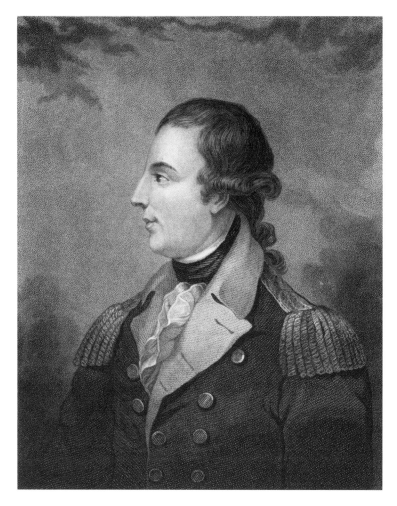

3.4 E. MacKenzie after Charles Willson Peale, *Richard Montgomery*, stipple
engraving, 1880. Emmet Collection, Miriam and Ira D. Wallach Division of Art,
Prints and Photographs, The New York Public Library, Astor, Lennox and Tilden
Foundations

In the 1780s when Trumbull was in his studio, West had thought
to undertake a series of history paintings documenting the American
Revolution, but as painter of historical pictures to George III this was not wise
politically.[54] And unlike Trumbull he did not have the firsthand knowledge
of the Revolution that Trumbull witnessed in Boston first as an adjutant in
the First Connecticut Regiment and later as an aide-de-camp to Washington.
Trumbull had joined the First Regiment soon after news of Lexington and
Concord reached him in his home in Hartford. His regiment reached Boston
in early May and was stationed in Roxbury. "Our first occupation was to

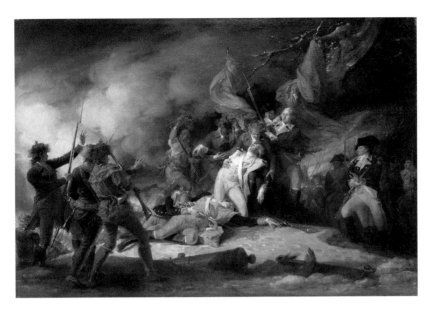

3.5 John Trumbull, *The Death of General Montgomery in the Attack on Quebec, December 31, 1775*, 24 5/8 × 37 in. (62.5 × 94 cm.), oil on canvas, 1786. Yale University Art Gallery, New Haven

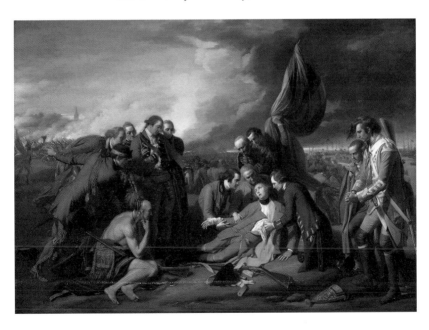

3.6 Benjamin West, *The Death of General Wolfe*, 60 1/8 × 84 1/2 in. (152.6 × 214.5 cm.), oil on canvas, 1770. © National Gallery of Canada, Ottawa, transfer from the Canadian War Memorials, 1921 (Gift of the 2nd Duke of Westminster, England, 1918)

secure our own position, by constructing field-works for defense."[55] It was from there that he witnessed the Battle of Bunker Hill, which he described in some detail in his autobiography: "On the 17th of June, I was out at daybreak, visiting the piquet-guard of the regiment which was posted in full view of Boston and the bay behind it, when I was startled by a gun, firing from a small sloop of war, lying at anchor between the town and Letchmere's point, about where the Cambridgeport bridge is now."[56] He and his regiment followed the fighting all day but they "had no correct information of the result of the battle of Bunker's Hill until late at night."[57] His regiment was soon under attack and they retreated further inland and remained in Roxbury for the duration of the siege. Trumbull's oldest brother was commissary general of the army, and after Washington arrived, he recommended John as someone who could draw. The new commander-in-chief needed "a correct plan of the enemy's works, in front of our position on Boston neck."[58] Trumbull's abilities as a draftsman soon led to a promotion as Washington's second aide-de-camp.[59] He was further promoted to the rank of major of his Connecticut brigade, and in March 1776 participated in the defense of Dorchester Heights, following which he witnessed the evacuation of the British from Boston Harbor. Trumbull soon was sent in a detachment under the command of General John Thomas "to reinforce the army in Canada." This was after Montgomery's death, and Trumbull spent the next 10 months ministering to the troops returning from Quebec, traveling south to help shore up the fortifications at Ticonderoga and build a fleet of boats in anticipation of a naval battle on Lake Champlain. He later wrote in his autobiography: "On the 11th of October the two fleets met, engaged and we were defeated with total loss. Gen. Arnold ran the galley which he commanded on shore, and escaped with the crew; the other vessels were either taken or destroyed, and their crews … remained prisoners of war."[60] In late October, as an adjunct to Horatio Gates, Trumbull left for winter quarters in Albany where they received orders to join Washington in Pennsylvania, but he abruptly resigned his commission in a dispute over the date of his earlier commission as deputy adjutant general.[61] He claimed that he had served "in that office since the 28th of June," and was resentful when he found that his congressional commission was dated the "12th of September, 1776."[62] He wrote an intemperate letter to Congress that was not well received and he learned from a friend that "every member is entirely willing to accord you a commission agreeable to the date you expect, but they are determined to lose even your acknowledged abilities, if they do not receive a different request from that now before them."[63] Trumbull refused to pen a conciliatory request and his resignation stood.

Over the next few years, Trumbull wandered about, living first with his family in Hartford before traveling to Boston to study art. This was a fruitless venture—Smibert was dead, Copley had left for England in 1774, and the city had not yet recovered from the British siege. Frustrated but still determined

to undertake a career as a painter, he found his way to England in 1784 and studied with West. Here, as he states, he began to "mediate seriously," on Revolutionary subjects. His first two were *The Death of General Warren at the Battle of Bunker's Hill, June 17, 1775* and the Montgomery, both chosen, as he stated from the prospect of the 1780s, as "these were the earliest important events in point of time, and I not only regarded them as highly interesting passages of history, but felt that in painting them, I should be paying a just tribute of gratitude to the memory of eminent men, who had given their lives for their country."[64]

No one has questioned Trumbull's choice or order of incidents particularly the first two, which he painted specifically for reproduction, taking both canvases to France to produce engravings that for various reasons were not published until 1792.[65] In 1784 history had not yet decreed who were to be the Revolution's heroes, and Trumbull's choices may have been based on his own experience, first the witnessing of the Battle of Bunker Hill and later his direct knowledge of the Canadian situation, an undertaking that was strongly supported by his father, Jonathan, governor of Connecticut, who had deployed provincial troops to aid Schuyler and Montgomery and closely followed the campaign. Over time Trumbull's father accumulated a great many Revolutionary War documents and he himself planned to write a history of events.[66]

What is striking about Trumbull's design for his painting of Montgomery's death is how similar it is to West's painting. Like Wolfe, the fallen Montgomery, surrounded by fellow officers rendered in various attitudes of shock and despair, is the focus of the composition. But the locale and atmosphere are different.[67] In Trumbull's painting billowing snow-filled gusts enliven the solemn scene, giving it a more melodramatic aspect than West's. This sense of drama is enhanced by three figures on the left who react to the deaths of Montgomery and their two comrades with excited histrionic gestures. Nonetheless, the comparison with West's painting is unmistakable. However, there is an even deeper connection between the two. Both men died heroically in Quebec and in the months that followed his death, Montgomery was called the American Wolfe. This connection is further confirmed by a wood engraving by Norman Thomas in which Wolfe's ghost floats above the fallen body of Montgomery in Quebec (Figure 3.7).[68] It first appeared in 1777 as a frontispiece to Hugh Breckenridge's play *The Death of General Montgomery* and several years later as an illustration for James Murray's Boston edition of *An Impartial History of the War in America between Great Britain and the United States*, the earliest chronicle of the war.[69] In Thomas's print Wolfe's ghost in full military regalia floats in a darkened cloud above Montgomery's prostrate body on the ramparts of Quebec. With his left hand held to his heart and his right in a rhetorical gesture, he addresses the slain hero, linking his sacrifice to the cause of independence and seemingly invokes Breckenridge's play in

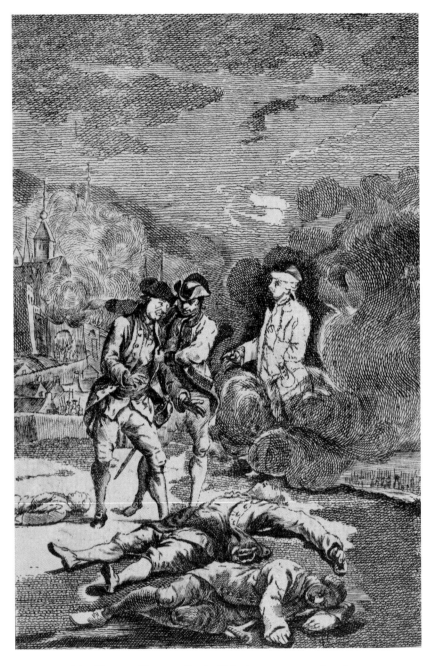

3.7 Norman Thomas, *Death of Montgomery*, engraving, from
Death of General Montgomery by Hugh Henry Brackenridge, 1777.
American Antiquarian Society, Worcester, MA

which Wolfe intones: "Yes, from your death shall amply vegetate, the grand idea of an empire new, clear independence and self-ballanc'd power, in these fair provinces, United States, each independent, yet rein'd in and brac'd, by one great council, buckling them to strength, and lasting firmness of immortal date."[70]

Earlier, Thomas Paine had evoked Wolfe's ghost, not as a spectral witness to Montgomery's death, but as an apparition who appeared in Boston to argue the rightness of the American cause with General Thomas Gage. Paine wrote *A Dialogue between General Wolfe and General Gage in a Wood near Boston* as a mini-drama in which the ghost of Wolfe encounters Gage in a wood and chastises him for the rousting of the colonials. The quarrel Wolfe has with Gage concerns liberty, specifically the right of American colonists to be represented in Parliament. As he argued: "A Briton or an American ceases to be a British subject when he ceases to be governed by rulers chosen or approved of by himself. This is the essence of liberty and of the British constitution."[71] Gage countered by saying that the rebellious citizens of the Massachusetts Bay Colony were not entitled to such rights since they respected neither Parliament, nor the crown, nor their loyal representative, namely himself. Paine was prescient. Even before the Battles of Lexington and Concord, he had laid out the essential areas of disagreement between England and America that would soon result in revolution. His essay also underscores the continued presence of Wolfe who, two decades after his death, continued to be a lodestar of liberty.

Montgomery and the Rhetoric of Independence

In addition to the eulogies, plays, and accolades read and published from 1776 into the early years of the Republic, Montgomery's memory was summoned in the debates surrounding independence, some of which were played out in Philadelphia between Paine and the city's leading divine, William Smith.

Pauline Maier in her book on the Declaration of Independence notes that "throughout 1775 every Congressional petition, address, or declaration insisted that, despite those provocations, the colonists sought a settlement of their difficulties with the Mother Country, not Independence."[72] This statement is confirmed by the patriots' discussions, letters, essays, and declarations. During the early years of the Revolution, they sought justification for their war with Great Britain while simultaneously declaring loyalty to the crown. Such rationalizations were often tortured. In the late summer of 1775, a Virginia newspaper writer acknowledged that the colonists did not seek "total separation from *Britain*," but a "constitutional Independence, founded on the ancient Charters and original contracts of the Colonies …

which would give "a total exemption from Parliamentary Government, under the allegiance of the Crown of England."[73] It was not until Tom Paine's *Common Sense*, published in January 1776, a week before the announcement of Montgomery's death reached Philadelphia, that the colonists and their spokesmen the Second Continental Congress began to publicly debate independence. Congressional debates began to shift from the immediate need for the lifting of the Intolerable Acts to an acknowledgment that the problems with Great Britain were systemic. Parliament would never "admit colonial representatives in proportion to their population," and even if that were to happen there was still the burden of having to travel to England and represent their constituents from afar.[74]

One of the issues they sought to undermine was the separation of powers between Parliament and the king. Since the Glorious Revolution, the crown had been beholden to Parliament for the right to raise taxes and maintain an army, obligations that Parliament in the 1770s wanted the colonists to support. The colonial representatives in turn thought to finesse Parliament and establish an autonomous state that would determine its own governance but would continue to pay allegiance to the king, an idea that confirms how little the colonists knew of the king's disdain of them. There was also justifiable fear among the colonists that independence would bring chaos—who would govern; whose laws would they follow; and would such laws be obeyed? These were the complex issues that Congress was debating in 1776 following Montgomery's death and the defeat of American forces in Quebec.

The immediate cause of these debates was *Common Sense*, a broadside published in Philadelphia by the English-born Paine in January 1776. While still in London he had won Franklin's admiration. Franklin encouraged him to settle in the new world and wrote to his son-in-law Richard Bache to extend Paine every courtesy. When Paine arrived in Philadelphia in December 1774 penniless and deathly ill with malaria, Bache came to his rescue. He did more than house Paine, he helped nurse him back to health and, on his father-in-law's say so, he introduced him to the city's booksellers, editors, and publishers. Paine's ascent was meteoric. He began his American journalistic career writing for Philadelphia's *Pennsylvania Journal*, and two months later the bookseller Robert Aitken invited him to become editor of his *Pennsylvania Magazine*, which by the fall of 1775 had become "the most widely read New World periodical."[75]

By temperament Paine was not a politician but a fervid observer who as a writer had an enviable knack of being able to simplify complex political issues into vernacular prose both accessible and impassioned. As Jefferson noted, "no writer has exceeded Paine in ease and familiarity of style, in perspicuity of expression, happiness of elucidation, and in simple and unassuming language."[76]

Paine wrote *Common Sense* primarily to undermine the loyalty British Americans felt toward George III, a fealty he labeled "an obstinate prejudice."[77] He believed, and rightly so, that this allegiance to the king was the last barrier the colonists needed to surmount before they could accept the idea of independence. He began his essay by challenging the British ideal of checks and balances that was established to ensure that Parliament would keep an eye on the king and vice versa. Acceptance of this myth, in Paine's words, was due to custom and habit, and he noted that at the end of the Glorious Revolution when parliament was afforded equal power with the king, it "only made kings more subtle—not more just."[78] In essence he was challenging the divine right of kings and upended the colonists' romance with the king, declaring that hereditary rule made for bad leaders. He legitimatized the efforts that the colonists had already taken and reminded readers that the principles that the citizens of British America believed were guaranteed following the defeat of the French in 1763 had been abrogated. He further believed that the colonists had the means and the will to best the British regulars in battle. Regarding fears that American trade, dependent as it was on Britain's infrastructure, would suffer, it was Paine's belief that as "eating is the custom of Europe" there would continue to be markets for foodstuffs and raw materials from America.[79]

In the months following the publication of *Common Sense* there were many who took great exception to Paine's call for independence, men who have been called loyal Whigs. They were sympathetic to the patriots' call for the restoration of liberties but opposed to independence. Chief among them was the Reverend William Smith, the leading Anglican minister in North America, who delivered Montgomery's eulogy, "An Oration in Memory of General Montgomery, and the Officers and Soldiers who fell with him, December 31, 1775 before Quebec" in February in Philadelphia's German Reformed Church. Smith was not anyone's first choice to deliver Montgomery's tribute, but as a leading theologian and provost of the Academy of Pennsylvania, his appointment was inevitable. Even Franklin, who had encouraged Smith to settle in Philadelphia in the 1750s, was disenchanted by the minister's anti-Quaker views and his undisguised desire to be appointed an Anglican bishop. Smith can rightfully be called a loyal Whig and was moved to evoke Montgomery's memory as evidence of the rightness of his stance by assuming that Montgomery died loyal to England.

The first half of his oration, cast in a flowery rhetorical manner, was replete with classical allusions to ancient heroes. Smith successfully conjured a virtual Elysian Fields in Philadelphia. It is only halfway through that he spoke of Montgomery personally, and referred somewhat apologetically of the delay: "As to that hero, whose memory you celebrate as a *Proto-Martyr* to your rights—for through whatever fields I have strayed, he has never escaped my view." He continued with the assertion that for Montgomery, like the ancients,

only "the great concerns of virtue, liberty, truth and justice would be tolerable to him."[80] None of this is surprising and is in keeping with the expressed sentiments surrounding Montgomery's death. Smith, however, ultimately commandeered Montgomery's memory for the Tory cause, claiming that Montgomery's "loyalty to his sovereign … remained firm and unshaken."[81] Nor was this an idle assertion, for Smith submitted as evidence a letter written by Montgomery to his superior, General Schuyler, in which he had expressed hope that the "British empire may again become the envy and admiration of the universe, and flourish till the consummation of earthly things."[82] This letter attested, in Smith's mind, to the presumption that Montgomery had not "gone forth in the rage of *conquest*" but in the "spirit of reconciliation."[83] Such a letter in fact existed, and in it Montgomery expressed the same sentiments that he had expressed to his brother-in-law. More to the point, Montgomery's expressions of desire for accommodation were held by a vast majority of colonists in 1775. What his response would have been to Paine's call for independence, regardless of the belief of the great divine, can never truly be known. In any case, Congress was unhappy with Smith's oration and did not support its official publication. Smith's claim that Montgomery would have remained loyal did not go unnoticed by Paine who publicly challenged Smith's assertions in a pamphlet titled *A Dialogue between the Ghost of General Montgomery just arrived from the Elysian Fields; and an American delegate in a wood near Philadelphia*. In it Paine called up Montgomery's ghost along with the names of his two aides and earlier heroes, including Wolfe, all of whom gave their lives for liberty:

> The day in which the colonies declare their independence will be a jubilee to Hampden—Sidney—Russell—Warren—Gardiner—Macpherson—Cheesman, and all the other heroes who have offered themselves as sacrifices upon the altar of liberty. It was no small mortification to me when I fell upon the Plains of Abraham, to reflect that I did not expire like the brave General Wolfe, in the arms of victory. But I now no longer envy him his glory. I would rather die in *attempting* to obtain permanent freedom … than survive a conquest which would serve only to extend the empire of despotism.[84]

The entire pamphlet, like the earlier *Dialogue between Wolfe and Gage*, is structured as a playlet in which Paine concocts a mock exchange between the delegate, who represents the voice of conservative Whigs, and Montgomery, who urges the representative to ignore any "terms of accommodations from the Court of Britain." It is Montgomery's belief that the freeman's cause is just and that a royal "pardon," would be an insult.[85] "To whom is pardoned offered?—to virtuous freemen. For what?—for flying arms in defence of the rights of humanity: And from who do these offers come?—From a ROYAL CRIMINAL." It then occurs to Montgomery that he now has "a new reason for triumphing in my death, for I had rather have it said that I died

by his vengeance, than lived by his mercy." The delegate then challenged Montgomery, asserting that war results in the destruction of communities, to which Montgomery replies that "the calamites of war are transitory …. But the calamities of slavery are extensive and lasting in their operation." The delegate then raised the issue of independence, and Paine, interestingly, has Montgomery respond: "I am for permanent liberty, peace and security, to the American colonies," which he concluded by toppling the Whigs' rationalization that sought to separate the king from the abuses of Parliament: "You complain of the corruption of the parliament, and on the venality of the nation, and yet you forget that the Crown is the source of them both."[86] Unconvinced, the delegate responded by detailing the "evils" that will ensue with independence—"our trade will be ruined from the want of a navy to protect it, each colony will put in its claim for superiority, and we shall have domestic wars without end."[87] From this point on until the end of the playlet, the assertions that Paine had Montgomery voice were nothing but prophetic and ranged from the declaration that "heaven has furnished you with greater resources [that is, lumber] for a navy than any nation in the world," along with the concerns of the delegate that "a Declaration of Independence [and this is two months before Congress convened the committee] [will] lessen the number of our friends, and increase the rage of our enemies in Britain." In response Paine had Montgomery state: "France waits for nothing but a declaration of your independence to revenge the injuries they sustained from Britain in the last war."

Knowing that Paine's essay was a damning riposte to his oration, Smith quickly responded through a series of letters that appeared in March and April under Smith's pseudonym, Cato.[88] Published in the *Pennsylvania Gazette*, he reiterated his claims of Montgomery's loyalty to Great Britain, extending his theses as passionate rejoinders to Paine's "treasonous" *Common Sense*.[89] In his second letter, Smith/Cato argued that "not many weeks yet elapsed since the first open proposition for Independence was published to the world. By what consequences this scheme is supported, or whether by any, may possibly be the subject of future inquiry. Certainly it has no countenance in Congress, to whose sentiments we look with reverence. On the contrary, it is directly repugnant to every declaration of that respectable body."[90] Paine, in turn, published his epistolary rejoinders under the pseudonym of The Forester. These appeared in the *Pennsylvania Journal* in April and May. Paine had little patience with Smith's conservative views and his poor writing. He reminded his readers that Congress refused "to return the *orator* thanks, and [to] request a copy for the press, the motion was rejected from every part of the house and thrown out without a division."[91]

Undeterred, and no doubt supported by other loyalists, Smith continued to restate in another Cato letter his conviction that "the true interest of *America* lies in reconciliation with *Great Britain* upon constitutional principles."[92] For Smith

the problem was with Parliamentary legislation, such as the Intolerable Acts, at the same time he could not support the "erecting [of] separate independent States."[93] Paine decried Smith's reasoning: "Though I am sometimes angry with him for his unprincipled method of writing and reasoning, I cannot help laughing at other times for his want of ingenuity." And in a subsequent letter he argued that "Cato … always endeavors to disgrace what it [he] cannot disprove."[94] In other words Smith's objections to Paine's call for independence were so weak that they could not be engaged.

As Paine articulated in *Common* Sense and his Forester letters, the cause of independence had to be fought on three fronts: on the philosophical one, on the political one, and on the military one. It is a credit to his foresight that he understood the importance of this three-legged stool, for independence to succeed the battle had to be waged in the press, in the halls of government, and on the battlefield. This latter conviction is expressed in his two essays in which the ghosts of two military leaders—Wolfe and Montgomery—are summoned. Their spirits are called forth in defense not just of liberty but of separation from the mother country—from the king and Parliament. Paine, through his employment of the trope of the hero as the defender of liberty, joins its ancient meaning to a contemporary event. While Smith, and his citation of ancient heroes, cannot transcend their traditional meaning. In contrast Paine's Montgomery, although he arrives from the Elysian Fields, is not a mere symbol but represents someone striving to understand the consequences of his sacrifice—that he did not die in vain. Smith treats Montgomery as an abstraction; Paine deems him a modern hero.

Paine uses evocations of both heroes to promote his views on liberty and independence. In his evocation of Wolfe, Paine's focus is on the larger implications of his death on the Plains of Abraham—the recognition of the liberties the colonists enjoyed as British Americans, liberties that were compromised over succeeding decades. Montgomery's death, in turn, symbolized a new generation of Americans determined to regain those liberties.

Benjamin Franklin Enters the Stage

During the spring, while Paine and Smith were dueling out the cause of independence in print, a committee from Congress that included Franklin made its way north to Montreal to assess the wisdom of continuing the Canadian campaign. When they finally met with the remaining troops, the on-the-ground information was discouraging, if not frightening. Canada was not going to join as a fourteenth colony and given the provocation of the American incursion, western New England and New York were even more vulnerable. But as history would prove, all was not lost. Carleton,

himself, mounted an unsuccessful southern assault in the summer of 1776, and London became even more committed to mounting a campaign from the St. Lawrence, which was to be led by General John Burgoyne. With fatal optimism, if not arrogance, Burgoyne believed that he and his troops could easily move southward along the prescribed routes of Lake Champlain and Fort Ticonderoga, taking both forts in anticipation of meeting General William Howe's troops that would be moving northward up the Hudson. Burgoyne, however, was defeated north of Albany and near Saratoga, when his exhausted and depleted troops encountered the militias of New York, Vermont, and Connecticut. Burgoyne's unanticipated surrender delivered an American victory that was a true morale booster for Washington and his troops fighting in southern Pennsylvania. Moreover, it encouraged the French to publicly support the American war effort and to sign the much-longed-for Treaty of Alliance. With the defeat of Burgoyne, British invasion from the north was checked.

But victory lay in the future, in the spring of 1776, and after a month spent traveling to Canada, Franklin returned to Philadelphia and in June received a congressional appointment to begin work with Thomas Jefferson and others on the wording of a declaration of independence. Congress and Franklin were greatly influenced by Paine's *Common Sense*, and on June 7, 1776, Richard Henry Lee of Virginia offered a motion declaring "that these United Colonies are, and of right ought to be free and independent states, that they are absolved from all allegiance to the British Crown, and that all political connection between them and the State of Great Britain is, and ought to be, totally dissolved."[95] All that was left to do was to create a formal document stating the colonials' position along with the particulars of their grievances. On July 4, 1776, Congress formally adopted the Declaration of Independence.

Having done so, Congress and Franklin now had their eyes on France. As far back as the fall of 1775, Franklin had been a member of the Committee of Secret Correspondence that worked quietly behind the scenes to plan how best to secure French financing, munitions, and most important, an alliance that would officially recognize the new nation. Given that in January 1776 Congress specifically stipulated that Montgomery's monument be procured in France by Franklin, it is clear that it was only a matter of time before he would be sailing for Europe.

Once in Paris, Franklin, while working with exceptional diplomatic finesse to secure French recognition of the new nation, attached himself to a community of like-minded individuals—men and women—who formed the most progressive elements of French society including Anne-Catherine de Ligniville, Mme Helvétius, who recommended Jean-Jacques Caffiéri, an artist who had sculpted a bust of her late husband, the well-known philosopher Jean-Claude Adrien Helvétius. During his years in France Franklin's friendships broadened, and he was confirmed in his commitment to the creation of new

social compacts he had fashioned in Philadelphia with the Junto and later the American Philosophical Society, and in London at the Society of Arts. It is through an understanding of Franklin's commitment to community, which included the construction of a symbolic visual culture, that the Montgomery Monument with its emblems of death, regeneration, and liberty can be more fully understood and appreciated. Through Franklin's efforts, the Montgomery Monument, which was originally destined for Philadelphia, found a home in Manhattan, becoming the fourth in a series of New York monuments to liberty's heroes.

Notes

1 Thomas Robinson, "Some Notes on Major-General Richard Montgomery," *New York History* 36 (October 1956): 388.

2 For biographical information on Montgomery, consult Hal T. Shelton, *General Richard Montgomery and the American Revolution: From Redcoat to Rebel* (New York: New York University Press, 1994), and Michael P. Gabriel, *Major General Richard Montgomery: The Making of an American Hero* (Madison, NJ: Fairleigh Dickinson University Press, 2002). In addition see Charles A. Royster, *A Revolutionary People at War: The Continental Army and American Character, 1775–1783* (Chapel Hill: University of North Carolina, 1979), 399–401, n 166, contains an excellent bibliography of earlier resources.

3 Janet Livingston Montgomery recalled their meeting in her "Reminiscences," 74: "I was at Clermont, and the vessel in which his company was grounded, and he and his officers remained with me that day." Her "Reminiscences" were drawn from letters written to her brother Edward in the *Yearbook of the Dutchess County Historical Society* 15 (1930): 45–76.

4 Richard Montgomery (hereafter RM) to John Montgomery, n.d., quoted in Thomas H. Montgomery, "Ancestry of General Richard Montgomery," *New York Genealogical and Biographical Record* 2 (July 1871): 129.

5 Gabriel, *Major General Richard Montgomery*, 53.

6 For an influential discussion on the conduct of the Continental Army and its relationship to patriot ideals, see Royster, *A Revolutionary People at War*.

7 The description of Montgomery's appearance was made by a member of Benedict Arnold's Canadian expedition, Return J. Meigs, who had met Montgomery before his death. His journal is reprinted in Kenneth Roberts, comp. and annot., *March to Quebec: Journals of the Members of Arnold's Expedition* (New York: Doubleday, Doran and Co., 1938), 192.

8 Delafield in "Reminiscences" of Janet Montgomery, 48–9: "After her husband's death, Mrs. Montgomery completed the house at Grasmere and lived there much of the time until a few years after her mother's death. Then about 1804, having built a new house on the bank of the bay in the Hudson River, south of where the Sawkill flows into it, she moved there. This is the mansion house at Barrytown near Annandale, named by her Chateau de Montgomery and since known as Montgomery Place. Here she lived until her death on November sixth, 1832."

9 Robert Middlekauff, *The Glorious Cause: The American Revolution, 1763–1789* (New York: Oxford University Press, 1982; rev. ed., 2005), 243–4.

10 Quoted in Justin H. Smith, *Our Struggle for the Fourteenth Colony: Canada and the American Revolution* (2 vols, New York: G.P. Putnam's Sons, 1907), l: 7.

11 Quoted in Gabriel, *Major General Montgomery*, 71.

12 Still standing, this large comfortable stone house bounded by old oaks and maples with magnificent views of the Hudson is today open to the public.

13 Smith, *Our Struggle for the Fourteenth Colony,* 1: 146, 153.

14 Gabriel, *Major General Montgomery,* 72.

15 Smith, *Our Struggle for the Fourteenth Colony,* 1: 171, 172.

16 Edward Countryman, *A People in Revolution: The American Revolution and Political Society in New York, 1760–1790* (Baltimore: Johns Hopkins University Press, 1981; reprint, New York: W.W. Norton, 1989), 136.

17 RM to Robert R. Livingston (hereafter cited as RRL), June 3, 1775, New York. Bancroft Collection, Robert R. Livingston Papers, 1775 to 1777, vol. 276, New York Public Library (hereafter cited as R.R. Livingston Papers).

18 RM to RRL, June 7, 1775, New York, ibid.

19 George Dangerfield, *Chancellor Robert R. Livingston, 1746–1813* (New York: Harcourt, Brace, 1960), vii.

20 Ibid., 26.

21 Ibid., 55.

22 For information on Montgomery's career as a member of New York's Provincial Congress, see Gabriel, *Major General Montgomery,* 67–82.

23 John Adams to James Warren, June 7, 1775, in Robert J. Taylor, ed. *Papers of John Adams,* (16 vols, Cambridge, MA: Harvard University Press, 1977–), 3: 17–18.

24 Smith, *Our Struggle for the Fourteenth Colony*, 1: 237.

25 Also known as Point Levi or Pointe Lévy.

26 RM to RRL July 1, 1775, New York. R.R. Livingston Papers.

27 RM to RRL August 6, 1775, Albany. Ibid.

28 Smith, *Our Struggle for the Fourteenth Colony*, 1: 317.

29 Ibid., 326.

30 RM to RRL, October 5, 1775, camp near St. John's, R.R. Livingston Papers.

31 RM to RRL, ibid.

32 Reprinted in the Philadelphia *Pennsylvania Evening Post*, November 30, 1775, 1.

33 RM to RRL, Montreal, November 13, 1775, R.R. Livingston Papers.

34 Ibid.

35 Robert Livingston (the Judge) to RM, November 15, 1775, Rhinebeck, NY. Ibid.

36 RM to Robert Livingston (the Judge), December 16, 1775, "Headquarters before Quebec." Ibid.

37 RM to RRL, December 17, 1775, "Headquarters before Quebec." Ibid.

38 Ibid.

39 Ibid.

40 Canadians later memorialized their victory with a shield-shaped plaque placed on the palisade near where Montgomery fell with the inscription: "Here stood the undaunted fifty-safe guarding Canada, defeating Montgomery at the Pres de Ville Barricade on the last day of 1775 Guy Carleton commanding at Quebec."

41 Justin Smith, *Our Struggle for the Fourteenth Colony*, 2: 169–70.

42 A summary of the tributes to Montgomery and an accounting of his celebration as a national hero can be found in Gabriel, *Major General Richard Montgomery*, 173–202.

43 Donald Campbell to RRL, January 12, 1776, "Head Quarters ½ a league from Quebec," R.R. Livingston Papers.

44 *Journals of the Provincial Congress, Provincial Convention, Committee of Safety and Council of Safety of the State of New York, 1775–1777* (2 vols, Albany, 1842), 1: 286.

45 All quotes can be found in Gabriel, *Major General Richard Montgomery*, 174–5.

46 Thomas Lynch to Philip Schuyler, January 20, 1776, in *Letters of Delegates to Congress, 1774–1789.* (26 vols, Washington, D.C.: Library of Congress, 1976–2000), 3: 26.

47 *Journals of the Continental Congress, 1774–1789*, Worthington C. Ford et al., eds (34 vols, Washington, D.C.: Government Printing Office, 1904–1937), 4: 89–90.

48 Mercy Warren, *History of the Rise, Progress and Termination of the American Revolution interpreted with Biographical, Political and Moral Observations* (3 vols, Boston: Manning and Loring for E. Larkin, 1805), 1: 268.

49 The Thomas Addis Emmet Collection at the New York Public Library contains a number of these images.

50 Peale's portrait of Montgomery is listed in his museum catalogues of 1795 and 1813. *An Historical Catalogue of Peale's Collection of Paintings* (Philadelphia: Richard Folwell, 1795), 14, no. L (50) with the entry: "General RICHARD MONTGOMERY was born in Ireland in 1737; being fired with the love of liberty, and in some measure naturalized to America by marriage, he early espoused the republican cause, and took the command of the force destined against Canada; took Montreal in 1775, and was killed storming Quebec, the same year.—A monument was erected to his memory at St. Paul's Church, New-York, by order of Congress—during his short, but glorious career, he conducted with so much prudence, as to make it doubtful whether we *ought to admire most the goodness of the man, or the address of the general*." According to Charles Coleman Sellers, *Portraits and Miniatures by Charles Willson Peale* (Philadelphia: American Philosophical Society, 1952), 144, it was painted between 1785 and 1795.

51 In the 1850s Peale's portrait collection contained 221 images, 155 of which are on view in a re-creation of his museum maintained by the National Park Service in William Strickland's Greek-Revival Second Bank of the United States,

Philadelphia. See Charles Coleman Sellers, *Mr. Peale's Museum: Charles Willson Peale and the First Popular Museum of Natural Science and Art* (New York: W.W. Norton, 1980), 330–31, and Brandon Brame Fortune, "Portraits of Virtue and Genius: Pantheons of Worthies and Public Portraiture in the Early American Republic, 1780-1820" (PhD diss. University of North Carolina, Chapel Hill, 1986), 53–8.

52 See Alan McNairn, *Behold the Hero: General Wolfe and the Arts in the Eighteenth Century* (Liverpool: Liverpool University Press, 1997).

53 Quoted in Helmut Von Erffa and Allen Staley, *The Paintings of Benjamin West* (New Haven: Yale University Press, 1986), 212.

54 Irma B. Jaffe, *John Trumbull, Patriot-Artists of the American Revolution* (Boston: New York Graphic Society, 1975), 187.

55 Theodore Sizer, ed. *The Autobiography of Colonel John Trumbull* (New Haven: Yale University Press, 1953), 18.

56 Ibid., 19.

57 Ibid., 20.

58 Ibid., 22.

59 Ibid., 23.

60 Ibid., 34.

61 Trumbull's views are laid out in detail, see ibid., 36–44.

62 Ibid., 39.

63 Ibid., 43.

64 Ibid., 89.

65 As Trumbull himself noted, "It was intended to publish a series of engravings from these pictures, and therefore a small size was adopted, suited to the use of the engraver." *Catalogue of Paintings by Colonel Trumbull* (New Haven: Yale College, 1835), 4.

66 Jaffe, *John Trumbull*, 79–81.

67 Ibid., 187.

68 Hugh Brackenridge, *The Death of General Montgomery at the Siege of Quebec: with an ode in honour of the Pennsylvania Militia, and the small band of regular Continental Troops, who sustained the Campaign in the depth of winter, January 1777 and repulsed the British forces from the Banks of the Delaware* (Philadelphia: R. Bell, 1777).

69 J. Norman engraved 12 portraits of Revolutionary heroes "to illustrate the Boston edition of Murray's 'An Impartial History of the War of America.'" William Loring Andrews, "Early American Copperplate Engraving." *Book Buyer* 15, no. 6 (January 1898): 656.

70 Brackenridge, *Death of General Montgomery*, 38.

71 Published January 4, 1775, in the *Pennsylvania Journal* and reprinted in Philip S. Foner, ed. *The Complete Writings of Thomas Paine* (2 vols, New York: Citadel Press, 1945), 2: 48.

72 Pauline Maier, *American Scripture: Making the Declaration of Independence* (New York: Vintage Books, 1998), 18.

73 Quoted ibid., 21.

74 Ibid.

75 Craig Nelson, *Thomas Paine Enlightenment, Revolution, and the Birth of Modern Nations* (New York: Viking, 2006), 61.

76 Quoted ibid., 93.

77 Foner, *Paine*, 1: 75.

78 Ibid., 1: 74.

79 Ibid., 1:18.

80 "An oration in memory of General Montgomery, and of the officers and soldiers who fell with him, December 31, 1775, before Quebec; drawn up (and delivered February 19th, 1776) at the desire of the Honourable Continental Congress. By William Smith." (Newcastle, Eng. T. Robson, 1776), 14.

81 Ibid., 20.

82 Ibid.

83 Ibid.

84 Published as a broadside, Philadelphia, March 8, 1776, and reprinted in *Papers of the Delegates to the Continental Congress*, 5: 131.

85 Foner, *Paine,* 2: 88.

86 Ibid., 90.

87 Ibid., 92–3.

88 This was the Roman Republican orator Cato the Younger, whose letters, which argued for personal liberties and freedom from tyranny, were translated, published, and widely distributed in pre-Revolutionary America.

89 "Cato, to the People of Pennsylvania," Letter I (March 8, 1776); Letter II (March 12, 1776); Letter III (March 21, 1776) [published as a pamphlet]; Letter IV (March 27, 1776); Letter V, (March 30, 1776); Letter VI (April 10, 1776); Letter VI (April 11, 1776); Letter VIII, undated, Philadelphia *Pennsylvania Gazette*.

90 Cato, Letter, II (March 12, 1775), ibid.

91 Foner, *Paine*, 2: 69.

92 Cato, Letter II (March 12, 1775), Philadelphia *Pennsylvania Gazette*. Smith repeats this sentiment in Letter III (March 21, 1776) [pamphlet].

93 Cato, Letter III (March 21, 1775).

94 Foner, *Paine,* 2: 69, 73.

95 Quoted in H.W. Brands, *The First American: The Life and Times of Benjamin Franklin* (New York: Doubleday, 2000), 510.

Benjamin Franklin and the Commission of America's First Monument

This book is replete with heroes, not the least of whom is Benjamin Franklin. Even before his leadership in the American Revolution, he was acclaimed internationally by European scientists and intellectuals for his scientific discoveries, his conduct as a natural philosopher, and, later in France, as a revered envoy of liberty. Here, through allegorical prints, he became the personification of America and liberty.[1] His storied life is amply documented, yet two aspects have not received enough attention, both of which pertain to this book's premise: his belief in the need for social, civic, and educational institutions and his contribution to America's early visual culture. Both inform his diligent oversight of the Montgomery Monument from its commission to its welfare during the war and to his urging Congress to find a home for it. If it were not for Franklin, America's first monument would not exist.

For Franklin it was important to promote communitarian ties, which for him took the form of "bonds of cooperation," and these were central to his "politics of improvement," which were "nothing less than shorthand for the civilizing process."[2] To this end Franklin spent his early years in Philadelphia establishing enduring community organizations. He published a local newspaper (the *Philadelphia Gazette,* 1729), founded the city's first library (Library Company of Philadelphia, 1731), its fire company (Union Fire Company, 1736), learned society (American Philosophical Society, 1743), first public academy (later the University of Pennsylvania, 1749–1751), and hospital (Pennsylvania Hospital, 1751).[3] Philadelphia's later commitment to the incorporation of public monuments and parks into the fabric of the community came after Franklin's demise but is ongoing and sustained.[4]

Central to his thinking was the Junto, a group of like-minded friends who met regularly to discuss topics ranging from politics to natural history to the establishment of a library.[5] They began meeting as early as 1727, when Franklin and 11 other Philadelphians met to discuss their mutual interests.[6]

Sixteen years later Franklin would formalize and outline the purpose of the group in a treatise titled *A Proposal for Promoting Useful Knowledge among the British Plantations in America*, which served as the founding document of the American Philosophical Society organized in 1743 and formally incorporated in 1768.[7]

It was Franklin's genius to see the colonies as unique entities with their own necessities for prosperity; each had needs that were different from those in the mother country. He began his 1743 proposal with an overview of the current state of community life in North America, which he believed was past "the first drudgery of settling new colonies."[8] This new phase was notable because there were now "many in every province in circumstances that set them at ease, and afford leisure to cultivate the fine arts and improve the common stock of knowledge ... [and] many observations occur, which if well examined, pursued, and improved might produce discoveries to the advantage of some or all the British plantations, or to the benefit of mankind in general."[9] Vital to the success of such communities were intercolonial and international exchanges among progressive thinkers that expanded the definition of community beyond the geographical limits of one's city or country. In his treaties Franklin went on to list the wide-ranging subjects upon which citizens should correspond:

> all new-discovered plants, herbs, trees, roots, their virtues, uses, &c.; methods of propagating them, ... improvements of vegetable juices, as ciders, wines, &c.; new methods of curing or preventing diseases; all new-discovered fossils in different countries, as mines, minerals, and quarries; new and useful improvements in any branch of mathematics; new discoveries in chemistry, such as improvements in distillation, brewing, and assaying of ores; new mechanical inventions for saving labor, as mills and carriages, and for raising and conveying of water, draining of meadows, &c.; all new arts, trades, and manufactures, that may be proposed or thought of; surveys, maps and charts ... and all philosophical experiments that let light into the nature of things, tend to increase the power of man over matter, and multiply the conveniences or pleasures of life.[10]

Franklin's "Proposal," in some detail, was adopted by London's Society of Arts, and its ambitions also were reflected in the philosophy of Paris's Masonic Lodge of the Nine Sisters, effectively establishing Franklin's communitarian ideals internationally. This international reach is another area that needs to be addressed in any discussion of America's first monument and is one that Franklin took for granted (as did Jefferson), namely the influence of European models on all aspects of colonial and later Republican life. As Frank Sommer noted in his study of the origin of America's Great Seal (on which Franklin worked before he left for France), "much of the study of American art has interpreted its subject as though it exists in a kind of cultural vacuum, without relation to the art of the Continent or Great Britain."[11] This European

background and context must be acknowledged in any study of America's first monument, which included such symbols as a liberty pole and cap and a ribboned band with the Latin phrase *libertas restituta*. Similar elements can also be found in prints, paintings, sculptures, and the decorative arts in England and France throughout the 1760s and 1770s. It was Franklin who, working from and dependent upon these sources, reimagined aristocratic and religious symbols not just for the Montgomery Monument but also in his designs for medals, emblems, devices, and political cartoons: he considered them powerful tools to promote comity and the public good.

At the same time, Franklin was not a connoisseur. Unlike Thomas Jefferson, whose early promotion of the fine arts in America is well known, Franklin's involvement was of a different kind and evidenced through his participation in the construction of a political and symbolic language that was drawn, printed, sculpted, and incised. His employment of a visual idiom in an era of limited literacy began when he was an apprentice in his brother's print shop in Boston. For James Franklin's newspaper the *New-England Courant*, he wrote and published a series of letters under the pseudonym Mrs. Silence Dogood that lampooned the theocratic Cotton Mather. Later in Philadelphia in his role as both printer and postmaster (colonial postmasters, by virtue of newspapers being delivered by post, were the first to know the latest news), Franklin created some of America's earliest political cartoons making a contribution to American visual culture that cannot be overestimated.[12]

Franklin was a born improver, a habit of mind that informed his first political cartoon, "Hercules and the Wagoneer" (Figure 4.1) in 1747. Rendered in the crude style characteristic of early woodcuts, "Hercules and the Wagoneer" is an illustration of the same-titled Aesop's fable. In Franklin's version, a wagoneer kneels in front of a heavily laden horse-drawn wagon beseeching a cloud-borne Hercules to help him get his cart out of a ditch. In the fable, Hercules responds by telling the man to "whip thy horses and set thy shoulder to the wheels."[13] Or in Franklin's words, "God helps him who helps himself." This image, however, was not just an illustration of personal philosophy; it served as the frontispiece of his pamphlet *Plain Truth* (1747), which urged his fellow Pennsylvanians to create their own militia in defense against the French and Indian incursions during King George's War. This cartoon held the convictions that he spent his life clarifying for himself, fellow colonialists, and enlightened Europeans—that colonial independence was not a God-given right but had to be earned, if not battled for.

In the next decade, on the eve of the French and Indian War, Franklin created an image that endures to this day, his famous cut-snake cartoon *Join or Die* (Figure 4.2), which was published along with an article calling for a colonial union to insure mutual defense. Published May 9, 1754, in his *Pennsylvania Gazette*, this plain black-bordered print of a snake cut into eight segments is underlined with the words "Join, or Die." Each segment bears

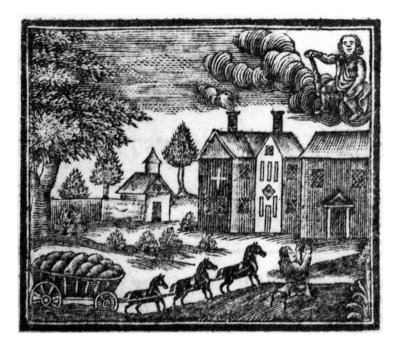

4.1 Benjamin Franklin, *Hercules and the Wagoneer*, woodcut, 1747. Rare Books division, The New York Public Library, Astor, Lenox and Tilden Foundations

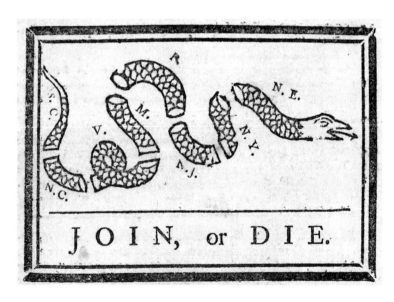

4.2 Benjamin Franklin, *Join, or Die*, woodcut, 1754. Library of Congress, Washington, D.C.

the initials of a colony. It became as Leo Lemay, a Franklin biographer, flatly states, "the first symbol of unification in the American colonies ... [making Franklin] among the most visually conscious writers of eighteenth-century America."[14] Franklin's argument was persuasive enough that the first colonial congress, the Albany Convention of 1754, was held a month later. Here he put forth the Albany Plan of Union, which called for a president general of all the colonies appointed by the king with supervisory responsibility over the activities of a "Grand Council" of representatives from every colony. Although unanimously adopted by the delegates, its provisions fell on deaf ears in colonial assemblies and in London.

As further evidence of Franklin's commitment to appropriating visual language for community service are the devices and mottos he created for the Associator Company (the Pennsylvania militia) including one with the "Figure of Liberty ... holding a Spear with the Cap of Freedom on its Point," common symbols that later appear in abbreviated form on the Montgomery monument.[15]

In addition to his work as a printer, political cartoonist, editor, postmaster, community organizer, Franklin was known internationally as a scientist and inventor, having experimented with electricity and invented the lightening rod, for which he was awarded honorary degrees from Harvard and Yale in 1753.[16] He was also active politically. As representative of Pennsylvania at the Albany Convention, he lobbied for greater financial support for the commonwealth from the Penn family, the English-based proprietors of the colony. To further the colony's interests the Pennsylvania Assembly sent Franklin as their colonial agent to England in the fall of 1757 to plead with Thomas Penn to increase his family's share of land taxes.

Franklin in England, 1757–1762

From all accounts, Franklin's first London trip was a great success. He traveled extensively throughout Great Britain and was warmly received by scientists, natural philosophers, mechanics, and writers, many of whom remained his lifelong friends.[17] He was also successful in securing the Penn family's agreement to contribute their share of property taxes and before returning to Philadelphia in 1762, he received an honorary doctorate from Oxford, and invented the glass harmonica. When he first arrived in London, Franklin was warmly greeted by several prominent men with whom he had corresponded. These included the Quaker merchant and botanist Peter Collinson, who brought Franklin's experiments with electricity to the attention of the Royal Society, and the president of the newly formed Society of Arts, William Shipley, who invited Franklin to become a member.[18] Not to be confused with the Royal Society (a scientific organization) or the Royal Academy (an

association of artists), the Society of Arts (known today as the Royal Society of Arts) offered Franklin the companionship similar to what he had experienced with the Junto and introduced him to "ways of life unfamiliar to America, and understanding of different attitudes, different standards of value, and different levels of intellectual and social activity than any he had known at home."[19]

The Society of Arts, founded in 1757 just prior to Franklin's arrival, was first known as the Society for Encouragement of Arts, Manufacturers and Commerce, and its constitution reflected ideas contained in Franklin's 1743 *A Proposal for Promoting Useful Knowledge among the British Plantations in America*.[20] Primarily its mission was to encourage the quality of the nation's manufactured goods, which would make Great Britain more self-reliant and less dependent on other European nations for high quality domestic wares. Over the next 15 years similar groups were created in North America: the Society for the Promotion of Arts, Agriculture and Economy, New York, 1767; the merging of the American Philosophical Society with the American Society for the Promotion of Useful Knowledge, Philadelphia, 1769; and the similarly titled Virginia Society for the Promotion of Useful Knowledge, Williamsburg, 1772. All of these associations had similar goals—the promotion of commerce, trade, and those useful and polite arts that were deemed essential for the functioning of a well-ordered community.

In London these aims were the seeds of the great manufacturing and trading empire that Britain became in the nineteenth century. In the eighteenth century, however, the British either had to make do with crudely homemade goods or import them from other countries. The society's constitution described in some detail the low state of the crafts in Great Britain and noted that the only type of British pottery then available was "of the very coarsest kind" and even "genteel and opulent families" used tableware "of wood, of pewter, and even of leather." Their linens were "from the looms of Germany and Holland," and their silks from "Italy and France." And "chintz, muslins, and all the other articles of finer fabrics were brought hither from India."[21] This is the preindustrial era that William Morris would later sentimentalize in the nineteenth century. At the dawn of the Industrial Revolution, however, improvements in manufacturing were closely tied to an emerging sense of nationhood, to progress, and to the new mercantile state.

The colonies were key players in this drive to expand England's manufacturing capacity. They supplied raw materials and were ready markets for British products. One of the critical issues that arose during the Stamp Act crisis, a concern shared by both Franklin and William Pitt, was that the colonies posed no threat to the fledgling manufacturers and were important markets for British exports. Both men were frustrated by the shortsightedness of Parliament and the king in the imposition of taxes that they believed in the long run inhibited the vital exchange of goods critical to the economic well-being of the empire.

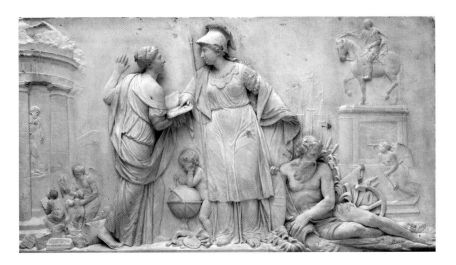

4.3 J.F. Moore, *Britannia, Reviver of Antique and Prompter to Modern Arts*, marble relief, 1766. Royal Society of Arts, London

From the beginning the society had a close relationship with the fine or polite arts, and William Shipley himself was an artist.[22] Among the early members were the painters William Hogarth, Francis Hayman, Joshua Reynolds, and Allan Ramsay, and the sculptors Henry Cheere and Joseph Wilton. Shipley's justification for the inclusion of the polite arts stemmed from his and other members' convictions that "drawing is absolutely necessary in many employments, trades, and manufacturers, and that the encouragement there of may prove to be of great utility to the public."[23] The society's commitment to the polite arts is visually summarized in a carved marble chimneypiece by J.F. Moore titled *Britannia, Reviver of Antique and Promoter to Modern Arts* (Figure 4.3), which he presented to the society in 1766. In it, the personification of Britannia, in a Minerva-like helmet and classical dress, turns to the image of Modern Art, also in antique attire holding an open book. Surrounding them are a panoply of images: a rounded temple, a mother instructing her child (as Britannia seems to do with Modern Art), a genie consulting a globe, a palette and brushes, a river god (the personification of the River Thames) leaning against an anchor and discarded trophies of war. In the upper right-hand corner is an equestrian figure on a high base, not unlike the equestrian of George III that Wilton was then undertaking, below which is an image of fame with her trumpet. Barely visible in the background are masts of tall ships. All of this is suggestive of British trade and its dependence upon tradition, the arts, and education for its future prosperity.

During the decades of the 1750s and 1760s and up to the mid-1770s, Franklin saw the British Empire as a beneficent web in which colonial interests were interdependent and coequal; as the colonies prospered, so did Great Britain and

vice versa. Given Franklin's enthusiasms, intelligence, and general optimism, his later espousal of independence was not through adherence to philosophical or moral principle; rather it was the only way in which his communitarian dream could continue, a dream embodied in Moore's marble relief.

Back home from his first European trip he resumed his duties as joint deputy postmaster general of North America and traveled throughout the northern provinces conducting post office inspections and establishing new postal routes. He was also elected speaker of the Pennsylvania Assembly. He did not remain long in Pennsylvania, however, as problems with the Penn family erupted again. Also, having been defeated for reelection as speaker, he and his supporters thought he could work more effectively on their behalf in London.

Franklin's Second London Stay, 1764–1775

When Franklin returned to London in December 1764, one of the first meetings he had as a colonial agent was with the British prime minister George Grenville, who informed him and his fellow agents that the colonies needed to contribute financially to help meet the debt of the recently concluded French and Indian War. The subsequent Stamp Act crisis altered Franklin's view of the relationship between the American colonies and the British government. Initially he believed that a stamp tax would be an easy burden for the colonists and was surprised by the fervid and violent responses following its passage in March 1764. Over the next 10 months his opinion began to change, not so much in response to the tax burden as to the dawning realization that the relationship between the colonies and Great Britain was not what he had imagined.[24] In point of fact Parliament did not see the Americans as equal citizens—a foreshadowing of the denouement 12 years later. The Stamp Act crisis also challenged his devotion to an international Atlantic community that was founded on his belief in the mutuality of benefits that accrued between Great Britain and America. The articulation of his regret, sorrow, and anger in the destruction of that worldview was expressed in a number of pamphlets and visually took the form of a cartoon titled *MAGNA Britannia: her Colonies REDUC'D* (Figure 4.4). In it a seated, dismembered female, the personification of Great Britain (her severed limbs represent the colonies of Virginia, Pennsylvania, New York, and New England), is propped against a globe of the world. A banner, which crosses the globe and the mutilated figure, bears the inscription: "Date obolum Bellisario" or "give a penny to Belisarius," a reference to the Roman general who "after impoverishing the provinces was in turn made a beggar in old age."[25] For the eighteenth-century reader the message was clear: a similar fate would befall Great Britain if like Belisarius it overtaxed its colonies. Franklin sent a small-size version to friends and

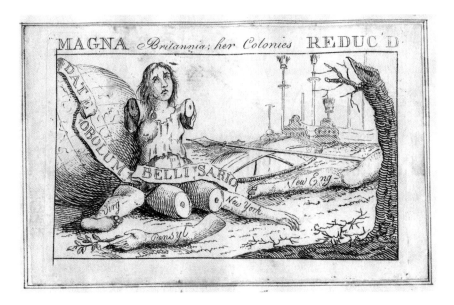

4.4 Benjamin Franklin, *MAGNA Britannia; her Colonies REDUC'D*, ca. 1766. Library Company of Philadelphia

family, explaining to his sister Jane Mecom: "The moral is that the colonies might be ruined, but that Britain would thereby be maimed."[26] Later it was engraved and published in Philadelphia as the frontispiece for a broadside that elaborated on the image and explained its "moral" implications.[27]

Over the next nine years, until his return to America in 1775, Franklin also served as colonial agent for Georgia (1768), New Jersey (1769), and Massachusetts (1770). In addition he found time to travel to France, where he made arrangements for the translation of his works and was formally presented to Louis XV at the court at Versailles. Not content to rest on his laurels, he continued to write essays for newspapers and publish pamphlets, including a history of the problems between Britain and her colonies titled "Causes of the American Discontents Before 1768." He created a phonetic alphabet, and after reviewing the data he had complied on his several transatlantic crossings, published the first map of the Gulf Stream.

Franklin had high status and visibility in London and was widely respected as a reliable spokesman not only for Pennsylvania but for all of the colonies, which made him an easy target for those opposing the extension of colonial liberties. He became especially vulnerable when his participation in the Hutchinson affair, which many in Parliament blamed for the resultant Tea Party rebellion, became public. Thomas Hutchinson, the controversial governor of Massachusetts, had written a number of letters to friends in England in which he reassured them that Boston protests should not be taken seriously and that

harsh punishment would be inflicted on those who opposed the policies of the king and Parliament. Franklin, in ways that are not known, got hold of these letters and sent them to a correspondent in Boston—asking that they not be shared. His avowed purpose was to show by the example of these letters that the truth surrounding colonial protests was being misrepresented. His correspondent, who was close to Samuel Adams and John Hancock, immediately shared the letters, which were then published in the *Boston Gazette* in June 1773 and confirmed the colonists' worst fears. At the end of the year, Bostonians rebelled in flamboyant fashion when in mid-December they dumped three shiploads of tea into the harbor. To say that Franklin was mortified, is not to put too fine a point on it, and he was called before the Privy Council to explain his actions. Here he was subject to humiliating denunciation at the hands of Alexander Wedderburn, England's solicitor general, who considered the Boston Tea Party riots treasonous. Franklin was not vindicated, and any hope that he had as an agent of reconciliation was lost, along with his position as postmaster general of America. At the same time, he liked living in London and stayed on a few more years before returning to Pennsylvania in the spring of 1775. There he was greeted as a hero. Over the next year and a half, Franklin acted as governor of Pennsylvania and served as its representative to the Second Continental Congress. As a delegate he was a member of the Montgomery memorial committee, helped draft the Declaration of Independence, and was one of the early designers of the Great Seal of the United States. His interest in visual language came to the fore with the commission of both the Montgomery Monument and the iconography of the Great Seal.

It was known as early as January 1776 that Franklin, even before the signing of the Declaration of Independence, would be sent to France to seek support for the colonial rebellion. As the most cosmopolitan of the Founding Fathers, Franklin was an obvious choice, but he had another mission as well. Congress, in its order for a memorial to Montgomery, stipulated that Franklin be charged with the commission of the monument and that it be "procured from Paris," a request that tacitly acknowledged that a British sculptor, given the wartime climate, could not be hired. This effectively eliminated Joseph Wilton, who of all European sculptors had the most experience creating American colonial monuments. Nor, it should be added, were there any American- or European-born sculptors in the colonies capable of undertaking such a commission. Given his many years in England and his familiarity with its cityscapes and monuments and his acquaintance with artists and sculptors at the Society of Arts, Franklin was the most qualified American to procure a sculptor. Given their loyalist leanings, the De Lancey family was *hors de combat*. Furthermore Franklin's success as a printer and constructor of civic and political iconography afforded him firsthand knowledge of the power of visual representation.

Franklin in France: Liberty's Hero

When Franklin returned to Europe at the end of 1776, it was not as a representative of colonial Pennsylvania but as an official representative of an emergent nation; his status in France was radically different from his standing in England. He came as an emissary of America, a new nation that needed French recognition and military aid in order to secure its independence from Great Britain. He traveled, however, as he had in England, as an internationally regarded scientist and natural philosopher, and as a writer who could articulate complex issues in everyday prose. He also knew how to have a good time.

He was the flywheel, an important cog in the delicate balancing act of international diplomacy. He knew that he could not appear to the French as a toady, someone who would accede to their demands for the sake of their support. Instead he had to make a legitimate case persuading them, convincing Louis XVI and his prime minister Charles Gravier, comte de Vergennes, that it was in France's best interests to acknowledge America's new status. Franklin proceeded, however, as if America was already a mature state by selling the romance of liberty and the New World. In Paris he was embraced as liberty's hero, and artists vied to capture his likeness, including the preeminent genre painter Jean-Baptiste Greuze, the rococo artist Jean-Honoré Fragonard, and the sculptors Jean-Antoine Houdon and Jean-Jacques Caffiéri. As noted by Charles Coleman Sellers, author of *Benjamin Franklin in Portraiture*, he "had become not only the living symbol of the new Enlightenment but was the official representative of a young and vigorous power, with armies, cities, and vast territories in his control."[28]

Even before Franklin arrived, the American cause was embraced by France's leading intellectuals, including Voltaire, the nascent economists the physiocrats, and Franklin's soon-to-be neighbor Anne-Catharine Helvétius, widow of Claude-Adrien Helvétius, the philosopher and political economist. Mme Helvétius's salon, where scientists and men of letters gathered, was referred to as l'Académie d'Auteuil.[29] In an undated letter to her, Franklin wrote: "I have in my way been trying to form some hypothesis to account for your having so many friends and of such various kinds. I see that statesmen, philosophers, historians, poets, and men of learning attach themselves to you as straws to a fine piece of amber."[30] His admiration of Mme Helvétius extended far beyond the intellectual and the social; his affection was such that the recently widowed Franklin even proposed marriage.[31]

In addition to enjoying himself and the company of Mme Helvétius, Franklin joined the newly established Masonic Lodge of the Nine Sisters that had been Claude Helvétius's dream before his death in 1771. Unlike other Masonic lodges, the Nine Sisters was organized specifically to promote the "arts, sciences and learning." Franklin, who had been a Mason since 1731

and later grand master of the Philadelphia lodge, was eager to join.[32] Voltaire became a member in 1778 and inherited Helvétius's apron, which Franklin was awarded upon Voltaire's death a few months later, becoming for a year the lodge's *Vénérable*, or grand master.[33]

The Lodge of the Nine Sisters, as the name implies was dedicated to the arts and sciences personified by the nine muses, and it operated effectively as an international learned society with a constitution that expanded upon the utilitarian ideals reflected in Philadelphia's American Philosophical Society and London's Society of Arts. As was true of these comparable institutions, lodge members were committed to promoting the arts and sciences as the highest of intellectual pursuits, their hope being that by "restoring them to their place of dignity" the arts and sciences would no longer be the purview of the aristocracy but could once again serve "as the foundation of great civilizations and nations."[34] These sentiments would be in keeping with Franklin's cultural and political ambitious for the new republic of the United States.

One indication of his understanding of the importance of the visual arts is his oversight of two lodge-sponsored exhibitions devoted to the artists Greuze and Houdon, who were at the time creating portraits of the sage of Auteuil: "Greuze showed his recent paintings of French villages and his portraits of eminent Frenchmen, and Houdon exhibited his busts of Franklin, Nicolas Bricaire de La Dixmerie, and other lodge members."[35] This support of the fine arts by the Lodge of the Nine Sisters was undertaken without the official sanction of the academy and its annual salon and was therefore tacit acknowledgment of the importance of the arts for a larger more democratic community. It is also evidence of Franklin's continued commitment to deploying the visual arts for the causes he believed in. It was also during his year's tenure as grand master that Franklin, in violation of Masonic regulations prohibiting political involvements, secured the lodge's support of the American Revolution.

Principally, this is why Franklin had come to France: to seek recognition of a new nation and to obtain funds, material, and men to help the war effort. His success was due in no small part to the fame that preceded him, as did his writings, including his 1757 *The Way to Wealth*, a compendium of the aphorisms published nearly two decades earlier under his pseudonym Poor Richard. Its principles of thrift, individualism, and hard work made it especially appealing to a group of early French economic theorists called the physiocrats, who believed that wealth accrued to nations from the self-sufficiency of independent industrious farmers rather than the impersonal materialism of free trade as advocated by Adam Smith. While Franklin's *Way to Wealth*, with its pious aphorisms, can be a bit trying to read, it was embraced by the physiocrats as an expression of their lofty ideals in words that could be understood by the common man. For them its author was a new Adam. As Jacques Wendel explained in his article on the statesman and economist

Anne Robert Jacques Turgot, "One of the major dilemmas of the eighteenth century was that of reconciling Voltaire with Rousseau, i.e., a reconciliation of reason, enlightenment and progress with a simple, natural and virtuous mode of life. It was not until the arrival of Benjamin Franklin [on his first trip to France] in 1767, that the rest of France came to realize that there was indeed a solution to this dilemma. Because of his intellectual and moral qualities, as well as his statesmanship, Franklin was, in the eyes of France, the living proof of that solution."[36] Nineteenth-century chroniclers of Franklin's years in France put it this way: "What contributed most of all ... to his welcome was the interest taken in his writings on politics, or what we should call social economics. At this moment indeed, the absorbing passion in France was for what they called political and rural economy," the purview of the French physiocrats.[37]

The chief spokesman of this group of physiocrats was Turgot who, although a great Franklin admirer, was against French involvement in the American Revolution for fear that France's entry would bring the fighting to Europe. At the same time he supported America's independency because it held the best "hope of the human race."[38] Or as one of his fellow philosophes put it: "It is perhaps in America that the Human race is to be recreated; that it is to adopt a new and sublime legislation, that it is to perfect the arts and sciences, that it is to recreate the nations of antiquity."[39] Turgot believed that, unlike Rousseau, who held that civilization led to luxury and corruption, Americans had the "ability to build a civilization which would make possible a simple and virtuous life."[40] And for Turgot, Franklin embodied the "reconciliation of reason, enlightenment and progress [Voltaire], with a simple natural and virtuous mode of life [Rousseau]."[41] According to the scholar Durand Echeverria, "America was suddenly the 'hope of the human race,' as Turgot was to say, ... it was to be the first practical construction of the Heavenly City of the *Philosophes*."[42]

Further evidence of France's enthusiasm for Franklin and the cause of liberty — the two were inseparable — is a series of allegorical prints published in 1778 shortly after Louis XVI received Franklin at court, a gesture that signaled France's recognition of the new nation. They also confirm that Franklin had become a new international symbol of liberty. Two of the prints were by Jean-Honoré Fragonard, whose identification with the frivolous dissipation of the French court makes these tributes surprising. The third was by the little-known Antoine Borel. The earliest of the two Fragonards is a drawing reproduced as an aquatint engraved by Jean-Claude Richard de Saint Non titled *Le docteur Franklin couronné par la Liberté* (Figure 4.5).[43] The print is an exalted view of a cloud-filled space in which the genius of Liberty, holding a wreath in each hand, descends from the heavens silhouetted by the rays of a rising sun, which illuminate a large globe that supports Caffiéri's bust of Franklin. The wreaths are to crown the author of Liberty whose bust is

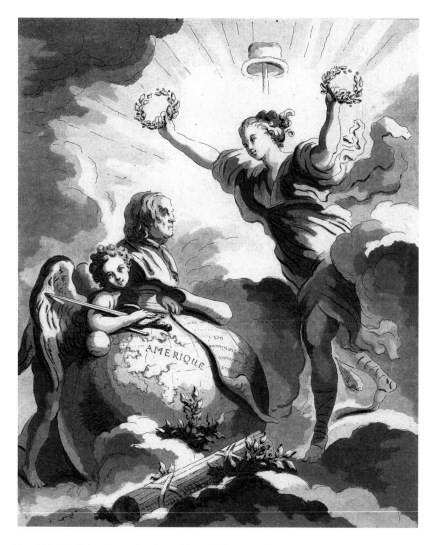

4.5 Abbé de Saint Non, after Jean-Honoré Fragonard, *Le Docteur Franklin Couronné par la Liberté*, aquatint, 1778. American Philosophical Society, Philadelphia

embraced by a young genie, who simultaneously unfurls a scroll that contain the words "Cons.tutions / du Government / de Pensilvanie / Art," referring not to the later U.S. Constitution but to the Pennsylvania Constitution of 1776, which Franklin had drafted shortly after signing the Declaration of Independence.[44]

Fragonard's print is an astonishing summary of two years of international history and vivid recognition of the impact of the American Revolution on French thought in which Franklin is given full honors for his contribution to

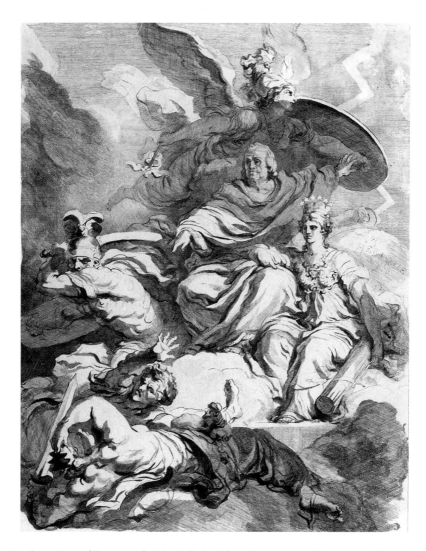

4.6 Jean-Honoré Fragonard, *Eripuit Coelo Fulmen Sceptrum que Tirannis au Génie de Franklin*, 19 × 14 1/2 in. (69 × 48 cm.), etching, 1778. American Philosophical Society, Philadelphia

putting words into action, a contribution that for the French had worldwide significance. "Franklin had done what no French *philosophe* had accomplished; he had transformed theory into practice."[45] Franklin's genius in this regard is the subject of the second of the two Fragonard representations—*Au Génie de Franklin* (Figure 4.6), etched by Marguerite Gérard, Fragonard's daughter-in-law.[46] The print bears a Latin inscription attributed to Turgot, which reads: "Eripuit coelo fulmen, sceptrumque tyrannis" or "He snatched the

thunder from the skies and the scepter from the tyrant." This is a phrase that is energetically illustrated by the cloud-filled print, the center of which is dominated by Franklin, seated on a dais in contrapposto similar to the pose of God in Michelangelo's Sistine Chapel ceiling. Franklin's left arm, extended backward, physically directs the shield of Minerva to protect the personification of America seated below him from the destructive force of lightning. With his other arm he points downward to a fierce sword-wielding Mars who carries out the annihilation of Tyranny and Avarice.[47] This print, unlike the first one, is a generalized allegory of Franklin's potency with little reference to the specifics of warfare between the United States and Great Britain or to the documents of liberty and independence.

The third print, a line engraving by Jean Charles Le Vasseur after a drawing by Antoine Borel, titled *L'Amerique Independante Dédiee au Congres des États unis de l'Amérique* [American Independence decreed by the Congress of the United States] (Figure 4.7) is more didactic.[48] At the same time it fulfills the physiocrats' desire to reconcile reason and virtue. In it Franklin, in the dress of an arcadian shepherd, stands in a sylvan setting surrounded by a variety of personifications and classical deities. He points with his staff in a protective manner to a seated supplicant image of America off to his right. Above her is a statue of Liberty with her requisite pole and cap. Behind them, an image of a sword-bearing Minerva flies to assist, not Mars as in the Fragonard, but Hercules, who with upraised club assaults aggressive images of Avarice and Tyranny. Borel, like Fragonard in his second print, deploys the conventions of traditional allegory, and only in his title does he allude to independence.

The new Enlightenment iconography that these prints share has been under studied, so it is worth noting that details from them can be found on the Montgomery monument and its frame, both of which were created by French artists. The club of Hercules turned downward and the staff with the Phrygian cap from the Borel engraving were included on Caffiéri's monument, and the image of the rising sun and a large globe from *Le docteur Franklin couronné par la Liberté* was included on the 1787 frame of the Montgomery designed by Pierre L'Enfant. Furthermore, as a symbol and defender of liberty, Franklin joined the ranks of Enlightenment heroes and *les grands hommes*, a category established for those men chosen not for their aristocratic standing nor for their churchly eminence but for their contribution as writers, poets, philosophers, playwrights, and artists to a new age.

Jean-Jacques Caffiéri and Monuments to Great Men

The Enlightenment adulation of the public hero was intertwined with the revival of the classical past and there were two studies in particular published in France that served as reference books for artists, sculptors, architects,

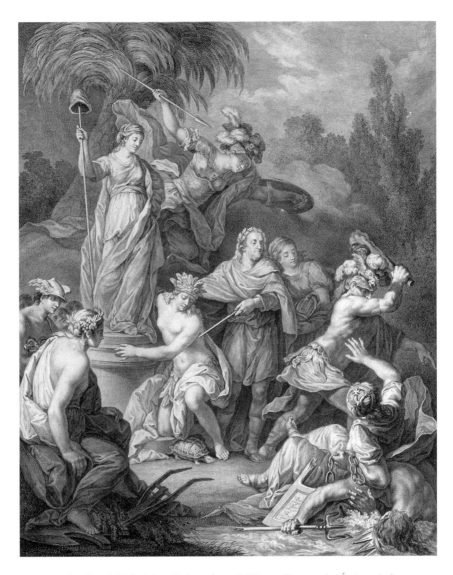

4.7 Antoine Borel, *L'Amérique Independante Dédiee au Congres des États unis de l'Amérique*, 52 × 40 cm., engraving, 1778. American Philosophical Society, Philadelphia

and connoisseurs. Both were multivolumed, the earliest being Bernard de Montfaucon's *Les Monumens de la monarchie Françoise, qui comprennant l'histoire de France, avec les figures de chaque, regni que l'injure des tems a epargnées*, published in 1721, with a five-volume supplement published four years later.[49] The second was Comte Anne Claude de Caylus's profusely illustrated seven-volume *Recueil d'antiquité, égyptiennes, étrusques, grecques et romaines* (*Collection of the ancient arts of Egypt, the Etruscans, Greeks and Romans*) published

at mid-century.[50] Both of these publications were quickly translated into English and published in London.

Montfaucon begins his survey with descriptions and drawings of monuments dedicated to the various Greek and Roman gods, goddesses, heroes, lesser gods, personifications, and other deities. The second volume is devoted to "the priests and ministers of religion among the Greeks and Romans," their temples, altars, feasts, and religious practices. This volume also has sections devoted to the religions of the Egyptians and Ethiopian as well as people in Arabia, Syria, and Persia. The third volume is devoted to daily life of the Greeks and Romans, including dress, housing, furniture, vases, marriage ceremonies, jewelry, baths, theaters, amphitheaters, games, circuses, dancing, hunting, fishing, and the arts. Also as part of this volume are images of the Seven Wonders of the World, while the fourth volume contains sculptures, bas-reliefs, altars, and frescoes that depict warfare including armor and battles, many of which are from Trajan's Column. It is in volume four with a section on "Victory, the Trophies, Triumphs, Crowns and Triumphal Arches and Pillars" that one can begin to see the origins of some of the elements found in the Montgomery Monument. The last volume is concerned with funerary practices and contains representations of urns and sarcophagi, and images of the underworld, and Elysian Fields. All together these volumes represent a veritable rebirth of the classical past that was furthered by the second set of antiquarian studies assembled by Comte Anne Claude de Caylus. Of the two, the Caylus work was more accessible, scientific, and attuned to the contemporary needs of the artist and collector. Along with the sketches of ancient monuments, Caylus also provided a detailed rationale for studying the art of the ancients (Egyptians, Etruscans, Greeks, and Romans). Importantly his illustrated compendium provided eighteenth-century sculptors alternative forms and symbols to those afforded by the church or the monarchy. As such these books could be used as reference without apology by the artists and patrons of the Enlightenment generation, who together created a new iconography of liberty and independence that often accompanied monuments to great men.

France during the time Franklin was in Paris and the Montgomery commission undertaken, witnessed a sea change in the public representation of great men and heroes. not dissimilar to the one experienced in Great Britain. Beginning in the 1760s, both countries witnessed the replacement of sculptures honoring the aristocracy and church dignitaries with sculpted dedications to civil and military leaders. In France these included commissions for sculpture to adorn the new École Royale Militaire, an initiative begun by the Comte d'Angiviller, director of the French Academy, who in the 1770s desired to raise the level of historical art: "For the paintings, he selected subjects from ancient and modern times, but for the statues he selected *grands hommes* exclusively from modern French history."[51] In early 1775 D'Angiviller was authorized

by the king to create a similar series for the Louvre that would include "writer-philosophers and men of the church or state."[52] These calls for statues of great men for the Louvre and for the École Militaire were simultaneous with the privately financed series of sculptures for the Comédie Française, which beginning in 1771, commissioned a series of works for the foyer of its newly built theater on the Place de l'Odéon. (They were later transferred to the theater's current location on the Place du Palais-Royal.) Alison West in her study of French neoclassical sculpture, credits the pavilion of British worthies at Stowe as a particularly important influence for the representations of Frances's *les grands hommes.* She further notes that, Caffiéri was the champion of this project, "producing nine busts (including two terracottas), among which are some of his masterpieces." [53] It was during this period that Caffiéri created tributes to two American *grand hommes*—a bust of Benjamin Franklin and a carved monument honoring the death of General Richard Montgomery.

Caffiéri had come to Franklin's attention through the good offices of Mme Helvétius Caffiéri came with good credentials; he had carved a portrait bust of her late husband (Figure 4.8), was sculptor to the king, and a distinguished member of France's artistic fraternity.[54] Following his introduction, he invited Franklin to sit for a portrait bust (Figure 4.9).[55] During one of these sittings, undertaken in the spring of 1777, Franklin discussed the congressional commission and was impressed enough to hire Caffiéri to create a memorial to Montgomery.[56] By mid-June, the sculptor was far enough along to ask Franklin for Montgomery's date of birth, his military appointment, and details of the battle in Quebec—information that was published in the Salon catalogue.[57]

Caffiéri had come to prominence as a member of a noted family of decorators who were the preeminent bronze founders of the period. They had worked in France since the mid-seventeenth century, creating vases, pedestals, chandeliers, tables, gates, altars, reredos, and busts in bronze for Versailles during the reigns of the various Louis, and for the Marquise de Pompadour, the Prince de Condé, and Madame du Barry, and were hired by the architect Charles Le Brun for the decoration of the Palais du Louvre. Jean-Jacques was thus well acquainted with the requirements of artistic patronage. Beyond the training he received in his father's workshop, he studied with the sculptor Jean-Baptiste Lemoyne. In 1748 he won the Prix de Rome for his sculpture *Cain Killing Abel* and subsequently spent the next five years in Italy. When he returned to Paris he brought a wide range of work which he exhibited at the Salon. In the late 1750s he was made a member of the academy and over the next 30 years "was consistently employed; by the crown for the Invalides ... and most memorably by the Comédie Française for busts of noted French playwrights."[58] He was also of the generation of sculptors who turned from the rococo to a fuller reliance on antique models that gave rise to neoclassicism, a style that would become associated with revolutionary movements.

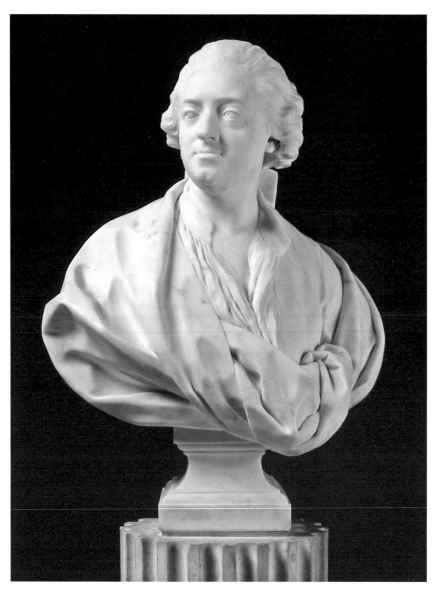

4.8 Jean-Jacques Caffiéri, *Claude-Adrien Helvétius*, 82.5 × 61.2 × 39.9 cm., marble, 1772.
Musée du Louvre, Paris, France, © RMN-Grand Palais/Art Resource, NY.
Photograph by Thierry Le Mage

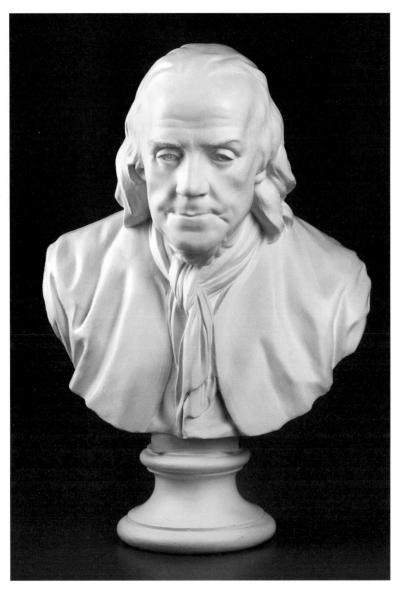

4.9 Jean-Jacques Caffiéri, *Benjamin Franklin*, bust, painted plaster, 1777.
The New-York Historical Society

Compared with the monuments found in Westminster Abbey, the Montgomery Monument is an unpretentious, 10-foot-high, nonfigurative marble wall sculpture (see Figure 5.1 in next chapter). Its principle elements are found on a bracketed mantel—a *trophée d'armes* with carved symbols of war and peace, including a shield, discarded armor, and palm fronds, all of which flank a short central column. The column, in turn, is topped by a stone cinerary urn that backs onto a flat dark obelisk. The only generalized reference to America's rebellion are the two Latin words *libertas restituta* [restore liberty], which Caffiéri carved on a stone ribbon entwined around an upside-down club of Hercules.

When the monument was exhibited in the fall of 1777, Montgomery's name did not appear in the Salon catalogue nor on the monument itself.[59] Nor did it contain any overt references to the Revolutionary War, which at the time was only a little over two years old. It was no doubt thought best not to include these specifics. France had not yet extended recognition to the fledging nation, and, although a perpetual enemy of Great Britain, it did not want to provoke a European war. France also wanted to play it safe, it had no notion, nor did anyone else, which side would win. Franklin, while he thought it important that the monument be exhibited as a reminder of the situation in America, was sensitive to the European ramifications of both the war and America's declaration of independence. So Caffiéri included only oblique allusions to the proximate causes for the Revolution: the yoke of tyranny, the restraint of trade, and the truncation of liberty. However, the monument, when exhibited at the Salon, was located strategically next to his bust of Franklin. The connection between the monument and the American ambassador, one of the most celebrated men in Europe, would be unremarkable to those not familiar with events in America, telling to those who were.

Sadly, later, Caffiéri's relationship with Franklin became bitter. In letters to Franklin's grandson, William Temple Franklin (known as Temple Franklin), who was acting as his grandfather's secretary in Paris, Caffiéri wrote that he was upset because Franklin had promised him further American commissions. He began his complaints in 1785 after Franklin had been replaced by Thomas Jefferson as ambassador, by wrongly assuming that Congress had awarded a commission of an equestrian statue of George Washington to Jean-Antoine Houdon. Acting on misinformation, Caffiéri was enraged at having been passed over and wrote angrily to the younger Franklin.[60] In reply he was told that no such commission had been given to Houdon from Congress, which at the time was factually true. The reality was that Jefferson and Franklin very much hoped that Houdon would be awarded this plum, and Franklin accompanied Houdon to the United States where Houdon was going for the express purpose of studying Washington from life for the creation of an equestrian as well as a standing marble of the president for the Richmond State House.[61] Caffiéri did not give up and over the years correspondence between

him and the Franklins became increasingly presumptuous on Caffiéri's part, and terse and noncommittal on the part of Franklin and his grandson. In essence Caffiéri became his own worst enemy.

A Monument for America

European monuments of the eighteenth century are many, their scale impressive, and the philosophic commitment to memorializing either the British worthies or the *les grands hommes* was pervasive. It was not the case on the other side of the Atlantic, which in the eighteenth century, certainly by Continental standards, was aesthetically barren. It was not until the second half of the century that the beginnings of this practice emerged, not in Philadelphia or Boston—the American cities most often associated with the flowering of colonial and early Republican visual culture—but in New York, the site of the country's first monuments in emulation of this Enlightenment tradition. One of the ways in which Caffiéri's monument to the memory of Richard Montgomery is connected to the Wilton statues for New York is that all were created within the context of this new international ideal—the commemoration of the great man or hero.

The man responsible for introducing the tradition of *grand homme* to America was Franklin, whose conscientious oversight of the Montgomery Monument was responsible for its survival and eventual placement in New York City. It was also a succinct manifestation of his commitment to Enlightenment ideals and the trappings of community. The new nation had a flag to declare its independence and a seal to certify its international agreements; its first monument signaled its ideals. In the midst of diplomatic chaos in France that extended over several years from his early negotiations with Vergennes to secure recognition of the United States, to the laborious and lengthy debates around the terms of the peace treaty, Franklin never lost sight of his responsibility in securing the monument for the new nation, an obligation that began in 1776 and did not end until the 1787, when the monument was finally housed in New York. Franklin also took command of the monument's narrative that conflates the slain hero's sacrifice with the restoration of liberty. He was able to control its meaning since he was responsible for its commission, chose the artist, and worked with him on its design and import. It can be assumed that Franklin gladly relinquished control of the monument, through congressional action, to New York. It was not foreseen that once it was placed in the city, the monument's narrative would be expanded by the architect Pierre-Charles L'Enfant. Hired to install it, he created a painted frame, the design of which referenced the epochal events that had taken place during the intervening 11 years: the Declaration of Independence, victory over the British, and the establishment of a new democratic nation.

Ultimately, the Montgomery Monument, originally commissioned to honor the fight and sacrifice for the restoration of liberty, upon its installation in a small Manhattan chapel morphed into the celebration of independence and the worldwide recognition of a federated government.

From the time of its commission in early 1776 until its installation in New York, the nation's first capital, in 1787, the country had declared independence, and against all odds, had defeated the British. Soon the United States Constitution would be ratified, and George Washington would be sworn in as president on the balcony at New York's City Hall. Yet the city was not destined to remain the capital; in a few years it was moved to Philadelphia and later Washington, D.C. Left behind was the Montgomery Monument, which had begun as a memorial to a dead hero and then transformed into a monument to liberty and independence. Today these early associations are largely forgotten, yet the Montgomery Monument remains an important reminder of those few short years when New York served as the first capital of a fledgling nation and hosted its celebration of the country's victories and future promise.

Notes

1 According to Durand Echeverria, in France "it had become the fashion to have an engraving of the sage over one's mantelpiece, and the prints published of Franklin were practically numberless. There were canes and hats à la Franklin, and his likeness appeared on medallions, snuff boxes, rings, watches, vases, clocks, dishes, handkerchiefs, and even pocketknives. Many hours of the summer of 1777 he was forced to spend sitting for portraits." See *Mirage in the West: A History of the French Image of American Society to 1815* (Princeton: Princeton University Press, 1957), 46.

2 Alan Houston, *Benjamin Franklin and the Politics of Improvement* (New Haven: Yale University Press, 2008), 13.

3 In addition, Franklin, who only had two years of formal education, assembled a library of over 4,000 books that included volumes in French, Italian, Latin, Spanish, and German.

4 With its statuary, historic buildings, recreational areas, and graceful plantings, Fairmont Park evolved from the city's desire to preserve its water supply to today's 9,200-acre park and it typifies Franklin's community ideal.

5 As Bruce Yenawine described it, the Junto was "a fraternity or academy of Philadelphia artificers [or artisans] who could help each other as they improved the quality of urban life ... [They] utilized volunteer organizations, new scientific inventions, and improved management systems to promote health care, roads, fire protection, insurance, education, law enforcement, and sanitation for the people of Philadelphia." Bruce H. Yenawine, "Benjamin Franklin's Legacy of Virtue: The Franklin Trusts of Boston and Philadelphia," PhD diss. Syracuse University, 1993, 20.

6 The early years of the Junto were contemporaneous with Bishop Berkeley's short-lived fraternity in Newport. See Edwin S. Gaustad, *George Berkeley in America* (New Haven: Yale University Press, 1979), 17.

7 See Peter Stephen Du Ponceau, *An Historical Account of the Origin and Formation of the American Philosophical Society* (Philadelphia: American Philosophical Society, 1914).

8 Leonard W. Labaree, et al., eds. *The Papers of Benjamin Franklin* (40 vols, New Haven: Yale University Press, 1959–) 2: 378a. Hereafter cited as *PBF*.

9 Ibid.

10 Ibid.

11 Frank H. Sommer, "Emblem and Device: The Origin of the Great Seal of the United States," *Art Quarterly* 24 (Spring 1961): 57.

12 Franklin's desire to link visual culture with communitarian goals is central to Lester G. Olson's thesis articulated in *Benjamin Franklin's Vision of American Community: A Study in Rhetorical Iconology* (Columbia: University of South Carolina, 2004).

13 J.A. Leo Lemay, "The American Aesthetic of Franklin's Visual Creations," *The Pennsylvania Magazine of History and Biography* 3 (October 1987): 469.

14 Ibid., 477.

15 Ibid., 496.

16 See Walter Crosby Eells, "Benjamin Franklin's Honorary Degrees," *College and University* (Fall 1961): 5–26.

17 Leonard W. Labaree, "Benjamin Franklin's British Friendships," *Proceedings of the American Philosophical Society*, 108, no. 5 (October 1964): 423–8.

18 D.G.C. Allan, "'Dear and Serviceable to Each Other': Benjamin Franklin and the Royal Society of Arts," ibid., 144 (September 2000): 246 and 248.

19 Labaree, "Benjamin Franklin's British Friendships," 428.

20 Franklin's paper was read at an early meeting of the society in June 1755. Allan, "Dear and Serviceable to Each Other," 248.

21 D.G.C. Allan, *The Houses of the Royal Society of Arts: A History and a Guide* (2nd rev. ed, London: Royal Society of Arts, 1974), 6.

22 According to D.G.C. Allan, *William Shipley Founder of the Royal Society of Arts: A Biography with Documents* (London: Hutchinson, 1968), 76: "During the period of Shipley's active association with the Society, rewarding the 'polite arts' grew to be one of its principal activities."

23 S.T. Davenport, "A Glance at the Past and Present of the Society of Arts, with some suggestions as to the Future." Appendix 1c in D.G.C. Allan, *RSA: A Chronological History of the Royal Society for the Encouragement of Arts, Manufactures and Commerce* (London: Royal Society of Arts, 1999?).

24 According to Verner W. Crane, *Benjamin Franklin and the Stamp Act*, in *Transactions of the Colonial Society of Massachusetts* 32 (February 1934): 56, "the Stamp Act controversy had a decisive influence upon his formulation of theories of empire and of American rights."

25 The Belisarius legend was current in the eighteenth century, making its appearance in an early painting by Benjamin West, ca. 1758–1759, done before his departure for Europe. It was a copy of Salvator Rosa's *Belisarius*, which appeared as an engraving and was called, "a seminally influential image." See Helmut von Erffa and Allen Staley, *The Paintings of Benjamin West* (New Haven: Yale University Press, 1986): 448. John Trumbull also copied Rosa's *Belisarius* for his 1778 or 1779 painting of the same name (Hartford: Wadsworth Atheneum). The best-known version is by Jacques-Louis David, *Belisarius Receiving Alms* of 1781 (Musée des Beaux-Arts, Lille France).

26 Benjamin Franklin, London, to Jane Mecom, Boston, March 1, 1766, *PBF* 13: 187.

27 Olson, *Benjamin Franklin*, 77–111, includes a detailed discussion of this print.

28 Charles Coleman Sellers, *Benjamin Franklin in Portraiture* (New Haven: Yale University Press, 1962), 47.

29 It was called l'Académie d'Auteuil by Claude-Anne Lopez, *Mon Cher Papa, Franklin and the Ladies of Paris* (New Haven: Yale University Press, 1966), 273.

30 Ibid., 251.

31 For a description of Franklin's infatuation with Mme Helvétius and his marriage proposal see Stacy Schiff, *A Great Improvisation: Franklin, France, and the Birth of America* (New York: Henry Holt, 2005), 230–36.

32 Echeverria, *Mirage in the West*, 57.

33 Lopez, *Mon Cher Papa*, 249.

34 Quoted in William R. Weisberger, "Parisian Masonry, the Lodge of the Nine Sisters, and the French Enlightenment," *Heredom: The Transactions of the Scottish Rite Research Society* 10 (2002): 169.

35 Ibid., 175.

36 Jacques M. Wendel, "Turgot and the American Revolution," *Modern Age* (Summer 1979), 286.

37 Edward E. Hale, and Edward F. Hale Jr., *Franklin in France* (2 vols, Boston: Roberts Brothers, 1888), 1: 6.

38 Wendel, "Turgot and the American Revolution," 284.

39 Quoted ibid.

40 Ibid., 286.

41 Ibid.

42 Echeverria, *Mirage in the West*, 3.

43 According to Sellers, *Benjamin Franklin in Portraiture*, 284, the Saint Non aquatint was based on a 1778 sepia and pencil drawing by Jean-Honoré Fragonard now lost. The artist is also known as abbé de Saint Non.

44 According to Echeverria, *Mirage in the West*, 18: "In the first half of the eighteenth century Pennsylvania became established in the minds of French liberals as a land where *bienfaisance*, the spirit of benevolence and humanitarianism reigned as an operative political principle."

45 Ibid., 48.

46 Sellers, *Benjamin Franklin in Portraiture*, 287: "Publication of the [Fragonard] print was announced in the *Journal de Paris* of Nov. 15, 1778."

47 See Pierre Rosenberg, "Franklin and Fragonard," *Proceedings of the American Philosophical Society* 150, no. 4 (December 2006): 575–90, and Mary D. Sheriff, "'Au Génie de Franklin': An Allegory by J.-H. Fragonard," ibid., 127, no. 3 (June 1983): 180–93. It is not clear why Fragonard chose to create these two allegorical portraits. At the same time the authorship of the drawings for both prints is controversial. Rosenberg, himself, quotes Saint-Non's biographer as stating that the Abbé created the printed image as a demonstration for Franklin, the American scientist/inventor, of the new aquatint process and on the basis of a lost sketch signed by Fragonard states that it was the basis for Saint-Non's print, yet there is no mention of how or why Saint-Non would engrave Fragonard's print under these circumstances. As far as is known, Fragonard was apolitical and according to Rosenberg, very little is known about the artist personally, since "he left nothing in writing" and "was rarely mentioned by his contemporaries."

48 Sellers, *Benjamin Franklin in Portraiture*, 195, "The *Journal de Paris* on the next day [May 31, 1778] printed a full description of [Borel's] design and announced that subscriptions would be taken for the finished work until August 20."

49 Bernard de Montfaucon, *Les Monumens de la monarchie françoise, qui comprennant l'histoire de France, avec les figures de chaque, régnie que l'injure des tems à épargnée*, (5 vols, Paris: F. Delaulne, 1722) and translated by David Humphreys as *Antiquity Explained and represented in sculptures* (5 vols, London: J. Tonson and J. Watts, 1725). Montfaucon, *Supplement au livre de L'antiquité expliquée …* (5 vols, Paris: F. Delaulne, 1724), translated by David Humphreys as *The Supplement to Antiquity explained, and Represented in Sculptures* (5 vols, London: J. Tonson and J. Watts, 1725).

50 Anne Claude Philippe Caylus, *Recueil d'antiquités, égyptiennes, étrusques, grecques et romaines* (7 vols, Paris: Desaint et Saillant, 1756–1767).

51 Francis H. Dowley, "D'Angiviller's *Grands Hommes* and the Significant Moment," *Art Bulletin* 39, no. 4 (December 1957): 259.

52 James Draper and Guilhem Scherf, *Augustin Pajou, Royal Sculptor, 1730–1809* (New York: Metropolitan Museum of Art, 1998), 301.

53 Alison West, *From Pigalle to Préault: Neoclassicism and the Sublime in French Sculpture, 1760–1840* (Cambridge and New York: Cambridge University Press, 1998), 8.

54 Ibid., 198, "Earlier, Caffiéri had made a striking and romantically conceived bust of Claude Adrien Helvétius, and it is possible that his widow, now Franklin's friend and neighbor, may have been one of the friends who urged him to sit for this portrait." Sellers further notes that "Houdon was not admitted [to the Royal Academy] until July 26, 1777, one obvious reason why he had not been recommended to Franklin at the outset." 118.

55 Caffiéri to Franklin, March 26, 1777: "M. Caffieri a l'honneur de soiter [souhaiter] le bonjoure a Monsieur Franklin et Le pris de lui faire dire quell jour il voudra bien lui donné, pour La derniere séance." [Mr. Caffiéri sends best wishes to Mr. Franklin and wants to ask what day he would be able to give him for the last session.] *PBF*, 23: 522. According to Sellers, *Benjamin Franklin in Portraiture*, 199:

"In 1792 the revolutionary authorities sent the [terra cotta] bust to the Hôtel de Nesle and then, in 1796, to the Bibliothèque Mazarine, where it has remained every since." Caffiéri's bust of Franklin was often replicated and sometimes misidentified as by Houdon or by Giuseppe Ceracchi, an Italian sculptor working in Philadelphia in the early nineteenth century.

56 Cited in Sellers, *Benjamin Franklin in Portraiture*, 117 n 47: "On April 7, 1777, Franklin confirmed the commission of the Montgomery Monument by a first payment to him [Caffiéri]."

57 Caffiéri to Franklin, June 13, 1777, *PBF*, 6: 63. "J'ai demandé à Monsieur votre fils [sic] les Noms, Surnoms et qualities du Général Montgomery, le Lieu et la Datte de sa naissance, en quell temps il a passé à Boston, les grades par lesquels il a passé et les plus belles actions de sa vie, comment il a attaqué Quebec, en quell lieu, il a été tué les dates surtout de sa mort et son âge et ses armes, cela me très nécessaire; comme je compte mettre un dessein du tombeau au Salon prochain, je ferai une description du tombe et de la personne pour laquelle on le fait faire, vous m'obligerez beaucoup de m'envoyer ces remarques le plus promptement qu'il vous sera possible."

["I have asked your son (grandson) for General Montgomery's surname, the place and date of his birth, and the period of time he spent in Boston (New York), the ranks he reached and the outstanding aspects of his life, how he attacked Quebec, and where was he killed, above all the dates of his death and his age and his weapons, all of which is very necessary for me; since I am counting on placing a design for the tomb in the next Salon, I need to create a description of the tomb."]

58 Wend Graf Kalnein and Michael Levey, *Art and Architecture of the Eighteenth Century in France* (Baltimore: Penguin Books, 1972), 99.

59 The Montgomery Monument was number 219 in the Salon catalogue of 1777 and included the following description: "Sur un retable soutenu par deux consoles s'élève une colonne tronquée sur laquelle est posée une urne cinéraire. D'un côté de la colonne est un trophée militaire accompagné d'une branche de cypress; de l'autre sont les attributes de la Liberté, groupés avec une branche de palmier. Derrière la colonne s'élève une pyramide. Sous le retablee entre les deux consoles, est un cartel et une table me marbre blanc pour l'inscription." ["On an altar supported by two brackets rises a truncated column on which is placed a cinerary urn. On one side of the column is a military trophy accompanied by a branch of cypress; on the other side are the attributes of Liberty, grouped with a palm branch. Behind the column arises a pyramid. Beneath the altar, between the two brackets, is a white marble plaque for the inscription."] Along with the Montgomery monument, Caffiéri also exhibited marble busts of Franklin, the dramatist Pierre Corneille, and Louis Nicolas, a marechal of France.

60 Caffiéri to William Temple Franklin, February 19, 1785, *PBF*, 37: 533.

61 For a detailed account of the proposed Houdon commission for an equestrian Washington, see Charles Henry Hart and Edward Biddle, *Memoirs of the Life and Works of Jean Antoine Houdon the Sculptor of Voltaire and of Washington* (Philadelphia: privately printed, 1911), 182–225; and Guilhem Scherf, "Houdon 'Above all Modern Artists,'" in Anne L. Poulet, *Jean-Antoine Houdon, Sculptor of the Enlightenment* (Washington, D.C.: National Gallery of Art, 2003), 16–27.

New York, Pierre-Charles L'Enfant, and a Monument for America

In comparison to the elaborate memorials found inside Westminster Abbey, Jean-Jacques Caffiéri's Montgomery Monument in New York's St. Paul's Chapel is a modest nonfigurative wall sculpture found outside on the chapel's porch (Figure 5.1). Its principal components, which rest on a high podium in front of a tall Palladian window, are a truncated column with an urn on top placed before a flat, dark marble pyramid. Surrounding the column's base are carvings of armor, shields, arrows, palm fronds, and cypress branches, which collectively allude to the death of a hero. Caught among these symbols of war and mortality are references to liberty—a liberty pole and cap, a downward club of Hercules and the Latin words *libertas restituta*.

Confirmation of this description is found within the precisely written instructions for the monument's reassembly and installation that accompanied the sculpture's original shipment.[1] This document, preserved in the papers of the Continental Congress, was probably written by Caffiéri and no doubt studied by Pierre-Charles L'Enfant who was hired by the vestrymen of Trinity Church to install the monument in its parish church, St. Paul's Chapel.

> This monument is ten feet high and five wide, an entablature supported by two brackets of blue Turkish marble, a column of marble atop of which is an Urn of Italian Griotte [marble with red and brown spots] on the side of the column is a military trophy with a branch of Cypress—on the other side is a club which has a broken yoke: *Libertas restituta* is wrote on the club—the cap of Liberty is grouped with a branch of palm— those two trophies are of white marble— behind the column raises a pyramid of marble of St. Anne [a deep blue black marble]. Under the Entablature, between the two brackets is a cartel of lead gild and under it a table of white marble for the inscription—the ground of the whole is black marble.[2]

The objects referred to in the description—a marble column, an urn, discarded armor, "a branch of Cypress," a down turned club, a broken oxen yoke, the

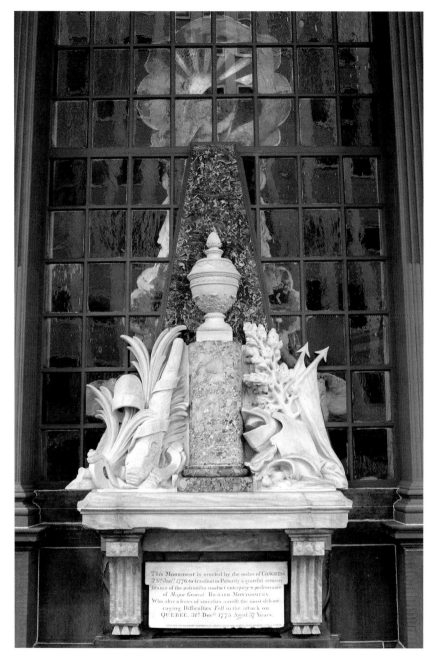

5.1 Jean-Jacques Caffiéri, *General Richard Montgomery Monument*, 120 × 60 in.
(304.8 × 152.4 cm.), marble, 1777. St. Paul's Chapel, New York,
Courtesy of Leah Reddy/Trinity Wall Street

words *libertas restituta*, a Phrygian cap atop a liberty pole, and palm leaves—represent several tropes: war, death, tyranny, liberty, and victory. For the patriots in early 1776 these symbols were emblematic of broader concerns—both fearful and hopeful—that Montgomery's death engendered. What the monument did not contain was any reference to independence. In early 1777, at the time Franklin commissioned the Montgomery Monument, the Declaration of Independence was less than a year old, and its significance internationally was not fully understood. Instead the immediate causes of the Revolution, the yoke of tyranny, the restraint of trade, and the truncation of liberty, were the issues alluded to in the Montgomery monument. At the same time Franklin's participation in the commission of the sculpture and the juxtaposition of images of oppression and exhortation for the restoration of liberty contributed to the monument's subtle revolutionary import. Their significance, however, marked a transitional moment; for soon the rebels' concerns over their loss of liberties would be overshadowed by the establishment of a new, self-governing nation.

The Montgomery Monument was originally destined for Philadelphia's State House, but the nation was at war and its shipment from Paris was delayed. In fact it would take 10 years before the monument was finally installed, not in Philadelphia as planned, but in New York. The monument's journey starts in France, when, shortly after its exhibition at the Salon of 1777, Franklin confirmed in a letter to the United States Senate Committee of Foreign Affairs that "the monument for General Montgomery is finished and gone to Le Havre, in nine cases, to lie for a conveyance. It is plain but elegant, being done by one of the best artists here, who complains that the three hundred guineas allowed him is too little; and we are obliged to pay the additional charges of package, etc."[3] But shipment across the Atlantic was risky, and it was not until Franklin was able to find a shipowner in England sympathetic to the patriots' cause that the monument began its journey westward: "We have had a marble monument made at Paris for the brave General Montgomery, which is gone to America. If it should fall into the hands of any of your cruisers, I expect you will exert yourself to get it restored to us."[4] But there was another problem—American ports were blockaded, and the monument could not be delivered to Philadelphia where Congress was sitting. Instead it was shipped to Edenton, North Carolina, one of the few American ports still open. Here it was stored for the duration of the war; its welfare overseen by Joseph Hewes, a successful merchant, shipowner, signer of the Declaration of Independence, and confidant of Franklin's.

Over the next several years Franklin continued to express his concern for the monument's fate. In October 1779, he wrote to John Jay, president of the Continental Congress, inquiring about its future placement, but no action was taken. Two years went by, and once again Franklin asked about the monument's status this time of Robert R. Livingston, secretary of foreign

affairs and brother-in-law of the slain hero. Franklin began by reminding Livingston of the monument and a need to find a home for it. He expressed his concerns in the context of a longer communication, which included mention of their mutual interest in having a medal struck "to perpetuate the Memory of Yorktown and Saratoga Victories" that would be affixed to an obelisk or column.[5] Franklin also mentioned that Caffiéri's instructions for installing the Montgomery Monument were included in the shipment and enclosed a print of which was engraved by Augustin de Saint-Aubin (Figure 5.2). Printed in 1779, it bears an inscription different from the one on the monument, which, according to Franklin, "was surely the Fancy of the Engraver."

> This puts me in mind of a Monument I got made here and sent to America by order of Congress 5 Years since. I have heard of its Arrival and nothing more. It was admired here [Paris] for its Simplicity of Design, and the various beautiful Marbles used in its Composition. It was intended to be fix'd against a Wall in the State house at Philadelphia. I know not why it has been so long neglected. It would me thinks, be well to inquire after it, and get it put up somewhere. Directions for fixing it were sent with it, and put some where. I enclose a Print of it. The Inscription on the Engraving is not on the monument: It was surely the Fancy of the Engraver. There is a white Plate of Marble left smooth to receive such Inscription as the Congress should think proper.[6]

There is no known record of Livingston's reply, which might shed light on his knowledge of the monument. One of the more puzzling aspects of the monument's history is that there is little mention of the Livingston family's involvement in its commission, welfare, or placement, particularly since Montgomery was a much loved husband and admired in-law.

Phoenix

Philadelphia became the seat of the rebel government following the battles of Lexington and Concord in 1775. Here the Second Continental Congress met, and over the next seven years, given the exigencies of war, moved several times—first to Baltimore and then to Lancaster and to York in Pennsylvania. With the end of hostilities, and before the ratification of the Treaty of Paris, Congress repeated its nomadic existence, moving to Princeton, then to Annapolis and Trenton, before settling in January 1785 in New York, which for five years was the nation's capital.

One cause of anxiety following the cessation of hostilities was the continued presence of British soldiers in key ports such as Charleston and New York, which meant that American troops had to remain on duty, and they became restive. Congress was behind in payments to them. The issue of pensions, particularly for officers, was delayed, and there was fear of a martial rebellion.[7] The situation was so dire that American troops in Philadelphia mutinied, and

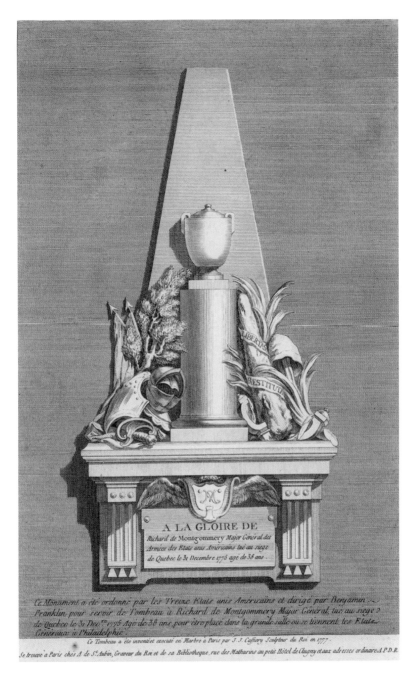

5.2 Augustin de Saint-Aubin, *Á la gloire de Richard de Montgommery …*, 11 9/16 ×
7 5/8 in. (29.4 × 19.4 cm.), engraving, 1779. I.N. Phelps Stokes Collection,
Miriam and Ira D. Wallach Division of Art, Prints and Photographs,
The New York Public Library, Astor, Lennox and Tilden Foundations

soldiers of the Continental Army blocked the doors to Independence Hall, virtually imprisoning the congressmen. Alexander Hamilton, a delegate from New York, pleaded with the soldiers to allow free passage with the promise that Congress would immediately address their concerns. Members of Congress then left the building but were so terrified that they abandoned Philadelphia and eventually found their way to New York, a city that ironically, up until Evacuation Day in November 1783, had served as home base for the British military. One consequence of this displacement was Congress's decision to later locate the central government in its own district, free of dependence on state governments for aid and protection. In 1784, when these debates took place, it was not fully decided where this district should be (eventually the federal government would be located in the District of Columbia) and until such a decision was made, New York seemed the best compromise.[8]

Yet even while Congress was still meeting in Baltimore, before it left for New York, Charles De Witt, a delegate from that state, proposed that the Hewes's executors in Edenton, transport the monument "to the City of New York, to be erected in such part of the State of New York, as the Legislature thereof may judge proper and that the expense accruing thereon be paid by the United States of America."[9] Why New York chose to offer the monument a home is not clear. One could speculate that its original destination, Philadelphia, with threats of military uprisings, was no longer an option. It also may have been thought that the city would become the nation's permanent capital. Another guess is that Livingston, back in the city and active in state and city's affairs, may have masterminded the transfer to New York. Or it could simply be that, as the home state of the fallen hero, it was an obvious choice. In any case De Witt's resolution passed, and Colonel Timothy Pickering, quartermaster general, was charged with oversight of the monument. Pickering first wrote New York State Governor George Clinton in October 1784 notifying him of Congress's actions and then made arrangements with David Wolfe, deputy quartermaster, to have the monument shipped to New York.[10]

Even so, New York was an odd choice. Following the evacuation of the British, the city was in shambles. James Duane, who was appointed the city's new mayor, found two of his houses looking as if they had been "inhabited by savages or wild beasts."[11] Also large sections of the city had suffered destruction from two fires, one in 1776, the other in 1778; one of the casualties being Trinity Church, the seat of Anglicanism in British America, which had been reduced to skeletal ruins (Figure 5.3). As described in Stokes's *Iconography of Manhattan Island* "churches [were] used as riding halls, hospitals, barracks, and prisons," while other buildings were transformed into storehouses.[12] Over the seven-year occupation fences were used for firewood and trees cut down for the construction of entrenchments, breastworks, and forts along the East and Hudson Rivers. Within the city itself street intersections were barricaded and the debris of a military encampment was everywhere. Following Evacuation

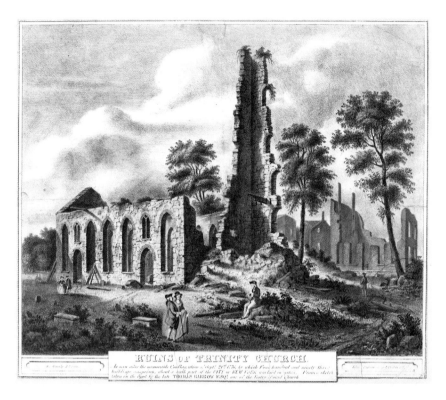

5.3 John Evers, after Thomas Barrow, *Ruins of Trinity Church after the memorable conflagration Sept. 21st 1776*, 10 7/16 × 12 3/16 in. (26.5 × 31 cm.), color lithograph, 1841. I.N. Phelps Stokes Collection, The Miriam and Ira D. Wallach Division of Art, Prints and Photographs, The New York Public Library, Astor, Lennox and Tilden Foundations

Day, New Yorkers—returnees and new émigrés, patriots and loyalists— worked hard and quickly to restore the city's infrastructure. Initially, there was little thought that Congress would move there. Within the year, however, city fathers knew they had won a plum, and work began in earnest to restore wharfs, warehouses, and streets, and to refurbish residences, churches, and hotels in order to ready Manhattan for an anticipated influx of visitors and those attached to the congressional delegation.

Central to the city's revitalization were several men. In addition to Duane, they included Chancellor Robert R. Livingston, and George Washington's former aide de camp, the military hero and a future author of the *Federalist Papers*, Alexander Hamilton. Both Duane and Livingston served as wardens of Trinity Church and were directly involved in the placement of the monument at St. Paul's, one of its parish churches. In addition all three— Duane, Livingston, and Hamilton—were enthusiastic members of the new

fraternal organization, the Society of the Cincinnati. As it turns out the design of the society's badge, undertaken by L'Enfant, would form an unexpected connection to the Montgomery Monument.

Duane had married well. His wife, Maria Livingston, was the daughter of another Robert Livingston, the third lord of the manor in Sullivan County, upriver from the Chancellor's family, the Livingstons of Clermont. Before the war, Duane had been a vestryman of Trinity Church and a trustee of King's College (later Columbia), positions he would regain after the Revolution.

Allied with Duane was the prominent representative of a post-Revolutionary concept of noblesse oblige, Robert R. Livingston, who had served in the Continental Congress on and off throughout the war. He was appointed chancellor of New York in 1777, the highest judicial officer in the state and a title he kept throughout his life, which helped distinguish him from other like-named Livingstons. In 1781 he was appointed secretary for foreign affairs (today's secretary of state), but after serving a little more than a year, he returned to New York in 1783 right after Evacuation Day. As the head of the Clermont Livingstons he was needed at home; likewise he wanted to reclaim his property in the city. As noted by Edwin Burrows and Mike Wallace in *Gotham,* their history of New York, native sons, such as Livingston and Duane, supported the patriot cause because of "stirrings of national pride, [and] a revival of confidence that the upper classes could maintain control."[13]

Of the three, Hamilton became the far better known. As his recent biographer Ron Chernow remarked: "perhaps no individual was identified more with the postwar resurgence of New York City—not to mention the city's future greatness—than Alexander Hamilton."[14] Earlier he had served as a respected aide to Washington; and as a major general, he led the New York militia in a successful campaign at Yorktown. What added to his luster was his marriage to General Philip Schuyler's daughter Elizabeth. During the war she lived with her family in Albany, as did a number of other prominent patriot New Yorkers. Many, including Elizabeth and her husband, returned to the city following Washington's triumphal return.

Livingston's biographer, George Dangerfield, described the decade of the 1780s in New York City as the "critical years" because, following the departure of the British, no one was sanguine about the city's, nor perhaps the nation's, future. Among the problems that absorbed Governor Clinton, Mayor Duane, the city's Common Council, and Hamilton were the adjudication of loyalist claims. Early on there were passionate efforts, including a bill of attainder, to punish the loyalists, both those who emigrated and those who stayed, by stripping them of their lands. Yet many of the loyalists and neutrals who remained were among the city's leading merchants, shipbuilders, and manufacturers, and their know-how and connections were needed to rebuild the town's economic engine and restart trade. The most persuasive of those working on the loyalists behalf was Hamilton, who debated and negotiated for their claims that were guaranteed in the Treaty of Paris.[15]

There were other problems that needed to be addressed, including the standing of Trinity Church, an Anglican church maintained by the Tory elite. Since its founding in 1697, the Crown had deeded it a great deal of land on Manhattan's lower west side, encompassing King's Farm and King's Garden, an area around today's Canal Street. What would be its new status in an independent America? The first step was taken by Clinton and the state legislature, which, because the church was no longer overseen by the Anglican Bishop in England, appointed Duane and Livingston vestrymen or wardens. Duane, in his dual role as mayor and warden, worked tirelessly on the church's behalf, turning his attention to several urgent problems: who would own the church lands that had formerly belonged to the Church of England? How quickly could Trinity, which had been destroyed by fire, be rebuilt and how best to ensure that the now Episcopalian church be thought of as a patriot, not a loyalist, institution? For the latter problem, what better solution than to house the monument to America's fallen hero at its still standing parish church St. Paul's?

But the monument, which had been scheduled to be shipped a year earlier, in October 1784, had still not arrived. This was due in part because the correspondence officially authorizing the transfer was mislaid by Livingston, no less, a fact evident in a letter from Clinton to Pickering dated March 1785:

> In answer to that of that of 22nd October last [1784]. I transmitted about the beginning of December by Mr. Chancellor Livingston who was then on his way to Philadelphia concurrent Resolutions of the Senate and Assembly of this State, fixing the place for erecting the Monument of General Montgomery, which it seems he must have neglected to deliver to you as he promised. I now enclose you a Duplicate of it which gives you the information you require.[16]

Finally, on April 29, 1785, a motion by United States Representative John Vining was made ordering stewardship of the monument to officially be transferred to New York. In October 1785 Pickering notified Governor Clinton that the monument's overseers in North Carolina were indeed ready to ship it to New York:

> Yesterday I rec'd advice from William Bennet of Edenton that he should receive General Montgomery's monument and in 10 days ship the same in the brig Rochahock, Frances Marchaulth, commander, bound to New York. I presume there will be time to erect it this fall if no time be left after its arrival. Be so good as to speak to Capt. Niven and urge dispatch. I think it will be best to consult some of the Livingston family on the subject—the Chancellor, in New York. I will pay the expense of the work on demand.[17]

But there were more delays, and Franklin, who was understandably irritated, wrote again to John Jay, who by then had replaced Livingston as secretary for foreign affairs: "The Monument of General Montgomery, may I ask what is become of it? It has formerly been said, that Republicks are naturally

ungrateful. The immediate Resolution of Congress for erecting that Monument contradicts that Opinion: But letting the Monument lie eight years unpack'd, if true, seems rather a Confirmation of it."[18]

It may well have been that the need to establish democratic forms of governance at the state and municipal level precluded action from being taken; for discussion of its placement did not take place until March 1787, when New York City's Common Council acknowledged that the monument was in the city and proposed that "measures proper [should] be taken with a Statue of Gen'l Montgomery." Duane then went on to designate St. Paul's as the monument's new home.[19]

Given that Thomas Jefferson would later call for a "wall of separation between Church and State," it is curious that the mayor would entrust the monument to a church.[20] City Hall might have been appropriate but it would not become Federal Hall, the home of the new national government until 1789 and the ratification of the United States Constitution. It could also be that the decision to entrust the monument to St. Paul's was because the chapel had a covered porch that could protect it and where it could easily be seen by the public. There was also the precedent of Westminster Abbey's secular hall of fame which would have been known to elite Americans, such as Livingston, who had traveled abroad. St. Paul's was also the church that Washington attended and where his pew is still maintained. It might be fairly said then that for the 16 months when New York was the capital of the United States, St. Paul's became, like Westminster, a national church.

In any case the Common Council agreed that "the Respect due to the Memory of that great Soldier and Patriot demanded the first attention of the Board to the fixing on a suitable Place in this City for the erecting of the said Monument and that the same should be put up without delay." The council unanimously voted that "the front of St. Paul's [was] the most proper place."[21] The mayor then proceeded to officially communicate this information to the Trinity vestry.[22]

Pierre-Charles L'Enfant in New York City

Why L'Enfant was chosen by the wardens of Trinity Church to restore the chapel and install the Montgomery monument cannot be firmly established, but circumstantial evidence, including his relationship with Washington and his involvement with the Society of the Cincinnati (both Duane and Livingston were members), were assuredly contributory. It was also the case that there were few professional designer-engineers in the city and certainly none with L'Enfant's French training and valorous participation in the Revolution. With the exception of the renovations of St. Paul's and of City Hall as Federal Hall in 1789, what else L'Enfant did while a resident of New York during

the 1780s is little known. An early biographer speculated that he may have built a number of residences in Brooklyn, Manhattan, and New Jersey, and "monuments in Trinity and St. Paul's courtyard."[23] To date none of these surmises can be confirmed except that inside St. Paul's there are several wall memorials that postdate the Montgomery Monument and are remarkably similar in design. These may have been undertaken by L'Enfant or by other French artisans in New York, their patrons inspired by the example of the Montgomery Monument. What is known is that on May 23, 1787, L'Enfant was formally hired by the wardens of Trinity Church to supervise the installation of the General Richard Montgomery Monument on the porch of their parish church, St. Paul's Chapel.

St. Paul's was built about 1765 (Figure 5.4), and with its four-columned porch, elegant Palladian window, and graceful steeple, it is the oldest religious building in New York.[24] Its tall fluted columns support a deep entablature, which together form an entrance porch. Above the porch is a pediment in the center of which is a small statue of St. Paul enclosed in a framed niche; to the right and left are round bull's-eye windows. Its columns, capped by Ionic capitals, serve as bold two-story frames for the two Broadway entrances and for the central window, in front of which is the Montgomery Monument. This is in keeping the city's specific order: "Mr. Duane … reported that at the request of the Corporation of the City, the Committee had given permission for the Monument of Gen'l Montgomery to be erected under the Portico of St. Paul's Chapel in front of the great Window." In other words the monument was to installed for all the world to see.[25]

L'Enfant worked quickly to carry out the order but ran into a problem—the rough unsightly back of the monument could be seen within the chapel. To solve this dilemma he came up with an ingenious but unusual solution, one that complied with the vestrymen's wish that he "ornament that part of the great Window of the Parish Chapel which will be obscured by the Monument of General Montgomery," the operative word being window.[26] In order to cover the unsightly back of the monument seen from the inside, L'Enfant created a great Shekinah, or Glory, that still dominates the east end of the nave (Figure 5.5). This elaborate plaster and wood baroque-style construction takes the form of white painted clouds with long golden rays that at their crown support a Hebrew inscription. At its base are two black marble tablets inscribed with biblical text. These tablets in turn rest on a bracketed shelf in front of which is a two-foot high crucifix (Figure 5.6).[27]

But now L'Enfant faced another difficulty—the back of the altarpiece could be seen through the windows above the Montgomery Monument. To solve this new difficulty, and here the solution gets complicated, L'Enfant carved out a niche on the back of the altarpiece into which he placed the back of the monument. On the lip of the niche he fastened a wood and plaster frame, which was placed behind the glass of the Palladian window, but from the

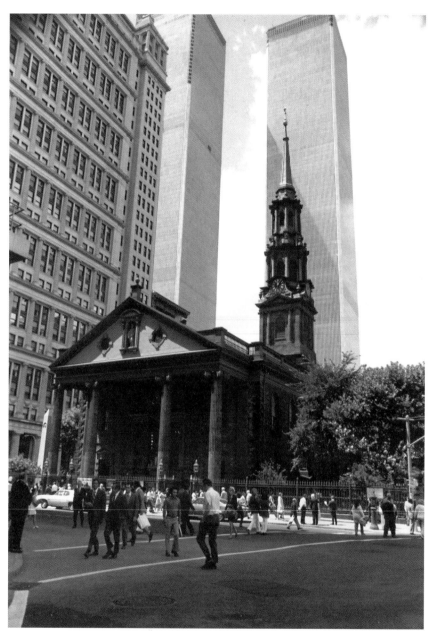

5.4 *St. Paul's Chapel*, 1764–1766; porch 1767–1768. Photograph taken before
September 11, 2001. Trinity Wall Street Archives.

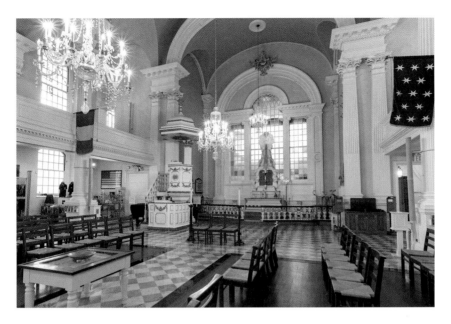

5.5 Interior of St. Paul's Chapel with altar by Pierre-Charles L'Enfant, 1787. Photograph by Brett Beyer

outside it appeared to surround the monument. In the 1920s when the chapel was restored to its original colonial design, the frame was rediscovered, and since then has been hiding in plain sight (Figure I.3).

Pierre-Charles L'Enfant and the American Revolution

L'Enfant's contribution as an influential architect and designer in the early years of the Republic is better understand in the context of his military service during the American Revolution. His wartime career was distinguished and he attracted the attention of several important generals including Frederich Wilhelm Baron von Steuben and George Washington. After the war they were instrumental in his involvement with the Society of the Cincinnati, which in turn facilitated his introduction to influential New Yorkers.

L'Enfant, born in Paris, was one of the many upperclass Frenchmen who came to North America to fight on the side of the Americans and the cause of independence. Prior to his enlistment L'Enfant had been enrolled in the painting and sculpture department at the École des Beaux-Arts, Paris's illustrious school of fine arts, where he had been a student since 1771. His father, Pierre (who spelled his name Lenfant), was an artist and an academician at the school.[28] The genesis of L'Enfant's personal enthusiasm for going to

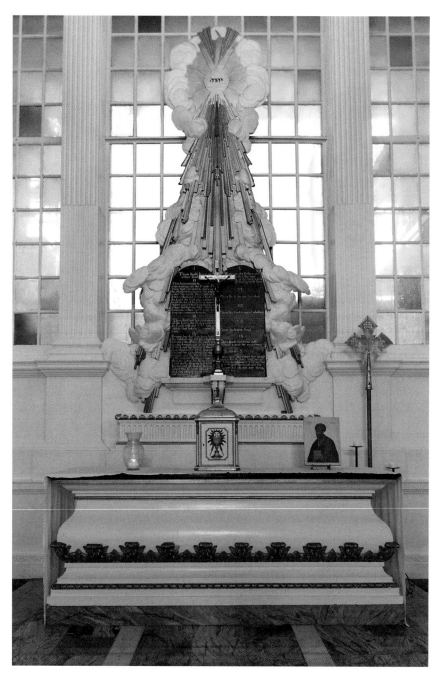

5.6 Pierre-Charles L'Enfant, altar, 1787. Interior of St. Paul's Chapel.
Photograph by Brett Beyer

America to fight for its independence is not known, but he was among the first volunteers who applied to Silas Deane, one of the Paris-based members of the American Committee of Secret Correspondence, for assignment with the Continental Army.[29] His first rank was lieutenant of infantry in the French colonial army. When his ship finally reached America in February 1777, he served under the command of Jean-Baptiste-Tronson du Coudray. Following Du Coudray's death in September, he was appointed to the staff of the Prussian military expert Baron von Steuben, who was stationed at Valley Forge, where L'Enfant first met General George Washington. These were dark days for the Continental Army: the British occupied Philadelphia; Congress was meeting in York, Pennsylvania; and army morale was at an all-time low. Steuben had been asked to instill better discipline in the American troops, and his efforts included the publication of a training manual that he asked L'Enfant to illustrate.[30]

With the retreat of the British from Philadelphia, Steuben and his aides returned there when it once again became the seat of Congress. It was here in April 1779 that L'Enfant was appointed a captain in the newly formed Corps of Engineers. Yet he wanted to see active service and volunteered to serve in General Casimir Pulaski's cavalry division. They took part in the siege of Savannah in the fall of 1779, where L'Enfant was wounded. Later during battle in Charleston, South Carolina, he was captured by the British and held prisoner for 14 months, before being paroled in July 1781. Following the victory at Yorktown in October of that year, L'Enfant returned to Philadelphia, where he was invited by the French ambassador Anne-César, chevalier de la Luzerne, to design a large pavilion to honor the birth of the French dauphin, the short-lived Louis Joseph.[31] L'Enfant included in the plan of this pavilion a representation of the newly authorized Great Seal of the United States, which may have been its first public display.

The Philadelphia celebration of the birth of the dauphin was just one of a number, although the most elaborate of American fêtes to honor the occasion. As several commentators have noted, it was a way Americans could demonstrate their gratitude for French support in their victory over British forces in the decisive Battle of Yorktown.[32] Built in what must have been the large courtyard of La Luzerne's house, the pavilion was surrounded by gardens in which illuminations and fireworks were displayed. There is no printed illustration of L'Enfant's building, but its dimensions, 75 by 45 feet, are known from written descriptions. One writer expounded at length on the different classical orders that were included in its design, evidence of L'Enfant's French training and knowledge of European models: "the Doric order, which is the motif used in this building, is no where neglected, unless in those particular parts where its plainness and simplicity, would disagree with the elegance of the pillars, which are decorated with the bases and proportions of the Ionic." The writer then went on to describe the installation

of the "arms of France" on one wall facing the "arms of the United States" or the Great Seal on the other.

> At the farthest extremity of the hall, and opposite the principal entrance are the arms of France upon a globe; suspended in the midst of a glory whose rays break upon the square of the ceiling, all whose parts it seems to enlighten at the same time slightly obscured by thin clouds. At the other extremity the arms of the United States (whole escutcheons are charged with thirteen pieces of argent [silver or white] and gules [red], having at the top thirteen stars upon an azure ground) are supported by the American bald eagle, having in his right talons an olive branch, and thirteen arrows in his left. In his bill, a legend with these words *E pluribus Unum*.[33]

This "arms of the United States," described as a bald eagle holding an olive branch and 13 arrows, is the Great Seal (Figure 5.7), which had been approved only a month earlier. While the eagle had been employed as a symbol of imperial power from ancient times, the American bald eagle was chosen because it was thought to be unique to the North American Continent and in that way "emblematical of the Sovereignty of the Government of the United States."[34]

The Great Seal of the United States

On the same day that the Declaration of Independence was ratified, Congress passed a resolution establishing a committee comprised of Benjamin Franklin, Thomas Jefferson, and John Adams to "bring in a device for a seal of the United States of America."[35] Initially they sought the help of Pierre Eugène Du Simitière, a Swiss-born artist then living in Philadelphia, to prepare drawings in accordance with their ideas.[36] Congress tabled most of the committee's suggestions, although it retained the "Eye of Providence in a radiant Triangle" and the Latin motto, *E pluribus Unum*, which was probably contributed by Franklin.[37] The first committee was disbanded, and the distractions of war prevented Congress from appointing a new one until 1780. But its design too was rejected. According

5.7 First Die of the Great Seal of the United States, 1782, 2 1/16 in. (5.2 cm.) in diameter, brass, 1782. National Archives and Records Administration, Washington, D.C.

to Frank Sommer, the Great Seal design submitted by this new committee, "again failed to live up to the [historical] rules for the device." Yet several of the elements they introduced, such as "the symbols of war and peace in the form of the olive branch and a sword," a "crest composed of a 'radiant constellation of 13 stars,' and a shield with thirteen stripes 'alternate rouge and argent'" were retained.[38] It was not until a third committee, appointed two years later in May 1782, that expert advice in the design specifically of emblems was sought, and they turned to Philadelphia lawyer William Barton, who was a self-described authority on emblems and heraldry. In his first proposal "he kept the idea of a red-and-white striped shield and the thirteen stars And he introduced the 'spread' or, more technically, 'displayed' eagle as the symbol of supreme power and authority."[39] The Congress was still dissatisfied, and by default the seal's final configuration was an amalgam created by the secretary of Congress, Charles Thomson, from the fragments contributed by all three committees, including a reverse patterned after Barton's. Thomson's design for the obverse contained an eagle "rising" with a shield of 13 stripes displayed on its chest, holding "in its talons an olive branch and a bundle of arrows and in its beak a scroll reading *E pluribus Unum*."[40] Before submitting this design to Congress, Thomson had Barton look at his drawing and description, and Barton suggested that the position of the eagle's wings be changed from rising to displayed. Congress accepted their final design on June 20, 1782, and the die, literally, was cast sometime before the end of the year.[41]

But what did all these symbols, individually and collectively, mean? The best way to answer that question is to consult the explanation given by Thomson to Congress at the time he submitted his final design. Using the language of emblems he explained:

> The Escutcheon [the shield on the eagle's breast] is composed of the chief [upper third of a shield] & pale [a vertical third of the field], the two most honorable ordinaries [major devices used in heraldry]. The Pieces, paly [alternating perpendicular fields of color], represent the several states all joined in one solid compact entire, supporting a Chief [upper third of the shield], which unites the whole & represents Congress. The Motto alludes to this union. The pales in the arms are kept closely united by the chief and the Chief depends on the union & the strength resulting from it for its support, to denote the Confederacy of the United States of America & the preservation of their union through Congress.

> The colors of the pales are those used in the flag of the United States of America; White signifies purity and innocence, Red, hardiness & valour, and Blue the colour of the Chief signifies vigilance perseverance & justice. The olive branch and arrows denote the power of peace & war which is exclusively vested in Congress. The Constellation denotes a new State taking its place and rank among other sovereign powers. The Escutcheon is born on the breast of an American eagle without any other supporters to denote the United States of America ought to rely on its own Virtue.[42]

Before the Constitution establishing the division of government into three branches was written, Congress was vested with powers that would later be shared with the president. Thus, in the Great Seal's design the chief (the topmost horizontal structure of the shield), which "unites the whole," at that time symbolized the Congress, and not the president. In turn, the chief, or Congress, "depends on the union & the strength" of the pieces, or states. The preservation of the union of the United States, and the maintenance of independence, that is, the power to declare war and make peace, were vested in Congress, with the consent of the governed.

As one of the earliest symbolic representations of the new nation, the Great Seal, with its learned references to European tradition, conveyed in condensed form a powerful message that could be understood internationally—that the new nation was self-governed. As far as is known, L'Enfant's representation of it in his decorations for the dauphin celebration was probably the first time it was publicly displayed. He also employed this patriotic iconography a year later for his designs for the badges and diploma of the Society of the Cincinnati. Membership in this organization signified elite status, particularly in New York where Duane, Livingston, and Hamilton, who were members, believed that their education and status endowed them as leaders for the new nation.[43]

Society of the Cincinnati

Formed originally as an international fraternity of officers—American and French—who fought in the American Revolution, the society, remains active today with elegant headquarters in Washington, D.C., where they sponsor public programs and maintain a valuable library of military history. In the late eighteenth century, however, the society's immediate purpose was to ensure that the military, particularly its officers, got paid, and that their pensions were secured following the end of hostilities. The great fear was mutiny—that the army, frustrated because Congress did not support their demands, would rebel and oust the country's civilian leaders. Several prominent officers, writing from Newburgh, New York, near Washington's winter headquarters, warned Congress in December 1782 that "the uneasiness of the soldiers for want of pay is great and dangerous; any further experiments on their patience may have fatal effects."[44] The officers' frustration came to a head in March 1783 with the circulation of several anonymous letters in which the author spoke of injustices and asked his comrades if they were willing to "consent to be the only sufferers by this revolution, and retiring from the field grow old in poverty, wretchedness and contempt?"[45] He then exhorted them to warn Congress that "though despair itself can never drive you into dishonor, it may drive you from the field … that in any political event, the army has its alternative."[46] This was indeed seditious talk, and Washington, who had

obtained copies of these letters, moved quickly to check an incipient revolt. On March 15 he responded to the anonymous letters, which he characterized as being written "to insinuate the darkest suspicion and to affect the blackest design."[47] He then went on with great force and eloquence to condemn the spirit of the letters and to call upon the honor of the military:

> Let me conjure you, in the name of our common country, as you value your own sacred honor, as you respect the rights of humanity, and as you regard the military and national character of America, to express your utmost horror and detestation of the man, who wishes, under any specious pretences, to overturn the liberties of our country; and who wickedly attempts to open the flood-gates of civil discord, and deluge our rising empire in blood.[48]

Washington was revered by his troops, and his appeal to their honor and patriotism turned the tide.

Shortly afterward, Washington was prompted to ask General Henry Knox, chief artillery officer of the Continental Army and later President Washington's secretary of war, to find ways to reassure and assuage the officers. Such a request coincided with Knox's own desire to create a fraternal society of officers. In April 1783 he had drafted an eight-page memorandum that became the basis of the constitution, or "Institution," for the Society of the Cincinnati. It was revised at a meeting of officers in May to include an invitation to French officers who had served in the American Revolution.[49] At the society's first general meeting, the entire "Institution" was approved and Washington was elected the society's first president.[50]

Among the early members was L'Enfant's old general, Steuben, who remembered L'Enfant's drafting skills and invited him to design a medal or badge for the society, the design of which was to be based on a description that Knox included at the end of his "Institution."

> The principal figure, Cincinnatus: Three Senators presenting him with a sword and other Military ensigns—on a field in the background, his wife standing at the door of their Cottage—near it. A plough and instruments of husbandry. Round the whole, Omnia Relinquit Servare Rempublicam [he leaves everything to serve the state] On the reverse, Sun rising—a city with open gates, and vessels entering the port—Fame crowning Cincinnatus with a wreath inscribed Virtutis Praemium [honor is the reward of virtue]. Below, hands joined, supporting a heart, with the motto Esto Perpetua [let it be forever]. Round the whole, Societa Cincinnatorum Instituta. A.D. 1783.[51]

This was more narrative detail than a small medal could accommodate, so L'Enfant incorporated only one of the Latin texts, *Omnia Relinquit Servare Rempublicam*, and a synopsis of Knox's elaborate visual program (Figure 5.8).

In the final version the badge of the society is suspended from a light blue satin ribbon bordered by white stripes. In some versions the material of the short ribbon is scrunched into a large rosette, while others have a

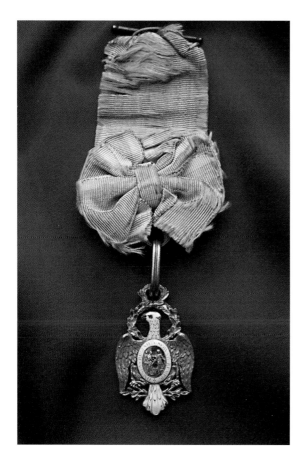

5.8 Society of the Cincinnati Eagle insignia owned by Lt. Col. Tench Tilghman. Made by Duval and Francastel, Paris, 1784. Gold, enamel, silk, and metal. The Society of the Cincinnati, Washington, D.C.

simple folded termination. Suspended from the ribbon is a gold clasp that connects the ribbon to the gold and painted enamel medal. The medal itself takes the form of an eagle that is a close approximation to the one represented on the recently adopted Great Seal. In L'Enfant's design, however, the eagle's wings are closed and its legs brought underneath the body; the talons carry only laurel. Above its head is a doubled wreath of laurel that connects the medal to the ribbon. On its breast is a cameo-type image of Cincinnatus with his wife—the cameo itself is a counterpart to the shield on the Great Seal.

However, L'Enfant was able to include more aspects of Knox's description in a second design for a silver medal (Figures 5.9 and 5.10) intended as a keepsake and not to be worn. This medal, not cast until the twentieth century, was included as part of L'Enfant's elaborate plan for the society's diploma (Figure 5.11).

All of these items, the badge or eagle, the design for the medal, and the diploma, L'Enfant completed in Paris, where he was sent by the society in late November 1783. Washington also asked him to deliver these emblems of membership to those French officers listed in the "Institution."[52] Washington, although often criticized for his support of the organization, approved the society's formation and gave L'Enfant proper documentation and financial aid so that he could make his way to France. He also took time to sign L'Enfant's membership certificate.[53]

L'Enfant spent five months in France, where he worked closely with the jewelers Duval and Francastel to fabricate the order and with the engraver Jean-Jacques-André Le Veau to incise the diploma on a copperplate.[54]

(left) 5.9 Pierre-Charles L'Enfant, ink drawing of proposed Society of the
Cincinnati medal, obverse, 1783. The Society of the Cincinnati, Washington, D.C.

(right) 5.10 Pierre-Charles L'Enfant, ink drawing of proposed Society of the
Cincinnati medal, reverse, 1783. The Society of the Cincinnati, Washington, D.C.

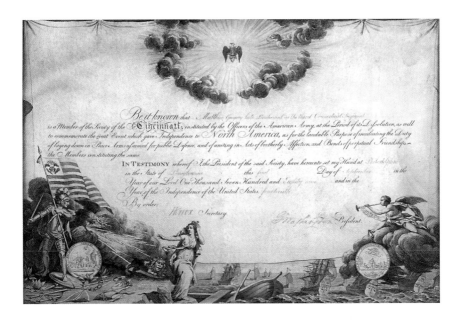

5.11 Jean-Jacques-Andre Le Veau, and Robert Scot, engravers; after
Pierre Charles L'Enfant and Augustin-Louis La Belle, artists,
Society of the Cincinnati membership diploma for Lt. Matthew Gregory,
September 1, 1789. The Society of the Cincinnati, Washington, D.C.

L'Enfant was not the only Frenchman creating medals for Americans. The medal engraver Augustin Dupré and others were hired by American officials in Paris, including Jefferson, to create 14 medals between 1783 and 1789 to "commemorate outstanding services to the American cause in the Revolutionary War."[55] At the time there were no fine medal manufacturers in the United States, and of necessity L'Enfant and the federal government turned to France for fabrication of these items. As noted by E. McClung Fleming in an article on the image of America in the early Federal period:

> The men who were establishing precedents for the new Federal Republic were intensely alive to the importance of presentation medals to honor national heroes and to commemorate great events. "Having," as Jefferson put it, "but little confidence in our own ideas in an art not familiar here," he and his associates were determined to seek the best advice possible for medallic traditions, procedures and practitioners. They turned to France and asked assistance of the royal Académie des inscriptions et belles-lettres in Paris.[56]

There was criticism that the wearing of such a badge or medal smacked too much of aristocracy, but members treasured them and passed them down to their children. Such was the importance of the society and its badge that one of its members, Samuel Shaw, traveled on the first American ship that sailed to the Pacific, the *Empress of China*, and brought his medal with him. In China he had the design replicated on porcelain dinnerware, a set of which was purchased by Washington and is now part of the collection at Mount Vernon.

The Society of the Cincinnati, New York City, and a Federal Constitution

Controversy was part of the Society of Cincinnati's history from its beginning, primarily because its critics—who included Franklin, Jefferson, and Adams— thought that a fraternal military society threatened republican values. Franklin, in particular was contemptuous and wrote a sarcastic letter to his daughter, Sarah Franklin Bache, in 1784 expressing his deep disapproval that the honor would be passed down to future generations in emulation of European nobility. Adams thought the Society was "the first step taken to deface the beauty of our temple of liberty."[57] And Jefferson wrote to Washington, the society's first president, saying that it should be abolished since it was "destructive of republican government."[58] He was the most vocal critic and repeatedly pleaded with Washington to disavow the society. Washington, however, unlike Jefferson, was a military man and sympathetic to his officers' concerns about the nonpayment of backpay and their fears of rebellion, since it was not clear who was responsible for putting down internal threats—Congress or the states? This issue was pointedly raised at the time of Shay's Rebellion in Massachusetts (1786–1787), when western farmers shut

down local courts to prevent the adjudicating of what they considered unfair tax and debt demands. A local militia, led by many who were members of the Cincinnati, put down the rebellion.[59]

The uprising occurred at the same time that many Revolutionary leaders were calling for a revision of the Articles of Confederation (1777). Congress was the only federal power but had little ability to finance itself, enforce its legislation or protect the nascent mercantile state. There was a felt necessity for the establishment of a national federal government, a movement endorsed by nationalists and members of the Cincinnati.[60] All three members of the New York delegation to the Constitutional Convention were members of the society: John Lansing, Robert Yates, and Alexander Hamilton. Hamilton did not play an influential role in the framing of the Constitution, but later, with James Madison and John Jay, he was among its most powerful supporters through the drafting, publication, and dissemination of the *Federalist Papers* (1787–1788). The Constitution was adopted on September 17, 1787, and a long process of ratification began in order to secure its adoption. New York did not fall into line until late July of 1788.

New York's slowness was due to strong feelings upstate of the Anti-Federalists, a faction led by Governor George Clinton. In contrast, city merchants, lawyers, artisans, and tradesmen were fervent backers of this new instrument of governance. Passions ran high and to put their point across the city fathers organized a gala celebration calling for the Constitution's adoption and to rally support for the rest of New York to do likewise. Called the Grand Federal Procession, this event was modeled on an earlier one held on the Fourth of July in Philadelphia, where the festivities were overseen by Charles Willson Peale.[61] New York City's Federalists hoped their procession would also be held on the fourth, but they deferred in anticipation that word would reach them from Poughkeepsie, where the state's convention was being held, that the state had endorsed the new Constitution. Almost three weeks went by, and in frustration and pique the city went ahead and held its celebration to put pressure on their upstate counterparts.[62]

L'Enfant, like Peale in Philadelphia, was put in charge of the festivities, which included a large float-like structure 20-feet long and 10-feet wide called the *Hamilton*. It was indeed a real ship and was moored at a pier prior to the celebrations.[63] Partying continued into the evening culminating with a lavish banquet attended by 3,000 people held in a pavilion, also designed by L'Enfant, and described as "a temporary structure featuring seven hundred foot-long tables radiating outwards from a giant circular dais," which was similar in plan to the one he designed earlier for Philadelphia to celebrate the birth of the dauphin.[64] A few days later, on July 27, New York became the eleventh state to ratify the federal constitution.

Among the many other benefits that accrued to New York City was its now official status, albeit temporary, as the capital of the United States. The city

set about plans to play host to a new government and a new president. The first priority was to find a place to meet. Under L'Enfant's direction City Hall became Federal Hall. He went about overhauling the entire building, adding an extension on the north side and an open portico on the south, or Wall Street, side above which was an arcaded balcony. A carving of the Great Seal of the United States, perhaps sculpted by L'Enfant, was placed on the pediment above, ornamenting the site of Washington's swearing-in ceremony.[65]

George Washington's Inauguration

The first official to arrive in New York was the newly appointed vice president of the United States, John Adams, who traveled south from his home outside of Boston and arrived in the city the afternoon of April 20. He was escorted by a large contingent of troops, officers, members of Congress, and a large number of citizens.[66]

Meanwhile, Washington was making his way north from Mount Vernon, accompanied by Charles Thomson, the congressional secretary, and Colonel David Humphreys, his former aide-de-camp. The journey took longer than normal since there was a celebration in every town along the way, including an elaborate fête in Philadelphia, again orchestrated by Peale. New York was not to be outdone. On the day of Washington's arrival, "thirteen pilots dressed in white uniforms" transported him from Elizabethtown, New Jersey, to Murray's wharf at the foot of Wall Street on Manhattan's east side.[67] Accompanying him across New York Harbor was a delegation that included Chancellor Livingston and other state and city officials. During the crossing, small boats and ships saluted the new president. Upon his arrival, he was welcomed by New York dignitaries, including Governor Clinton and Mayor Duane. All joined a procession that included a number of military men, members of the Society of the Cincinnati, "the French and Spanish Ambassadors in their carriages and an amazing concourse of citizens," all of whom escorted him to his new home at 3 Cherry Street, the former home of William Franklin, the loyalist son of Benjamin Franklin.[68] In the evening bells were rung from church steeples, fireworks exploded at the Battery, and virtually every house was decorated with silhouetted illumination. According to Rufus W. Griswold writing in the nineteenth century: "The transparent paintings exhibited in various parts of the City ... were equal at least to anything of the kind ever before seen in America. That displayed before the Fort at the bottom of Broad-way, did great honor to its inventors and executors, for the ingenuity of the design, and goodness of the workmanship; it was finely lighted and advantageously situated: The virtues. Fortitude (The President), Justice (The Senate) and Wisdom (The Representatives of the United States) were judiciously applied."[69] An eyewitness described the

town as a "scene of triumphal rejoicing. His [Washington's] name in every form of decoration appeared on the fronts of the houses; and the streets through which he passed to the Governor's mansion were ornamented with flags, silk banners of various colours, wreaths of flowers, and branches of evergreens."[70]

On the day of the inauguration, April 30, 1789, "a salute was fired from the Battery and at nine o'clock in the morning services ... were held in all the churches."[71] About noon Congress led a procession from Federal Hall to Washington's lodgings and there a larger convoy escorted him back to Federal Hall. "When the head of the procession reached Federal Hall, the troops opened their ranks, through which the President entered the building."[72] Washington was then conducted into the hall where the congressmen met and from there to the Senate Chamber and "the gallery in front of the Senate Chamber," where the oath of office was administered by Chancellor Livingston (Figure 5.12). Washington officially affirmed: "I do solemnly swear that I will faithfully execute the office of President of the United States, and will, to the best of my ability preserve, protect, and defend the Constitution of the United States."[73] Following the inauguration, Washington and his party attended religious services at St. Paul's. How fitting then, given his support of L'Enfant's career and his acclaim as a military hero, that greeting the new president at the church's Broadway entrance was the Montgomery Memorial enclosed by L'Enfant's frame. Perhaps overshadowed by the pomp and ceremony surrounding the new president's arrival and inauguration, the unpretentious monument garnered scant attention. It could well be that the monument had too much competition, since a new, living hero had come to town.

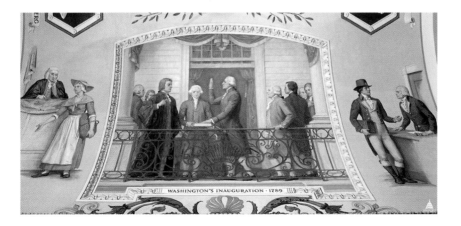

5.12 Allyn Cox, *Washington's Inauguration*, oil on canvas, 1973–1974. United States Capitol. Architect of the Capitol

Old Wine in New Bottles: Establishing an American Iconography

Today, after a recent cleaning the L'Enfant frame can be clearly seen behind the Montgomery Monument (Figure 5.13), yet it is still hard to read the imagery. Fortunately there is an eighteenth-century description that was published in New York the day after the monument was installed: "Hymen, extinguishing his torch mourns over his tomb (Figure 5.14). From behind the pyramid rises a sun with thirteen rays, which enlightens the quarter of a terrestrial globe, emblematical of America. Above the whole is the American eagle flying from East to West, carrying in his talons a starry curtain, in which the globe appears to have been wrapped"[74] (Figure 5.15). A second observer, writing a year later, was not impressed and severely criticized the additions to the monument: "Those absurd, bizarre and ginger-bread addendas are a disgrace to taste; and would even discredit the mind *d'un Enfant* [a child, surely a pun on L'Enfant's name]. These tawdry ornaments might decorate the stern of a French packet, but have not that majestic simplicity or greatness, or that *perennius are*, which becomes the Monument of a Hero. If I had the honour of being related to

5.13 Jean-Jacques Caffiéri, *General Richard Montgomery Monument*, 120 × 60 in. (304.8 × 152.4 cm.), marble, 1777, detail of frame. St. Paul's Chapel, New York. Courtesy of Leah Reddy/Trinity Wall Street

so great a man, I would, with an indignant hand, pull the Sun from its sphere, over-turn the Globe, and kindle a bonfire with the Clouds."[75]

This latter criticism aside, these notices remain the only written explanations of L'Enfant's program, which is simultaneously mournful and celebratory — mournful in that it surrounds a monument to a dead hero; celebratory in that through the inclusion of an image of the sun with 13 rays of light, it introduces a new nation to the world. There are also specific references to mourning, including on the left the representation of Hymen, the god of marriage, who holds a downward turned torch, symbolic of the extinguishing of life. Grief stricken, he turns his back and closes his eyes with his finger tips. His pose signifies the loss of a hero and of a bridegroom. Montgomery had been married only two years before his death in Quebec. Above and behind Hymen is a sun with

5.14 Pierre-Charles L'Enfant, wooden casing with paint and plaster for *General Richard Montgomery Monument*, 1787, detail. Photograph by Frederick Schang

13 rays that rises above and illuminates a globe. Surmounting the entire composition is an eagle in flight that pulls back a cloud-like curtain revealing a new nation to the world.

L'Enfant's frame is an important rediscovery. It is among the earliest extant designs and artifacts created by this artist, architect, and engineer prior to his work in Washington. It also includes a new iconography for an independent nation, which can be connected to the Seal of the State of New York (1778), the Great Seal of the United States (1782), and L'Enfant's design for the badge for the Society of the Cincinnati (1784), and an architectural embellishment atop the sally port, Fort Jay, Governor's Island, New York.

What supports these connections are two paintings (Figures 5.16 and 5.17), reputedly by L'Enfant, found inside St. Paul's. One is a painting of the Seal of New York, which hangs on the south wall above the governor's pew. The other, the Great Seal of the United States, is on the north wall above

5.15 Pierre-Charles L'Enfant, wooden casing with paint and plaster for *General Richard Montgomery Monument*, 1787, detail. Photograph by Frederick Schang

Washington's pew (Figure 5.18) and was ordered by the vestry of Trinity Church in October 1785.[76] It is not known who may have been commissioned or when the painting was undertaken, and it could well be that its realization did not transpire for a year or so, meaning that it could have been designed and/or painted by L'Enfant. Furthering this speculation is the placement in St. Paul's of the arms of the United States opposite the arms of the state of New York, an arrangement that repeats one that L'Enfant created earlier in 1781 for his decorations of the dauphin's pavilion in Philadelphia where the insignia of France was placed opposite that of the United States.

In the painting of the Great Seal, the emblem is represented against a flat background flanked by elaborate, deep red, tied-back curtains. So conceived the composition reads as an announcement of a new nation on the international stage—the seal being the instrument by which foreign treaties and agreements are formalized. Opposite the Great Seal on the south side is the seal of New York. Its design is more elaborate and figurative. Two women—liberty and justice—flank an elaborately designed rococo-styled, garlanded frame that encloses a scene of a rising sun with golden rays behind a deep expanse of water. Below this central cartouche is the word *excelsior* spelled out on a wide ribbon. Above it is an eagle represented in flight above a globe.

The iconography of the Great Seal and its relationship to L'Enfant's frame are furthered by the recent identification of a sandstone sculpture that appears above the parapet of the main sally port or gateway of Fort Jay on Governor's Island (1795–1796). This architectural embellishment was brought to my attention by Judy Jacobs, senior conservator of the National Park Service, who has been overseeing the renovation of Fort Jay. One aspect of her work was

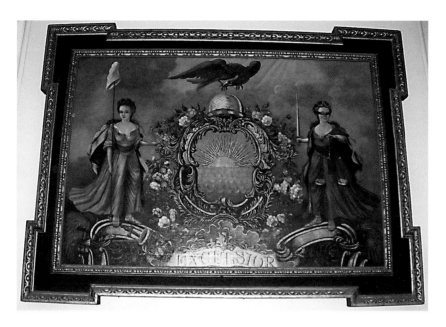

5.16 Pierre-Charles L'Enfant, *Seal of the State of New York*, ca 1787.
Interior St. Paul's Chapel. Photograph by author

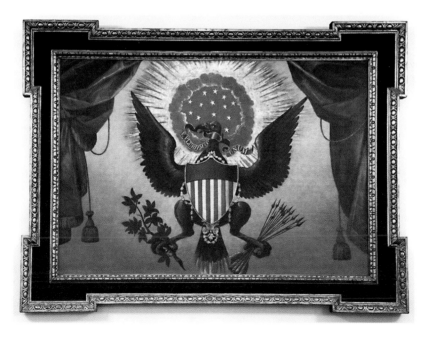

5.17 Pierre-Charles L'Enfant, *The Great Seal of the United States*, ca. 1787.
Interior St. Paul's Chapel. Photograph by Brett Beyer

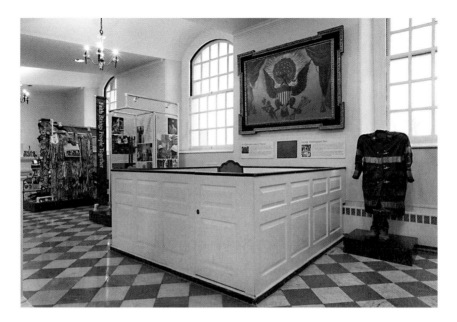

5.18 Interior of St. Paul's Chapel, view of Washington's pew and painting of the
Great Seal of the United States. Photograph by Brett Beyer

the restoration of this *trophée d'armes* (Figure 5.19). It is somewhat deteriorated
but its principal elements can still be discerned—a cluster of carved symbols
centered on a truncated column on the top of which is a phrygian cap. The
column is surrounded by military flags and cannon. At the front is a large
eagle which supports with its right talon a carved representation of the seal of
New York. Although the organization of its components is different than the
Montgomery Monument, certain images on both the monument and its frame
are found at Fort Jay—a truncated column, a liberty pole and cap, furled flags,
and the instruments of war.

Over a 20-year period from 1777 and the creation of the Seal of New York to
1797 and the completion of the *trophée d'armes* for Fort Jay, these new symbols
were established, reworked, and referenced, signaling the beginnings of
a new state and a new nation. If we assume L'Enfant as the author of the
two paintings in St. Paul's, it appears that he combined symbols from both
to create the emblematic references found on the frame for the Montgomery
Monument. In so doing he expanded the meaning of the monument to
include the formation of a new nation, an historical development unforeseen
when Franklin and Caffiéri first discussed the monument as a tribute to heroic
sacrifice and the restoration of liberty.

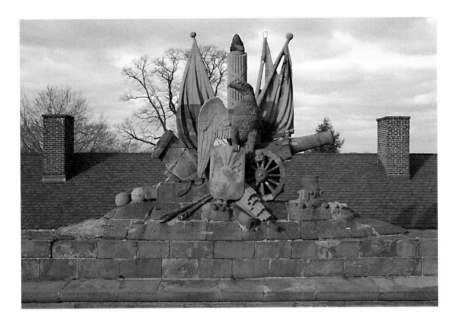

5.19 Joseph Mangin and Le beau (?) *Trophée d'armes*, sandstone, 1795–1796, above the main sally port, Fort Jay. Courtesy Christopher Payne, National Park Service, Governors Island National Monument

The Origins of the American Commemorative Tradition

Unlike the earlier New York colonial monuments, that of Montgomery is still in its original location, but it is uncelebrated certainly in comparison to the better known national memorials such as the Bunker Hill Monument, Horatio Greenough's ill-fated seated Washington (1832–1841) intended for the United States Capitol, or Henry Kirke Brown's equestrian Washington now in Union Square (1853–1856).[77] After the inauguration New York did not remain the capital for long. It was moved to Philadelphia in 1790 and 10 years later to Washington, D.C. With the transfer of the federal government to the banks of the Potomac, the Montgomery Monument slipped into oblivion. An early symbol of the American cause, Montgomery died too soon to establish a significant military reputation, and both his deeds and monument were all but lost from public memory.

Maybe if the United States capital had remained in New York, the monument would not have been forgotten. Contrariwise, if the monument had been installed in Independence Hall in Philadelphia as planned, or removed from St. Paul's and placed in the new Capitol in Washington, the Montgomery Monument, like the Liberty Bell or the Washington Monument,

might be a national icon. Another explanation may be that New York, unlike Philadelphia and Boston, has no "Heritage Trail." If it did, what would it look like? A map of where Washington and his troops were defeated; a loyalist's guide to lower Manhattan? New York's relationship to the Revolution has always been a complicated one.

So part of my effort has been directed toward restoring the monument's reputation and bringing to light part of New York's forgotten Revolutionary history. It has also been my ambition to use the history of the Montgomery commission as a rearview mirror in which earlier colonial monuments can be glimpsed; trying to see if their history and circumstances had any bearing on the commissioning and design of the Montgomery Monument. It has been an engaging challenge, since the early years of the American commemorative tradition are little known, as are the De Lanceys, the Tory family that supported the commissioning of three earlier monuments. So too are the relatively obscure battles that produced America's first heroes; the New York Stamp Act crisis; L'Enfant's years in New York and his contribution to early republican iconography; and even Montgomery himself. These are the pieces of the puzzle I have brought together to create a template that can help us begin to formulate the origins of the American memorial tradition.

To begin, it is important to acknowledge the impact of the European tradition, which is often treated as if it were something apart or foreign. For instance, Wayne Craven's *Sculpture in America* is still the only history that includes mention of these late eighteenth- and early nineteenth-century European manifestations. These are included in a chapter titled "The Foreign Interlude," as if to suggest that they should be thought of as separate from homegrown examples.[78] My research, however, has led me to regard them all together—European and American alike—in order to establish a more accurate and coherent history of the American commemorative impulse. What is needed now is a survey of early public monuments, many of which, including the Montgomery Monument, were originally authorized by the Continental Congress.[79] With the exception of the Montgomery, none of these dozen or so commissions were completed at the time, yet collectively they suggest a richer early commemorative history than has been imagined and one that can be securely linked to European precedent.

Exemplary among these early tributes was one ordered by the Continental Congress to honor George Washington: an equestrian statue voted in 1783 to pay tribute to his military leadership, with the stipulation that the sculpture be made of bronze and Washington "represented in a Roman dress, holding a truncheon in his right hand and his head encircled with a laurel wreath." Like the Montgomery Monument, the statue was to be "executed by the best artist in Europe, under the superintendence of the Minister of the United States at the Court of Versailles."[80] Said minister, Thomas Jefferson, offered the commission to Jean-Antoine Houdon, who traveled to the United States

in 1785 expressly to obtain a life mask and to study Washington from life.[81] While Houdon never completed the equestrian statue, at Jefferson's request he undertook a standing marble statue of the general, for the Commonwealth of Virginia, which was installed in 1793.[82] It would be over 50 years before the official equestrian ordered by Congress would be completed, this time not by a Frenchman but by the American Clark Mills. His *Lieutenant General George Washington* (1860), placed on a high base at Washington Circle along Pennsylvania Avenue, was the first equestrian monument designed by an American and cast in the United States.

Similarly, it would take many more years to fulfill the other memorials authorized by Congress.[83] Most of these did not see the light of day until the late nineteenth century and were often paid for by private associations or state and local governments. In the early years of the Republic, perhaps it was the distractions of creating new forms of governance that precluded the luxury of honoring the past. There was little money available for such undertakings, since the Revolution "had left exhausted treasuries of the individual States and in the General Government."[84] And there were those in Congress who disdained marble monuments with their associations to a despotic European past.

For instance, a movement arose to complete the commission for "a Marble Monument" to Washington ordered in 1799 at the time of his death by the United States Congress. The discussion began in 1825 when it was proposed that a committee be appointed "to inquire in what manner the resolutions of Congress passed on the 24th December, 1799 ... may be best accomplished."[85] The proponents argued that, "Every wise nation has paid honor to the memory of the men who have been the saviors of their country. Sculpture and painting have vied with each other in transmitting their images and the memory of their deeds to the remotest generation. By these means, the holy fire of virtuous emulation has been kindled in the bosoms of youth of succeeding ages."[86] Opposition was strong and dissent was voiced by those who believed that: "We need no monuments to tell us that Washington has lived; he has a monument, he will continue to have one, in the heart of every American; such a monument as none before him has ever had; and let it be our peculiar pride to enshrine him there alone."[87] Dissent carried the day and the motion was defeated.

Yet the call for a Washington monument that celebrated his civilian and military leadership did not die, and eight years later, at the time of the celebration of the centenary of his birth, it was taken up again by a group of private citizens and public officials who in 1833 formed the Washington Monument Society. After years of wrangling, the American sculptor and architect Robert Mills was charged with designing the tribute, and the monument's cornerstone was laid July 4, 1848. It would take, however, 40 more years before today's familiar granite obelisk the Washington Monument was finally completed.[88]

This initiative on the part of private citizens, associations, and local governments to commission public monuments was particularly marked following the end of the War of 1812, when many Americans began to reflect on the nation's early history and to understand that this fragile experiment in representative democracy might have a chance of succeeding. These projects included calls in Baltimore, Raleigh, New York, and Boston to honor George Washington and embraced a surprising array of memorials, such as: the Washington Monument (1815–1829), a 178-foot-high Ionic marble column for Baltimore by Robert Mills; a standing marble Washington statue (1827) for the Massachusetts State House by the British sculptor Sir Francis Chantry; and a third tribute to Washington, this time a seated bronze (1821) showing him in Roman attire by the foremost Italian sculptor of the day, Antonio Canova, for the North Carolina State House in Raleigh.

A pattern had emerged. Nearly all of these post-War of 1812 monuments were by European artists or based on European models, including the *Bunker Hill Monument* (1825–1843), designed by Horatio Greenough and Solomon Willard for Charlestown, Massachusetts. The obelisk shape had the virtue, according to Greenough, of a pedigree that extended back to ancient Egypt.[89]

This truncated survey, even in its rough form, yields a surprising amount of rich material and could be used as a foundation for a history of American monuments, which, in addition to identifying the forms of early commemoration, would also document the failures and successes, the naysayers and supporters, and report on the motivations behind these efforts and how over time monuments, such as the one for Bunker Hill, emerged as national emblems. It would also address the meaning of these monuments for a democratic nation and in so doing provide a vital framework for the Montgomery Monument.

As I completed this manuscript, conservators were at work repairing and cleaning the Montgomery Monument. They began by constructing a wooden shed around the monument and building a scaffold. They then carefully dismantled the monument so that its component parts could be cleaned and repaired. When these parts were laid out on nearby worktables, an air of vulnerability pervaded the site, a sensation heightened by the neighboring reconstruction of Ground Zero.

After all these years the monument is in remarkably good shape, which may be because it was placed deep enough on the chapel's porch to protect it from the elements. The only secret that the restoration revealed is that the monument, which backs onto a mullioned window, is attached to a brick wall held in place by a wooden frame. This was the casing built to fit around the monument by L'Enfant, to which he attached a plaster body inscribed with symbols for a new nation. Seen from the front, it looks as if Montgomery is framed by these aerial symbols of an eagle pulling back the curtain to reveal a sunrise with 13 rays of light illuminating the United States on a floating

globe. Now cleaned and restored, the Revolutionary War monument and its frame are more visible. Together with the contemporary objects honoring the firemen and first responders who helped in the 911 recovery and who are commemorated inside, and like the city itself, the church survives, as does this little-known monument.

Notes

1 "The nine cases baled and sealed with lead containing the carved marble sent by M. Caffiéri, the King's carver directed to Mr. Walker, Sr. Inspector General of the Manufactories at Rouen are marked M.C. No. 1 to 9 for the Islands. Shipped in Vincent Bedouin's boat. Sailed Oct. 28, 1777," *Papers of the Continental Congress*, microfilm 247, reel 72, item 59, vol. 1, p. 29.

2 Ibid., 15 and 17.

3 Franklin, Deane, and Lee to Committee of Foreign Affairs November 30, 1777, in *The Revolutionary Diplomatic Correspondence of the United States* (6 vols. Washington: Government Printing Office, 1899), 2: 438. In this same letter Franklin acknowledged that he knew Congress had voted to have other monuments commissioned "but we have received no orders relating to them." The other monuments that Franklin referred to were ones for Generals Joseph Warren (April 12, 1777), Hugh Mercer (April 12, 1777), and David Wooster (May 19, 1777).

4 Franklin, Passy, France, to James Hutton, June 23, 1778 (Leonard W. Labaree et al., eds. *The Papers of Benjamin Franklin* (40 vols. to date, New Haven, Yale University Press, 1959–), 26: 674.

5 Like many other Revolutionary War monuments, those marking victories at Saratoga and Yorktown were not completed until late in the nineteenth century. The *Yorktown Victory Monument*, which was authorized by the Continental Congress in 1781, was not completed until 1884 by the architects Richard Morris Hunt and Henry Van Brunt, and the sculptor John Quincy Adams Ward. The *Saratoga Battle Monument* was finished in 1886 by the architect Jared Markham with standing bronze statues by George Bissell, Alexander Doyle, and William O'Donovan.

6 The inscription referred to by Franklin is hand printed in French on the print and details Montgomery's death in Quebec, the order from Congress, Franklin's involvement with the commission, and its design by Caffiéri. On the plate it reads: "A la Gloire de Richard Montgomery Major Général des Armée des Etats unis Américains tué au siege de Quebec le 31 Decembre 1775 agé de 38 ans." Below the plate and on the margin is a longer inscription and repeats some of the material from above with the addition, "pour être place dans la grand sale ou se tiennent les etats generaux à Philadelphia." The inscription then continues with the details of the commission: "Ce tombeau a été invente et execute en Marbre à Paris par J. J. Caffiery Sculpteur de Roi in 1777." In the mid- to late eighteenth century Saint-Aubin was a distinguished portrait engraver and earlier had undertaken engravings of Helvétius, Caffiéri, and Franklin.



7 A good discussion of the critical issues surrounding military pensions is included in Minor Myers, Jr. *Liberty without Anarchy: A History of the Society of the Cincinnati* (Charlottesville: University Press of Virginia, 1983; paperback ed., 2004), 1–22.

8 *Journals of the Continental Congress, 1774–1789*, ed. Worthington C. Ford et al. (34 vols, Washington, Government Printing Office, 1904–37), 27: 697 and 700. The first choice for a "federal city" was on the west side of New Jersey, but this resolution was not passed and "Georgetown on the Potomac" was substituted. This resolution was not adopted, and further suggestions were put forth for Trenton, Philadelphia, Newport, and New York. The latter was chosen as a temporary capital and became the nation's first city on January 11, 1785.

9 De Witt, ibid. (June 1, 1784), 27: 504–5. De Witt's resolution read in full: "Whereas on the 25th day of January, 1776 Congress did resolve that a monument be procured in Paris, or any other place in France, with an inscription sacred to the Memory of General Montgomery; which, in consequence thereof, was procured and sent to the care of Mr. Hewes in North Carolina, and is now in the care of his executors. That the executors of Joseph Hewes, esq., or the person in whose hands the Monument is, be requested to deliver the same to the order of Superintendent of finance, to be transferred [missing text] may judge proper; and that the expense accruing thereon, be paid by the United States of America." De Witt, a lawyer from Ulster County on the west bank of the Hudson, had for many years been a representative to the colonial and then the state assembly.

10 November 1784, Joint Resolution requesting that the Hewes descendants send the monument to New York, *New York Assembly Journal*, 8th Session; 76, and *Votes and Proceedings of the Senate*, November 26, 1784.

11 Edwin G. Burrows and Mike Wallace, *Gotham: A History of New York City to 1898* (New York: Oxford University Press, 1999), 265.

12 Stokes, *The Iconography of Manhattan Island, 1498–1909* (6 vols: New York: R.H. Dodd, 1915–1928), 1: 368.

13 Ibid. 221.

14 Ron Chernow, *Alexander Hamilton* (New York: Penguin Press, 2004), 186.

15 For an important description of the New York loyalists' situation at the end of the war, see ibid., 155–95.

16 George Clinton, New York, to Col. Thomas Pickering, Philadelphia, March 14, 1785, Box 579, Cong. 1, "Gift," Trinity Church Archives, New York.

17 Timothy Pickering, Philadelphia, to David Wolfe, New York, October 18, 1785, ibid.

18 Franklin to Jay; August 24, 1786, *Papers of Benjamin Franklin*, 44: 278.

19 *Minutes of the Common Council*, March 21, 1787, 1: 285. The monument was shipped to New York sometime in May since it was put in storage before being delivered to St. Paul's. See notice of payment to James Watson for 5 pounds, 2 pence for "storage [of the] Monument to Gen'l Montgomery." *Minutes of the Common Council*, May 16, 1787, 1: 296.

20 Thomas Jefferson, "Letter to the Danbury Baptists," January 1, 1802. *The Papers of Thomas Jefferson*, 41 vols. (Princeton University Press, 1950-), 36: 258.

21 Ibid., April 3, 1787, 1: 190.

22 The wording of the announcement to the vestry of Trinity Church is virtually the same as what was given to the Common Council: "Mr. Duane further reported that at the request of the Corporation of the City, the Committee had given permission for the Monument of Gen'l Montgomery to be erected under the Portico of St. Paul's Chapel in front of the great Window. Resolved that this board so approve of the Proceedings of the Committee and hereby ratify the same. "Minutes of the Vestry of Trinity Church," May 23, 1787, 489, Trinity Wall Street Archives, New York.

23 See H. Paul Caemmerer, *The Life of Pierre Charles L'Enfant: Planner of the City Beautiful, the City of Washington* (Washington, D.C.: National Republic Publishing Company, 1950), 103.

24 It is often noted that St. Paul's Chapel, built between 1764 and 1768, was designed by the Scots architect Thomas McBean, who trained with James Gibbs of London, but this attribution cannot be confirmed. Vestry minutes, however, do note that master craftsman Andrew Gautier was the builder of the chapel, and that James Crommelin Lawrence designed the steeple in the 1790s.

25 "Minutes of the Vestry of Trinity Church," May 23, 1787, 489.

26 Ibid., June 18, 1787, 492.

27 For an important analysis of L'Enfant's *Glory* and its relationship to French examples, see Michael Paul Driskel, "By the Light of Providence: The Glory Altarpiece at St. Paul's Chapel, New York City," *Art Bulletin*, 89, no. 4 (December 2007): 715–37. Also see Margaret Elliman Henry, "L'Enfant and St. Paul's Chapel," *Trinity Parish Herald* (October/November 1947), 464.

28 Traditionally the younger L'Enfant is referred to as Pierre-Charles to differentiate him from his father. Also, his father's name is often given as Lenfant. Some recent historians and writers also refer to Pierre-Charles as Peter, the name he himself used in his correspondence as a sign of his allegiance to his adopted country.

29 Caemmerer, *The Life of Pierre Charles L'Enfant*, 25. The most recent biography of L'Enfant is Scott Berg, *Grand Avenue, the Story of the French Visionary who Designed Washington, D.C.* (New York: Pantheon, 2007). Also see Kenneth R. Bowling, *Peter Charles L'Enfant: Vision, Honor and Male Friendship in the Early American Republic* (Washington, D.C.: Friends of the George Washington University Libraries, 2002); Elizabeth S. Kite, *L'Enfant and Washington, 1791–1792* (Baltimore: Johns Hopkins University Press, 1929); and J.J. Jusserand, "Major L'Enfant and the Federal City," in his *With Americans of Past and Present Days* (New York: Charles Scribner's Sons, 1916), 137–95.

30 Approved by Congress, March 29, 1779, Steuben's manual was officially called, *Regulations for the Order and Discipline of the Troops of the United States*. L'Enfant did eight illustrations for which he received $500 from Congress; see Bowling, *Peter Charles L'Enfant*, 5.

31 La Luzerne wrote to Washington asking permission for L'Enfant's services. George Washington, Newburgh, NY, to Anne-Cesar, chevalier de la Luzerne, Philadelphia, 27 April 1782, George Washington Papers, Library of Congress, 1741–1799, Digital Edition, ed. John C. Fitzpatrick, Letterbook 2: 19, no. 299.

32 The most thoroughgoing discussion of the importance of these celebrations in America is William C. Stinchcombe's "Americans Celebrate the Birth of the Dauphin," in *Diplomacy and Revolution: The Franco-American Alliance of 1778*, ed. Ronald Hoffman and Peter J. Albert (Charlottesville: University Press of Virginia, 1981), 39–72. Also see Beverly Orlove Held, "'To Instruct and Improve ... to Entertain and Please': American Civic Pageants, 1765.1784," PhD diss., University of Michigan, Ann Arbor, 1987.

33 *Philadelphia Freeman's Journal*, July 31, 1782, 1.

34 Richard Patterson and Richardson Dougall, *The Eagle and the Shield: A History of the Great Seal of the United States* (Washington, D.C.: Office of the Historian, 1978), 61. Charles Thomson, secretary of Congress, who worked on the third design for the Great Seal noted in his "Remarks and Explanations," which he submitted to Congress June 20, 1782, that "the Escutcheon is born on the breast of an American Eagle." 85.

35 Ibid., 6.

36 Ibid., 10–13.

37 Frank H. Sommer, III, "Emblem and Device: The Origin of the Great Seal of the United States," *Art Quarterly* 24 (Spring 1961): 68.

38 Ibid.

39 Ibid., 68 and 71.

40 Ibid., 71.

41 Patterson and Dougall, *Eagle and Shield*, 85.

42 Ibid., 84–5.

43 For instance Robert R. Livingston gave the oration, *An Oration Delivered before the Society of the Cincinnati of the State of New-York; in Commemoration of the Fourth Day of July(1786)* (New York: Francis Child, 1787), 178.

44 *"Memorial from the officers of the army,"* December 1782, *Journals of the Continental Congress*, vol. 24 (April 1783), 290–93.

45 "To the Officers of the Army," paper No. 2, ibid., 296.

46 Ibid., 297.

47 George Washington, "Address," March 15, 1783, Cantonment (Newburgh, NY), paper No. 5, ibid., 306–7.

48 Ibid., 309.

49 Hume, ed., *General Washington's Correspondence*, 6–8.

50 Ibid., 8.

51 Ibid., xii–xiii.

52 George Washington to Major-General Henry Knox, Rocky Hill, NJ, October 16, 1783, ibid., 22–3.

53 Ibid., 20–21.

54 The diploma was drawn by Augustin-Louis La Belle and its copperplate
 engraved by Jean Jacques André Le Veau. See ibid., xv.

55 E. McClung Fleming, "From Indian Princess to Greek Goddess: The American
 Image, 1783–1815," *Winterthur Portfolio*, 3 (1967): 39.

56 Ibid.

57 Myers, *Liberty without Anarchy*, 54.

58 Ibid., 94.

59 Ibid., 86–7.

60 Ibid., 91.

61 See: Whitfield J. Bell, "The Federal Processions of 1788," *New-York Historical
 Society Quarterly* 46, no. 1 (January 1962): 5–39.

62 See Sarah H. J. Simpson, "The Federal Procession in the City of New York," *New-
 York Historical Society Quarterly Bulletin* 9 (1926): 39–57.

63 Ibid., 45.

64 Berg, *Grand Avenues*, 64.

65 Federal Hall, formerly colonial New York's city hall, was demolished in 1812 and
 replaced by the Greek-Revival style United States Custom House (1833–1842)
 designed by the New York architects Ithiel Town and Alexander Jackson Davis,
 and the sculptor John Frazee. From 1862 until 1920 it served as the Federal Sub-
 Treasury Building. In 1939 the building was declared a Federal Hall Memorial
 National Historic Site, renamed Federal Hall National Memorial, and its
 operation overseen by the National Park Service. Sections of the balcony where
 George Washington was inaugurated are in the collections of the New-York
 Historical Society.

66 New York *Gazette of the United States*, April 22, 1789.

67 Thomas E.V. Smith, *The City of New York Washington's Inauguration* (New York:
 privately printed, 1889), 219.

68 Ibid., 220. It was later the residence of Samuel Osgood, a member of the Treasury
 Department.

69 Quoted in Stokes, *Iconography* 5: 1245.

70 Recounted in Thomas E.V. Smith, *The City of New York in the Year of Washington's
 Inauguration*, 223.

71 Ibid., 228.

72 Ibid., 229.

73 United States Constitution, article 2, Section 1, Clause 8.

74 *New York Daily Advertiser*, November 22, 1787, reprinted in Stokes, *Iconography* 5:
 1222.

75 Ibid., October 27, 1788.

76 According to "Minutes of the Vestry of Trinity Church," October 7, 1785: "RESOLVED that the Committee of Repairs procure a painter to paint the Arms of the United States to be put up in St. Paul's Church."

77 Commissioned by Congress to celebrate the centennial of Washington's birth, Horatio Greenough's *Washington*, originally planned for the Rotunda of the United States Capitol, is a classically inspired sculpture of a semi-nude figure. It was not well received and was relegated for 65 years to the east lawn of the Capitol. In the early twentieth century it was transferred to the Smithsonian Institution and installed in the National Museum of American History.

78 Wayne Craven, *Sculpture in America* (New York: Thomas Crowell, 1968), 46–83.

79 Such a list was compiled from the *Journals of the Continental Congress* by Benjamin H. Irvin and published in *Clothed in Robes of Sovereignty: The Continental Congress and the People Out of Doors* (New York: Oxford University Press, 2011), 219. It included: Maj. Gen. Joseph Warren and Brig. Gen. Hugh Mercer, both honored April 12, 1777; Brig. Gen. David. Wooster, May 19, 1777; Brig. Gen. Nicholas Herkimer, October 4, 1777; Brig. Gen. Francis Nash, November 4, 1777; Brig. Gen. Casimir Pulaski, November 29, 1779; Maj. Gen. Baron de Kalb, October 14, 1780; Brig. Gen. William Lee Davidson and Brig. Gen. James Screven, both September 20, 1781; and Maj. Gen. Nathanael Greene upon his death October 1787. A monument to the prison ship martyrs was designed by Stanford White for Brooklyn's Fort Greene Park (which itself was named to honor Nathanael Greene) in 1907.

80 *Journals of the Continental Congress,* 24: 494–5. The congressional stipulation that Washington be represented in Roman dress with laurel wreath and truncheon was to recall the Roman equestrian of *Marcus Aurelius*, AD 161–80 for the Piazza del Campidoglio, Rome. The *Marcus Aurelius* also served as a model for the George III equestrian monument placed in New York's Bowling Green that was destroyed in 1776. Arthur S. Marks, "The Statue of King George III in New York and the Iconology of Regicide," *American Art Journal* 13 (Summer 1981): 72.

81 Jefferson noted in a letter to members of the Virginia legislature that the principal reason for Houdon's trip was "to make General Washington's Equestrian statue for Congress." Quoted in Charles Henry Hart and Edward Biddle, *Memoirs of the Life and Works of Jean Antoine Houdon the Sculptor of Voltaire and of Washington* (Philadelphia: privately printed, 1911), 191.

82 Houdon exhibited a small-scale "statuette" (now lost) of the equestrian at the Salon of 1793. Ibid., 195.

83 There were some local monuments built by native artisans such the *Monument to Major-General Joseph Warren and Associates*, ca. 1794, brick and wood, 28 feet, commissioned from an unknown artist by King Solomon's Lodge of Freemasons (now contained within Bunker Hill Monument). And that same decade citizens of Lexington petitioned Massachusetts for funds to construct a stone monument dedicated to the sons of Lexington who lost their lives in the heroic standoff in April 19, 1775. Completed in 1799, the obelisk- shaped monument still stands on Lexington Green. There was also another monument by a European sculptor, the Tripoli Memorial (1806–1808), by the little-known Italian artist Charles Micali. Commissioned by naval officers to honor the American navy's success

in defeating the Barbary pirates on the north coast of Africa, it was originally planned for Washington, D.C., but is now at the Naval Academy in Annapolis, Maryland.

84 Hart and Biddle, *Houdon*, 183.

85 *Annals of Congress*, House of Representatives, 18th Congress, 1st Session, January 1824, 1044.

86 Ibid., 1045.

87 Ibid., 1046.

88 The tortured history of the Washington obelisk is told by Kirk Savage in "The Self-made Monument: George Washington and the Fight to Erect a National Monument," Harriet F. Senie and Sally Webster, eds., *Critical Issues in Public Art: Content, Context and Controversy* (New York: IconEditions, Harper Collins, 1992), 5–32.

89 For the early history of the Bunker Hill Monument Association, see George Washington Warren, *The History of the Bunker Hill Monument Association during the First Century of the United States of America* (Boston: J.R. Osgood, 1877). One of the few studies to incorporate colonial monuments into a post-Revolutionary context is Pamela Scott, "Robert Mills and American Monuments," in John M. Bryan, ed. *Robert Mills Architect* (Washington: American Institute of Architects, 1989), 143–8.

Bibliography

Manuscript Sources

American Antiquarian Association, Worcester, MA
 Graphic arts
 Newspapers and periodicals

American Philosophical Society, Philadelphia
 Benjamin Franklin Papers
 Charles Willson Peale Papers

Columbia University, New York, Avery Library
 Pierre-Charles L'Enfant files

Louvre Museum, Paris
 Department of Sculpture curatorial files on Jean-Jacques Caffiéri

New York Public Library
 Bancroft Transcripts, Robert R. Livingston Papers
 Thomas Addis Emmet Collection of Manuscripts, etc., relating to American History

Royal Society of Arts, London
 Minutes of the Society Committees, 1758–1762

Trinity Wall Street Archives, New York
 Vestry minutes
 Photographic and archival files

Printed Primary Sources

Annual Register or a View of the History, Politicks, and Literature … 9 (December 1766): 106, and 15 (December 1772): 132.

Anonymous. *A Description of the Gardens of Lord Viscount Cobham, at Stow[e] in Buckinghamshire*. Northampton, UK: 744.

Bangs, Edward, ed. *Journal of Lieutenant Isaac Bangs, April 1 to July 29, 1776.* Cambridge: John Wilson and Son, 1890.

Berkeley, George. The *Works of George Berkeley, Bishop of Cloyne.* A.A. Luce and T. E. Jessop, eds. 9 vols. London and New York: Thomas Nelson, 1948–1957.

Bickham, George. *The Beauties of Stowe: or, a Description of the Pleasant Seat, and Noble Gardens …* London, 1750.

Boyd, Julian P., ed. *The Papers of Thomas Jefferson.* 41 vols., Princeton: Princeton University Press, 1950–.

Brackenridge, Hugh Henry. *The Death of General Montgomery in Storming the City of Quebec.* Philadelphia: R. Bell, 1777.

Brigham, Charles S. *Paul Revere's Engravings,* Worcester, MA: American Antiquarian Society, 1954; rev. edn, New York: Athenaeum, 1969.

Catalogue of Paintings by Colonel Trumbull. New Haven: Yale College, 1835.

Caylus, Anne Claude Philippe. *Recueil d'antiquités, égyptiennes, étrusques, grecques et romaines* (7 vols, Paris: Desaint et Saillant, 1756–1767).

Chastellux, François-Jean, marquis de. *Travels in North America in the Years 1780, 1781 and 1782.* Revised translation by Howard C. Rice, Jr. 2 vols. Chapel Hill: University of North Carolina Press, 1963.

The Colonial Laws of New York from the Year 1664 to the Revolution … 5 vols. Albany, NY, 1894.

Continental Congress. *Annals of the Congress of the United States.*

De Lancey, Edward Floyd, ed. Thomas Jones. *History of New York during the Revolutionary War and of the Leading Events in the other Colonies of that Period.* 2 vols. New York: New York Historical Society, 1879.

———. *New York and Admiral Sir Peter Warren at the Capture of Louisbourg 1745: An Address at the Inauguration of the Monument at Louisbourg on the One Hundred and Fiftieth Anniversary of its Capture.* New York: Society of Colonial Wars, 1895.

De Lancey, James. "Address to the Council and General Assembly," December 6, 1759. *Journal of the Votes and Proceedings of the General Assembly of the Colony of New York …, 1665–1765,* 2 vols. New York: Hugh Gaine, 1766.

Delafield, John Ross, ed. "Reminiscences Written by Janet Livingston, Widow of General Richard Montgomery." *Year Book of the Dutchess County Historical Society* 15 (1930): 45–76.

Downing, Andrew Jackson. "A Visit to Montgomery Place." *The Horticulturist and Journal of Rural Art and Rural Taste* 2 (October 1847): 153–60.

Foner, Philip, ed. *The Complete Writings of Thomas Paine …,* 2 vols. New York: Citadel Press, 1945.

Ford, Worthington C., et al., eds. *Journals of the Continental Congress, 1774–1789.* 35 vols. Washington: Government Printing Office, 1904–1976. Also located on "American Memory" website, Library of Congress: http://memory.loc.gov/ ammem/amlaw/lawhome.html.

Freeman's Journal. Philadelphia: F. Bailey, 1781–1792.

Hesiod. *Works and Days.* Translated by Glenn W. Most. Cambridge, MA: Harvard University Press, 2006.

An Historical Catalogue of Peale's Collection of Paintings. Philadelphia: Richard Folwell, 1795.

Hume, Edgar Erskine, ed. *General Washington's Correspondence Concerning the Society of the Cincinnati.* Baltimore: John Hopkins University Press, 1941.

Hunt, Louise Livingston. *Biographical Notes Concerning General Richard Montgomery, Together with Hitherto Unpublished Letters.* Poughkeepsie, NY, 1876.

———. "General Richard Montgomery." *Harper's Magazine* 70, no. 417 (February 1885): 350–59.

Ingersoll-Smouse, Florence. "Lettres inédites de J.-J. Caffiéri." *Bulletin de la Société de 'histoire de l'art français* 3 (1913): 202–22.

Journals of the Provincial Congress, Provincial Convention, Committee of Safety and Council of Safety of the State of New York, 1775–1777. 2 vols, Albany, 1842.

Labaree, Leonard W., ed., et al. *The Papers of Benjamin Franklin.* 40 vols. to date. New Haven: Yale University Press, 1959–.

Letters of Delegates to Congress, 1774–1789. 26 vols, Washington, D.C.: Library of Congress, 1976–2000.

Livingston, Robert R. *An Oration Delivered before the Society of the Cincinnati of the State of New-York; in Commemoration of the Fourth Day of July [1786].* New York: Francis Childe 1787.

Miller, Lillian B., ed., *The Selected Papers of Charles Willson Peale and His Family.* New Haven: Yale University Press, 1983.

Montfaucon, Bernard de. *Les Monumens de la monarchie françoise, qui comprennant l'histoire de France, avec les figures de chaque, régnie que l'injure des tems à épargnée* (5 vols, Paris: F. Delaulne, 1722) and translated by David Humphreys as *Antiquity Explained and represented in sculptures* (5 vols, London: J. Tonson and J. Watts, 1725).

———. *Supplement au livre de L'antiquité expliquée …* (5 vols, Paris: F. Delaulne, 1724) translated by David Humphreys as *The Supplement to Antiquity explained, and Represented in Sculptures* (5 vols, London: J. Tonson and J. Watts, 1725).

Montgomery, Thomas H. "Ancestry of General Richard Montgomery," *New York Genealogical and Biographical Record* 2 (July 1871): 129.

Morse, Jedidiah. *A True and Authentic History of His Excellency George Washington … Also, of the Brave Generals Montgomery and Greene … To which is Added an Ode on General Washington's Birth Day. By the Reverend Mr. Thomas Thornton.* Philadelphia: printed by Peter Stewart, 1790.

Murray, James. *An Impartial History of the War in America between Great Britain and the United States.* Boston: Nathaniel Coverly and Robert Hodge, 1781–1784.

New York broadside. *To the Sons of Liberty in this City.* February 3, 1770.

New York City Common Council. *Minutes of the Common Council of the City of New York, 1675–1776*, Osgood, Herbert L, ed. 8 vols. New York, 1905.

New York Colony. *Journal of the Votes and Proceedings of the General Assembly of the Colony of New York, from 1766 to 1776, Inclusive.* 9 vols. in 1. Albany, 1820.

Papers of the Continental Congress. Washington, D.C.: National Archives, 1958–1959.

Pindar. *Olympian.* Cambridge, MA: Harvard University Press, 1997.

The Revolutionary Diplomatic Correspondence of the United States. 6 vols. Washington: Government Printing Office, 1899,

Scull, G.D., ed. *The Montresor Journals in Collections of the New-York Historical Society for the Year 1881.* New York, 1882.

Sizer, Theodore, ed. *The Autobiography of Colonel John Trumbull.* 1953; Reprint ed., New York: Da Capo Press, 1970.

Smith, William. *The History of the Late Province of New York from Its Discovery to the Appointment of Governor Colden in 1762.* 2 vols. New York: New-York Historical Society, 1829.

Smith, William, Rev. "An oration in memory of General Montgomery, and of the officers and soldiers who fell with him, December 31, 1775, before Quebec," February 19, 1776, Philadelphia.

Stokes, I.N. Phelps. *The Iconography of Manhattan Island, 1498–1909. 6 vols.* New York: R.H. Dodd, 1915–28.

Taylor, Robert J. ed. *Papers of John Adams*. 16 vols, Cambridge: Harvard University Press, 1977.
Trumbull, John. *Autobiography, Reminiscences, and Letters*. New York, 1841.
Warren, Mercy. *History of the Rise, Progress and Termination of the American Revolution interpreted with Biographical, Political and Moral Observations*. 3 vols, Boston: E. Larkin, 1805.

Secondary Sources

Abbott, Carl, "The Neighborhoods of News York, 1760–1775," *New York History* 55 (January 1974): 35–54.
Abrams, Ann Uhry. *The Valiant Hero, Benjamin West and Grand-Style History Painting*. Washington, D.C.: Smithsonian Institution Press, 1985.
Alexander, Edward P. *A Revolutionary Conservative, James Duane of New York*. New York: Columbia University Press, 1938.
Allan, D.G.C. "'Dear and Serviceable to Each Other': Benjamin Franklin and the Royal Society of Arts." *Proceedings of the American Philosophical Society* 144 (September 2000): 245–66.
———. *The Houses of the Royal Society of Arts: A History and a Guide*. London: Royal Society of Arts, 1974.
———. *RSA, A Chronological History of the Royal Society for the Encouragement of Arts, Manufactures and Commerce*. [London: Royal Society of Arts, 1998].
———. *William Shipley, Founder of the Royal Society of Arts*. London: Hutchinson, 1968.
Allen, Brian. "The Society of Arts and the First Exhibition of Contemporary Art in 1760." *RSA Journal* 139 (1991): 265–9.
Allen, Thomas B. *Tories Fighting for the King in America's First Civil War*. New York: Harper Collins, 2010.
Anderson, Fred. *Crucible of War: The Seven Years' War and the Fate of Empire in British North America, 1754–1766*. New York: Alfred A. Knopf, 2000.
Anderson, R.B.W., et al. *Enlightening the British: Knowledge, Discovery and the Museum in the Eighteenth Century*. London: British Museum Press, 2003.
Andrews, William Loring. "Early American Copperplate Engraving." *The Book Buyer* 15 (January 1898): 653–8.
Art in New England: Early New England Printmakers. Worcester, MA: Worcester Art Museum, 1939.
Ayres, Philip. *Classical Culture and the Idea of Rome in Eighteenth-Century England*. Cambridge and New York: Cambridge University Press, 1997.
Babbitt, Katherine M. *Janet Montgomery, Hudson River Squire*. Monroe, NY: Library Research Associates, 1975.
Becker, Carl. "Growth of Revolutionary Parties and Methods in New York Province 1765–1774." *The American Historical Review* 7, no. 1 (October 1901): 56–76.
Bederman, David J. *The Classical Foundations of the American Constitution: Prevailing Wisdom*. Cambridge and New York: Cambridge University Press, 2008.
Beiswanger, William L. "Thomas Jefferson's Vision of the Monticello Landscape." In *British and American Gardens in the Eighteenth Century*. Williamsburg, VA: Colonial Williamsburg Foundation, 1984.
Bell, Whitfield J. "The Federal Processions of 1788." *New-York Historical Society Quarterly* 46, no. 1 (January 1962): 5–39.

Berg, Scott. *Grand Avenue, the Story of the French Visionary who Designed Washington, D.C.* New York: Pantheon, 2007.

Bindman, David, and Malcolm Baker, *Roubiliac and the Eighteenth-Century Monument: Sculpture as Theatre.* New Haven: Published for the Paul Mellon Centre for Studies in British Art by Yale University Press, 1995.

Bishop, Joseph Bucklin. *The Chronicle of One Hundred Fifty Years: The Chamber of Commerce of the State of New York, 1768–1918.* New York: Charles Scribner's Sons, 1918.

Bolton, Reginald Pelham. *Washington Heights, Manhattan, Its Eventful Past.* New York: Dyckman Institute, 1924.

Bond, W.H. *Thomas Hollis of Lincoln's Inn: A Whig and His Books.* New York: Cambridge University Press, 1990.

Bonomi, Patricia, U. *A Factious People: Politics and Society in Colonial New York.* New York: Columbia University Press, 1971.

Bowling, Kenneth R. "New York City, Capital of the United States 1785–1790." In Stephen L. Schechter and Wendell Tripp, eds. *World of the Founders, New York Communities in the Federal Period*, 1–23. Albany, NY: State Commission on the Bicentennial of the United States Constitution, 1990.

———. *Peter Charles L'Enfant: Vision, Honor and Male Friendship in the Early American Republic.* Washington, D.C.: Friends of George Washington University Libraries, 2002.

Brands, H.W. *The First American: The Life and Times of Benjamin Franklin.* New York: Doubleday, 2000.

Bridenbaugh, Carl. *Cities in Revolt: Urban Life in America, 1743–1776.* New York: Knopf, 1955; Oxford University Press paperback, 1971.

Bullock, Alan. *The Humanist Tradition in the West.* New York: W.W. Norton, 1985.

Bullock, Steven C. *Revolutionary Brotherhood: Freemasonry and the Transformation of the American Social Order, 1730–1840.* Chapel Hill: University of North Carolina Press for the Institute of Early American History and Culture, 1996.

Burrows, Edwin G. and Mike Wallace. *Gotham: A History of New York City to 1898.* New York: Oxford University Press, 1999.

Bushman, Richard L. *The Refinement of America: Persons, Houses, Cities.* New York: Alfred A. Knopf, 1992.

Caemmerer, H. Paul. *The Life of Pierre Charles L'Enfant, Planner of the City Beautiful, the City of Washington.* Washington, D.C.: National Republic Publishing Co., 1950.

Champagne, Roger J. "Family Politics versus Constitutional Principles: The New York Assembly Elections of 1768 and 1769." *The William and Mary Quarterly* 20, no. 1 (January 1963): 57–79.

———. "Liberty Boys and Mechanics of New York City, 1764–1774," *Labor History* 8, no. 2 (1967): 115–35.

———. "New York's Radicals and the Coming of Independence," *The Journal of American History* 51, no. 1 (June 1964): 21–40.

Chancellor, E. Beresford. *The Lives of British Sculptors and Those Who Have Worked in England …* London: Chapman and Hall, 1911.

Chernow, Ron. *Alexander Hamilton.* New York: Penguin Press, 2004.

Chopra, Ruma. *Unnatural Rebellion: Loyalists in New York City during the Revolution.* Charlottesville: University of Virginia Press, 2011.

Cooper, Helen A. *John Trumbull: The Hand and Spirit of a Painter.* New Haven: Yale University Art Gallery, 1982.

Countryman, Edward. *A People in Revolution: The American Revolution and Political Society in New York, 1760–1790.* Baltimore: Johns Hopkins University Press, 1981. Reprint, New York: W.W. Norton, 1989.

Coutu, Joan. "Eighteenth-Century British Monuments and the Politics of Empire," Ph.D. diss., University College, London, 1993.

———. *Persuasion and Propaganda: Monuments and the Eighteenth-Century British Empire.* Montreal: McGill-Queen's University Press, 2006.

Crane, Verner, W. "Benjamin Franklin and the Stamp Act," 56–77. In *Transactions of the Colonial Society of Massachusetts* 32. Boston: 1934.

Craske, Matthew. "Westminster Abbey 1720–70: A Public Pantheon Built upon Private Interest." In Richard Wrigley and Matthew Craske, eds. *Pantheons: Transformations of a Monumental Idea,* 57–79. Aldershot, UK and Burlington, VT: Ashgate Publishing, 2004.

Craven, Wayne. *Sculpture in America.* New York: Thomas Crowell, 1968.

Cumming, W.P. "The Montresor-Ratzer-Sauthier Sequence of Maps of New York City, 1766–76" *Imago Mundi* 31 (1979), 545–65.

Dangerfield, George. *Chancellor Robert R. Livingston of New York, 1746–1813.* New York: Harcourt, Brace, 1960.

Dawson, Henry B. *The Park and Its Vicinity, in the City of New York.* Morrisania, NY, 1867.

Desjardin, Thomas A. *Through a Howling Wilderness: Benedict Arnold's March to Quebec, 1775.* New York: St. Martin's Press, 2006; Griffin Edition, 2007.

Dix, Morgan. *A History of the Parish of Trinity Church in the City of New York.* New York: Putnam, 1898.

Driskel, Michael Paul. "By the Light of Providence: The Glory Altarpiece at St. Paul's Chapel, New York City," *The Art Bulletin* 89, no. 4 (December 2007): 715–37.

Dowley, Francis H. "D'Angiviller's *Grands Hommes* and the Significant Moment," *Art Bulletin* 39, no. 4 (December 1957), 259–77.

Draper, James, and Guilhem Scherf. *Augustin Pajou, Royal Sculptor, 1730–1809* (New York: Metropolitan Museum of Art, 1998).

Dunlap, William, *History of the Rise and Progress of the Arts of Design in the United States.* 3 vols. New York, 1834; reprint ed. edited by Rita Weiss. New York: Dover Publications, 1969.

Du Ponceau, Peter Stephen. *An Historical Account of the Origin and Formation of the American Philosophical Society.* Philadelphia: American Philosophical Society, 1914.

Echeverria, Durand. *Mirage in the West: A History of the French Image of American Society to 1815.* Princeton: Princeton University Press, 1957.

Eells, Walter Crosby. "Benjamin Franklin's Honorary Degrees," *College and University* (Fall 1961): 5–26.

Egnal, Marc, and Joseph Ernst. "An Economic Interpretation of the American Revolution." *The William and Mary Quarterly* 29, no. 1 (January 1972): 3–32.

"The Elusive Monument Erected to General James Wolfe." *New-York Historical Society Quarterly Bulletin* 4, no. 3 (October 1920): 74.

Eustace, Katharine. *Michael Rysbrack, Sculptor 1694–1770.* Bristol: City of Bristol Museum and Art Gallery, 1982.

Evans, Dorinda. *Benjamin West and his American Students.* Washington, D.C.: National Portrait Gallery, 1980.

Fehl, Phillip. "John Trumbull and Robert Ball Hughes's Restoration of the Statue of Pitt the Elder." *The New-York Historical Society Quarterly* 56, no. 1 (January 1972): 8–28.

Fleming, E. McClung. "The American Image as Indian Princess, 1765–1783." *Winterthur Portfolio* 2 (1965): 65–81.

———. "From Indian Princess to Greek Goddess, the American Image, 1783–1815." *Winterthur Portfolio* 3 (1967): 37–66.

Fortune, Brandon Brame. "Portraits to Virtue and Genius: Pantheons of Worthies and Public Portraiture in the Early American Republic, 1780–1820." PhD diss., University of North Carolina, 1986.

French, Hollis. *Jacob Hurd and His Sons Nathaniel and Benjamin*. Cambridge, MA: Riverside Press, 1939.

Frost, Joseph William P. Pepperell. "Living with Antiques: Pepperell Mansion, Kittery Point, Maine." *Antiques* 89 (March 1966): 368–73.

Gabriel, Michael P. *Major General Richard Montgomery: The Making of an American Hero*. Madison, NJ: Fairleigh Dickinson University Press and Associated University Press, 2002.

Gaustad, Edwin S. *George Berkeley in America*. New Haven: Yale University Press, 1979.

Gerlach, Don R. *Proud Patriot: Philip Schuyler and the War of Independence, 1775–1783*. Syracuse: Syracuse University Press, 1987.

Gothein, Marie Luise. *A History of Garden Art*. Edited by Walter R. Wright, translated by Laura Archer-Hind. 2 vols. New York: E.P. Dutton, 1928.

Grey, Peter P. *The First Two Centuries: An Informal History of the New York Chamber of Commerce*. New York: New York Chamber of Commerce, 1968.

Guiffrey, Jules. *Les Caffiéri, Sculpteurs et Fondeurs-Ciseleurs*. Paris: D. Morgand et C. Fatout, 1877. Reprint, Nogent Le Roi: Jacques Laget, 1993.

Gummere, Richard M. *The American Colonial Mind and the Classical Tradition: Essays in Comparative Culture*. Cambridge, MA: Harvard University Press, 1963.

Gwyn, Julian. *An Admiral for America: Sir Peter Warren, Vice Admiral of the Red, 1703–1752*. Gainesville, Florida: University Press of Florida, 2004.

———. *The Enterprising Admiral: The Personal Fortune of Admiral Sir Peter Warren*. Montreal: McGill-Queen's University Press, 1974.

———. "Money Lending in New England: The Case of Admiral Sir Peter Warren and His Heirs 1739–1805." *The New England Quarterly* 44, no. 1 (March 1971): 117–34.

Hale, Edward E., and Edward E. Hale, Jr. *Franklin in France*. 2 vols. (Boston: Roberts Brothers, 1888).

Hall, Edward Hagaman, and Jennie F. Macarthy, "Monument to General James Wolfe," *Annual Report of the American Scenic and Historic Preservation Society to the Legislature of the State of New York* (1914): 112–20.

Halsey, R.T. Haines. "America's Obligation to William Pitt, Earl of Chatham," *The Metropolitan Museum of Art Bulletin* 13, no. 6 (June 1918): 138–43.

———. "'Impolitical Prints' The American Revolution as Pictured by Contemporary English Caricaturists: An Exhibition." *Bulletin of the New York Public Library* 43 (November 1939): 795–829.

Hart, Charles Henry. "Charles Willson Peale's Allegory of William Pitt, Earl of Chatham." *Proceedings of the Massachusetts Historical Society* 5 (1915): 291–303.

———, and Edward Biddle. *Memoirs of the Life of Jean Antoine Houdon, the Sculptor of Voltaire and Washington*. Philadelphia: privately printed, 1911.

Held, Beverly Orlove. "'To Instruct and Improve … to Entertain and Please': American Civic Protests and Pagents." PhD diss., University of Michigan, 1987.

Henry, Margaret Elliman. "L'Enfant and St. Paul's Church." *Trinity Parish Herald* (October/November 1947): 17–19.

Hershkowitz, Leo. "Federal New York: Mayors of the Nation's First Capital." In *World of the Founders: New York Communities in the Federal Period*, ed. Stephen L. Schechter and Wendell Tripp, 25–55. Albany, NY: State Commission on the Bicentennial of the United States Constitution, 1990.

Hoermann, Alfred R. *Cadwallader Colden: A Figure of the American Enlightenment*. Westport, CT: Greenwood Press, 2002.

Houston, Alan. *Benjamin Franklin and the Politics of Improvement*. New Haven: Yale University Press, 2008.

Hudson, Derek, and Kenneth W. Luckhurst. *The Royal Society of Arts, 1754–1954*. London: John Murray, 1954.

Irvin, Benjamin H. *Clothed in Robes of Sovereignty: The Continental Congress and the People Out of Doors*. New York: Oxford University Press, 2011.

Jaffe, Irma B. *John Trumbull, Patriot-Artist of the American Revolution*. Boston: New York Graphic Society, 1975.

Jasanoff, Maya. *Liberty's Exiles: America's Loyalists in the Revolutionary World*. New York: Alfred Knopf, 2011.

Jenkins, Stephen. *The Greatest Street in the World: The Story of Broadway, Old and New, from the Bowling Green to Albany*. New York: G.P. Putnam Sons, 1911.

Jones, Thomas. *History of New York during the Revolutionary War and of the Leading Events in the other Colonies at that Period.* Edward Floyd De Lancey, ed. New York: New-York Historical Society, 1879.

Jusserand, J.J. "Major L'Enfant and the Federal City." In *With Americans of Past and Present Days*. New York: Charles Scribner's Sons, 1916.

Kalnein, Wend Graf, and Michael Levey. *Art and Architecture of the Eighteenth Century in France*. Baltimore: Penguin Books, 1972.

Kammen, Michael G. *Colonial New York: A History*. New York: Scribner's: 1975; paperback, Oxford University Press: 1996.

———. *A Rope of Sand: The Colonial Agents, British Politics, and the American Revolution*. Ithaca: Cornell University Press, 1968.

Kent, Henry W. "The Monument to General Richard Montgomery." *Trinity Church Year-Book and Register*, 292–306. New York, 1929.

Ketchum, Richard M. *Divided Loyalties: How the American Revolution Came to New York*. New York: Henry Holt, 2002.

Kierner, Cynthia A. *Traders and Gentlefolk: The Livingstons of New York, 1675–1790*. Ithaca: Cornell University Press, 1992.

Kimball, Fiske. "The Beginnings of Sculpture in Colonial America." *Art and Archaeology* 8, no. 3 (May–June 1919): 184–9.

Kite, Elizabeth S. *L'Enfant and Washington, 1791–1792*. Baltimore: Johns Hopkins University Press, 1929.

Klein, Milton. "Democracy and Politics in Colonial New York." *New York History* 40 (July 1959): 221–46.

Labaree, Leonard W. "Benjamin Franklin's British Friendships." *Proceedings of the American Philosophical Society*, 108, no. 5 (October 1964): 423–8.

Lamb, Martha, and Mrs. Burton [Constance Cary] Harrison, *History of the City of New York: Its Origin, Rise, and Progress*. 3 vols. New York: A.S. Barnes and Co., 1896, originally published, 1877.

Launitz-Schűrer, Jr., Leopold S. "Whig-Loyalists: The De Lancey's of New York." *The New-York Historical Society Quarterly* 56 (July 1972): 179–98.

Lawson, Philip. "'Sapped by Corruption': British Governance of Quebec and the Breakdown of Anglo-American Relations on the Eve of Revolution." *Canadian Review of American Studies* 22, no. 3 (Winter 1991): 301.

Lee, Ronald. *Family Tree of the National Park System*. Philadelphia: Eastern National Park & Monument Association, 1972.

Lemay, J.A. Leo. "The American Aesthetic of Franklin's Visual Creations." *The Pennsylvania Magazine of History and Biography* 111 (October 1987): 465–99.

"The Liberty Pole on the Commons." *The New-York Historical Society Quarterly Bulletin* 3, no. 4 (January 1920): 109–27.

Lockwood, Alice B., ed. *Gardens of Colony and State*, 2 vols. New York: Charles Scribner's Sons, 1931.

Long, J.C. *Mr. Pitt and America's Birthright: A Biography of William Pitt Earl of Chatham 1708–1778*. New York: Frederick A. Stokes Company, 1940.

Lopez, Claude-Anne. *Mon Cher Papa: Franklin and the Ladies of Paris*. New Haven: Yale University Press, 1966.

Lossing, Benson J. "Historic Houses of America: The De Lancey Mansion." *Appleton's Journal* 2, no. 272 (June 6, 1874): 705–8.

Lovell, Margaretta M. *Art in a Season of Revolution: Painters, Artisans, and Patrons in Early America*. Philadelphia: University of Pennsylvania Press, 2005.

Lutz, Donald S. "The Relative Influence of European Writers on Late-Eighteenth-Century American Political Thought." *American Political Science Review*, 78, no. 1 (March 1984): 189–97.

Maccubbin, Robert P. and Peter Martin, eds. *British and American Gardens in the Eighteenth Century: Eighteen Illustrated Essays on Garden History*. Williamsburg, VA: Colonial Williamsburg Foundation, 1984.

Maier, Pauline. *American Scripture: Making the Declaration of Independence*. New York: Random House, 1997; New York: Vintage Books, 1998.

Manning, Susan and Francis D. Cogliano. "Introduction: The Enlightenment and the Atlantic." In *The Atlantic Enlightenment*. Aldershot, UK and Burlington, VT: Ashgate Publishing, 2008.

Marks, Arthur S. "Benjamin West and the American Revolution." *The American Art Journal* 6 (1974): 15–35.

———. "The Statue of King George III in New York and the Iconography of Regicide." *The American Art Journal* (Summer 1981): 61–82.

McNairn, Alan. *Behold the Hero: General Wolfe & the Arts in the Eighteenth Century*. Liverpool: Liverpool University Press, 1997.

Middlekauff, Robert. *The Glorious Cause: The American Revolution, 1763–1789*. New York: Oxford University Press, 1982; revised and expanded edition, 2005.

Miles, Ellen G. "Portraits of the Heroes of Louisbourg, 1745–1751." *The American Art Journal* 15, no. 1 (Winter 1983): 48–66.

Montagna, Dennis. "Benjamin West's The Death of Wolfe: A Nationalist Narrative." *The American Art Journal* 13 (Spring 1981): 72–88.

Morgan, Edmund S. *Prologue to Revolution: Sources and Documents on the Stamp Act Crisis, 1764–1766*. Chapel Hill: University of North Carolina Press, 1959.

———, and Helen M. Morgan. *The Stamp Act Crisis: Prologue to Revolution*. Chapel Hill: University of North Carolina Press, 1953.

Musée Carnavalet, Paris. *Benjamin Franklin, un Américain á Paris (1776–1785)*. Exh. cat. by Miriam Simon et al. Paris: Musée Carnavalet, 2007.

Myers, Minor, Jr. *Liberty without Anarchy: A History of the Society of the Cincinnati*. Charlottesville: University of Virginia Press, 1983; paperback ed., 2004.

Nash, Gary. *The Unknown American Revolution: The Unruly Birth of Democracy and the Struggle to Create America*. New York: Viking Press, 2005.

Nelson, Craig. *Thomas Paine Enlightenment, Revolution, and the Birth of Modern Nations*. New York: Viking, 2006.

O'Toole, Fintan. *White Savage: William Johnson and the Invention of America*. London: Faber, 2005. Reprint, New York: Farrar, Straus and Giroux, 2005.

Olson, Lester C. *Benjamin Franklin's Vision of American Community: A Study in Rhetorical Iconology*. Columbia: University of South Carolina Press, 2004.

———. *Emblems of American Community in the Revolutionary Era: A Study in Rhetorical Iconology*. Washington, D.C.: Smithsonian Institution Press, 1991.

Parkman, Francis. *Montcalm and Wolfe: The French and Indian War*. 1884; reprint ed. New York: Da Capo Press, 1984.

Patterson, Richard, and Richardson Dougall. *The Eagle and the Shield: A History of the Great Seal of the United States*. Washington, D.C.: Office of the Historian, 1978.

Pomerantz, Sidney I. *New York, an American City, 1783–1803: A Study of Urban Life*. New York: Columbia University Press, 1938.

Purcell, Sarah J. *Sealed with Blood: War, Sacrifice, and Memory in Revolutionary America*. Philadelphia: University of Pennsylvania Press, 2002.

Rantlet, Philip, ed. "Richard B. Morris's James DeLancey: Portrait in Loyalism." *New York History* 80 (April 1999): 185–210.

Réau, Louis. "Le buste en marbre de Franklin, par J.J. Caffiéri." *Gazette des Beaux-Arts* 18 (September–October 1928): 167–72.

Reinhold, Meyer. *Classical Americana: The Greek and Roman Heritage in the United States*. Detroit: Wayne State University Press, 1984.

Richard, Carl J. *The Founders and the Classics: Greece, Rome, and the American Enlightenment*. Cambridge, MA: Harvard University Press, 1994.

Richardson, E.P. "Four American Political Prints." *The American Art Journal* 6 (November 1974): 36–44.

Roberts, Kenneth. Comp. and annot., *March to Quebec: Journals of the Members of Arnold's Expedition*. New York: Doubleday, Doran and Co., 1938.

Robinson, John Martin. *Temples of Delight: Stowe Landscape Gardens*. London: National Trust and George Philip, 1990.

Robinson, Thomas P. "Some Notes on Major-General Richard Montgomery." *New York History* 36, no. 4 (October 1956): 388–98.

Rosenberg, Pierre. "Franklin and Fragonard." *Proceedings of the American Philosophical Society* 150, no. 4 (December 2006): 575–90.

Royster, Charles. *A Revolutionary People at War: The Continental Army and American Character, 1775–1783*. Chapel Hill: University of North Carolina, 1979.

Sale, Edith Tunis, and James River Garden Club. *Historic Gardens of Virginia*. Richmond, VA: The William Byrd Press, 1923.

Saunders, Richard H. *John Smibert: Colonial America's First Portrait Painter*. New Haven: Yale University Press, 1995.

———, and Ellen G. Miles. *American Colonial Portraits: 1700–1776*. Washington, D.C.: National Portrait Gallery, 1987.

Savage, Kirk. "The Self-made Monument: George Washington and the Fight to Erect a National Monument." Harriet F. Senie and Sally Webster, eds. In *Critical Issues in Public Art: Content, Context and Controversy*. New York: IconEditions, Harper Collins, 1992.

Schama, Simon. *Dead Certainties: Unwarranted Speculations*. New York: Alfred Knopf, 1991.

Scherf, Guilhem. "Houdon "Above all Modern Artists." In Anne L. Poulet, *Jean-Antoine Houdon, Sculptor of the Enlightenment*, Washington, D.C.: National Gallery of Art, 2003, 16–27.

Schecter, Barnet. *The Battle for New York: The City at the Heart of the American Revolution*. New York: Penguin Books, 2002.

Schechter, Stephen L., ed. *The Reluctant Pillar; New York and the Adoption of the Federal Constitution*. Troy, NY: Russell Sage College, 1985.

Schiff, Stacy. *A Great Improvisation: Franklin, France, and the Birth of America*. New York: Henry Holt, 2005.

Schlesinger, Arthur M. "Liberty Tree: A Genealogy." *New England Quarterly*, 25, no. 4 (December 1952): 435–58.

Scott, Pamela. "Robert Mills and American Monuments." In John M. Bryan, ed. *Robert Mills Architect*. Washington, D.C.: American Institute of Architects, 1989.

Sellers, Charles Coleman. *The Artist of the Revolution: The Early Life of Charles Willson Peale*. Hebron, CT: Feather and Good, 1939.

———. *Benjamin Franklin in Portraiture*. New Haven: Yale University Press, 1962.

———. *Charles Willson Peale*. New York: Charles Scribner's Sons, 1969.

———. *Portraits and Miniatures by Charles Willson Peale*. Philadelphia: American Philosophical Society, 1952.

———. "Virginia's Great Allegory of William Pitt." *The William and Mary Quarterly* 9, no. 1 (January 1952): 58–68.

———. *Mr. Peale's Museum: Charles Willson Peale and the First Popular Museum of Natural Science and Art*. New York: W.W. Norton, 1980.

Shelton, Hal T. *General Richard Montgomery and the American Revolution: From Redcoat to Rebel*. New York: New York University Press, 1994.

Sheriff, Mary D. "'Au Génie de Franklin': An Allegory by J.-H. Fragonard," 127, no. 3 (June 1983): 180–93.

Silverman, Kenneth. *A Cultural History of the American Revolution*. New York: Thomas Crowell Company, 1976.

Simpson, Sarah H. J. "The Federal Procession in the City of New York." *New-York Historical Society Quarterly Bulletin* 9 (1926): 39–57.

Singleton, Esther. *Social New York under the Georges, 1714–1776*. New York: D. Appleton and Co. 1902.

Sloan, Kim, ed. *Enlightenment Discovering the World in the Eighteenth Century*. London: British Museum Press, 2003.

Smith, Helen Burr. "John Mare (1739–ca. 1795), New York Portrait Painter." *New-York Historical Society Quarterly* 35, no. 4 (October 1951): 355–99.

Smith, Helen Burr, and Elizabeth V. Moore. "John Mare: A Composite Portrait." *North Carolina Historical Review* 44 (1967): 18–52.

Smith, Justin H. *Our Struggle for the Fourteenth Colony: Canada and the American Revolution*. 2 vols. New York: G.P. Putman's Sons, 1907.

Smith, Thomas E.V. *The City of New York in the Year of Washington's Inauguration 1789*. New York: A.D.F. Randolph and Co., 1889.

Smith, William. *Historical Memoirs of William Smith*, ed. WH.W. Sabine. New York: *New York Times*, 1971.

———. *The History of the Late Province of New-York from Its Discovery to the Appointment of Governor Colden in 1762*, ed. William Smith Jr. 2 vols. New York: New-York Historical Society, 1829.

Sommer, Frank H., III. "Emblem and Device: The Origin of the Great Seal of the United States." *The Art Quarterly* 24 (Spring 1961), 57–76.

Stinchcombe, William C. "Americans Celebrate the Birth of the Dauphin." In Ronald Hoffman and Peter J. Albert, eds., *Diplomacy and Revolution: The Franco-American Alliance of 1778*. Charlottesville: University Press of Virginia, 1981, 39–72.

Stow, Charles Messer. "The Franklin of Caffiéri and His Contemporaries." *The Antiquarian* 15 (November 1930): 58–60, 92.

Strand, Ginger. "The Many Deaths of Montgomery: Audiences and Pamphlet Plays of the Revolution." *American Literary History* 9 (Spring 1997): 1–20.

Trafton, Burton W.F., Jr., "Louisbourg and the Pepperell Silver." *Antiques* 89 (March 1966): 366–7.

Trowles, Tony. *Treasures of Westminster Abbey*. London: Scala Publishers, 2008.

Van Buskirk, Judith. *Generous Enemies: Patriots and Loyalists in Revolutionary New York*. Philadelphia: University of Pennsylvania Press, 2002.

Varga, Nicholas, "Robert Charles: New York Agent, 1748–1770." *The William and Mary Quarterly* 18, no. 2 (April 1961): 211–35.

Von Erffa, Helmut and Allen Staley. *The Paintings of Benjamin West*. New Haven: Yale University Press, 1986.

Wall, Alexander J. "The Equestrian Statue of George III and the Pedestrian Statue of William Pitt." *New-York Historical Society Quarterly Bulletin* 4 (July 1920): 37–57.

Wallace, Mike, and Edwin G. Burrows. *Gotham: A History of New York City to 1898*. New York: Oxford University Press, 1999.

Warren, George Washington. *The History of the Bunker Hill Monument Association during the First Century of the United States of America*. Boston: J.R. Osgood, 1877.

Warren, Mercy. *History of the Rise, Progress and Termination of the American Revolution Interpreted with Biographical, Political and Moral Observations*. 3 vols. Boston: Manning and Loring for E. Larkin, 1805.

Weisberger, R. William. "Parisian Masonry, the Lodge of the Nine Sisters, and the French Enlightenment." *Heredom* 10 (2002): 155–202.

Wendel, Jacques M. "Turgot and the American Revolution." *Modern Age* (Summer 1997): 282–9.

Wertenbaker, Thomas Jefferson. *Father Knickerbocker Rebels: New York City during the Revolution*. New York: Charles Scribner's Sons, 1948.

West, Alison. *From Pigalle to Préault: Neoclassicism and the Sublime in French Sculpture, 1760–1840*. New York: Cambridge University Press, 1998.

Whinney, Margaret D. *Sculpture in Britain, 1530 1830*. Baltimore: Penguin Books, 1964.

Willis, Peter. *Charles Bridgeman and the English Landscape Garden*. Newcastle Upon Tyne: Elysium Press, 2002.

Wilson, James Grant. *The Memorial History of New York*. 4 vols. New York: New York History Co., 1895 edition.

Wood, Gordon S. *The Americanization of Benjamin Franklin*. Chapel Hill: University of North Carolina Press, 1969; paperback reprint 1998; New York: Penguin Press, 2004; paperback reprint, 1998.

———. *The Creation of the American Republic, 1776–1787*. 1969; repr. Chapel Hill: University of North Carolina Press, 1998.

Yarrington, Alison. *The Commemoration of the Hero 1800–1864: Monuments to the British Victors of the Napoleonic Wars*. New York: Garland Publishing, 1988.

Yenawine, Bruce H. "Benjamin Franklin's Legacy of Virtue, the Franklin Trusts of Boston and Philadelphia." PhD diss., Syracuse University, 1993.

Yoshpe, Harry. "The DeLancey Estate: Did the Revolution Democratize Landing Holding in New York?" *New York History* 17 (April 1936): 167–79.

Index

column/s
 Monument … (J.-J. Caffiéri) and, 154,
 160n59, 161–4, *162*, 190
 Pillar of Liberty in Dedham, MA and,
 52, 83n5
 St. Paul's Chapel and, 171
 Washington Monument (Mills; in
 1815–1829 in Baltimore, MD), 194
commemoration. *See* memorialization
 in America; memorialization in
 Europe; memorialization in Great
 Britain
Common Council of New York, 64, 71,
 87n50, 168, 170, 197n22
Commons (Fields, now City Hall
 Park), 7, 54, 71
communitarian efforts, 44, 127–8, 133–
 40, 144, 156n4, 157n12, 157n22
Constitution of the United States,
 170, 183
Continental Army, 92, 97–8, 103,
 104–11, 164, 166, 178–9, 182–3
Continental Congress
 "Articles of Capitulation" from
 Montreal and, 108
 Canada invasion and, 104–5, 108,
 110, 126
 Committee of Secret
 Correspondence and, 127, 175
 Declaration of Independence and, 2,
 61, 86n44, 127, 142, 163
 eulogy for RM and, 123–4
 federal power and, 178, 182–3
 Great Seal and, 177
 history of, 97–8
 independence and, 5–6, 91
 internal threats and, 182–3
 liberty and, 5–6, 91
 meeting locations of, 164
 military pensions and, 164, 166,
 178–9, 182–3
 Monument … (J.-J. Caffiéri) and, 5–7,
 65, 91, 113–14, 128, 142, 161, 163–4,
 196n9

public memorialization and, 192–3,
 195n3, 195n5, 200nn79–83
 Quebec campaign and, 108–12
 reconciliation versus independence
 and, 100–102, 102–3, 111–12, 114
 RM's heroes/heroism and, 5–6, 91,
 111–14, 168
 Stamp Act Congress and, 58, 85n25
 symbolic elements and, 8
 Tea Act and, 96
 Townsend Acts and, 96
Countryman, Edward, 48n52, 101
Coutu, Joan, 50n71
Cox, Allyn, *Washington's Inauguration*,
 185, *185*
Crane, Verner W., 157n24
Craske, Matthew, 25
Craven, Wayne, 192
Cruger, John (mayor), 63–4
Cruger, John (nephew of mayor),
 58, 63
cult of hero, 6
cultural ambitions, in America, 3, 13,
 17–20, *18*, *21*, 30, 44, 53, 56, 144.
 See also civic society
Cumming, W.P., 35

Dalton, Richard, 17, 46n16
Dangerfield, George, 168
D'Angiviller, Comte, 150–151
De Lancey, Anne (later Jones), 55–6,
 86n38
De Lancey, Edward, 55–6, 61, 86n38
De Lancey, James ("Jamie" or "Captain
 James"), 44, 63, 66, 88n61
De Lancey, James, 13, *15*, 23, 39, 57
De Lancey, Oliver (ODL). *See also*
 Wolfe obelisk, at Greenwich
 Village estate
 Greenwich Village estate and, 44,
 49n64
 private memorialization and, 7, 23,
 38–40, 49n63, 49n66, 56